THE LOST IMPRESSIONISTS

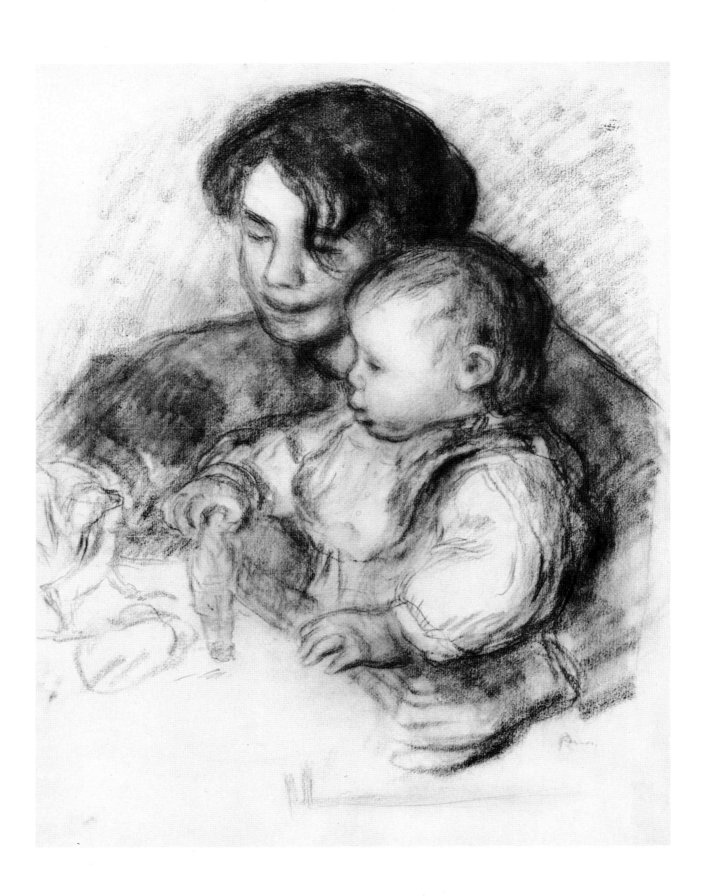

THE LOST IMPRESSIONISTS

Masterpieces from Private Collections

Susanna de Vries-Evans

ROBERTS RINEHART PUBLISHERS

Copyright © Film Art Holdings Ltd., 1992
Copyright © David Bateman Ltd., New Zealand

Published in the United States of America by Roberts
Rinehart Publishers, Post Office Box 666, Niwot, Colorado 80544,
in association with David Bateman Ltd., "Golden Heights",
32–34 View Rd, Glenfield, Auckland, New Zealand

International Standard Book Number 1-879373-25-4
Library of Congress Catalog Card Number 92-80168

Published in Canada by Key Porter Books
70 the Esplanade, Toronto, Ontario M5E 1R2

Designed by Errol McLeary.
Printed in Hong Kong by Everbest Printing Co. Ltd.

CONTENTS

THE PAINTINGS

THE COLLECTORS

DEDICATION

To my multi-talented husband Jake, with many thanks for all his moral and practical support, particularly during the three years it took to compile this book.

ACKNOWLEDGEMENTS

I would like to thank those private collectors who wish to remain anonymous but have so generously consented to let us share the beauty of their treasures and allowed me to publish them. I am also most grateful to owners and curatorial staff of great private collections and the library staff who have given so generously of their time and scholarly expertise to this project; particularly Frances Chaves, Curator of the Reader's Digest Corporate Collection; Lachlan Phillips and Ignacio Moreno of the Phillips Collection, Washington D.C.; Baron Thyssen-Bornemisza's curator, Maria Antonia Reinhard; Dr. Dennis Farr of the Courtauld Institute Galleries; Mr. and Mrs. Paul Mellon's curator, Beverly Carter; Mr. and Mrs. Walter Annenberg's secretarial assistant, Linda Sinclair Brooks; Matthias Frehner of the Oskar Reinhart Collection; Susan Alysson Stein of the Metropolitan Museum of Art, New York; Johanna Ling and Margery Delpeche of Sotheby's, London; Katherine Fleet of Christie's Impressionist Department, New York; Lord Mark Poltimore and James Roundell of Christie's, London; Jamie Smith of the Daniel J. Terra Museum; Lorah Dulisse of the Getty Museum, Malibu; Group Captain Alastair Aird, Comptroller to Her Majesty the Queen Mother; David S. Brooks, Director, Sterling and Francine Clark Art Institute, Mass.; Mrs. Hortense Anda-Bührle of the Bührle Foundation, Zurich; the directors of Altman-Burke Fine Art; Robert Clémentz of the Fondation Dr. Rau du Tiers-Etat; Margret Meagher, art consultant of Sydney; William Acquavella of Acquavella Galleries, New York; Dr. Sara Campbell of the Norton Simon Museum; Charles E. Hilburn and the directors of Gulf States Paper Corporation; Dr. Anna Castberg, art consultant of London; Professor John Tyrer; and Viscountess Bridgeman of the Bridgeman Library. Tammy Morley and John Cook of the State Library of Queensland; Judy Gunning, Librarian, Queensland Art Gallery. Special thanks to Joan Shepherd who helped type the manuscript; publishers Janet and David Bateman, and Mike White; and those dedicated collectors and conservers of great paintings, James Liautaud, Heinz Berggruen, Baron Thyssen-Bornemisza, Janet Holmes à Court, John Shaeffer, Peter Fairbanks, Walter Annenberg, Laurence Graff, the late Lady Peggy Trout, Norton Simon and, last but not least, Miss Elizabeth Taylor.

INTRODUCTION

Claude Monet

Pierre-Auguste Renoir
Victor Chocquet.
Oskar Reinhart Collection.

At the Impressionists' first exhibitions, most collectors jeered at what they regarded as unfinished sketches. Accustomed to 'brown pictures' painted in the studio and the classicism of Claude and Poussin, they laughed at the unfamiliar feathery brushstrokes and the scarlet disc of the sun in Monet's *Impression: sunrise*.

This was the painting which was singled out for special derision by a young journalist named Louis Leroy, and which gave its name to the group. Of course, had Leroy bought Monet's *Impression: sunrise* rather than ridiculing it, in his old age he could have sold it for a large sum. Instead, Monet's 'impression' was purchased by Dr. Georges de Bellio, whose daughter eventually bequeathed it to the Marmottan Museum (short biographies of Dr. de Bellio and of the other principal collectors of Impressionist paintings from the pioneer days to the 1980s start on p. 160). Just over a century after Leroy jeered at *Impression: sunrise*, specialist art thieves broke into the Marmottan and stole the painting, believing they could sell it to a Japanese collector for many millions.

Laughter and scorn are often a result of apprehension: Paris in the 1870s – the period during which the Impressionists held their first exhibitions – was a city that had recently undergone a bloody revolution with Communards dying at the barricades. Although, with the exception of Pissarro, the Impressionists were generally apolitical, the egalitarian subject-matter of their paintings only reinforced the fear among the haute bourgeoisie that the Impressionists (or *Intransigents* as they were initially styled) were a subversive left-wing group, intent on promoting social reform through their art. At the first Impressionist exhibition in April 1874 Cézanne's parody of Manet's *Olympia* set in a brothel outraged a journalist, who warned pregnant women not to attend the exhibition in case they should faint with shock.

However, the art critic Théodore Duret did champion the new art movement. He was a keen collector of modern art and was angry with those who did not appreciate that the Impressionists were trying to mirror the social upheaval that was taking place around them and portray France's changing society. 'You have made a grave error of judgement, but one day you will alter your opinions,' wrote Duret in 1878, chiding the smug collectors who refused to buy Impressionist paintings.

The Impressionists' prices were not the problem, because in their eight exhibitions from 1874 to 1886 they charged relatively little, but still the aristocrats and the newly prosperous middle class did not patronise them. This was a disaster for Renoir, Monet and Pissarro, who, unlike most of the others, did not have financial support from their parents. As there were no Government grants or social security payments for them, it was either sell or starve.

The handful of collectors the Impressionists did manage to attract came from the affluent bourgeoisie. The sole exception was Victor Chocquet, a customs official who deprived himself of luxuries in order to buy works by Renoir and Cézanne. The famous baritone Jean-Baptiste Faure was the only collector actually prepared to take the gamble of speculating in Impressionist art rather than buying art 'for art's sake'. Faure liked the Impressionists' style from the

very first, and realising that his earnings would end when his voice went, he bravely bought paintings direct from the artists hoping to re-sell them profitably in his old age.

During the 1870s and 1880s the Impressionists' work was considered far too radical and avant-garde for national collections or even for most dealers to buy it. Paul Durand-Ruel, the only dealer who would buy their work for eventual re-sale to collectors, was vital to the poorer members of the group. So too were the amateurs in the group who bought their fellow-artists' work – true art-lovers like refrigeration tycoon Henri Rouart and the young millionaire who would help organise their exhibitions, Gustave Caillebotte. Caillebotte and Rouart collected Impressionist paintings because they enjoyed painting out of doors themselves and wished to use their wealth to help their fellow-artists.

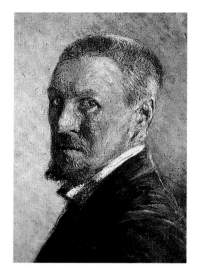

Gustave Caillebotte

Fortunately, whenever possible, the members of the group supported each other. Edgar Degas was a keen collector of paintings by others from the group. Using his father's allowance, Manet commissioned paintings from Monet when the younger artist faced a financial crisis at Argenteuil. Gauguin also collected Impressionist works when he worked as a stockbroker. However, after the stock-market crash of 1882, when Gauguin gave up his broking career in order to become an artist himself, his deteriorating financial state forced him to sell most of his collection.

The financial and psychological support of the handful of early collectors was vital. Monet's letters to Dr. de Bellio reveal that without the doctor as a collector he would have been forced to abandon art as a career. Monet did not earn enough to support his family until eleven years after the first Impressionist exhibition; not until 1885, when he had his first exhibition at the elegant Georges Petit Gallery, did 'establishment' French collectors and American tourists see his work, take it seriously and buy it.

During the 1890s, the work of Monet, Renoir, Sisley, Cézanne, van Gogh and Gauguin began to sell for good prices, while the previously top-selling 'Salon' canvases of Meissonier and Bougereau actually decreased in value relative to inflation. In 1880 Meissonier's military scenes sold for three to ten times the price of a major Monet. A century later the top auction price for a Meissonier was only £5,460, while Monet's *Santa Maria della Salute* (pp. 44–5) had soared to £6,000,000 in value. How delighted Duret would have been with history's vindication of his judgement!

Through exhibitions at enterprising galleries like those of Paul Durand-Ruel and Georges Petit, the once omnipotent power of the Paris Salon was weakened, until it was no longer considered the only place for collectors to buy paintings by up-and-coming artists. Of course, from their dealers' point of view, the Impressionists had the advantage that they painted rapidly and prolifically, ensuring that Durand-Ruel, Petit and fellow-dealers like Vollard and the Bernheim brothers could create a 'collectors' market' for Impressionism through exhibitions and publicity.

During the prosperous and stable years which ended with the Great War of 1914, prices of Impressionist and Post-Impressionist works increased by as much as 1,000%. By 1903 even works by the once-despised Cézanne and van Gogh had become collectible, though van Gogh was no longer alive to enjoy his

new-found reputation.

Due to the pioneer American collectors of these Belle Epoque years, America possesses a wealth of great Impressionist art – both in public and private collections. The majority of the early American collectors came from the booming Mid-West. Chicago industrialists sent the farm machinery which their factories manufactured to the great international exhibitions held in Paris, then, after they and their wives had visited their stands at the exhibitions, they went shopping for French wine and fashions and also bought paintings by Monet and Renoir at the galleries of Georges Petit and Durand-Ruel.

Bertha Honoré Potter Palmer bought enough Monet landscapes on her annual trips to Paris to form a great frieze around her Chicago ballroom. In between buying dresses from Doucet and Pingat, Mrs. Potter Palmer also found time to buy a Degas and four Renoirs. Eventually she arranged a great exhibition of French paintings at Chicago's Exposition of 1893 (held to commemorate Columbus's voyage in 1492). Her Monets and Renoirs are now in Chicago's Art Institute – another product of the booming 1890s.

Louisine Elder borrowed $100 to buy her first Degas (a purchase which provided the artist with much-needed financial support). After her marriage to Harry Havemeyer, she infected her husband with her own enthusiasm for 'modern French painting'. He had an alcohol problem which had destroyed his first marriage to Louisine's aunt, but collecting contemporary art provided a new interest to overcome his drinking. Shunned by 'polite' society due to Harry's divorce, the Havemeyers built a collection containing some of the greatest works of Impressionism. Louisine was the embodiment of the altruistic art collector: she never collected for money but cared deeply about her paintings and bequeathed only her very best canvases to New York's Metropolitan Museum.

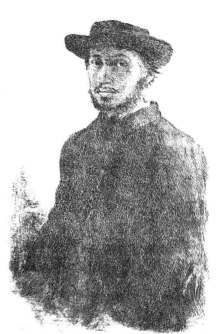

Edgar Degas
Self-portrait

The seductive colour and charm of many of the Impressionists' and Post-Impressionists' works ensured that by the mid-twentieth century they were the world's most popular school of artists, because they made viewers and potential buyers *feel* happy. In 1927 Theodore Pitcairn, middle-aged son of the founder of the gigantic Pittsburg Glass Company, saw a Monet in a New York art dealer's window and described how, 'I bought it in ten minutes for about $11,000. I wasn't thinking of investment. We were both struck by its cheerful quality and thought this... picture would always give us a lift.' Perhaps this 'cheerful quality' (with no references to the dark side of human nature or to religion) is what makes Impressionist works especially irresistible to middle-aged collectors, starting to feel premonitions of mortality. These rich, self-confident Americans loved the sense of democracy they found in Pissarro's peasants, the fresh colour in Monet's landscapes and the joy of life they experienced anew from Renoir's young girls.

The patronage of so many free-spending Americans after long years of neglect and disapproval in Europe provided the Impressionists with much-needed financial support and psychological encouragement. Unlike central European and Jewish collectors, accustomed to wars and pogroms and the need for portable wealth, these wealthy American collectors of the Belle Epoque came relatively late to the idea that it was possible to make money out of art. Chester

Dale, the Cone sisters and Mrs. Potter Palmer bought art 'for art's sake' and for the sheer pleasure of taking French culture home to America, as did Duncan Phillips and Robert Sterling Clark in the 1920s. Each painting removed from its crate was proof that European civilisation could be exported to America. Impressionist collections in America were rapidly up-graded from third to first class in quality.

In 1888 Paul Durand-Ruel set up a branch of his gallery in New York. His early efforts to sell to American collectors were aided by American Impressionists who had lived and worked abroad, such as William Merritt Chase, Theodore Robinson and Mary Cassatt. Initially the high import duty payable on foreign paintings inhibited many American collectors from buying. However, in 1911 Customs duty was repealed, and American imports of modern French paintings soared.

The great English art-dealer Joseph Duveen eventually persuaded multi-millionaires like Andrew Mellon and Samuel Kress to pay fortunes for art masterpieces and then to ensure their own immortality by bequeathing their collections to American museums. Andrew Mellon's son Paul has continued this great American tradition of giving. Of course, unlike their British counterparts, tycoons and speculators who made great wealth in America could not obtain titles by discreet donations to political parties, but they could greatly increase their social status by owning a prestigious art collection, even if, like Dr. Alfred Barnes, they denied most people access to it.

From the 1920s, well-educated heirs to great American fortunes, such as Sterling Clark and Duncan Phillips, with time, taste and money to burn, bought Impressionist works with no desire for increased wealth or social status, as they already possessed these as their birthright. A generation later, members of Chicago's establishment could boast how they did not need to buy Renoirs: theirs were inherited from their grandmothers. Americans had dominated the French Impressionist market until 1914, when the outbreak of World War I caused most American collectors to stop buying.

But not all were noble philanthropists. Dr. Alfred Barnes was one of the very few to collect art throughout World War I, a period when most Americans thought it unpatriotic to spend large sums on foreign art. The thick-skinned Barnes boasted that he had bought art treasures from impoverished French collectors for a pittance, convinced that they would rise in value again later. He was right. When the war ended, prices of Impressionist paintings virtually doubled.

This increase continued throughout the stable boom years of the 1920s, but paintings did not increase nearly as steeply in value as did stocks and bonds, into which the rich and the middle-class rushed headlong, heedless of impending disaster. The late 1920s were the golden years for major collectors in America and Europe like financier Chester Dale, textile millionaire Samuel Courtauld, and heiresses Adelaide Milton de Groot and Helene Kröller-Müller (who bought 278 van Goghs and eventually bequeathed them to her own museum in Otterlo, Holland).

In the stock market crash of 1929 many collectors like Helene Kröller-Müller lost their spending power, although art did not slump as badly as stocks

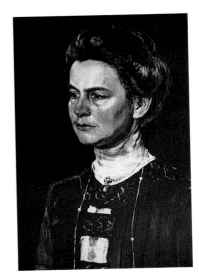

Helene Kröller-Müller

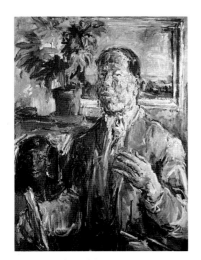

Oskar Kokoschka
Portrait of Emil Bührle
Private collection

and bonds, because usually the last things dedicated collectors are willing to part with are their best paintings. This depression in the art market continued throughout World War II to the end of the 1940s. Armaments manufacturer Emil Bührle was one of the very few collectors still buying from Swiss dealers during World War II. Now Reichsmarshall Goering and Adolf Hitler became Europe's most prominent collectors. Goering gave orders that all paintings confiscated from Jewish collectors should be displayed in Paris's Jeu de Paume Museum, where he would personally select which paintings to ship back to Germany for himself and the Führer. Renoir's beautiful *Woman with a rose* (p. 82) spent World War II in Goering's collection but was returned to its rightful owner by the Allies.

After the war, Impressionist works, with their intimate scale, became far more popular with many collectors than larger, earlier paintings in heavy gilded frames: domestic servants were no longer readily available, and even the very rich now lived in smaller houses or apartments.

While America opened its heart to the Impressionists, British collectors have never been numerous, and even today the big buyers at auction do not generally come from Britain. During the early 1870s Durand-Ruel attempted to sell Impressionist works in his Bond Street gallery and nearly bankrupted himself in the process. Conservative British aristocrats preferred 'traditional' British artists like Gainsborough, Reynolds, Turner and Constable or 'literary' paintings which told the viewer a story. There was also a financial reason. During the agricultural crisis of the 1870s, the annual income of most British landowners declined due to the import of cheap subsidised wheat, and many had to sell inherited British paintings and antiques rather than buy 'modern' French paintings. Although Sickert, Wilson Steer and Conder attempted to change public taste, exhibiting a modified version of Impressionism at the New English Art Club from 1886 onwards, progress was slow. However, dedicated collectors Samuel Courtauld and Sir Hugh Lane donated Impressionist works to the National Gallery, helping to change public taste towards Impressionism.

During World War II many great European collections of Impressionist art were stored underground, their owners fearing air-raids. Others were sold, as their owners fled from the Nazis to London and America; many, such as the bankers Siegfried Kramarsky and Jakob Goldschmidt, used them as portable capital. Post-war economic recovery in Europe was slow. In 1952 Mme. Juliet Walter (formerly married to the art dealer Paul Guillaume and now re-married to an architect fortunate enough to own a mine in Morocco) created a media furore when she paid a record price for Cézanne's great *Apples and biscuits* at the sale of Gabriel Cognacq's collection. Prices started to rise again.

In 1954 Wilhelm Weinberg, a German-Jewish collector who started collecting art to forget the deaths of his wife and children in the Holocaust, sold his great collection of works by van Gogh through Sotheby's in London. Although there are numerous van Gogh forgeries, Weinberg's paintings had all been authenticated in the J. B. Faille catalogue of the artist's work. Sotheby's was then run as a cosy club for dealers and a few knowledgeable collectors and lacked what is now an essential adjunct of every major auction house – a Press Department. However, the saleroom's senior partner, Peter Wilson, was not

afraid to take risks if the odds were in his favour, and he hired J. Walter Thompson to do the advance publicity for the sale. There was enormous public interest in the sale, especially when H.M. Queen Elizabeth II requested a private viewing. It had taken nearly three decades since the Stock Market crash of 1929, but by 1954 prices were almost back to the levels of the art boom of 1928.

Sotheby's successful sale of the Weinberg collection began a gradual shift of Impressionist auctions away from Paris, and London became the centre of the art trade in the 1960s and '70s. This was partly because the French Government charged exorbitant taxes to vendors at the Government-run auctioneers Drouot in Paris. Then in the 1980s, as the new highly leveraged buyers took over from the older art collectors, the Impressionist market shifted once again: to New York.

Peter Wilson was the man who changed art collecting. He had a magnetic presence and a wide circle of wealthy acquaintances. Wilson followed up the success of the Weinberg sale with the sale of Alfred Schwabacher's collection of Impressionists. Realising that the rich all over the world were alarmed by the way inflation was rapidly eroding the value of their money, Wilson marketed Impressionist art as a 'blue chip' investment. The days of Sotheby's and Christie's as cosy clubs for dealers were over when Peter Wilson instituted the publication of Sotheby's Art Indexes. For the first time art prices were recorded like stocks and bonds and mailed out to collectors. Graphs and explanations effectively removed much of the mystique of art collecting that dealers had relied upon so much. The power of the dealer-client relationship was noticeably weakened; in its place the concept of Impressionist art as a portable investment for speculators slowly gained ground.

Edgar Degas
Manet seated, facing right

In October 1958 Peter Wilson sold off with flair and showmanship a remarkable Impressionist collection built up by German-Jewish banker Jakob Goldschmidt. This was Sotheby's first 'black tie' evening sale, held at 9.30 p.m. as Wilson wished to imitate Parke Bernet's success with the Lurcy sale in New York. To beat Christie's and win the collection from Goldschmidt's heirs, Wilson had initiated a flexible vendors' commission. He ordered that the Goldschmidt catalogue be illustrated in colour (previous sale catalogues had been all black-and-white) and masterminded vast pre-sale publicity. American and European collectors flocked to the sale. American multi-millionaire art-lover Paul Mellon bought Manet's *Rue Mosnier with flags*, which he was to re-sell for a profit of many millions to the Getty Museum two decades later. He also paid a record price for Cézanne's *Boy in the red waistcoat*, which he subsequently donated to Washington's National Gallery.

In the 1960s intense rivalry began between Greek tanker owners to buy Renoirs and van Goghs at greatly inflated prices. The closure of the Suez Canal in 1967 had brought them undreamed-of riches, and the icon of success for Stavros Niarchos and Aristotle Onassis became a van Gogh cornfield or a Renoir nude hanging on the bulkhead of their yacht. Onassis, Niarchos and Basil Goulandris often bid against each other at auction, entrusting their bidding to different dealers. Their aggressive business rivalry, now transferred to the saleroom, often doubled or trebled the auctioneer's estimated prices. In

1968 Onassis paid a record $1,541,550 for Renoir's *Pont des Arts* at a New York auction, because he wanted the painting as a wedding present for his new bride – Jacqueline Kennedy. Eventually Goulandris started bidding for himself, finding to his surprise that the publicity Gauguin's great *Mau tapozo* gave him was far greater than that won from his business successes.

Hollywood stars like Edward G. Robinson also started collecting Impressionists. Elizabeth Taylor, whose father was an art dealer, invested some of her millions earned from the film *Cleopatra* in a van Gogh – bought by her father at auction. Greta Garbo bought herself a few pretty Renoirs in her retirement. Hollywood producers Hal B. Wallis, whose collection would eventually be sold by Christie's, and Sam Spielberg became keen collectors. However, Edward G. Robinson's bitterly-contested divorce forced him to sell his magnificent collection to Niarchos.

The 1970s saw Impressionist works increase in value as inflation continued on both sides of the Atlantic. Now many of the great collectors bid for themselves. But there were problems: Norton Simon's bidding code was so eccentric that he sometimes left the auctioneer totally confused, and the painting had to be re-offered. Simon's code included rubbing his nose, sitting down and standing up. On one memorable occasion Simon and his wife, film star Jennifer Jones, bid against each other by mistake. But at this stage the great art museums could still afford to bid for Impressionist works (in 1970 the Metropolitan Museum held the bidding record of $4 million for a Cézanne). In addition to the great American tradition of cultural philanthropy, donations of art to public galleries had been given an enormous boost by the American Government's tax-minimisation legislation, which encouraged such gifts and so kept many masterpieces out of the hands of Christie's and Sotheby's.

In 1973 the traumatic rise in the price of oil saw the stock market collapse to pre-war levels, resulting in a slow-down in the art trade and a fall of between 15% and 20% in art prices. This slump in the New York art market lasted eighteen months and triggered a scandal about 'buy-ins' and imaginary 'bids off the chandelier', when it became obvious that the auctioneer's 'Lists of Paintings Sold' included many that had failed to reach reserve price and had been returned to their vendors after auction. The ensuing publicity saw the system changed – unsold lots are now always omitted from the lists of reputable auction houses. In 1975 Christie's imposed a 10% buyers' premium, which infuriated collectors; but Sotheby's, whose overdraft had now soared five-fold, soon followed suit.

In June 1978 the economy revived – at the vast sale of Robert von Hirsch's artworks his Impressionist paintings more than doubled their estimates – but during the recession of 1982–83 prices dropped once again. However, the combination during the mid-80s of rising prosperity and high inflation meant that collecting Impressionists became highly profitable for all concerned. Major Impressionist works soared in value by an incredible 200–500% over the decade. Enlarged PR departments at Sotheby's and Christie's churned out a constant stream of media publicity about their latest auction successes, and magazines were bombarded with free colour transparencies. These tactics worked well in the booming economy, as did the fact that many of the new rich were buying

either with 'black money' or with funds that the over-confident banks and leasing companies were only too happy to lend them, mistakenly believing that Impressionist art was like bullion and would rise and rise indefinitely.

In 1985 Peter Wilson staged a pre-sale tour in New York, Tokyo, London and Lausanne for the well-chosen collection of Florence J. Gould. Sotheby's American chairman John L. Tancock announced that the Gould Sale would be 'preceded by press coverage... to rival that of a presidential campaign'. It was. Peter Wilson cleverly hyped the image of Florence Gould as a 'great' art collector, when she had merely bought paintings for decoration. But Florence was a colourful figure, widow of Frank J. Gould, younger son of that archetypal American robber baron Jay Gould, and following her husband's death she had retired to the French Riviera, where she had been a neighbour of Peter Wilson. Sotheby's had gained an important advantage over their rivals by the time of the Gould Sale, because American property developer Alfred Taubmann had bought the firm (some wags joked that it had been a wedding present for Taubmann's second wife, Judy, who had once worked on Christie's front desk). Everyone expected sparks to fly between Wilson and Taubmann, but they confounded critics by working harmoniously together. Taubmann's vast financial resources enabled Sotheby's to inflate its PR campaigns and advertising budgets to unprecedented levels. Although some art critics sneered over the merits of Florence Gould's paintings, her van Gogh of Saint-Rémy – the only major work in the collection – achieved a world record of $32.6 million (£26.5 million).

Peter Wilson now realised that Japanese collectors and corporations and non-taxpaying Swiss 'residents' would attend major name black-tie sales and bid top prices – provided that they had first seen the paintings on their home ground. So major Impressionist paintings were now crated up and airfreighted off to private viewings at selected galleries and department stores in Switzerland and Japan. Black-tie evening sales gradually acquired the atmosphere of a casino; by the end of the decade a painting had to make at least ten million before *anyone* clapped. Film and TV stars, like collector-dealer Alain Delon, joined in the Art Game. Cindy Spelling, wife of 'Dynasty' producer Aaron Spelling, bought a Monet for millions; Australian entrepreneur Alan Bond paid a then-record price for van Gogh's *Irises*, with money supplied by Sotheby's Financial Services (who were now lending millions for the leveraged purchase of all kinds of artworks bought through them). American and Australian banks also loaned money on paintings as though they were real estate. Speculators paid millions for their paintings, treating them as portable assets, often placing them in special art storage warehouses and bank vaults – especially favoured by armaments dealers is the one near Zurich Airport – or, like Bond, on boardroom walls in tower blocks.

For a time it seemed that the Japanese were so gullible they would buy virtually anything signed Monet, Renoir or van Gogh, even those dreadful, scrappy little oil sketches out of Renoir's wastepaper basket. However, everything began to change when the Osaka-based land developer Itoman Company collapsed, owing billions to the Sumitomo Bank. Itoman's art buyer committed suicide in 1990 after it was revealed that he had spent over $500 million on

Vincent van Gogh
Portrait of Dr. Gachet (detail)

paintings, all bought from the art gallery run by the daughter of Itoman's chairman at vastly inflated prices based on 'valuation' certificates supplied by the gallery – using loans from the Sumitomo Bank. For a time Impressionist art risked becoming a dirty word, considered tainted rather than bestowing spiritual values. Paintings had been used to bribe politicians and tax officials and to avoid corporation tax. Japanese private collectors had also bought them to avoid exceptionally high inheritance taxes: when grandfather died, his children and grandchildren simply walked out with the paintings under their arms before the taxman arrived.

In May 1990 74-year-old paper manufacturer Ryoei Saito was still prepared to pay $210 million in one week for two paintings – a version of Renoir's well-known *Ball at the Moulin de la Galette* (a painting once owned by Victor Chocquet) and van Gogh's own copy of his portrait of art collector Dr. Gachet. However, the art merry-go-round stopped abruptly in December 1990 when Christie's followed Sotheby's 'famous provenance' technique for their attempted sale of Elizabeth Taylor's van Gogh (p. 105). The painting of the Saint-Rémy asylum was estimated at around $20 million – double the price Florence Gould's more dramatic van Gogh of Saint-Rémy had fetched five years previously. While Miss Taylor's van Gogh was reportedly offered to benefit AIDS research, and everyone thought that following the success of Greta Garbo's collection it must sell, threats of recession and the Gulf War loomed, and Elizabeth Taylor's van Gogh was bought in.

The storm of unfavourable publicity about Sotheby's dual role as auctioneer and money-lender, and the fact that both auction houses had given guarantees of financial returns to important vendors, had also removed some of the gloss from their image, as had Alan Bond's failure to keep up his payments to Sotheby's Financial Services for *Irises*. This had been the sale which had kept up confidence in the art market after the stock market crash of 1987. During the 1980s – the 'decade of greed' – many older collectors, like Norton Simon, dismayed by what was happening, had simply stopped buying, leaving the field clear for Japanese dealers and corporations, like Itoman, Mitsubishi, Aska and Yasuda Insurance, South American drug barons, armaments dealers, Mafia bosses (often referred to in the press as being 'in the transport business') and the Yakuza. All these groups used Impressionist paintings as portable money. Elderly dealers recounted wistfully how it had all been very different in the golden days of the 1920s when dedicated, knowledgeable collectors bought paintings because they loved them. The boom also affected prices of, and interest in, American and Australian Impressionists in their own countries and second-generation French Impressionists. However, banks and leasing companies stopped lending money on Impressionist masterpieces when they found they had lost millions after their owners went bankrupt.

The 1980s art boom, combined with the removal of the American Government's tax minimalisation laws for donations of art to museums, ensured that some spectacular Impressionist works from private collections appeared at auction. These masterpieces were either sold with enormous publicity at auction, or with the minimum of fuss through leading dealers. Many of the great paintings reproduced in this book will never be exhibited to the art-loving public.

Instead they hang in mansions or janitor-protected condominiums, or lie in crates in bank vaults or art warehouses in Tokyo, Zurich or London. Few auction catalogues today contain works of outstanding quality now that prices have slumped and, due to vigorous protests from art museums, the tax donation scheme has been revived – at least temporarily – by the U.S. Government.

Naturally, the enormous publicity surrounding the value of Impressionist paintings has greatly increased art thefts. Many stolen paintings found new homes in Japan, where, after only two years, stolen art legally belongs to any buyer who has purchased it 'in good faith', or in Switzerland, where it becomes legal property after five years. Provenance (the pedigree of ownership) became far more important as the stakes became higher, especially as a guarantee against forgeries, which also boomed. The scandal of the fake of *The reader* (p. 85) is still going through the courts at the time of writing. But it is important to remember that not all forgeries are so recent: Renoir and Monet had problems with clever forgers of their work during their lifetimes. Manet's in-laws, several of whom were failed artists, made some excellent forgeries in Manet's style and 'seeded' them into the collection of Suzanne Leenhoff-Manet, the artist's widow, after she was dead, in order to obtain that all-important provenance.

The stories of the individual collectors at the end of the book reinforce the great differences in attitude between those early cultural philanthropists – Samuel Courtauld, Helene Kröller-Müller and the pioneer American collectors – and the speculator-collectors of the late twentieth century. Tycoons – whether in steel, shipping, property development or armaments – seem to bring that tenacity and aggression to the saleroom which made them successful in business. Frequently, though not always, they appear to have higher than average problems with their adolescent children. Suicides, car accidents and 'unsuitable marriages' proliferate amongst estranged heirs (some of whom are clearly jealous of their parents' collections).

This might explain why many collectors describe their paintings as their 'children' or their 'family' – a habit not confined to the childless ones, who clearly have a strong motive for collecting.

Collecting is both therapeutic and endless: the task of building the perfect collection never ends. There is always another exciting auction catalogue describing yet another desirable painting. Important collectors like Lady Peggy Trout also clearly derived great pleasure from the sense of power that the disposal of a great collection brings with it. But in today's world of break-ins the proud possessor can easily become the possessed: some collectors are so terrified of burglary that they have become agoraphobic – unable to leave their paintings.

But fortunately not all collecting is based on greed, status-seeking and desire for power, especially amongst women, who are prominent as collectors of Impressionist art. The women collectors detailed here loved their paintings and were frequently extremely knowledgeable about them. Most made wise and selfless decisions about the eventual disposal of their collections – Juliet Walter and Janet Holmes à Court even insisting that their collections bear the names of their deceased husbands. The stories of the collectors I have selected reveal that great art brings out the best as well as the worst in human behaviour.

THE FIRST IMPRESSIONISTS

Edouard Manet (1832–1883)
Hilaire Edgar Degas (1835–1917)
Gustave Caillebotte (1840–1894)
Eugène-Louis Boudin (1824–1898)
Claude Monet (1840–1926)
John Peter Russell (1859–1930)
Theodore Robinson (1852–1896)
Alfred Sisley (1839–1899)
Berthe Morisot (1841–1895)
Camille Pissarro (1830–1903)
Pierre-Auguste Renoir (1841–1919)
Paul Cézanne (1839–1906)
Mary Stevenson Cassatt (1845–1926)

EDOUARD MANET (1832–1883)

Manet painted women with great originality as well as technical brilliance, and some of his finest portraits were done in the last few years of his life, when increasing bouts of paralysis in his left leg forced him to abandon large complicated canvases. Manet had first experienced problems with his leg during the weeks he spent with the Hoschedés at Montgeron in 1876. From the autumn of 1879 he had undertaken expensive hydrotherapy at the spa of Bellevue, on the Seine north of Versailles, for what Manet and his doctors believed at first was no more than rheumatism, though it was in fact the consequence of the tertiary stage of syphilis, contracted in his youth. In 1880 there was a marked deterioration in his health, and he began to spend more of his time away from the city so as to be able to rest and take cures. During 1882 the Manets rented a house at Rueil, near Bellevue.

Feeling homesick for the boulevards and cafés of his beloved Paris, Manet channelled the despair caused by the pain from his fatal illness into painting views of the houses and gardens at Bellevue and Rueil. But during these years he also painted 'impressions' of beautiful young women who came to see him – among them not only his closest friend, the celebrated actress and courtesan Méry Laurent, but also acquaintances and family friends such as Mme. Gamby, who is the subject of this painting. These intelligent, sophisticated Parisiennes attempted to console the artist with flowers and flirtations.

Initially, Mme. Gamby, a young woman shrouded in black, seems insignificant against the vivid green of the sun-dappled garden with its sandy path and flashes of scarlet flowers. Gradually, however, the spectator becomes aware that she is a chic, coquettish 'Merry Widow', wearing a black bonnet seductively trimmed with lilac blossom and lace. Manet loved seeing the latest Paris fashions; he has painted the young widow with a delicate cobweb of black lace shrouding her soft shoulders, while long, cream-coloured kid gloves suggest well-rounded arms. Manet's tender, sensual brush cleverly reveals her dark intelligent eyes, high cheekbones, delicate nose and sensual mouth.

Mme. Gamby bears a marked resemblance to other favourite sitters of Manet's, Berthe Morisot and Eva Gonzalès, who, like her, were slim, dark-haired, vivacious Parisiennes. This 'type', which attracted Manet, the great womaniser, all his life, was, ironically, the total opposite to his wife Suzanne, who was a stout, blonde, placid Dutchwoman.

The gradual wasting of the muscles in Manet's leg eventually caused paralysis, and the doctors decided on amputation. But gangrene set in, and ten days after the operation, on 30 April 1883, Manet died at the age of fifty-one. His premature death was a tragedy for modern art: the respectable rebel of the art world had left unfinished his great dream of interpreting 'modern' Parisian life in a whole series of major paintings like A bar at the Folies-Bergère.

Edouard Manet
The promenade, c.1880.
Oil on canvas.
36½×27½ in (93×70 cm).
The painting remained in Manet's own collection until his death and was sold at his studio auction in 1884 to the singer Jean-Baptiste Faure for 1,500 fr. (today's equivalent of $960). In 1987 dealer Paul Durand-Ruel sold it to Auguste Pellerin. It entered the Jakob Goldschmidt Collection and was bought by Paul Mellon at the 1958 Goldschmidt Sale at Sotheby's for $249,200. Eight years later it again appeared at Sotheby's and was bought by Alan Bond for £3.6 million. Three years after that *The promenade* was re-auctioned by Sotheby's to an unknown buyer for $13.09 million (more than twice the price Mr. Bond had paid). Part of the purchase money was retained by Sotheby's to pay the balance outstanding on van Gogh's *Irises*.

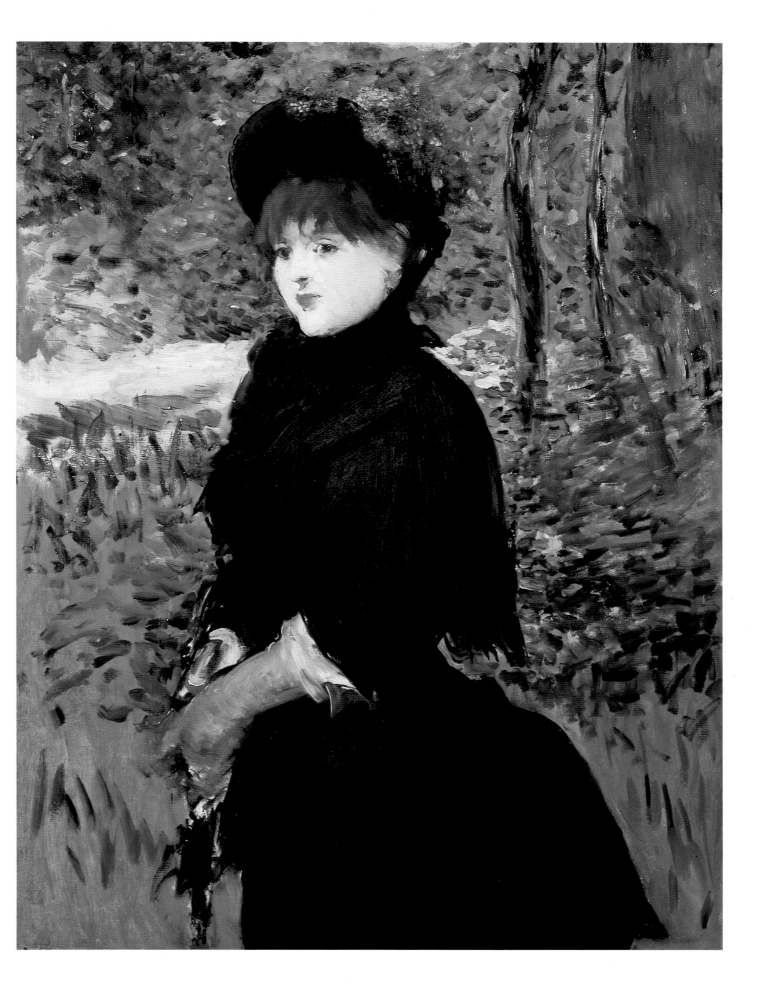

In 1878, two months after the opening of the Exposition Universelle in Paris, the French government declared a new public holiday: June 30 was to be celebrated as *la Fête de la Paix* – the Holiday of Peace. Both the World's Fair and the holiday were loaded with political significance in their defiant affirmation that France had now recovered completely from the disastrous war with Prussia in 1870–1. On the morning of the holiday, the streets of Paris were filled with tricoloured flags hanging from every window.

On that day, Manet, who regarded himself as a 'painter of modern life', stood at the window of his second-floor studio on the rue Saint-Pétersbourg. The artist must have been feeling nostalgic, knowing he had to leave his studio the following week when his lease expired, and he decided to record his bird's-eye view over the rue Mosnier (now rue de Berne).

Although Manet had painted the view from his studio earlier that year, he had sold the work, and in order to have a permanent record of the place where he had spent so many happy and creative hours, Manet made two paintings that day of the street decked with flags. The loose, rapid brushwork, the comparatively short shadows, and the absence of any signature or date suggest that the present work may well have been painted early in the day. (The other version, which now hangs in the Getty Museum, was formerly in the collection of Mr. and Mrs. Paul Mellon, who bought it at the great Jakob Goldschmidt sale in 1958.)

Both versions of Manet's important painting have a deep underlying political message. The Getty's version shows a man on crutches to the left of the picture, who may be a veteran of the Franco-Prussian war, or, as some historians believe, he could be a victim of the uprising of the Paris Commune in 1871, when there had been bitter hand-to-hand fighting at the barricades and French soldiers had been forced to fire on French civilians.

In this highly impressionistic rendering of Manet's every-day view from his studio, the left side of the street is masked by a flapping swathe of red. This is the gigantic tricolour, hanging from a flagpole beside Manet's window. The artist has emphasised the red sections of the other flags, while their blue and white areas are much paler. Analysts see Freudian undertones in his ironic portrayal of the red flag on this 'Holiday of Peace', and some experts feel that Manet's emotive handling of the colour red may be inspired by bitter memories of the red banners and bleeding corpses that he would certainly have seen during the street-fighting in Paris during the Commune.

Edouard Manet
Rue Mosnier decorated with flags, 1878.
Oil on canvas.
25½ × 32 in (65 × 81 cm).
The painting was in Manet's personal collection and is now in a Swiss private collection.

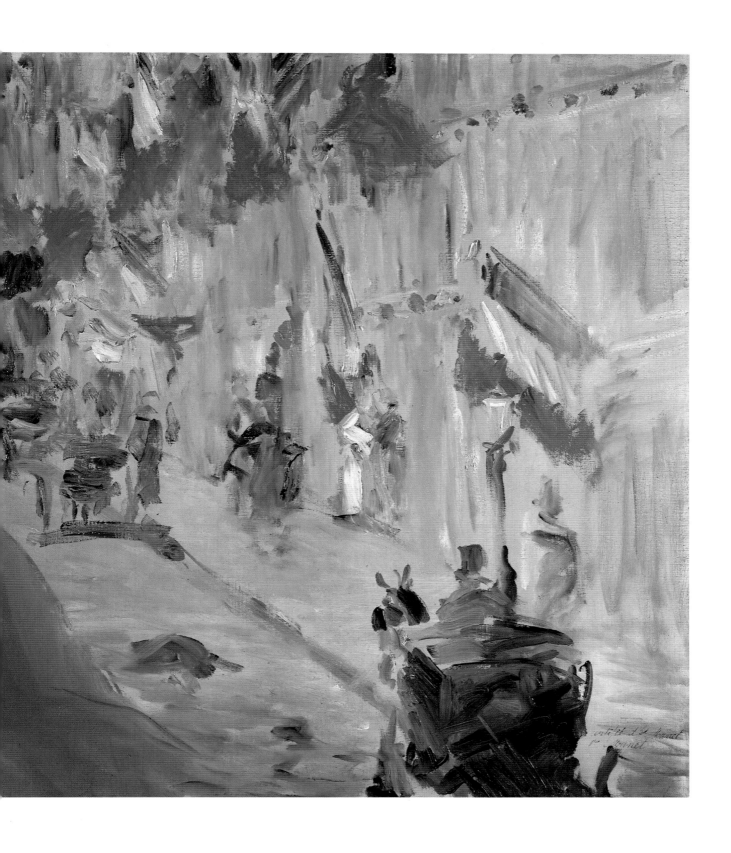

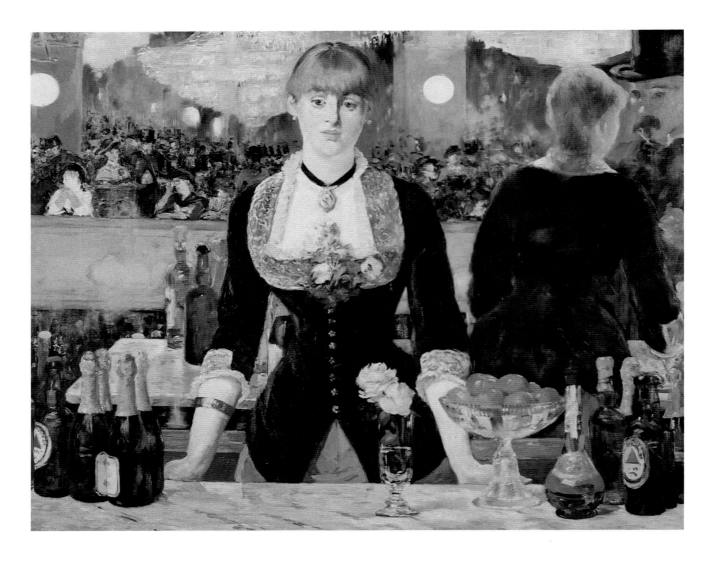

A world-famous composer, two industrial tycoons and a Hungarian nobleman have all paid vast sums for the pleasure of owning this icon of Impressionism – Manet's last masterpiece. When Manet was painting it, magazine illustrator George Jeanniot visited his studio, where he found Suzon, dressed in her barmaid's outfit, posing behind a table laden with flowers, fruit and champagne bottles. Jeanniot was surprised to find that 'Manet did not copy nature at all . . . Everything was abridged; the tones were clearer, the colours more vivid.'

When first exhibited at the Paris Salon of 1882, this painting outraged many spectators, as the Folies-Bergère was widely known as a place of entertainment which men visited without their wives. While singers, acrobats and dancers performed, male patrons and female prostitutes cruised around a series of small intimate bars where the evening's assignations were arranged. Salon viewers also knew that, like the bottles on the marble-topped bar, Suzon the barmaid was for sale.

Edouard Manet
A bar at the Folies-Bergère,
1881–2.
Oil on canvas.
37½ × 51 in (96 × 130 cm).
When Manet's widow auctioned the contents of the artist's studio in 1884, this was bought for 5,850 fr. by Manet's friend, the composer Emmanuel Chabrier. It was bought from Chabrier's widow by Paul Durand-Ruel in 1897 and sold to Auguste Pellerin. It was sold by the Berlin dealer Paul Cassirer to Eduard Arnhold, but by 1919 was in the collection of Baron Ferenc Hatvany. In 1926 it was purchased by Samuel Courtauld, and it is now in the Courtauld Institute Galleries, London.

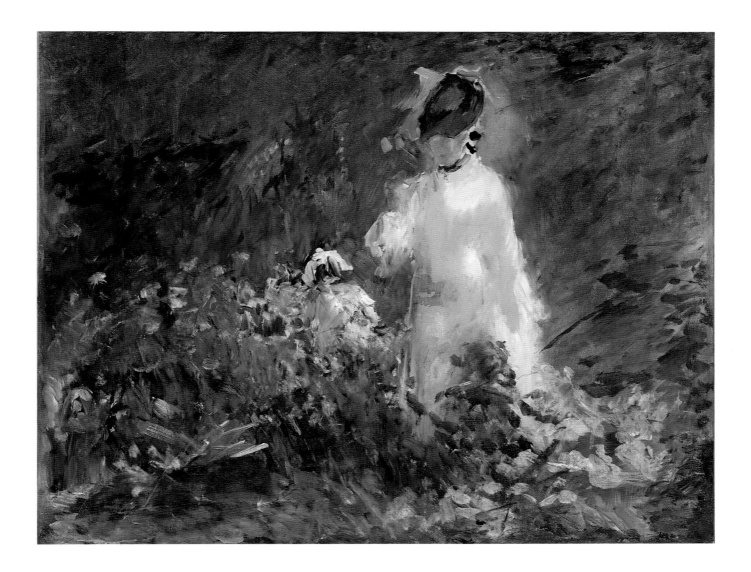

Edouard Manet
Young woman among flowers,
1876.
Oil on canvas.
24½ × 30½ in (62 × 78 cm).
Auctioned in Manet's studio
sale in 1884, it was later in the
collection of Auguste Pellerin.
Purchased by Lila Witt
Wallace, it has been part of the
Reader's Digest Corporate
Collection since 1949.

In the summer of 1876 Manet accepted an invitation to visit the Château de Rottembourg at Montgeron, home of the department-store owner Ernest Hoschedé. In the gardens there he painted several impressionistic scenes, which appear to have been influenced by the work of Monet and Berthe Morisot. Here, a woman in a white dress stands out from the flowering shrubs and brilliant green lawn that surround her. Her face, half-hidden by her fashionable hat, reveals no recognisable features. Could this be the missing portrait of the château's owner, Alice Hoschedé, who, two years later, would leave her husband for the impoverished young Claude Monet? It could easily be a companion to the other impressions Manet painted at Montgeron, one of which shows Alice's husband, another her young son Jacques, while a third portrays one of the couple's daughters. Manet would surely not have failed to paint his charming hostess, who was so intrigued by art and artists.

This flattering portrait may well be the last Manet painted of his wife, Suzanne Leenhoff-Manet, who during his last illness nursed him devotedly until his death. In the garden of their rented house, 18 rue du Château, in Reuil, Manet made a companion portrait of his mother (private collection), which bears an uncanny similarity to that of his wife. Both women wear almost identical hats and both pose against the same green lawn. These twin portraits contain significant hints about the way the artist viewed his wife, suggesting that Manet, the perpetual 'enfant terrible of nineteenth-century art', subconsciously looked for a second mother figure in his marriage. Undoubtedly, Suzanne's devotion to Manet and her tolerant, placid character enabled her to endure the constant infidelity of her husband, who was famous for turning his models into his mistresses.

An atmosphere of mystery surrounds Suzanne's meeting with Manet, two years her junior. Her father was an organist in Delft, and she was an accomplished pianist, to whom Emmanuel Chabrier later dedicated his 'Impromptu in C Major'. The most reliable accounts describe the nineteen-year-old Suzanne Leenhoff entering the prosperous Manet household in 1849 as a piano teacher for Manet's younger brother (although it has also been suggested that the meeting came about through her brother, Ferdinand Leenhoff, an unsuccessful artist and sculptor and also a great scallywag). She married Manet in 1863, but eleven years earlier Suzanne had borne a son, Léon-Edouard Koëlla, called Leenhoff, who was always described in 'polite' society as her younger brother. Manet was almost certainly his father, and after his birth Suzanne lived in an apartment paid for by the painter. But Léon's existence was kept a secret from Manet's father, probably for fear that, like Cézanne's father, he would cut his son's allowance.

In *Reading* (Musée d'Orsay), probably painted two years after their marriage, Suzanne is depicted as a plump, pretty, young bourgeois matron, her stolid features and fair complexion shown off to best advantage by her white dress (the figure of Léon was added to the painting many years later).

In the late 1860s and the 1870s Manet's models and mistresses increasingly became younger, more svelte and seductive. However, Manet's portraits of his wife, *Mme. Manet on a divan* (Louvre, Cabinet des Dessins) and *Mme. Manet at the piano* (Musée d'Orsay), show Suzanne as a frumpy pouter pigeon, who had obviously aged far more rapidly than the artist – who was to remain an eternally youthful Dorian Gray. *Mme. Manet at Bellevue* is the most flattering of all Manet's later portraits of Suzanne – doubtless expressing his gratitude for her care.

After Manet's death, Suzanne found herself deep in debt, facing large accounts for his medical and hospital expenses, and in 1884 she auctioned off 168 of the paintings from his studio. Although some of the larger ones, including *Olympia*, failed to sell, she was able to live quietly on the proceeds, turning their former home at Gennevilliers into a shrine to her late husband. A year after the Manet studio auction, the American artist John Singer Sargent wanted to buy one of Manet's works, but Suzanne Manet refused, although several years later she was forced to sell some more paintings, including this portrait (sold through a German dealer in the hope that none of Manet's fellow-

Edouard Manet
Mme. Manet at Bellevue, 1880.
Oil on canvas.
31½ × 23½ in (80 × 60 cm).
Inherited by Suzanne Leenhoff-Manet. By 1902 it was in the collection of wealthy artist Max Liebermann, and when Liebermann was a victim of Nazi persecution it was sent to the Zurich Kunsthaus on loan; after Liebermann's death it was sold to Kurt Riezler, then to pianist Vladimir Horowitz. It is now in the collection of Mr. and Mrs. Walter Annenberg.

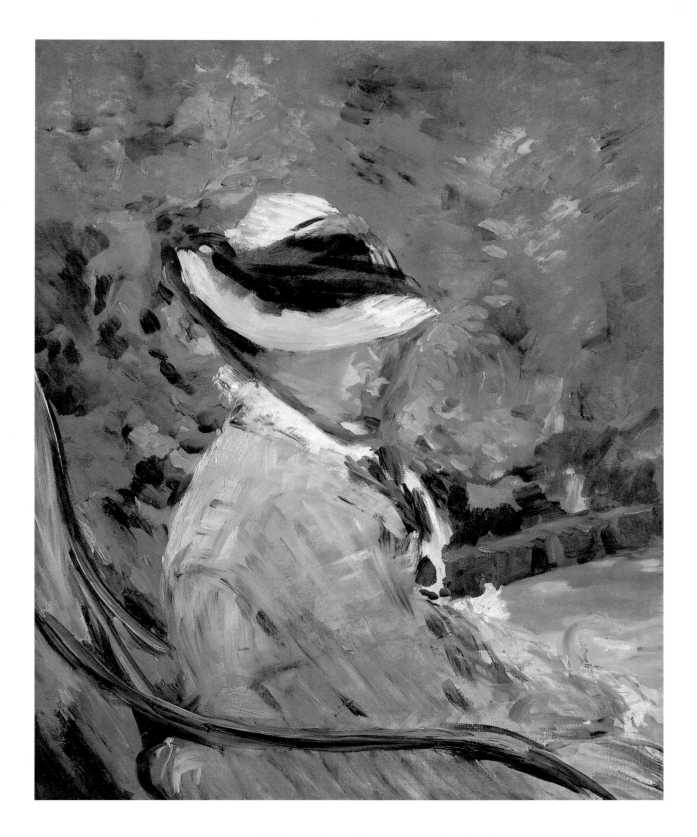

artists would hear about the transaction). She then commissioned her sister Marthe's son, Edouard Vibert, to make replicas of all the paintings she had sold, so that she could hang them instead of the originals. After Suzanne's death in 1906, both Vibert and Ferdinand Leenhoff 'seeded' their own forgeries of Manet's work into the auction of Suzanne's personal art collection, where they were bought by leading collectors of the period.

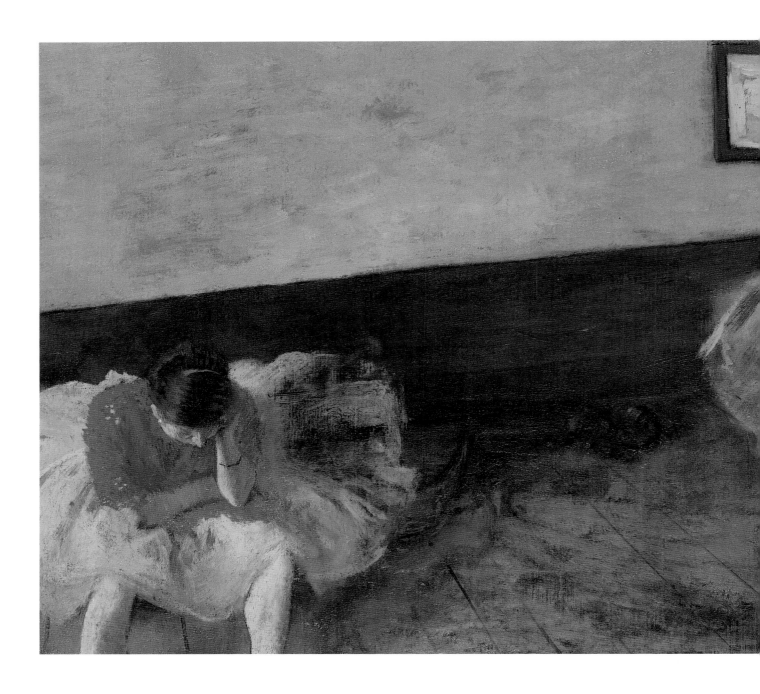

HILAIRE EDGAR DEGAS (1835–1917)

'They call me the painter of dancers. They don't realise that for me the dancer has always been a pretext for painting fabrics and representing movement,' Degas insisted. In this early masterpiece the diagonals of the floorboards provide a sense of depth, although as Degas's eyesight grew worse, detail became far less important to him until, finally, he omitted floorboards and background scenery altogether. The artist was one of the early devotees of the camera; he borrowed from photography – cropping limbs of dancers at the edge in the way a photograph or a Japanese woodblock print would do, in order to create the impression that his world extended beyond the picture-frame.

Although Degas is famous for dancers, he rarely painted them on stage, preferring instead to draw and paint them at practice sessions. This was because

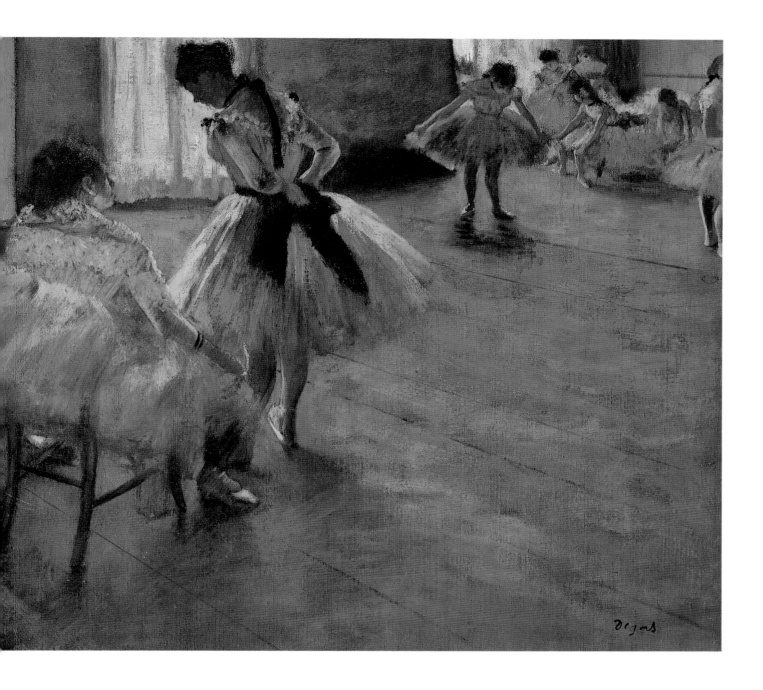

Edgar Degas
The dance lesson, 1880–85.
Oil on canvas.
15 × 34¾ in (38 × 88 cm).
From the collection of Mr. and
Mrs. Paul Mellon.

he had unrestricted access to the rehearsal rooms of the Paris Opéra. At that time a short ballet was part of every opera, so the Opéra ran the ballet classes which trained impoverished teenage girls to dance. Sketchbook in hand, Degas would spend hours watching them practise, and he delighted in catching them in casual, unrehearsed gestures. They stretch aching limbs, yawn, untie their ballet shoes and chatter to each other. Adjusting her sash, her back half-turned to the viewer, is fifteen-year-old Nelly Franklin. Little Nelly, an English dancer with a pert turned-up nose and a black velvet ribbon round her neck, features in three other Degas paintings.

Degas was fascinated by the way the underpaid, undernourished teenagers who danced in the Opéra's chorus were ugly ducklings at rehearsals, then, under the footlights, turned into glamorous swans. But there was a dark side to ballet in Degas's era. The young dancers' sexual availability attracted the interest

of wealthy members of the Jockey Club and the Stock Exchange, who had permission to wander the passageways or *coulisses* and rehearsal rooms in search of a mistress. The dancers' mothers were very poor and often happy for these wealthy married men to act as their daughters' 'protectors'. The Oskar Reinhart Collection contains a particularly revealing pastel by Degas of a dancer's dressing-room: the teenage dancer's costume is adjusted by her elderly protector while her mother watches approvingly.

By 1896, the year when he drew *The pink dancer*, Degas was nearly blind, but having no hobby apart from his work, he continued painting. The obsessive interest in movement that had earlier led Degas to haunt the ballet school attached to the Paris Opéra, where he filled entire sketchbooks with pencil and charcoal studies, served him well, for by the time his sight failed, he could paint dancers from memory. However, instead of oils, he was now forced to use pastels. Finding them pale and insipid after the brilliance of oils, Degas experimented. He steamed his pastels and added coloured inks, forming them into a richly coloured paste which provided the deeper colour effects he sought. *The pink dancer* is one of Degas's finest pastels: her skirt glows with the repeated applications of this mix, which has been sprayed with fixative between each application to add even more depth.

The pink dancer was entirely painted from memory. Degas remarked revealingly: 'It is all very well to copy what you see, but it is much better to draw what you see in your mind... You reproduce only what has struck you – in other words, the essentials.' Degas has dramatically foreshortened his human figure in a manner reminiscent of Hiroshige, one of the Japanese artists whose woodblock prints he collected and hung on his walls or kept in a display cabinet in his sitting room.

Edgar Degas
The pink dancer, 1896.
Pastel on paper.
16 × 12 in (41 × 29 cm).
Originally in the collection of Georges Viau, it was later sold by Durand-Ruel to Mrs. Montgomery Sears, Boston. Lila Witt Wallace loved it, and since 1946 it has formed part of the Corporate Art Collection of the Reader's Digest Association, Inc.

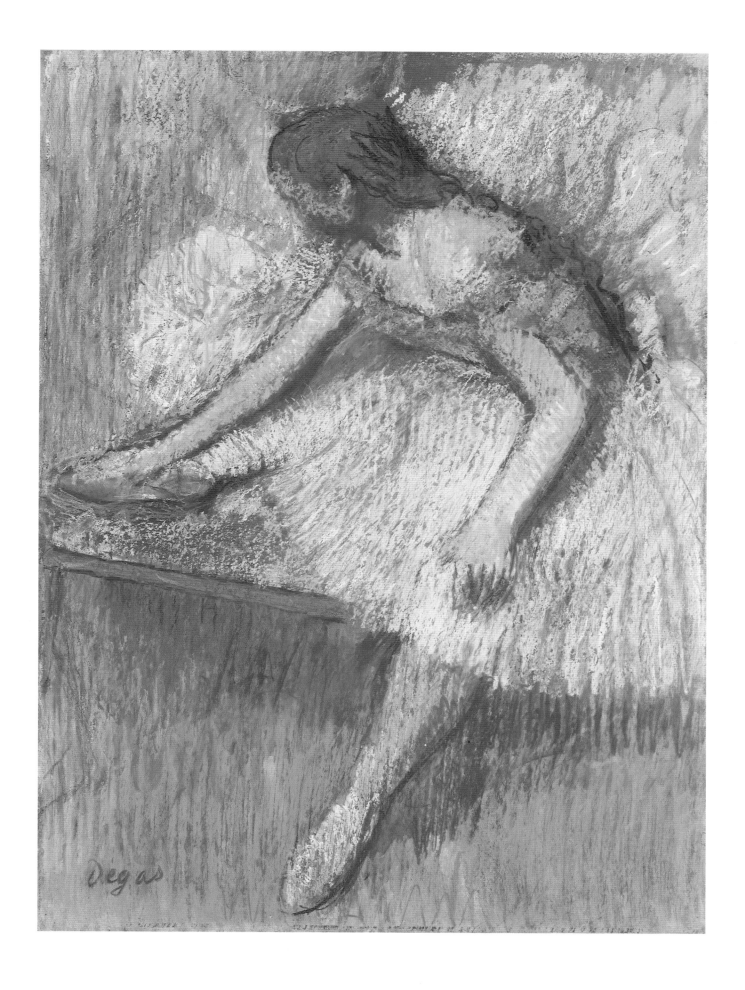

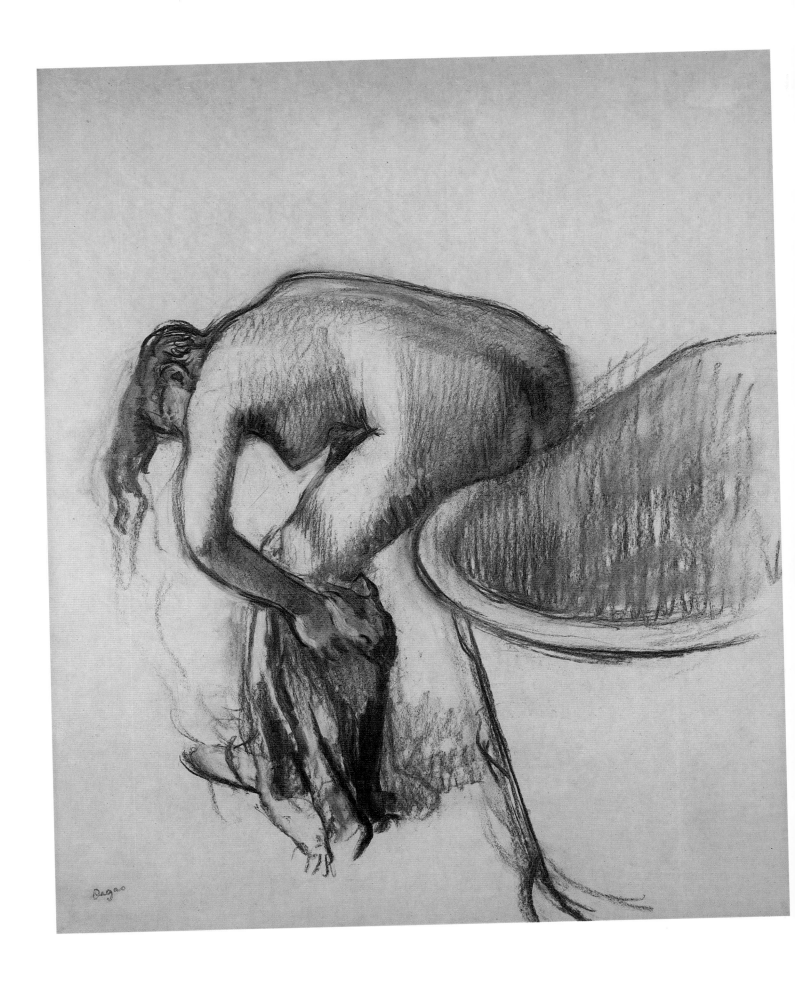

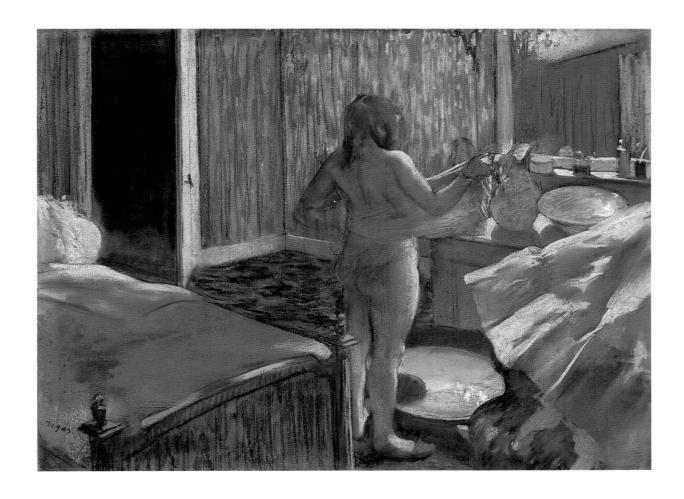

Edgar Degas
Woman at her toilette, 1886–90.
Pastel over monotype.
18×24 in (46×61 cm).
A preliminary study in pencil
for this pastel is now in the
Ashmolean Museum, Oxford.
The pastel itself is in the
collection of the Norton Simon
Foundation, Pasadena,
California.

Edgar Degas
After the bath, c.1885.
Charcoal on paper.
28½×23½ in (73×60 cm).
The drawing relates to a pastel
around the same date (Lemoisne
no. 1380). It was first owned by
dentist Georges Viau and was
until recently in the collection
of Alain Delon.

(Photograph: courtesy of
Browse and Darby, London.)

At the eighth Impressionist exhibition in 1886 there was an outcry when bachelor Degas showed a series of pastels of women, entitled 'nude women bathing, washing, drying, wiping themselves, combing their hair or having it combed'. At this time there was a vast difference between the living standards of the haute bourgeoisie, like Degas, and the poor of Paris, who lived in wretched hovels, often without running water. Degas was widely believed to have offered street walkers a hip bath with hot water provided by his elderly housekeeper and probably a free meal as well. Then, while the models bathed and combed their hair, Degas took up a position in an adjacent room and drew them through a concealed window or two-way mirror.

Such revealing pastels and drawings caused a furore: critics denounced them as obscene; they accused Degas of degrading women, treating them like animals, spying on them and taking unfair advantage of those too poor to afford washing facilities. Through all the outrage, Degas remained outwardly unmoved. He had achieved exactly what he had intended – the creation of 'impressions' of a body occupied with itself, seen from unusual angles, often dramatically foreshortened. 'This is the human animal cleaning itself, [like] a cat...', he argued.

In contrast to *After the bath*, the crimson interior of *Woman at her toilette* suggests a room in one of the brothels the artist frequented. While most of Degas's bordello scenes were destroyed by his brother after the artist's death, this brilliant pastel escaped destruction because it had already been bought by Claude Monet.

33

Degas had been a member of the Impressionist group from the outset, and for their fourth group exhibition in 1879 he was the principal organiser, after several of the original group defected because of his insistence that they should not submit works to the official Salon.

Laundresses carrying linen in town was one of twenty-five of his works listed in the exhibition catalogue. Degas had made his first painting of laundresses some years earlier, just before travelling to New Orleans. At that period, pretty young laundry-maids delivering or collecting heavy wicker hampers from private homes were an everyday sight in the streets of Paris. Homesick for Paris, Degas wrote from Louisiana to fellow-artist James Tissot, 'Everything is beautiful in the world of people. But one Paris laundress with bare arms is worth all here, for such a pronounced Parisian as myself.' While Degas considered the work of laundresses beautiful, for them it was a backbreaking, badly paid job. However, for most working-class girls the only alternatives were domestic service or prostitution. Degas enjoyed giving his comfortable bourgeois spectators a realistic glimpse into the private world of underpaid servant girls and overworked prostitutes.

There is no attempt here to idealize or to condemn, for Degas never used his art to present a moral message. He would make a series of preliminary drawings; then, and for many years afterwards, he would paint fuller variations on them. *Laundresses carrying linen in town*, with its tonal harmonies of browns and yellows, is a brilliant piece of bravura brushwork as well as a study of movement. In 1876 this impressionist study raised many eyebrows when exhibited as a 'finished' painting, although it was singled out for praise by some critics. Today Degas's control of line and his use of unusual colours, based on those used in the Japanese prints which he collected, are greatly admired. The artist has used the compositional devices of photography – blurred focus, distorted perspectives and images cropped by the edge of the frame. In this remarkable painting he foreshadows the future development of much of twentieth-century art.

Laundresses carrying linen in town was one of three important works by Degas owned by Sir William Eden and used to hang above the collector's writing desk. His son Timothy recalled in his memoirs that this particular Degas was Sir William's 'chief delight and pride...those wonderful washerwomen leaning against the weight of their baskets in front of a yellow wall'.

Edgar Degas
Laundresses carrying linen in town, c. 1876–8.
Oil colours freely mixed with turpentine on paper mounted on canvas.
32 × 30 in (81 × 76 cm).
In the collection of the actor Coquelin Cadet at the time of its exhibition in 1879, it was purchased at Christie's, London, in 1918 by Sir William Eden, Bt. for 2,300 guineas (£2,415). In March 1988 it was again sold at Christie's – for £3,960,000 ($7,270,560). It is now in a private collection.

(Photograph: courtesy of Christie's, London.)

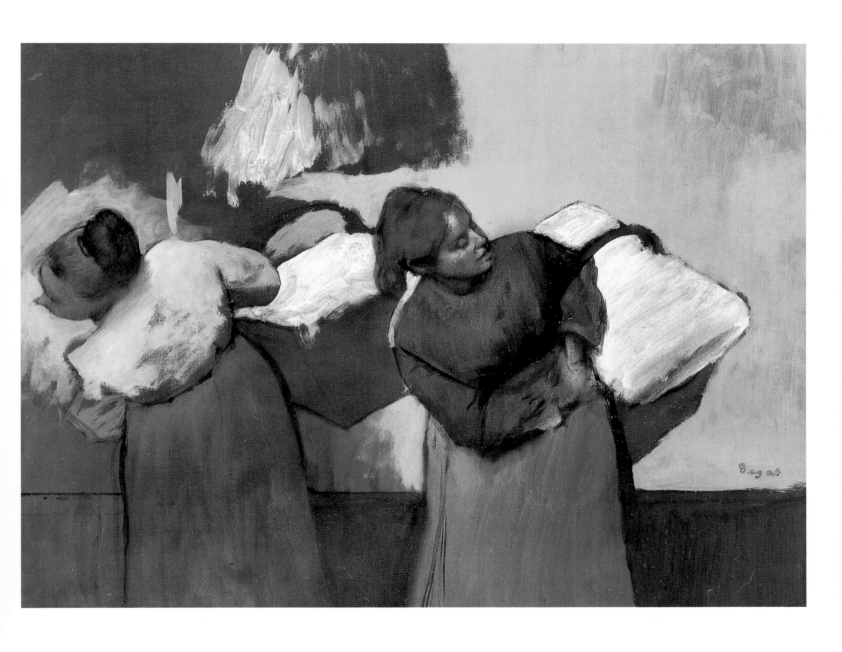

Throughout the early 1880s Degas produced a brilliant series of pastels showing upper-class women trying on clothes in milliners' and dressmakers' shops. It was the intimacy of this colourful, sheltered world that intrigued Degas, the confirmed bachelor. In one of his notebooks he wrote, 'Consider an essay on the ornaments worn by women, on their feelings for clothes and other things, their ways of observing and combining them. All day long they compare a thousand visible things that go unnoticed by men.'

Degas accompanied fellow-artist Mary Cassatt and her sister on shopping expeditions, not because the latest fashions interested him in the way they did Manet, but because he was searching for unusual subjects and textures suitable for a 'painter of modern life'. Mary Cassatt commented dryly that Degas only used her as a model 'when he finds the movement difficult and the model cannot seem to get his idea'. Initially Mary Cassatt may have hoped that romance would blossom between the two of them, but gradually she realised that Degas was only interested in her as a platonic friend. The chauvinistic, acid-tongued Degas, whose nudes are generally full-bodied, muscular brunettes, once told a friend that, much as he enjoyed Cassatt's company, he did not find her red-headed colouring and slim angular body appealing. The figures in this picture may be the Cassatt sisters, so that Degas would have been standing directly behind Lydia Cassatt as she tried a hat on her sister. The artist looked straight down on to the corner of the chesterfield sofa with its diamond pattern of raised chenille work.

The Thyssen-Bornemisza Foundation contains a slightly larger pastel made the same year which may also depict the two expatriate Americans trying on hats, but in that version Degas replaced the sofa with a table holding elaborately-feathered hats on wooden stands. It was bought direct from the artist in 1882 by Paul Durand-Ruel, who, recognising its exceptional quality, exhibited it at his London gallery before selling it to Degas's friend and fellow-artist Henri Rouart.

Durand-Ruel's stock book reveals that the present version, showing the two women sitting on the sofa, was delivered to him by Degas in October 1881 and purchased by Russian-born businessman-turned-publisher Charles Ephrussi. Ephrussi kept his version of At the milliner's for thirteen years before asking Durand-Ruel to find a buyer for it. Remembering the version that he had sold so successfully, Durand-Ruel promptly repurchased this pastel for his own flourishing art collection.

Edgar Degas
At the milliner's, 1881.
Pastel on five pieces of wove paper joined together and mounted on linen.
27½ × 27½ in (70 × 70 cm).
Purchased from the Durand-Ruel Gallery in April 1882 by Charles Ephrussi. It was repurchased by Paul Durand-Ruel in 1895 and remained in the collection of his family until it was acquired by Mr. and Mrs. Walter Annenberg.

GUSTAVE CAILLEBOTTE (1840–1894)

The wealth Gustave Caillebotte inherited was acquired from a lucrative contract to supply bedding to the entire French army, and his vast unearned income ensured that he never needed to sell his paintings. An unfortunate consequence of this has been that Caillebotte's reputation as a powerful creative artist with a strong feeling for colour and perspective has been greatly overshadowed by his importance as a collector.

In 1873, Gustave, then a twenty-four-year-old law student, abandoned his legal training and enrolled at the Académie des Beaux-Arts to study painting with Léon Bonnat. The following year his father died, leaving his large fortune to his sons, and after the death of their mother in 1878 Gustave moved into a modestly furnished apartment on the Boulevard Haussmann with his younger brother Martial.

Gustave Caillebotte
Banks of the Seine at Argenteuil,
1889.
Oil on canvas.
21½ × 25½ in (54 × 65 cm).
Owned by Caillebotte's sailing friend, Paul de Boulogne, to whom it was given by the artist, the painting remained with de Boulogne's descendants until it was sold through Christie's, London, in 1990 to a corporate collection in Tokyo.

Gustave Caillebotte
The yellow boat, 1891.
Oil on canvas.
28¾ × 36¼ in (73 × 92 cm).
The man in the boat is Eugène
Lamy, a friend of Caillebotte's,
who shared his love of boating.
It is now in the Norton Simon
Foundation, Pasadena,
California.

Caillebotte submitted *Floor-planers* (Musée d'Orsay), then considered a strikingly realist, avant-garde work, to the Salon of 1875. Its rejection drove him into the arms of the Impressionists, who welcomed him to their group and included the rejected painting along with seven others by him in their second exhibition in 1876. It was Claude Monet, one of their leaders, who encouraged Caillebotte to lighten his palette, as well as teaching him the difficult technique of painting shimmering reflections of light on water, using short feathery brushstrokes.

After his brother's marriage in 1887, Gustave retired to his summer home at Petit-Gennevilliers on the Seine, to devote himself to sailing, rowing and designing racing yachts. His other hobbies were painting and gardening – a passion he shared with his friend Monet. Caillebotte died in 1894, at the age of forty-five, and it is only in the past decade that some of his best work has appeared on the market.

EUGÈNE-LOUIS BOUDIN (1824–1898)

The poet Baudelaire once described Boudin as a painter of the 'magic of air and water'. Born at Honfleur in Normandy, Boudin grew up in the bustling maritime atmosphere of Le Havre. Initially he worked in a shop selling stationery and artists' materials, and he was encouraged to take up painting by some of the shop's clients – visiting members of the Barbizon school. A municipal grant enabled Boudin to study in Paris from 1851 to 1853.

Boudin continued the Barbizon landscape tradition by working in the open air. When several of his beach scenes were accepted for the 1859 Paris Salon, Baudelaire referred to them delightedly as 'sketched from what is most fleeting, most imperceptible in form and colour, from waves and clouds'. Boudin himself always believed that three strokes of the brush made directly from nature were worth more than three days labouring at the easel, and it was he who first impressed this maxim on the young Claude Monet.

Around 1856 Boudin spotted some vivid caricatures of local dignitaries by Monet in a shop window and persuaded the teenage amateur artist to paint with him on the beach. Boudin taught Monet how to capture reflected light on water, and they remained friends, sometimes painting together during the summers in the 1860s. It was probably Monet who persuaded Boudin to contribute several works to the first Impressionist exhibition in 1874.

Eugène Boudin
On the beach, sunset, 1865.
Oil on panel.
15 × 23 in (38 × 58 cm).
From the collection of Mr. and Mrs. Walter Annenberg.

40

Eugène Boudin
Le Havre: the shore at sunset,
1889.
Oil on canvas.
20 × 29 in (50 × 74 cm).
A later and more impressionist
work, it was acquired from the
artist by the Belgian collector
Paul van de Perre and later by
the Robert Holmes à Court
Collection.

Although his eventual success enabled him in later years to winter on the French Riviera and in Venice, Boudin's finest and most characteristic works were his scenes of the beaches of Le Havre, Trouville and Deauville.

CLAUDE MONET (1840–1926)

In 1869 Monet was living at Bougival, on the Seine west of Paris. During the summer Renoir joined him almost every day to paint in the open air, frequently at La Grenouillère, a nearby café and bathing establishment. The canvases they produced there marked the emergence of a new artistic movement. But their work was interrupted by the Franco-Prussian War, and Monet and his family took refuge in London. On their return they soon moved out of Paris to the rapidly developing industrial and holiday town of Argenteuil, half an hour's train journey from the Gare Saint-Lazare.

Although Monet worked hard at painting – he was the most prolific and the most inventive of the Impressionists – his open-air 'impressions' had at first found few buyers, and even after his paintings began to sell, his financial situation was always threatened by his spendthrift ways. However, in the early '70s matters improved, as Paul Durand-Ruel's gallery bought many of his paintings – 30 canvases in 1872 and 34 in 1873. Although these were difficult years, Monet was supported by a few collectors, including Manet and – from 1876 – his principal patrons, Gustave Caillebotte and Dr. de Bellio.

In October 1874 Monet, his wife Camille and their son moved to this brand-new gabled house with green shutters in the Boulevard Saint-Denis (now Boulevard Karl Marx) at Argenteuil. Monet immediately planted flowers and shrubs to soften the house's raw 'newness'. Two years later Monet painted the pale figure of Camille standing beside a bed of hollyhocks. Monet had grown up in a prosperous bourgeois household and even when in financial trouble he still employed two maids and a part-time gardener. Not surprisingly, he was behind with the rent once again. Camille, who would soon be diagnosed as suffering from tuberculosis, may already have been constantly tired from the debilitating disease. Monet, who was thirty-six, probably felt trapped by the responsibilities of a marriage which his family had bitterly opposed because he and Camille came from such widely differing backgrounds. Although the house and flower garden appear the epitome of suburban domestic bliss, Monet was shortly to begin a passionate affair with another woman.

He received a commission from Ernest Hoschedé to paint a series of murals for the Château de Rottembourg, near Montgeron, which was part of the dowry of Hoschedé's wife, Alice. Life at the château had its tensions: Ernest's own textile business and new department store, founded with Alice's money, were in financial trouble, due to his unfortunate speculations and lavish spending.

Monet left Camille behind at Argenteuil and went to stay with the Hoschedés at Montgeron. Ernest was frequently away, and Alice Hoschedé, strong-minded, sophisticated and cultured, was everything that quiet, provincial Camille was not. Monet painted Alice in the romantic surroundings of the château's lake. It is not certain when they became lovers, nor whether he or Hoschedé was the father of Alice's sixth child, Jean-Pierre, born in August 1877. Camille, too, bore Monet a second son, Michel, in March 1878.

Claude Monet
Camille Monet in the garden at the house in Argenteuil, 1876.
Oil on canvas.
32 × 23½ in (81 × 60 cm).
Believed to have been sold by the artist to Paul Durand-Ruel, the painting is now in the collection of Mr. and Mrs. Walter Annenberg.

43

44

Claude Monet 1908

45

In October 1908 Monet and Alice stayed in Venice at the Grand Hotel Britannia. Monet started work on thirty-seven major canvases here, including this lyrical view of the dome of the Salute seen through a bluish-lilac mist. Frustrated at being unable to finish so many paintings at once, he wrote to Durand-Ruel, 'I am doing a few paintings... to have a record of the place, but I intend to return next year'.

Monet, always insecure about money even when he was famous, enjoyed playing his dealers off against each other. The day after he returned to Giverny, instead of offering the unfinished Venetian scenes to Durand-Ruel, he sold twenty-eight of them to Durand-Ruel's rivals Bernheim-Jeune, and for the rest of the year he worked on his great waterlilies series, which was exhibited at the Galerie Durand-Ruel in May 1909.

He never returned to Venice. Alice became ill and died the following year, and in his grief Monet was unable to take up work on his Venetian scenes again for another four years. Fortunately, he had made notes on the colours when in Venice, for he could not bear to revisit the city without Alice.

Previous pages:
Claude Monet
Santa Maria della Salute and the Grand Canal, Venice, 1908.
Oil on canvas.
28½ × 36 in (73 × 91 cm).
This view was bought from Bernheim's in 1912 by Paris couturier Jacques Doucet. It was later in the British Rail Pension Fund Collection before being sold by Sotheby's, London, to a private collector. The painting is now on loan to the Kunsthaus, Zurich.

Early in 1878 Monet was deep in debt and moved his family to Vétheuil, a less expensive village than Argenteuil, on the Seine some forty miles from Paris. Camille, already dying of tuberculosis, had not recovered from the birth of her son and needed constant nursing. So, as there was no money to pay a nurse, Alice Hoschedé, whose husband had lost her entire fortune, took over caring for Camille and the household. This unusual ménage consisted of Alice, her lover Claude Monet, his dying wife, Alice's husband Ernest and eight children, including two small babies. However, Hoschedé spent most of his time in Paris, involved in auctioning off his art collection and Alice's château in order to satisfy the bankruptcy court. Ironically, the Hoschedé auction damaged Monet's artistic reputation, as Hoschedé had been one of his largest buyers and the prices the works fetched at the forced sale were very low.

Within a year of their move, Monet's wife, patient uncomplaining Camille, was dead. Racked by guilt and grief, Monet asked Dr. de Bellio to lend him money to redeem from pawn a locket that had once belonged to Camille, so that he could bury it with her. Ernest Hoschedé visited the house occasionally, demanding his conjugal rights, as he believed Alice was only staying on at Vétheuil to look after Monet's motherless children. Eventually Ernest wrote to Alice from Paris imploring her to return to his tiny bachelor apartment in the city with their six young children, observing frostily that 'your behaviour towards M. Monet creates a particularly strange situation for us all'. When Hoschedé was informed of the truth, he had a nervous collapse, leaving Alice and Monet financially responsible for all eight children.

Claude Monet
Landscape with orchard and figures, Vétheuil, 1879.
Oil on canvas.
28 × 36 in (72 × 91 cm).
It was bought from the artist by Théodore Duret in 1880. After Duret's death it was sold to Mrs. Potter Palmer of Chicago, and it was in various American collections before being purchased in 1960 by Lila Witt Wallace for the Corporate Art Collection of the Reader's Digest Association, Inc.

No hint of the enormous stress Monet endured appears in the radiant 'impression' of the garden at Vétheuil with its waving sunflowers and elegant blue-and-white jardinières, a relic of grander days at Alice's château. Painted in short energetic brush strokes, the canvas vibrates with sun-drenched colour, as does *Landscape with orchard and figures, Vétheuil*. Here Monet has carefully built up an 'impression' of pink and white blossom with small flecks of colour, following his own precepts, 'When you go out to paint, try to forget whatever objects you have before you – a tree, a house, a field... Merely think, here is a little square of blue, here an oblong of pink, here a streak of yellow. Paint it just as it looks to you... to give your own naive impression of the scene before you.'

Monet stayed at Vétheuil for three years, moving in 1881 to Poissy and, finally, in 1883 to Giverny, which was to be his home for the rest of his life.

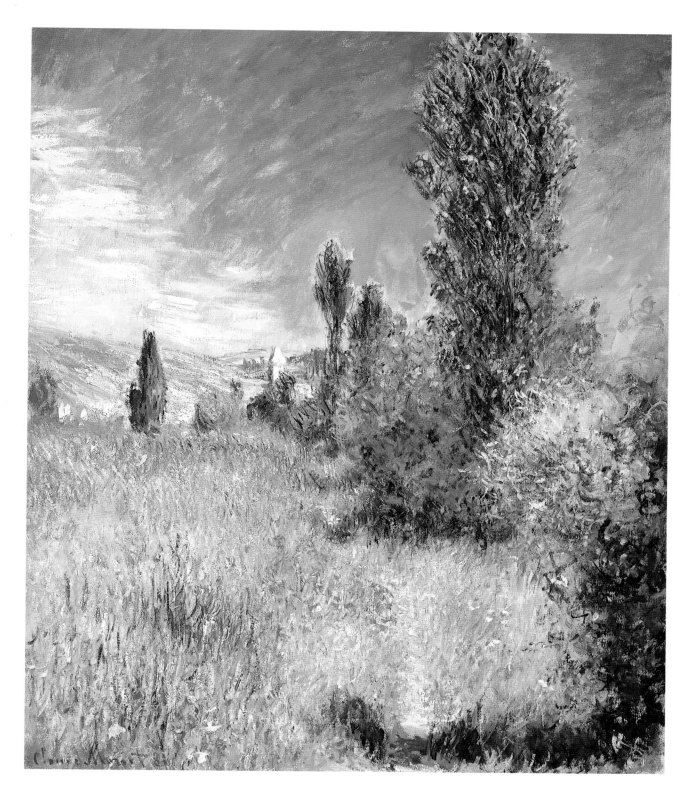

Claude Monet
The artist's garden at Vétheuil,
1881.
Oil on canvas.
39 × 32 in (99 × 81 cm).
From the collection of the
Norton Simon Foundation,
Pasadena, California.

Claude Monet
Path in the Ile Saint-Martin,
Vétheuil, 1881.
Oil on canvas.
28 × 33 in (72 × 58 cm).
It may be the work of this title
exhibited at the seventh
Impressionist exhibition, 1882.

After being in a New York
collection for decades, the
painting was purchased by Lila
Witt Wallace in 1963 and is
now in the Corporate Art
Collection of the Reader's
Digest Association, Inc.

The River Creuse winds through central France's rugged Massif Central, its name derived from the Celtic word 'caro', meaning 'river of rocks'. In February 1889 Monet visited this mountainous area with the critic Gustave Geffroy (whom he had met at Belle-Isle three years before), at the invitation of the poet Maurice Rollinat, who lived in the small town of Fresselines. The friends spent a week touring the Creuse area, and Monet was awed by the dramatic, plunging chasms and rocky outcrops. Returning briefly to Giverny to see Alice Hoschedé and collect his painting materials, Monet spent the next three months at Madame Barronet's *auberge*, opposite the church at Fresselines, painting during the day and dining with Rollinat.

But, as winter turned to spring, the snow melted, and the freezing cold wind chapped Monet's hands until they bled. He was forced to cover them with vaseline, or paint in gloves, which he hated. The weather became capricious. Dismayed, Monet wrote to Alice, 'I am in a state of utter despair and feel like throwing everything into the river;... the weather's wearing me down – a terrible cold wind which wouldn't have bothered me in the least if I had captured my desired "effect". This endless succession of clouds and sunny intervals couldn't be worse... The thing that is upsetting me the most is that, with the drought, the Creuse is shrinking... its colour altering drastically so that everything is transformed. Where water once fell in torrents all you see now are brown rocks and dried-up riverbed... To give up now would mean that all my efforts have been wasted... I am worn out and longing to come home.'

In spite of the hostile weather, Monet finally managed to complete twenty-four canvases. When the weather became warmer, he took his paints and easel up the mountains, where he made this *Study of rocks*, in which a massive reddish-brown volcanic outcrop seems to force its way out of the earth, practically pushing the trees off the canvas. At the Creuse Monet fulfilled the promise he made in a letter to Berthe Morisot that he 'was going to do some astonishing things here'. His Creuse paintings are not just pretty 'impressions' of poppyfields and orchards in bloom designed to please his patrons, but masterly studies of the forces of nature.

In June 1889 Georges Petit (who from now on would compete with Durand-Ruel to exhibit and sell the best works of Monet and Renoir) arranged what became an artistic tour de force – a joint Monet-Rodin exhibition during Paris's great international trade fair – the Exposition Universel. Critically and financially this well-promoted exhibition at Petit's elegant gallery in the tourist centre of Paris signalled a turning point for Monet. It contained fourteen of his bold, dramatic Creuse canvases along with fifty-two 'typical' subjects – poppy fields, flowering gardens, seascapes and snow scenes. Naturally Petit's show attracted many Americans who were in Paris for the Exposition. Some of them bought Monet's paintings and became keen collectors of his work.

Claude Monet
Study of rocks, Creuse, 1889.
Oil on canvas.
28½ × 36 in (73 × 92 cm).
Given by Monet in 1899 to
radical politician Georges
Clémenceau, it was later
purchased in 1954 by H.M.
Queen Elizabeth, The Queen
Mother, from Marlborough Fine
Art, London.

John Peter Russell
Rocks at Belle-Isle.
Oil on canvas.
21½ × 25½ in (54 × 65 cm).
This was one of several of
Russell's finest works once
owned by Sir Leonard and Lady
Trout and included in Christie's
Everton House sale in Brisbane
in June 1989. Like many of
Russell's best works, it is now in
the Queensland Art Gallery.

(Photograph courtesy of the
late Lady Trout.)

Monet visited Belle-Isle, a remote windy island off the south coast of Brittany, from September 14 to November 15, 1886. He stayed in a fisherman's hostel, writing to Alice Hoschedé that the food they served was 'terrible'. On his fourth day there, Monet met an Australian artist, John Peter Russell (1859–1930), who was some twenty years younger than himself. Russell had inherited a vast fortune from his grandfather's Sydney foundry and had come to study painting in Paris, where he had met and befriended van Gogh.

Russell recognised the black-bearded Monet immediately from the description he had been given by van Gogh, who had also warned him that Monet was liable to be aggressively rude if disturbed while painting. So Russell silently watched Monet for half an hour. Finally he plucked up courage and asked if indeed Monet was 'the prince of the Impressionists'. Totally disarmed by Russell's inquiry, Monet wrote to Alice later that afternoon, recounting how 'a delightful person' had invited him to dinner at the Manoir de Goulphar. At that time it was very cheap for foreigners to live in France; aspiring American artists flocked to Giverny in droves to try to meet Monet. Naturally Monet took Russell for an American.

At Russell's renovated stone manor house, high above Porte Goulphar, Monet met Russell's companion, Marianna Matiocco, a beautiful Sicilian who had formerly modelled for Rodin. Monet loved good food, good wine and good company, and he found the food provided by Russell's Parisian chef magnificent. Two days later Monet invited Russell to paint with him, and they then spent the next two weeks painting together. He wrote to Alice, 'the ocean is so

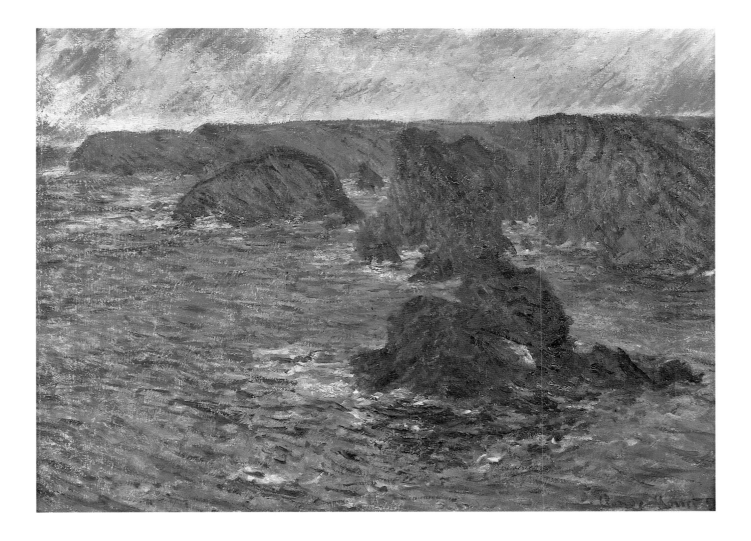

Claude Monet
Rocks at Belle-Isle, 1886.
Oil on canvas.
25½ × 33½ in (65 × 85 cm).
Bought from the artist by
Georges Petit in 1887, he
included it in his Monet-Rodin
exhibition of 1889, where it
was sold to P. Aubry. In 1898
Petit resold it to Sergei
Shchukin, whose collection was
'nationalised' by the Russian
Government after the
Revolution, and it was later
transferred to Moscow's
Pushkin Museum.

beautiful that... the more I work the more I become enchanted... I am quite
carried away... [by] the incredible colours in the sea.' Russell felt the same; the
island of Belle-Isle had an almost mystical association for him.

Monet and Russell frequently risked their lives by clambering down steep
rockfaces in wind and rain carrying their paints and canvases, while the waves
surged and boiled around jagged rocks far below them. Russell paid Hippolyte
Guillaume (Poly), a burly Breton fisherman, to carry their easels and to rig a
tarpaulin over them so that they could continue painting in the rain.

Three years after he met Monet, Russell finally married Marianna. Rodin
was a frequent visitor to their home and much admired Russell's Belle-Isle sea-
scapes. He told the young Australian, 'Your works will live, I am certain. One
day you will be placed on the same level with our friends Monet, Renoir and
van Gogh.' In 1889, at Rodin and Monet's joint exhibition at the Georges
Petit Gallery, the great sculptor was so impressed by Monet's *Belle-Isle-en-mer*
that he purchased it for his own collection, and it now hangs in the Musée
Rodin, Paris. Also there are some of John Peter Russell's Belle-Isle seascapes,
donated by his daughter.

Russell spent thirty-one years painting in France before finally returning to
Sydney.

By 1890 Monet had enough money to buy Le Pressoir, the house in the village of Giverny, west of Paris, which he and Alice Hoschedé had previously rented. The feeling of relative stability which his increasing fame and the purchase of a home gave him, after so many years of bitter financial struggle, now enabled Monet to create some of his greatest masterpieces.

In the late summer Monet began to paint the grainstacks in a field near his home. Initially he thought two canvases would be enough to show the widely-differing and elusive effects of cloudy weather or sunshine on the stacks and their shadows. But new effects of light continued to appear, so Monet started more canvases, working on several for eight or ten minutes at a time. Every day one of the Monet or Hoschedé children carried the artist's canvases to the field behind their house. As the light changed, Monet switched from one canvas to another – through summer and winter, at sunset, midday and sunrise. On October 7 1890 Monet informed his biographer Gustave Geffroy 'I'm hard at it, working stubbornly on the grainstacks, but at this time of the year the sun sets so fast I can't keep up with it.' *Grainstack; sun, misty twilight* is one of the most beautiful of the entire series, observed by the artist through a translucent pink misty veil.

By winter Monet wrote 'I am working terribly hard, struggling with a series of different effects. But at this time of year the sun sets so quickly that I can't keep up with it. I am working so slowly that I despair. But the more I go on, the more I see how necessary it is to work really hard to try to get the effect I want, that "instantaneousness"... Now, more than ever, things which come easily disgust me.' This ambitious series came to an end when the farmer demolished his grainstacks, but not before the wily peasant blackmailed the artist into paying him money to keep them there a few days longer.

In May the following year, Galerie Durand-Ruel exhibited fifteen of the grainstack paintings with fifteen more from Monet's own collection in reserve in the gallery's stockroom – just in case buyers wanted more. The exhibition sold out – twenty grainstacks were bought by American collectors, while ten of the series were purchased by French collectors and rival dealers.

Claude Monet
Grainstack; sun, misty twilight,
1890–1.
Oil on canvas.
23½ × 39½ in (60 × 100 cm).
Originally sold by Durand-Ruel.

(Photograph: courtesy of the Robert Holmes à Court Collection.)

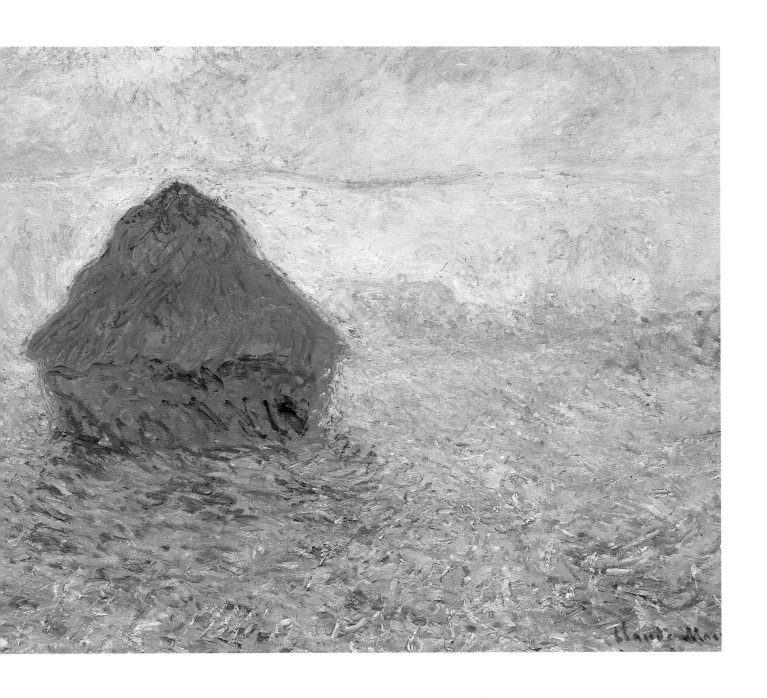

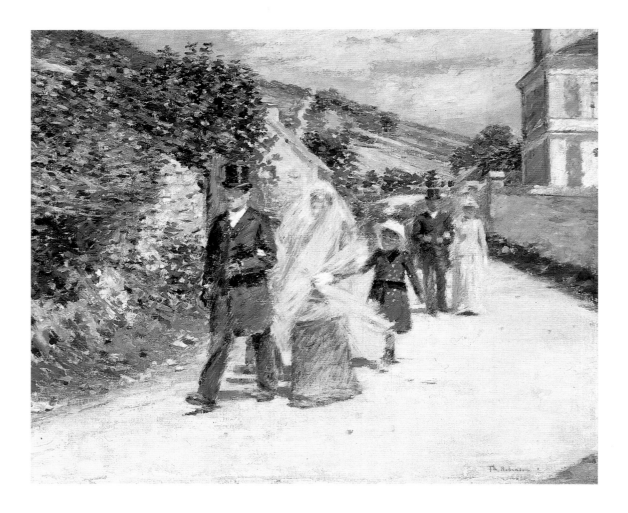

Young American Theodore Robinson (1852–96) who lived close to Le Pressoir, was one of the few artists the Monets admitted to their close-knit family circle at Giverny.

In 1892 Suzanne Hoschedé was to marry Theodore Robinson's friend Theodore Butler, another young American painter. Faced with her daughter's church wedding, Suzanne's mother, Alice, decided that it was time she and Monet were married. Ernest Hoschedé had just died, so four days before Suzanne's wedding Alice Hoschedé and Claude Monet finally celebrated their own. Theodore Robinson's delightful 'impression' shows Suzanne walking through the village on the arm of her step-father, Claude Monet. The artist, who normally hated formal clothes, has been forced by circumstances into wearing top hat and tails for the ceremony in Giverny's small church.

Strong-minded Alice Hoschedé observed the sexual temptations offered to middle-aged male artists and sculptors by beautiful young models and consistently refused to allow Monet to employ any. So Monet had to content himself making portraits of Alice's daughters, Suzanne and Blanche Hoschedé. Suzanne died in 1899 only seven years after her marriage; Blanche eventually married Monet's eldest son, Jean. Jean Monet died in 1914, three years after Alice, when a grieving Blanche Hoschedé-Monet returned to Giverny to care for her widowed step-father until his death.

Theodore Robinson
The wedding march, 1892.
Oil on canvas.
22 × 26 in (45 × 66 cm).
Originally owned by Suzanne Butler (née Hoschedé), it was in a number of collections in the U.S.A. before entering the Daniel J. Terra Collection (Terra Museum of American Art, Chicago.)

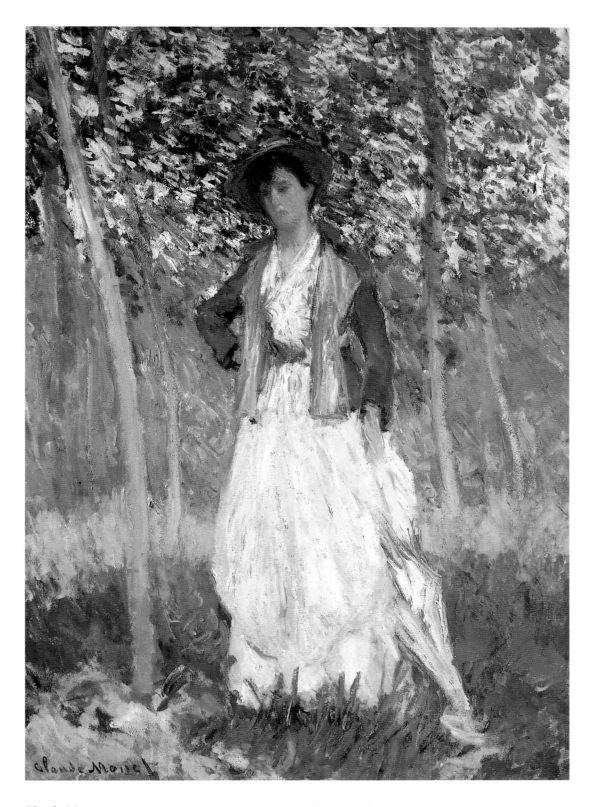

Claude Monet
The stroller (Suzanne Hoschedé),
1887.
Oil on canvas.
39½ × 27½ in (100 × 70 cm).
Exhibited in 1899 in the
Monet-Rodin exhibition at the
Galerie Georges Petit from the
artist's own collection, the
painting was bequeathed to
Blanche Hoschedé-Monet and
inherited by her nephew,
J. M. Toulgouat, before being
bought for the collection of Mr.
and Mrs. Walter Annenberg.

ALFRED SISLEY (1839–1899)

In 1899 Sisley died in poverty, worn out by a lifetime of struggle for recognition that never came. Sisley, an intensely dignified but shy man, was born in France to English parents. He never took out naturalisation papers. The success that eluded him in life came a year after his death: his landscapes suddenly soared in value at auction. As a young man Sisley's wealthy parents sent him to study commodity dealing in London, which he hated, and it was his deep interest in painting that brought him back to Paris to study art. During the disastrous Franco-Prussian war, Sisley's father, like many other businessmen, lost all his money, which meant that Sisley's living allowance stopped. The struggling young artist was then forced to support himself and his family entirely from his art.

By 1876, the year when he painted *Women laundering*, Sisley's brushwork had become more energetic. His laundresses are indicated by a few masterful strokes and outlined in bluish-black. The sole highlight against their dull clothing is the little yellow straw hat.

In *Barges on the Canal Saint-Martin, Paris*, Sisley has succeeded brilliantly in capturing the charm of light and water. Collector Oskar Reinhart, who bought this painting, had a keen eye for quality, and this is generally regarded as one of Sisley's finest works. The artist has cleverly drawn the viewer's eye to a focal point – the brown and black hulls of the barges; while the deep violet-blue of the mansarded Parisian roofs in the distance lends some colour contrast.

To create a feeling of light sparkling on the surface of the canal Sisley primed his canvas in a pale tone and then superimposed a web of short brushstrokes in silvery-blue, lemon and lilac to create dancing highlights. For Sisley, this attention to surface texture was crucial. In many of his aims Sisley was way in advance of his times; he wrote in a letter to Adolphe Tavernier, 'To give life to the work of art is certainly one of the most necessary tasks of the true artist. Everything must serve this end: form, colour, surface... I am in favour of differing techniques within the same picture. This is not the general opinion at present, but I think I am right, especially when it is a question of light.'

There have been numerous attempts to forge Sisley's paintings of water, but even the cleverest of forgers have found it difficult to achieve Sisley's mastery of technique. In addition, many of the forgeries bear the wrong signatures for their period: Sisley was one of the few Impressionist artists who signed and dated all his paintings, but whereas up until 1872 he signed 'A. Sisley', after that date he used only his surname.

The hardest 'Sisley' forgeries to spot are paintings made by the artist's daughter Jeanne which have had their signature changed to that of her father, for in the late 1880s and the early 1890s Sisley taught Jeanne to paint in a similar style to his own. Jeanne died young, and initially no one wanted her paintings when they came on the market, but once her father's works started to command high prices, unscrupulous dealers bought them and gave them to forgers, who duly changed the 'J' of Jeanne's signature into an 'A' for 'Alfred'. The dealers then resold the paintings as having the provenance of the Sisley family. Since Jeanne painted the same subjects and also used the same paints and can-

Alfred Sisley
Women laundering, 1876.
Oil on canvas.
21½ × 28 in (54 × 71 cm).
After Durand-Ruel, it was with
Mme. de la Chapelle, Paris. It
was chosen by Lila Witt
Wallace for the Corporate Art
Collection of the Reader's
Digest Association, Inc., in
1961.

vas as her father, these works stand up extremely well under paint analysis.

In view of the high prices now paid for his work, it is ironic that Sisley spent his final years weighed down by financial worries. Only Paul Durand-Ruel (who personally owned four hundred canvases by Sisley) and van Gogh's brother Theo (acting for the Montmartre dealers Boussod et Valadon) managed to sell Sisley's canvases in reasonable numbers: Georges Petit held a Sisley one-man exhibition at his elegant Paris gallery but never sold a single painting. Nevertheless, Sisley was supported by some collectors, including Théodore Duret, Jean-Baptiste Faure and Georges Viau, while Eugène Murer accepted some paintings from the artist in return for free meals at his Paris restaurant.

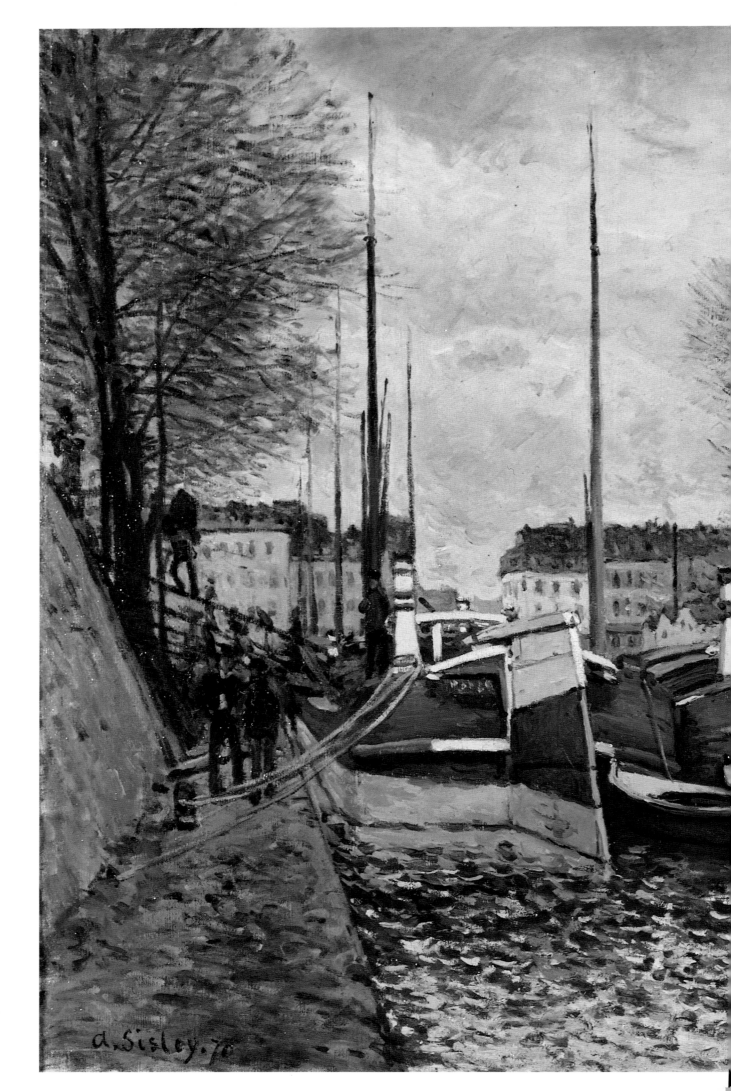

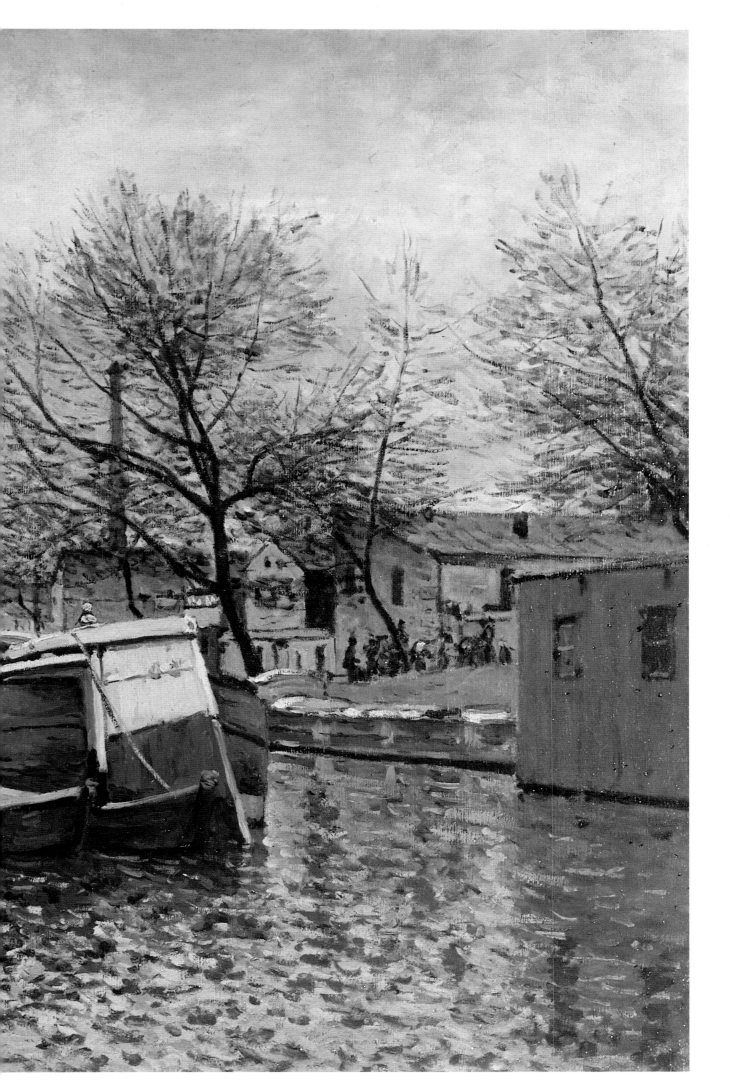

In 1871, at the height of violent street battles in Paris, Alfred Sisley and his wife, Marie Eugénie, sought refuge from the bloodshed in the village of Voisins-Louveciennes, to the north-east of the city. Sisley already knew this unspoiled area on the edge of the forest of Saint-Cloud, because Pissarro had lived here before departing for England. Renoir's parents, now retired, also lived in the village, and their son often stayed with them when his funds were low. Sisley installed his wife and his two young children, Jeanne and Pierre, in a modest house in the rue de la Princesse. The import business of Sisley's father had failed due to the war, and it was an anxious time for the young artist, who had previously painted for pleasure rather than to earn his family's daily bread.

In June that year, Camille Pissarro and his family arrived back from London, and Sisley and Pissarro made painting excursions together. Both artists were attracted by similar scenery – lush summer landscapes or snow scenes.

Sisley painted this beautiful wintry scene from the windows of his house in the rue de la Princesse, and he later painted another snow scene (now in the Musée d'Orsay) from a slightly different vantage point. Both paintings examine the pearly effects of reflected light on snow and the sadness and muffled quality of life in a snowy winter. Sisley clearly enjoyed the sense of mystery acquired by quite ordinary buildings when seen under a mantle of snow.

Describing his vision, Sisley wrote: 'The spectator should be led along the road that the painter indicates to him and ... be made to notice exactly what the artist has felt.'

Sisley's skilful composition leads the viewer's eye along a straight path, bordered on one side by a fence and on the other by a high stone wall. In the second version, the snow is piled up in deeper drifts and lies heavy on the branches, but here the branches of the trees are stark, as though the wind has blown the snow away. To provide a focal point, Sisley has painted a sombre woman with a dark umbrella; her long black dress and grey apron are silhouetted against the snow. To add more colour, Sisley emphasised the pink and lilac shadows in the snow, in a way that recalls some of Monet's winter scenes at Vétheuil.

Previous pages:
Alfred Sisley
Barges on the Canal Saint-Martin, Paris, 1870.
Oil on canvas.
21½ × 29 in (55 × 74 cm).
One of two views of the canal that were accepted by the Salon of 1870: Later it was purchased by Oskar Reinhart, and it now forms part of the Reinhart Collection in his house-museum, 'Am Römerholz', at Winterthur, Switzerland.

Alfred Sisley
Snow at Louveciennes, 1874.
Oil on canvas.
22 × 18 in (56 × 46 cm).
It was in the Kirkpatrick collection, London, and was later purchased by Duncan Phillips from Paul Rosenberg's Paris gallery.

(Reproduced courtesy of The Phillips Collection, Washington, D.C.)

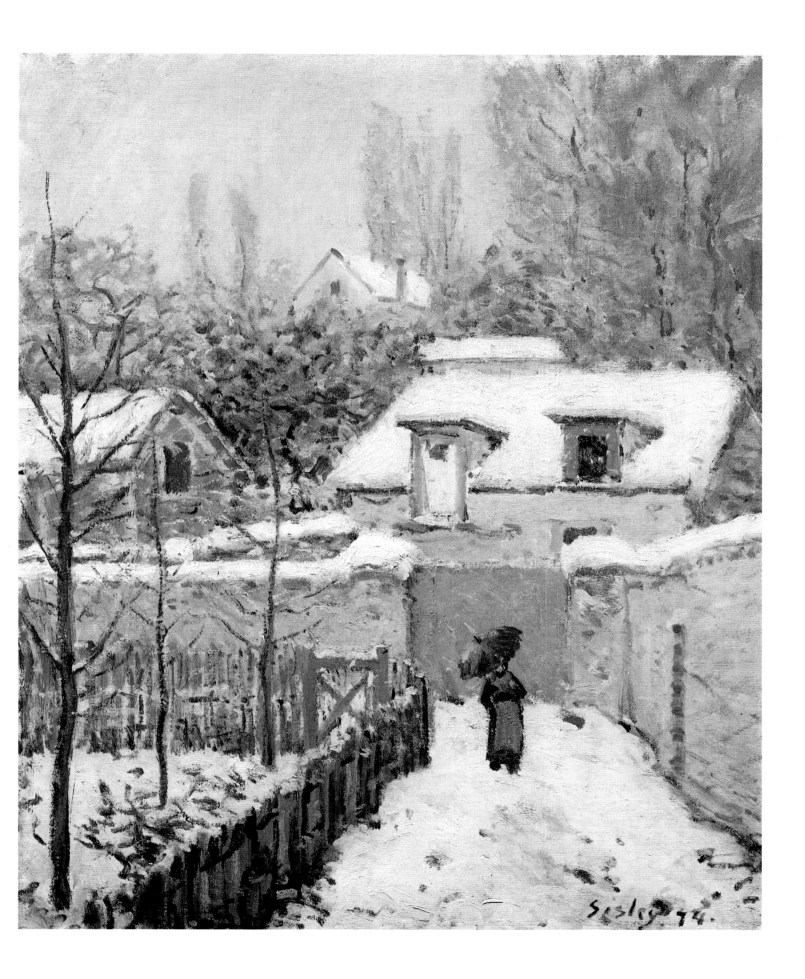

63

BERTHE MORISOT (1841–1895)

Berthe Morisot
The cheval glass, 1876.
Oil on canvas.
25½ × 21½ in (65 × 54 cm).
Thyssen-Bornemisza
Foundation, Lugano,
Switzerland.

Berthe Morisot was an important founder member of the Impressionist group and consistently played a strong role in their policy-making. However, after her death her reputation faded quickly, and until recently she was known principally as Edouard Manet's sister-in-law and the model for his famous painting *The balcony* (Musée d'Orsay). The blame for this neglect lies not with her delicate and fascinating paintings, which, at their best, equal those of Renoir, Degas or Manet, but because Berthe Morisot lived at a time when the art world was a totally male-dominated fraternity. Only men were allowed to study at the Ecole des Beaux-Arts: the sight of full-frontal male nudes in the life class was deemed far too shocking for delicately reared unmarried girls, so Berthe and her sister had to have private art classes with Corot.

Throughout her life Morisot was limited by the conventions of upper middle-class society, with its insistence that a women's place was 'in the home'. Instead of haunting cafés and cabarets to paint modern life, as did her male fellow-artists, she solved the problem neatly by showing us glimpses of her own domestic world. Her nephew by marriage, Paul Valéry, described how Morisot 'lived her paintings and portrayed her life… She picked up the brush, put it down and picked it up again in the same way as a thought comes into your mind, disappears and then returns.'

The French title of Morisot's painting here, *La Psyché*, has a double meaning, since 'Psyché' is the word for a long cheval mirror as well as the name of the young girl loved by Eros in Greek mythology. A young girl dressed up to attend her first ball is a favourite Morisot theme, reflecting her study of Old Master paintings on the theme of Vanity regarding herself in a mirror. Morisot's command of light in interiors and her delicate, feathery brushstrokes are unique in Impressionism. This gentle image of a young girl in a virginal white dress, surrounded by soft draperies and a flower-scattered sofa, is one of her finest works.

Morisot's oils and luminous pastels received the best critical appreciation of all works shown at the first Impressionist exhibition. Ernest Hoschedé purchased one; a second was bought by Degas's friend, the collector and amateur artist Henri Rouart; and Morisot's future husband, Eugène Manet, brother of her warm admirer Edouard Manet, purchased a third. She married Eugène in December of the same year, and he became a loyal and supportive husband in an era when many female artists, including Morisot's sister, were forced by jealous husbands to abandon painting altogether.

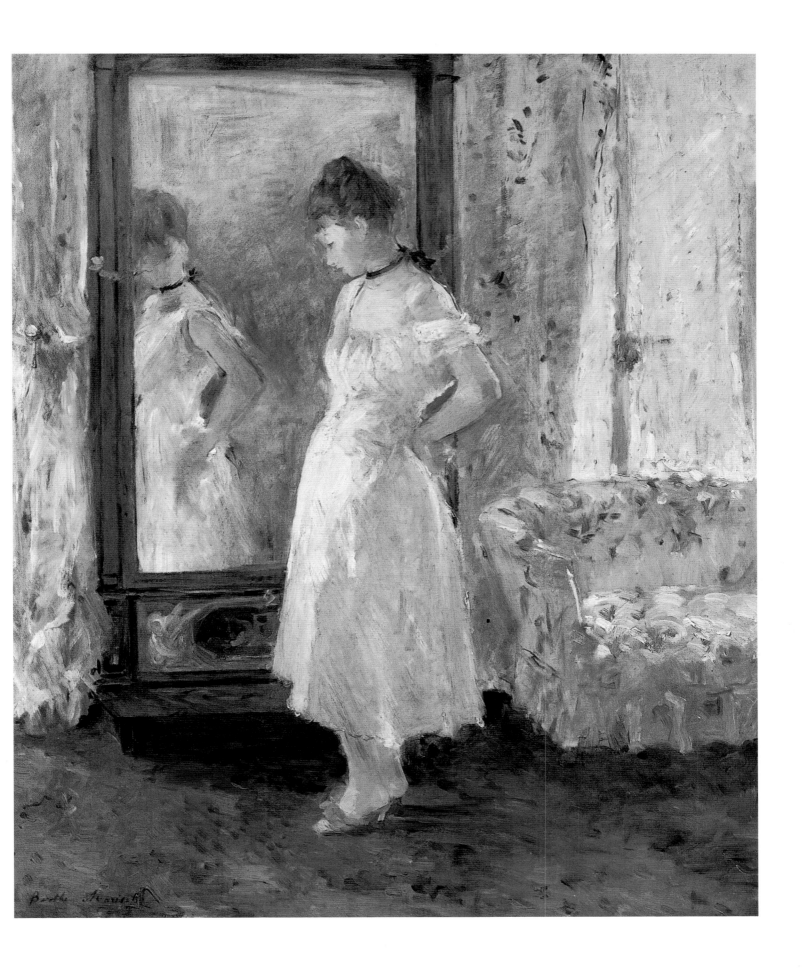

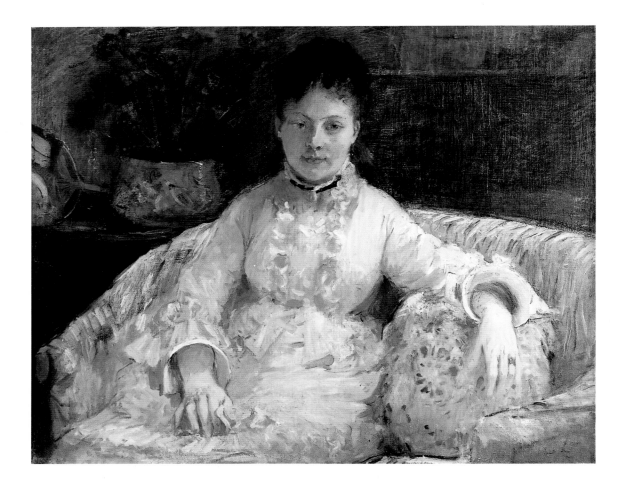

Berthe had met her future brother-in-law Edouard Manet in 1868, when she and her sister Edma were copying paintings in the Louvre. With her dark eyes and high cheekbones, her lively intelligence, her knowledge of art and her charm, Berthe enchanted Manet. Manet's mother and Mme. Morisot became close friends, and, chaperoned by her mother, Berthe was allowed to visit Manet's studio. There she modelled for a series of portraits, the light playing across her vivacious, delicate features. Morisot's close friendship with Manet had the effect of lightening her palette and loosening her brushwork. Unfortunately, no faded letters or old diaries remain to show if there was ever anything more than a mutual love of art between them. Manet had recently married Suzanne Leenhoff, the mother of his illegitimate son, and Suzanne seems to have been very friendly with Berthe whenever the two women met. But Manet tended to keep his home life and his studio work separate, and Morisot was certainly jealous when Manet made a portrait of his young pupil Eva Gonzalès, another dark-eyed beauty.

This haunting portrait of Berthe's neice, Alice Gamby, was done in the drawing room of the house Berthe and Eugène Manet shared in rue de Villejust (now rue Paul Valéry). Here, this art-loving couple entertained leading artists and writers every Thursday evening. Although Morisot had a strongly individual style, the sloe eyes of little Alice bear a resemblance to those of children in some of Renoir's portraits. The two artists occasionally painted together, and Renoir was godfather to Berthe's only daughter, Julie.

Berthe Morisot
The pink dress, c. 1870.
Oil on canvas.
21½ × 26½ in (55 × 68 cm).
This early work is believed to be of a Morisot family friend, Marguerite Carré, whose position on the sofa has an ironic echo of the pose of Suzanne Leenhoff-Manet in Manet's *Reading* (Musée d'Orsay). Originally in the collection of the sitter, it was probably acquired directly from her by the Argentine collector Antonio Santamarina. It was bought at the Santamarina sale at Sotheby's, London, in 1974 by Mr. and Mrs. Walter Annenberg.

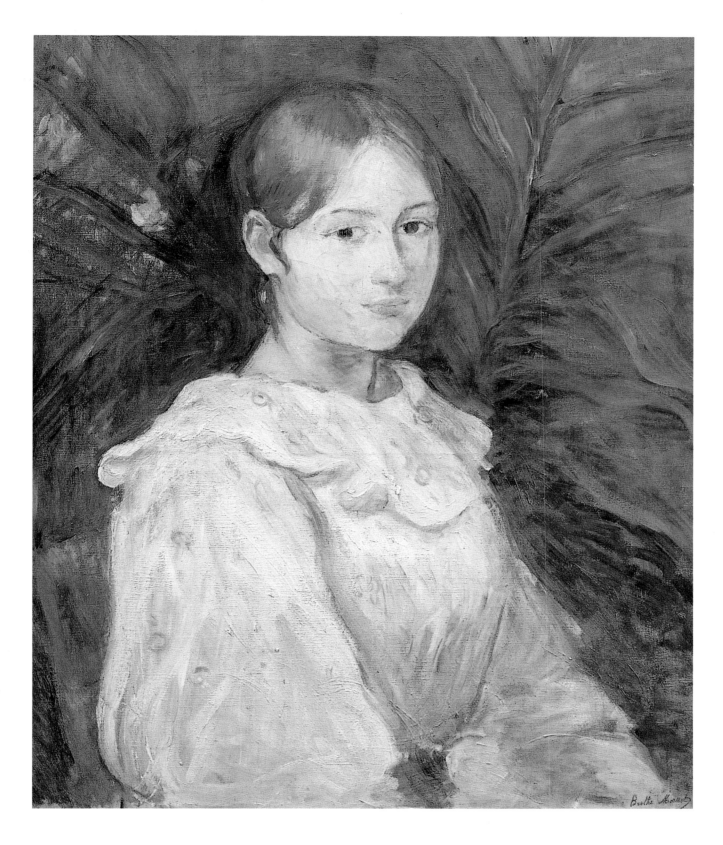

Berthe Morisot
Portrait of Alice Gamby, 1890.
Oil on canvas.
21½ × 18 in (55 × 46 cm).
Exhibited the year it was
painted at the Durand-Ruel
Gallery, it was owned for a
period by the Durand-Ruel
family. It is now in the
collection of the Fondation Dr.
Rau pour le Tiers Monde,
Zurich, Switzerland.

(Photograph courtesy of
Christie's, London.)

CAMILLE PISSARRO (1830–1903)

Pissarro grew up on the island of St. Thomas in the Virgin Islands, where his father, who was of Jewish, French and Portuguese extraction, ran a prosperous ships' chandlery. When he was fourteen he was sent to school in France for three years, then returned to join the family business. At twenty-two, bored and frustrated by work he hated, Pissarro took off on a two-year painting tour of Venezuela with the Danish landscapist Fritz Melbye.

Stifled by the claustrophobic atmosphere of St. Thomas, Pissarro left again, this time for Paris, where he studied with Fritz Melbye's brother Anton and then attended the Académie Suisse, where he met Monet. Through Monet, Pissarro met Manet, Cézanne and Renoir and was introduced to *plein air* painting. At around the same time, Pissarro's mother took into service a pretty young maid, Julie Vellay, and Pissarro's love affair with her brought family condemnation; in 1863 their eldest child, Lucien, was born.

Early in the 1860s Pissarro met the wealthy amateur artist Ludovic Piette, who became his most generous patron. Piette always provided him with a home when Pissarro could not pay the rent and he, Julie and their children had nowhere else to go. Pissarro and Piette often painted in a similar style, feeling their way towards what would later become known as impressionist techniques, and Piette showed works in the second and third Impressionist exhibitions. (The creative similarity of the two artists at this period would later cause problems, when fakers substituted Pissarro's signature for that of Piette.)

In 1870 Pissarro and his family fled from the advancing Germans, leaving pictures and furniture behind, to stay with relatives on the outskirts of London. He and Julie married in a registry office there; she was expecting his third child, and the couple had severe financial problems, although Durand-Ruel did buy some of Pissarro's work.

Returning home to Louveciennes after the war, they found that the Germans had commandeered their house and destroyed most of Pissarro's paintings. Some were used as stepping stones in the garden so that the Germans could avoid dirtying their boots. Only forty canvases out of 1,500 were left undamaged.

A weaker man might have swallowed his pride, given up art and returned to work in his lucrative family business; but Pissarro quietly and determinedly carried on painting. In order to keep going, he and Renoir decorated the interior of Murer's restaurant, and Murer bought some of his paintings, even running a lottery with one of Pissarro's paintings as the prize – but the winner preferred to receive a cream cake instead. After Piette, whose death in 1878 was a major blow to Pissarro, his early buyers were Theódore Duret, the banker Gustave Arosa (who was Gauguin's godfather), Jean-Baptiste Faure and those dedicated collectors of Impressionism Caillebotte and Dr. de Bellio.

Pissarro was a highly literate force in the development of Impressionism. He drew up the charter of the ponderously named *Societé anonyme coopérative d'artistes, peintres, sculpteurs etc.* It was set up along the Socialist co-operative lines recommended by Pissarro in order to manage the Impressionists' own exhibitions. It was intended that every exhibiting member would share the

Camille Pissarro
Père Melon sawing wood, Pontoise, 1879.
Oil on canvas.
35 × 45½ in (89 × 116 cm).
It was already owned by Paul Gauguin at the time it was exhibited in the fifth Impressionist exhibition in 1880, but he later sold it to finance his first voyage to Tahiti. It was acquired at Christie's, London, in 1985 for the Robert Holmes à Court Collection.

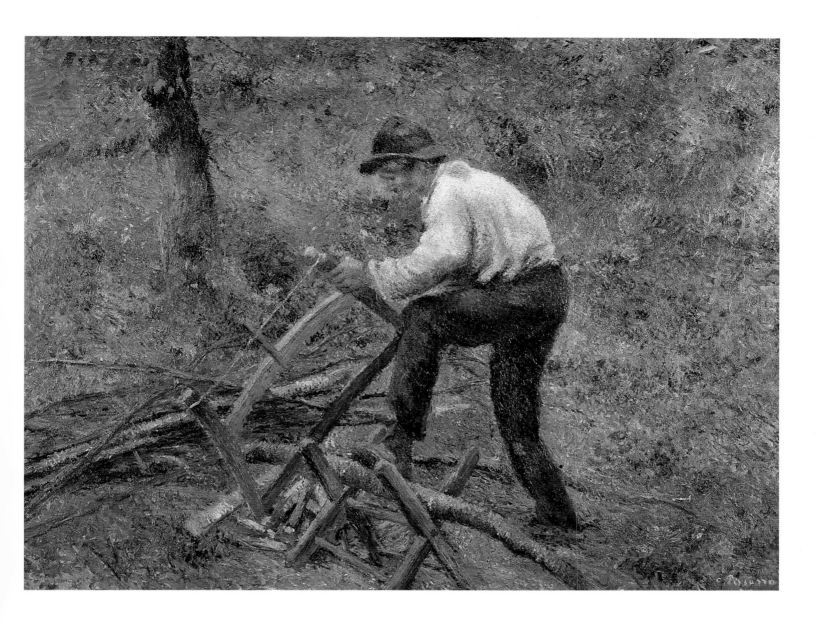

Following pages:
Camille Pissarro
*A corner of the Hermitage,
Pontoise,* 1874.
Oil on canvas.
24 × 32 in (61 × 81 cm).
Owned by Gauguin, the
painting was later purchased by
Oskar Reinhart and can be seen
at his house-museum, 'Am
Römerholz', at Winterthur,
Switzerland.

profits from the group's exhibitions, but, unfortunately, the company had to be wound up after the first exhibition.

Nevertheless, Pissarro became the group's father figure – the only artist to exhibit in all eight Impressionist exhibitions. His Socialist principles led him to believe that he had a duty to teach art to others. Mary Cassatt described how 'he could have taught a stone to draw', and he derived great pleasure teaching Cézanne and Gauguin to paint out of doors, using the rapid, intuitive techniques of Impressionism. Forthright and down-to-earth, he enjoyed arguments with these younger painters as he taught them.

Pissarro's work, filled with genuine feeling, but always concentrating on the lives of the downtrodden rural poor, was never as popular with collectors as that of Monet and Renoir. Rather than doing society portraits for money, like Renoir, Pissarro preferred to paint peasants at their daily tasks, in order to stress the nobility of work. Père Melon was Pissarro's neighbour at Pontoise, and Pissarro depicts the tough old man, nearly as bent as the saw with which he cuts

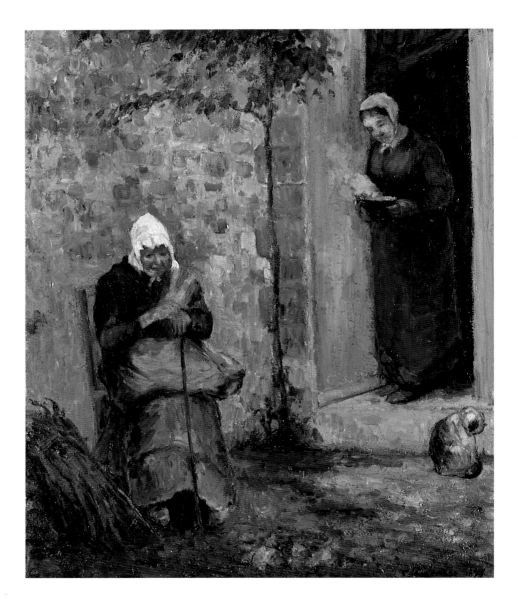

Camille Pissarro
Charity, 1876.
Oil on canvas.
22 × 18 in (56 × 46 cm).
Originally owned by wealthy
dentist Dr. Georges Viau, the
painting is reproduced courtesy
of the Robert Holmes à Court
Collection but was recently
re-offered at Christie's New
York saleroom.

Camille Pissarro
The rue de l'Epicerie, Rouen,
1898.
Oil on canvas.
32 × 25½ in (81 × 65 cm).
One of three versions of this
view at different times of the
day painted in late summer
1898, the others being in the
Metropolitan Museum, New
York, and in the Durand-Ruel
family collection. This painting,
which shows the street bathed
in golden afternoon light, was
in the Moch collection in Paris.
Later it was owned by the
British Rail Pension Fund, who
sold it through Sotheby's,
London, to a private collector.

his wood, with deep humanity. Pissarro sold the painting to a pupil who came
for lessons each Sunday; this was Paul Gauguin, and it was Pissarro who would
eventually encourage Gauguin to devote himself entirely to his art.

Pissarro loved the small market town of Pontoise and for over a decade
painted women working in the fields there. *Charity* shows a Breton woman
giving a bowl of soup to another woman, who is obviously down on her luck.
Here again Pissarro paints from the heart, for he too had known desperate
poverty; his wife, who bore him eight children, once threatened to drown her-
self because she was so worried about their mounting debts.

In 1885 Pissarro met Signac and Seurat and, receptive as he always was to
new ideas, he found himself artistically and politically in agreement with them.
His own paintings were included with theirs (and those of his own son Lucien)
in the room devoted to Neo-Impressionism in the eighth and last Impressionist
exhibition in 1886. From now on, in works such as *The poultry market at Pon-*

toise, Pissarro replaced the looseness of his former Impressionism with a semi-geometric composition – a series of dashes and commas of paint; eventually clusters of coralline dots would mark his conversion to a modified version of Divisionism or Pointillism. His subject-matter was also affected by new ideas: Pissarro's readings from the works of Kropotkin had convinced him that rural work, conducted in collective harmony, was the only antidote to rural workers' oppression by the bourgeoisie. His paintings of rural markets arose from his passionate belief that peasant farmers should cut out the middle-man and make a fair profit by selling their own produce at street markets.

He still had great difficulty selling his paintings, although in 1892 he had some success when the Galerie Durand-Ruel gave him an exhibition, and the following year Durand-Ruel purchased works to the value of Fr. 23,600. Later, in 1897, Durand-Ruel organised an exhibition of Pissarro's Rouen views in his New York gallery, the majority of which were purchased by American collectors. In the autumn of 1896, and again from August to October 1898, Pissarro had stayed in Rouen, at the Hôtel d'Angleterre. From the windows of the hotel Pissarro painted some of the bridges and streets of the city and made a series of bird's-eye views of the Friday market in the rue de l'Epicerie. But by now, eye trouble, the result of an infection contracted some ten years earlier, made it imperative that he change his working methods and paint indoors to avoid exposure to the sun.

Success finally came – but at the end of his long life. It never changed him. Cézanne wrote his finest epitaph when he described Pissarro as 'both humble and colossal – the most honest and noble of all the Impressionists – the true creative artist'. In 1883 Pissarro wrote his eldest son, Lucien, in a letter which reveals his inner motivations: 'I have just concluded my series of paintings. I look at them constantly... I understand them only at rare moments, when I have forgotten all about them, on days when I feel kindly disposed and indulgent to their poor maker... However, at times I come across works of mine which are soundly done, and really in my style. And at such moments I find great solace... Painting, art in general delights me. It is my life. What else matters? When you put all your soul into a work, all that is noble in you, you cannot fail to find a kindred soul who understands you... Is not that all an artist should wish for?'

Camille Pissarro
The poultry market at Pontoise, 1882.
Oil on canvas.
31 × 25 in (79 × 65 cm).
One of the outstanding paintings in the collection of the Norton Simon Foundation, Pasadena, California, its technique anticipates the artist's pointilliste period with its deliberate semi-geometric construction of forms.

PIERRE-AUGUSTE RENOIR (1841–1919)

The promenade was painted in 1870, when Renoir was twenty-nine and formed part of the group of young avant-garde artists who met to discuss theories of art at the Café Guerbois with Manet. The previous summer he had spent almost every day painting out of doors at La Grenouillière with Monet, who encouraged him to move towards a lighter and more luminous palette. *The promenade* is an important landmark in the history of Impressionism, as it demonstrates the start of Monet's influence on Renoir in its forward-looking treatment of light and atmosphere. The figures of the young lovers have been fully integrated into a dappled landscape, which is no set scenic backdrop in a studio; the painting has obviously been done outdoors. At the same time, the air of rococo sensuality in *The promenade* derives from Fragonard or Watteau, whose works Renoir had often copied while he was a decorator of porcelain.

A ray of sunlight shines through dark trees creating the sun-dappled effect on faces and clothes which was to become the trademark of some of Renoir's finest paintings, such as *The swing* and *Ball at the Moulin de la Galette* (both originally owned by Gustave Caillebotte and now in the Musée d'Orsay). Renoir always preferred a thin, oily paint mix and used his own technique of feathery brushwork derived from his porcelain decorator's training. His thin colour glazes literally float into each other to provide depth. The blue in the woman's dress is echoed by shadows on the right of the painting.

The identity of the young man remains a mystery; but it has been suggested that the young woman in the white dress filled with blue and pink shadows could be Rapha, mistress of Edmond Maître, a wealthy collector, amateur painter and musician. So it is logical to assume that Maître might be the young man. Another fact linking Maître to the painting is that in June 1870, around the time it was painted, Renoir spent several weeks as a guest at Maître's Paris apartment. Still unmarried, Renoir was leading his normal hand-to-mouth existence and was short of money to pay his rent. The painting shows some of the joy in simple pleasures that would later characterise all Renoir's work.

Pierre-Auguste Renoir
The promenade, 1870.
Oil on canvas.
31½ × 25 in (80 × 64 cm).
The painting was purchased by Gustave Goupy from the artist, and was bought at the auction of his collection in 1898 by Renoir's dealer, Paul Durand-Ruel. It has been in several important private collections, including that of Paul Cassirer and, more recently, the British Rail Pension Fund, who sold it in 1989 to the J. Paul Getty Museum in California, the private museum founded by the oil millionaire and collector.

(Reproduced courtesy of the J. Paul Getty Museum, Malibu, California.)

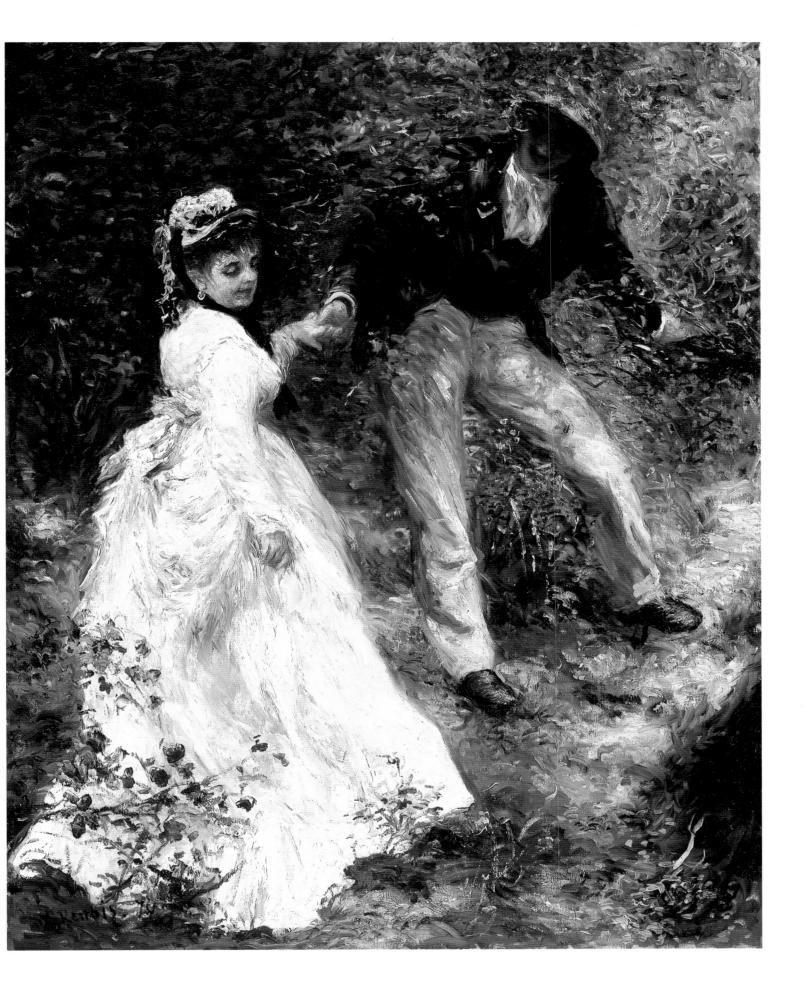

Pierre-Auguste Renoir
Spring at Chatou, c. 1872–5.
Oil on canvas.
23×29 in (59×74 cm).
This painting was included in
the inventory of Durand-Ruel's
stock in 1891 and was sold to
Paul Cassirer in 1910. It is now
in a private collection.

According to the memoirs of Renoir's son, film director Jean Renoir, his father once told him how much he 'liked pictures that make me want to walk about in them'.

Spring at Chatou falls into this category. It was painted in the lush meadows that surrounded the riverside village of Chatou, three miles downstream from the yacht basin of Argenteuil, where Monet was living. With the advent of the railways, Chatou, with its multiplicity of rowing boats for hire, rapidly became popular with the newly-prosperous bourgeoisie of Paris as a destination for Sunday outings, particularly as there were also riverside restaurants and rustic snack bars with dancing, popularly known as *guinguettes*. It was here that Renoir painted *Luncheon by the river* (Art Institute of Chicago), *Oarsmen at Chatou* (National Gallery, Washington) and *Luncheon of the boating party* (Phillips Collection). The rural villages on the banks of the Seine west of Paris were all changing as they were 'developed' by wealthy Parisian speculators, so that in the 1860s and '70s the area around Chatou epitomised the rapidly developing pace of 'modern life' for both Monet and Renoir.

Spring at Chatou shows the fields before the developers arrived. Renoir's technique here has much in common with that of Monet: his landscape dissolves into paint before the viewer's eyes. To balance his composition and provide a sense of scale, with the flick of his brush the artist has added in one small human figure. Other small brushstrokes in the foreground suggest white, pink and purple wildflowers, just as Monet's dashes of pink and white suggest fruit trees in *Landscape with orchard and figures, Vétheuil* (p. 47).

Spring at Chatou was painted during Renoir's lean years – a time when he often had insufficient money for wood for the kitchen stove or even to buy essentials like bread and milk, canvas and paints. During this difficult period few collectors were interested in his works, other than Victor Chocquet and staunch supporters of the Impressionist group such as Dr. Georges de Bellio, Gustave Caillebotte and Jean-Baptiste Faure.

However, nearly two decades later, Renoir found that some important collectors wanted to buy his paintings, and Paul Durand-Ruel was at long last able to sell Renoir's work at a good profit. Mindful of the lean years, Renoir listened attentively to Durand-Ruel's advice regarding subject-matter for his major canvases. When the dealer told him that flower paintings always appealed to collectors, Renoir painted two versions of flowers in a majolica vase, each with a slightly different arrangement of fruit beside it. Durand-Ruel liked this magnificent version of the still-life so much that he kept it for his own collection. It shows Renoir's appreciation of Dutch Old Masters in its deft handling of pure, rich colour in the fruit, as well as on the intricate patterning of the vase. Renoir must have liked using this particular vase as a prop, as it had appeared on the piano in his portrait of *The daughters of Catulle Mendès*, painted a year earlier, and he would use it again in 1899 in two versions of one of his favourite themes, *Young girls at the piano*.

Pierre-Auguste Renoir
Still life; flowers and fruit, 1889.
Oil on canvas.
25½ × 21 in (65 × 53 cm).
The painting was bought by Paul Durand-Ruel for 300 Frs. in September 1890, and he liked it so much it remained with him until after the artist's death.
Private collection.

(Photograph: courtesy of Sotheby's Impressionist Department, London.)

Late in April 1888, Renoir wrote to the poet Catulle Mendès asking him if he would like to commission a life-size portrait of his three beautiful daughters. Renoir proposed to do the preliminary drawings at Mendès's house and complete the portrait in his studio, and he asked a fee of 500 Frs. He proposed that Huguette, the eldest girl, should sit at the piano; Claudine would stand beside her, holding a violin; while Helyonne, the youngest, would lean against the piano. The mother of the girls, Catulle Mendès's live-in lover, was the Irish pianist and composer Augusta Holmès, but they were brought up by Mendès's sister, because Augusta had a horror of domestic responsibility and resolutely refused to marry – even when Saint-Saëns proposed to her. Knowing that the relationship of this fiery, unconventional couple was turbulent and financially unstable, Renoir prudently added a postscript to his letter, 'The 500 francs are payable at 100 francs a month.' But even on Renoir's generous terms, Mendès was still very slow to pay.

Pierre-Auguste Renoir
Woman with a rose.
Oil on canvas.
14 × 10½ in (35 × 27 cm).
This portrait so enchanted Marshal Goering that he confiscated it from the Stettiner collection in Paris and took it back to Germany for his own collection. After the war it was found by the Allies and returned to Paris. It now forms part of the collection of the Fondation Dr. Rau pour le Tiers Monde, Zurich, Switzerland.

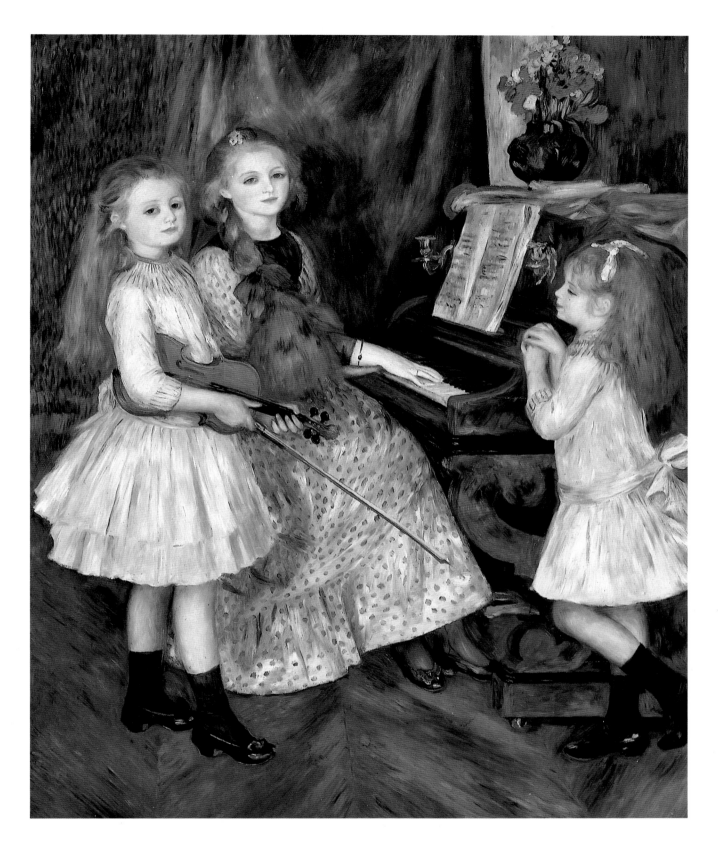

Pierre-Auguste Renoir
The daughters of Catulle Mendès,
1888.
Oil on canvas.
64 × 51 in (162 × 130 cm).
After Mendès himself, the

portrait was owned by the
Prince de Wagram and then by
the Princesse de la Tour
d'Auvergne. It is now in the
collection of Mr. and Mrs.
Walter Annenberg.

In spring 1877 Renoir devoted time and energy to preparing for the third Impressionist exhibition, which was being organised, almost single-handed, by Gustave Caillebotte. Caillebotte had brought together Manet, Degas, Monet, Sisley and Pissarro, as well as Renoir, at a dinner at his house early in the year, persuading them (with the exception of Manet) to take part in another group exhibition. Renoir assembled twenty-one paintings, thirteen of which he had already sold – mainly to the Charpentiers, his principal patrons at the time and to Dr. de Bellio. In addition, Caillebotte himself had already bought Renoir's *The swing* (Musée d'Orsay) and he purchased the larger version of *Ball at the Moulin de la Galette* (Musée d'Orsay) after the exhibition. Most of the Cézannes in the exhibition were bought (before or after the exhibition) by his dedicated admirer Victor Chocquet, who used to go in to the exhibition as often as he could and explain the group's aims to other uncomprehending spectators. Chocquet also endeavoured to persuade his wealthier friends to buy their work.

But Chocquet's efforts met with little success: a political crisis in May 1877 sent the French economy into recession, and the harsh economic climate soon shattered the fragile solidarity that Caillebotte had fostered. Although the exhibition received great critical attention – and much of the discussion was well-balanced, often favourable to the artists – the press in general continued to regard the whole group as potential revolutionaries. Lacking the Socialist convictions of Pissarro, Renoir felt that his own work would earn much greater success with critics and collectors if he were to submit paintings to the Salon's jury once more.

With this aim, Renoir decided to paint a series of gentle, idealised portraits of young girls. He was loath to break with friends like Degas, who regarded it as treachery for a member of the Impressionists to submit paintings to the Salon, but others finally persuaded Renoir that if he wanted to survive as a professional, he would have to return to exhibiting at the Salon and risk the anger of his Impressionist colleagues.

The reader (of which the artist painted three different versions) shows Marguerite Legrand, one of Renoir's favourite models. Originally he had intended to include his brother Edmond in this version, leaning over Marguerite's shoulder, as in an earlier one, but at the last minute he painted out Edmond's figure with a richly-textured wallpaper. Marguerite posed for her portrait in a high-necked dress with white frilled cuffs, but she was not nearly as demure as she seemed: she and the artist were lovers, but she would often fail to come to his studio for her sittings. Renoir, fuming with impatience, would storm around Montmartre looking for her, only to find her blithely drinking wine in a café with some young tearaways. When Marguerite died of smallpox, Renoir paid for her funeral.

Pierre-Auguste Renoir
The reader, 1877.
Oil on canvas.
25½×21½ in (65×54 cm).
Renoir's original oil was bought from Christie's, New York, by a dealer on behalf of a private collector, for $14 million. The painting became internationally famous when the Japanese tax authorities discovered that both Mitsubishi and the Soka Gakkai religious sect claimed to have bought this painting on the *same day* and in the *same hotel room* from two unknown Frenchmen trading under the name of 'Art France'. Mitsubishi claimed to have paid the mysterious Frenchmen £1.5 million sterling and sold their copy of *The reader* for a profit of a million yen to the Fuji Art Museum in Tokyo (for whom they had been doing construction work). The religious sect claimed they were donating their *The reader* to the Fuji Museum. It has now been revealed that in Japan expensive paintings have been widely bought to avoid tax, often sold and bought back at a massive mark-up.

(Photograph: courtesy of Christie's, New York.

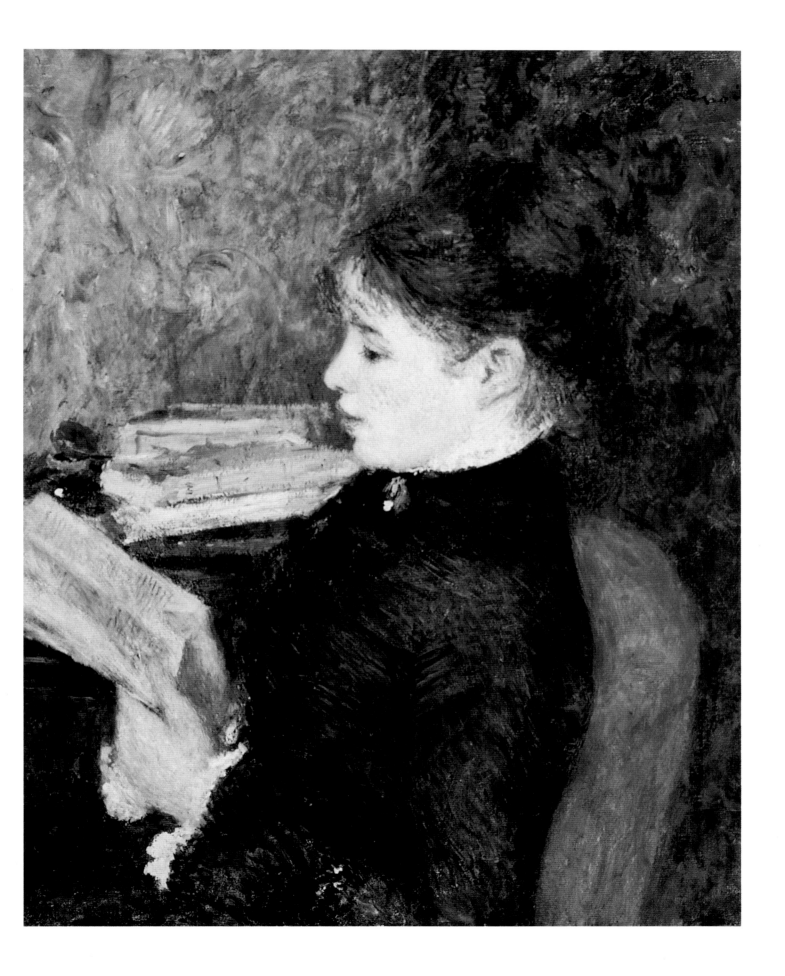

In the late summer of 1880 Renoir started work on a painting that, over a century later, would be described as the most popular in the world. One focal point is the pretty blonde sixteen-year-old on the left playing with her terrier. This was the artist's inamorata and future wife. Renoir had met Aline in the autumn of the previous year under rather unromantic circumstances – she arrived to collect his laundry – but for Renoir Aline was the epitome of all the sweet-faced, snub-nosed young girls he had ever loved and painted. Four years after this painting was made, Aline, a simple country girl, bore Renoir a son. Renoir kept their liaison a secret for years, probably feeling he would find more success with his 'society' patrons like Mme. Charpentier and her circle as a bachelor.

Luncheon of the boating party was painted on the Ile de Chatou in the Seine. The subject is a group of friends lunching informally at the open-air Restaurant Fournaise, which also hired out boats. Alphonse, the landlord's burly son, who acted as boatman-cum-waiter, stands at the verandah rail behind Aline.

The actress Jeanne Samary, who had had her portrait painted by Renoir, also appears in the foreground, while Renoir's influential patron, banker and art-publisher Charles Ephrussi, resplendent in top hat and morning coat, stands at the rear. The blond young man on the extreme right in boating attire is Gustave Caillebotte. (As Renoir was intent on painting 'beautiful people', he has flattered Caillebotte by making him look much younger than his forty years.) Beside him sits Ellen Andrée, another famous actress.

Renoir presents the viewer with a classless world of paintable pleasure, where handsome men, bankers and boatmen, millionaires, fashionable actresses and pretty laundresses can all enjoy themselves in the open air. Threads of intense, sensual colour flicker through the painting, giving it enormous vitality. A red-and-white scalloped awning frames Renoir's attractive cast of characters: diffused sunlight filters softly through the greenery. In this masterpiece Renoir has created a warm, intimate atmosphere, where sparkling wineglasses and flirtatious glances are captured for eternity.

Pierre-Auguste Renoir
Luncheon of the boating party,
1881.
Oil on canvas.
51 × 68 in (130 × 173 cm).
The painting was purchased by
Paul Durand-Ruel from the
artist and exhibited by him
(rather than by Renoir) in the
seventh Impressionist
exhibition in 1882. Renoir, as

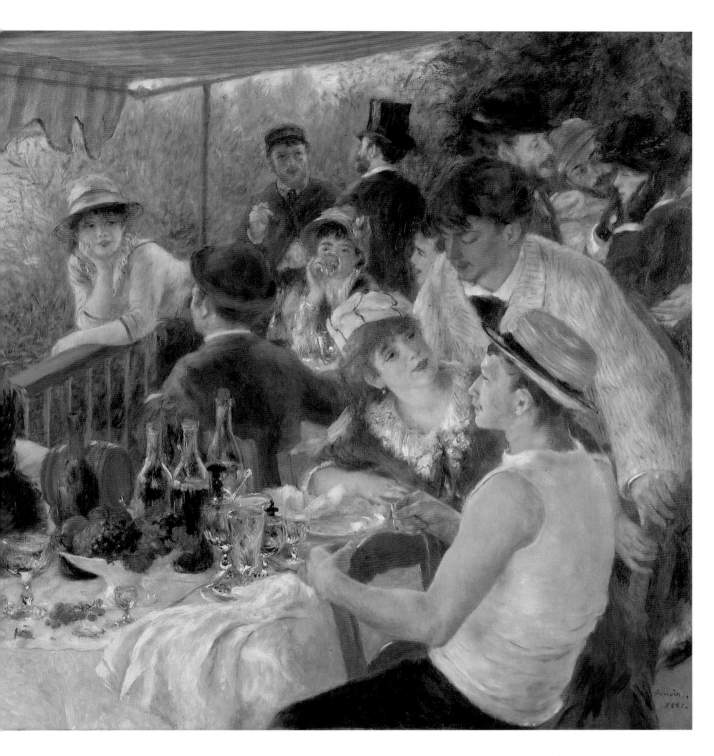

always, was short of money. He told Caillebotte that he feared that exhibiting with Pissarro and Guillaumin was like 'exhibiting with a group of Socialists... the public doesn't like anything smelling of politics!' However, he could not prevent Durand-Ruel, whose gallery hosted the exhibition, showing works he already owned, and *Luncheon of the boating party* was one of twenty-five Renoirs that were included in the show.

In 1923 Paul Durand-Ruel's son, Joseph, set up another luncheon party in his own home. This time its purpose was to show Renoir's masterpiece to the American collector Duncan Phillips. Phillips fell in love with the *Boating party* and bought it at a record price for that period. Both collector and dealer were delighted with the deal, as Joseph Durand-Ruel wanted the money to purchase new premises for his family's art gallery.

(Courtesy of The Phillips Collection, Washington, D.C.)

Pierre-Auguste Renoir
Gabrielle with Jean, c. 1900.
Pencil and crayon on paper.
9 × 7 in (24 × 18 cm).
This is the second of two
preliminary drawings for a
finished portrait; in this one
Gabrielle wears her nursemaid's
apron. It is now in a private
collection.

Pierre-Auguste Renoir
Gabrielle with jewellery,
c. 1910.
Oil on canvas.
32 × 25½ in (81 × 65 cm).
Renoir bequeathed it to his
son Claude. It is now in a
private collection.

(Photograph: courtesy of
Acquavella Galleries, New
York.)

Gabrielle Renard (1878–1959) was the niece of Renoir's wife, Aline. At seventeen, Gabrielle, the simple unsophisticated daughter of a Burgundian peasant, came to live with the Renoirs to work as nursemaid to their younger sons, Jean (seen on her lap in the drawing) and Claude. Gabrielle stayed with the Renoirs for twenty years; when the artist's hands were semi-paralysed by rheumatism, one of her duties was to strap special long-handled brushes to his wrists.

In Renoir's large portrait *The artist's family*, 1896 (Barnes Foundation), a radiant Aline Renoir wears a flattering hat and holds Pierre, her eldest son. Gabrielle, her figure concealed by a long white apron, kneels down supporting

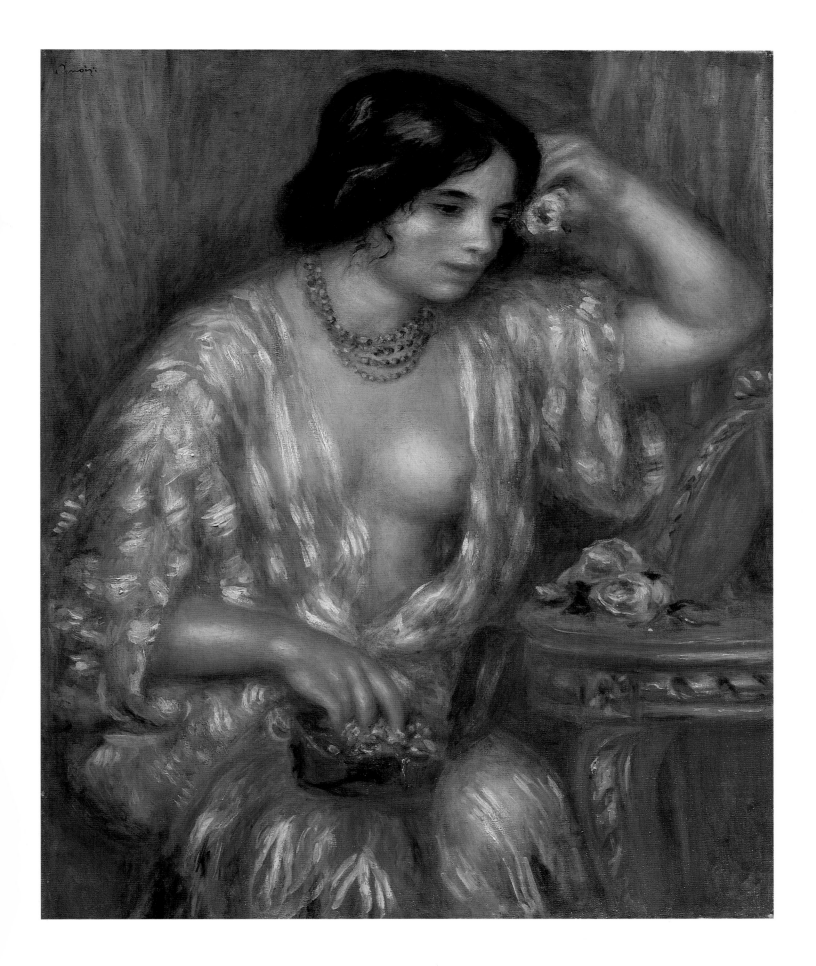

baby Claude, who is still unsteady on his legs. Over a decade later, in *Gabrielle with bare breasts*, 1907 (private collection), and *Gabrielle with a rose*, 1911 (Musée d'Orsay), Renoir depicted Gabrielle as a tanned Mediterranean Venus. Her childminding days over, she had exchanged her prim nursemaid's uniform for a long white translucent peignoir, which revealed one bare breast. She posed like this again in *Gabrielle with jewellery*, c.1910, and the even more revealing *Gabrielle with mirror*, 1913 (private collection.)

Renoir shows a beautiful young woman with dark, almond-shaped eyes under long lashes, wide, generous mouth and supple rosy body. It was tactless of Renoir to paint a candid portrait of his wife in the same year, where Aline appears middle-aged and obese, her face furrowed with deep lines. Aline, once Renoir's voluptuous model for *Young girl bathing* and other nudes, could not fail to be hurt by the contrast between her husband's unflattering portrait of herself and the transformation of Gabrielle into Renoir's Mona Lisa. When Jean Renoir grew up, he wrote his memoirs and denied rumours that Gabrielle had been his father's mistress. But in 1914 Gabrielle left, supposedly at Aline's request, and soon after married an American artist. This portrait of her remained in Renoir's studio until his death.

Renoir's pastel portrait of Cézanne was commissioned by Victor Chocquet, a customs official who had originally purchased many of Cézanne's earliest paintings direct from Père Tanguy's art supply shop. Tanguy used to hang Cézanne's works on his walls and try to sell them on commission. Cézanne liked Renoir's portrait enough to copy it for his own collection (Feilchenfeldt Collection, Zurich). But Cézanne, the eternal seeker after truth, painted his own version with a sterner expression and deeper shadows under his eyes than the more flattering brush of Renoir had depicted.

Pierre-Auguste Renoir
Portrait of Cézanne, 1880.
Pastel on paper.
21 × 17½ in (53 × 44 cm).
Formerly in the Ittleson Collection, New York, and in the collection of the British Rail Pension Fund, it is now in the Graff collection, London.

(Photograph: courtesy of Sotheby's, London.)

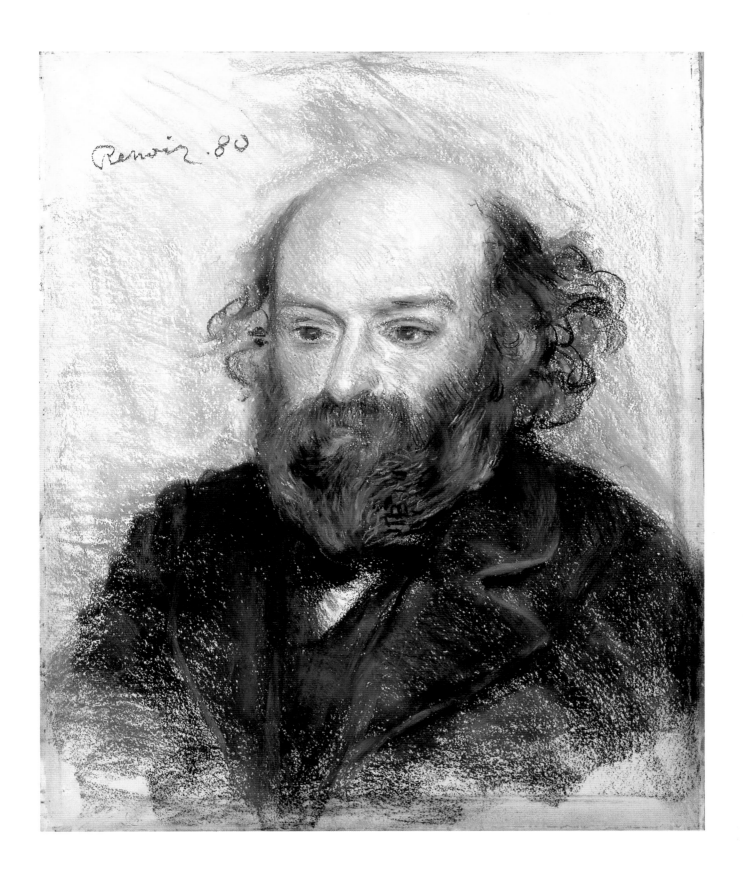

91

PAUL CÉZANNE (1839–1906)

Paul Cézanne was associated with the Impressionists from the beginning, but he remained the most isolated of the group. He was an anti-social introvert, happiest when painting alone at the family home in Provence, and he was so neurotic that he could not bear anyone to touch him. His marriage, hardly surprisingly, was a disaster. Gustave Geffroy, Monet's biographer and one of his closest friends, described the reclusive artist as '...unknown yet famous, having only rare contacts with the public, yet considered influential by seekers in the field of painting; known but to a few, living in savage isolation, disappearing and appearing suddenly among his intimates'.

Geffroy's description of Cézanne was published in 1894, the same year Père Tanguy's extensive collection of works by Cézanne, Pissarro, van Gogh and Seurat was auctioned off in a desperate attempt to raise money for the collector's destitute widow.

At the sale the sculptor Rodin bought the version Tanguy had himself owned of his now-famous portrait by van Gogh; and a young dealer named Ambroise Vollard bought six paintings which Cézanne had given Tanguy in return for oil paints. Other bidders thought Vollard crazy, considering Cézanne's paintings far too geometric. But Vollard was not crazy; he had taken advice from the 'father of Impressionism' – Cézanne's former teacher, Camille Pissarro – who always believed his former pupil had enormous talent.

In September 1894 Mary Cassatt met Cézanne at Giverny's Hôtel Baudet and wrote, 'When I first saw [Cézanne] I thought he looked like a cut-throat with large red eyeballs standing out from his head in a most ferocious manner and a rather fierce-looking beard... I found out later I had misjudged his appearance, for, far from being fierce or cut-throat, he has the gentlest nature possible. His manners at first startled me – he scrapes his soup plate and lifts it to pour the last drops in the spoon... he eats with his knife and accompanies every gesture... with that implement. Yet in spite of his total disregard of the dictionary of manners, he shows a politeness towards us which no other man would have shown.'

Cézanne's work reveals a concern with form and structure which sets it apart from the mainstream of Impressionism. During his early years he suffered ridicule from critics and public both because of his subject-matter and his style of painting. The death of Cézanne's father in October 1886 meant that finally, in his mature years, Cézanne's financial troubles were at an end.

The house with cracked walls is one of the most powerful yet disturbing images the artist ever painted. A deep crack divides this isolated Provençal farmhouse into two halves right down to its stone foundations. A lone dark window in the upper storey bears an uncanny resemblance to a blind eye in its simplified form, and the terracotta tiles are starting to slide from the sloping roof. The artist's underlying message would appear to be that in life nothing endures.

The painting poses a question to the viewer. How much longer can the abandoned farmhouse last before it finally cracks in two and slides down the

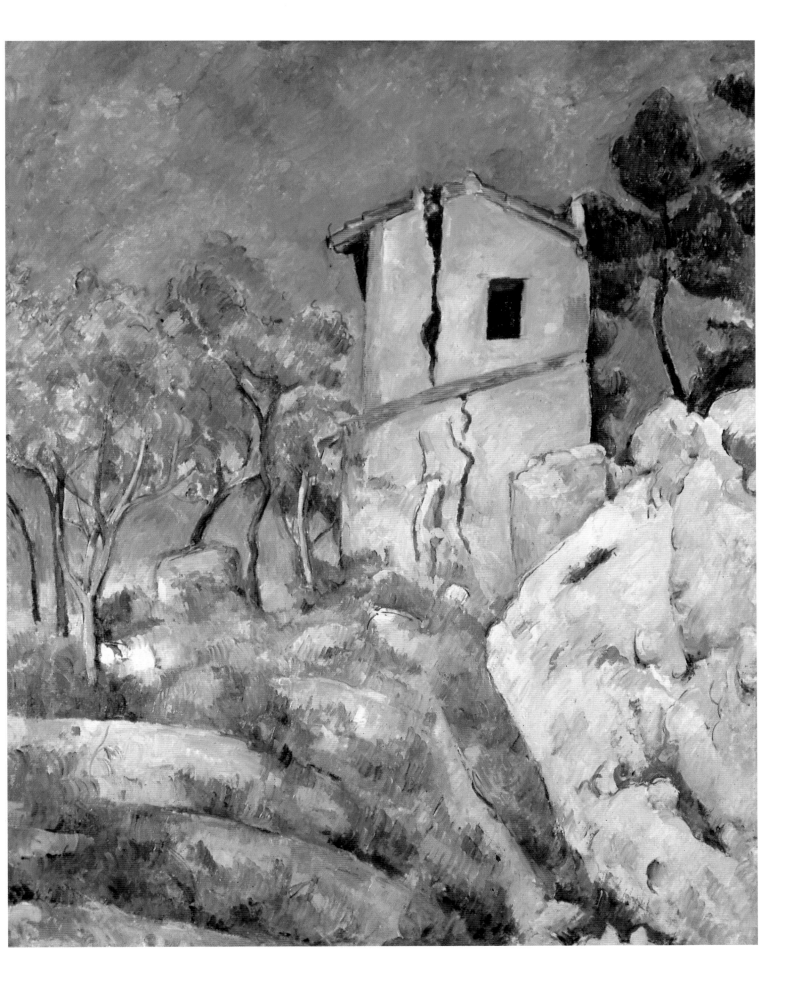

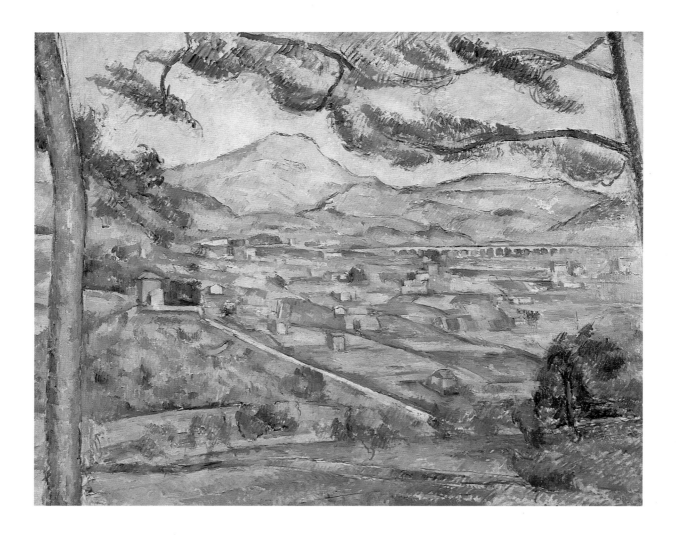

steep rockface? The isolated house is surrounded by hard, bleak rock and the strong verticals of wind-swept trees – only Cézanne's clever use of colour creates a sense of perspective.

This painting has clear affinities with another Cézanne masterpiece, the eerie stone house in which the peasants of Auvers recounted in whispers that a man had committed suicide: *The house of the hanged man* (Musée d'Orsay). Another sinister house that the artist loved painting was 'Le château noir' or 'house of the devil'. Cézanne was drawn to isolated uninhabited areas by his overriding desire to work in privacy, undisturbed by visitors. He actually tried to purchase the 'house of the devil', but the owner refused to sell.

Ambroise Vollard, Cézanne's Paris dealer, bought *The house with cracked walls* from the artist. Vollard ensured that Cézanne's work was written up favourably in influential art journals, and in 1895 he organised a major one-man exhibition in his Paris gallery, at which 150 of Cézanne's works were exhibited. The exhibition helped make Cézanne famous and Vollard rich. Vollard even sold two Cézannes to the National Gallery in Berlin, although the Kaiser objected and forbade that they be hung.

Cézanne was never as popular with collectors as Monet or Renoir but, by the turn of the century, he had at last started to receive widespread recognition.

Paul Cézanne
Mont Sainte-Victoire, c. 1886–7.
Oil on canvas.
23½ × 28½ (60 × 73 cm).

(Courtesy of The Phillips Collection, Washington, D.C.)

Paul Cézanne
Mont Sainte-Victoire, 1905–6.
Oil on canvas.
23½ × 28½ in (60 × 73 cm).
It was purchased from Vollard
in 1911 by Sergei Shchukin for
his collection in Moscow. This
was nationalised by the
Bolsheviks after the Revolution,
and the painting was placed in
Moscow's Pushkin Museum.

At the age of forty-four, disillusioned with Paris and the critics' hostile reaction to his work, Cézanne retreated to his home-town of Aix-en-Provence. The skyline there is dominated by the great truncated cone of Mont Sainte-Victoire, which preoccupied Cézanne for over twenty years.

In the mid-1880s he painted the mountain from the pine grove at the edge of his brother-in-law's vineyard: the valley of Arc appears in the foreground with its great Roman aqueduct to the right.

In numerous studies of the mountain he attempted to reduce natural forms to their elements, which he once described as the geometric prototypes of 'the sphere, the prism and the cone'. His intellectualised approach to painting reveals itself in the tightly-woven mesh of colour that shows the viewer a jumble of sheds, fields, tracks and scrub, which appear almost to dissolve into the broader contours of the landscape. Cézanne's composition breaks away from the traditional picturesque approach to landscape, where branches of trees were often used to frame the painting. Instead, pine branches crowd the sky, filling it with curved arabesques that echo the contours of the mountain.

In the year of his death, Cézanne painted a far more sombre view of his beloved mountain, this time from the valley of Les Lauves, and it is fascinating to compare the alterations in his style over two decades.

MARY STEVENSON CASSATT
(1845–1926)

'I am an American…, simply and frankly an American,' said Mary Cassatt, when interviewed by her biographer towards the end of a long life spent in France. Cassatt became not only the greatest American woman artist of the nineteenth century but one of the finest woman painters in the world. The term 'woman artist of the nineteenth century' should not be regarded as down-grading the *quality* of her art: instead it celebrates her triumph over the rigid limitations imposed by a narrow-minded society on women artists of the period. Because Cassatt and her fellow Impressionist Berthe Morisot were 'ladies', they were not allowed to walk in the streets or paint in parks unchaperoned. Unlike their male equivalents, they were forbidden entry to the bars, theattres,music halls and other places of amusement where so much of the male Impressionist oeuvre was painted. Initially, Cassatt had to overcome enormous opposition from her father to be allowed to paint professionally. She made sacrifices to enjoy a professional career as an artist and was just as committed to rendering 'modern life' as her male contemporaries.

However, Victorian convention dictated that no lady could be alone in a room with a man unchaperoned, which made it impossible for Cassatt to paint many male portraits. So for her sitters she used either members of her own family or female friends and their young children.

Dorothy in her 'very large bonnet' is probably one of Mary Cassatt's nieces, while the younger girl in the boat in *Summertime* may be another. Two girls in a boat surrounded by ducks also appear in a colour aquatint made the same year as *Summertime*, though in the aquatint Cassatt toned down the pink reflections in the water, and the younger girl leans towards an even younger child, who feeds the ducks. The vividly hatched background, the depth of pure colour and the strength of line in Dorothy's portrait shows Cassatt at her best, even though little Dorothy was not a conventionally 'pretty' child.

The cup of chocolate, probably painted in Cassatt's Paris apartment, also shows her remarkable talent for brilliantly observed domestic scenes – a speciality she shared with Berthe Morisot. The blue background is similar to the one Cassatt later employed for Dorothy; the delicate oval of the young girl's face is exquis-itely delineated, and the elegance of her hands is painted in a way that is both vivid and expressive.

Although Cassatt made few return visits to America, her impact on Ameri-can art and taste was immense. She transmitted the Impressionists' ideas about form and colour to art-lovers in her own country, as her work was exhibited in America and acquired by American collectors.

She also influenced wealthy Americans, including her own brother Alex-ander, and the Havemeyers and their circle, to purchase works by Degas, Renoir, Manet and Monet. When Harry and Louisine Havemeyer arrived in Paris in 1895, Harry asked Mary Cassatt to help him locate the finest Impres-sionist paintings; and Mary happily agreed – much to the delight of her friend Louisine, whom she had already persuaded to buy a Degas, a Monet and a Pis-

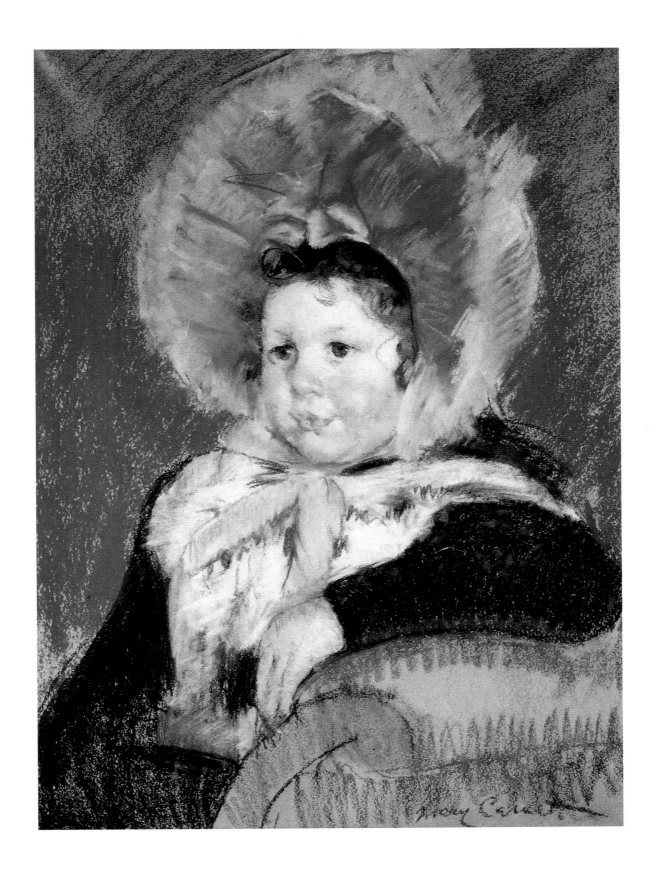

sarro. The excitement of helping to build a great art collection for the Have-meyers provided an excellent therapy for Mary, who was recovering from the death of her mother. Advised by Cassatt, the Havemeyers purchased some of Degas's greatest works.

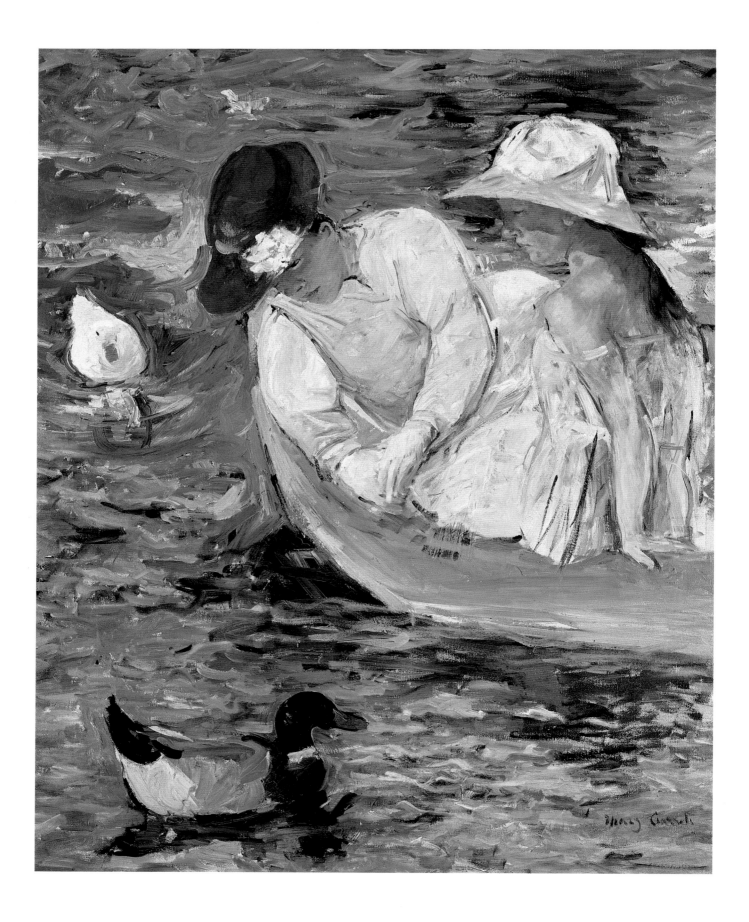

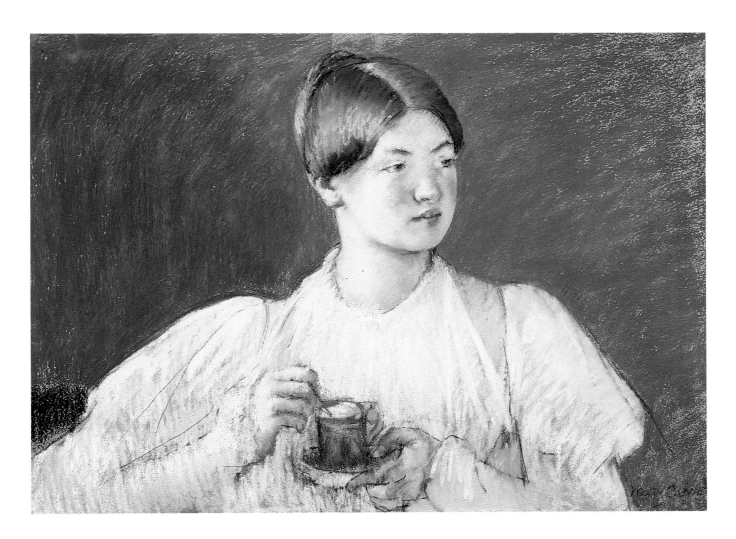

Mary Cassatt
The cup of chocolate, 1898.
Pastel on paper mounted on
canvas.
20 × 29 in (51 × 74 cm).
It remained with Durand-Ruel
in New York from the year it
was painted until 1942. It is
now in the Daniel J. Terra
Collection (Terra Museum of
American Art, Chicago).

Mary Cassatt
Summertime, 1894.
Oil on canvas.
42 × 30 in (107 × 76 cm).
Purchased by the artist's dealer,
Ambroise Vollard, in 1906, it
remained in private collections
in Paris until 1985. It is now in
the Daniel J. Terra Collection
(Terra Museum of American
Art, Chicago).

THE POST-IMPRESSIONISTS

Vincent van Gogh (1853–1890)
Paul Gauguin (1848–1903)
Count Henri de Toulouse-Lautrec-Montfa (1864–1901)
Georges Seurat (1859–1891)
Paul Signac (1863–1935)

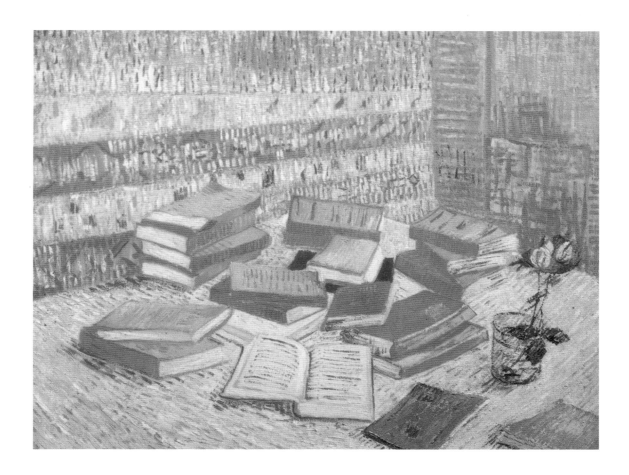

Vincent van Gogh
The yellow books, 1887.
Oil on canvas.
28½ × 36½ in (73 × 93 cm).
When Vincent departed for
Arles, he left this painting with
Theo. After Theo's death it
passed to his widow, Johanna
van Gogh-Bonger, who for
many years supported herself
and her young son by
promoting Vincent's work and
selling it.

(Photograph: courtesy of the
Robert Holmes à Court
Collection.)

VINCENT VAN GOGH (1853–1890)

At twenty-seven years of age, Vincent van Gogh had unsuccessfully tried teaching, art-dealing and missionary work before he decided to become a professional artist. His brother Theo, who was an art-dealer in Paris and who had been supporting Vincent in Antwerp while he struggled to learn to paint, invited him to Paris to see works by the avant-garde Impressionist painters. At the eighth Impressionist exhibition, in 1886, Vincent met Pissarro, Gauguin and Signac, and under their influence he learned to shorten his brushstrokes and lighten his palette.

The yellow books reflects Vincent's enthusiasm for the realist novels of Zola, Flaubert and de Maupassant and his interest in Japanese art. From the shop of Samuel Bing, the largest importer of Japanese prints in Paris, Theo and Vincent bought between four and five hundred inexpensive Japanese woodblock prints. In 1888 this painting was displayed at the fourth exhibition of the Society of Independent Artists, along with two of Vincent's views of Montmartre.

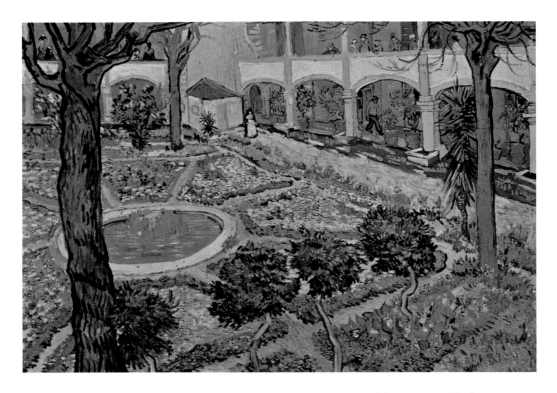

Vincent van Gogh
*Garden of the asylum at
Saint-Rémy*, 1889.
Oil on canvas.
28½ × 36 in (73 × 92 cm).
Oskar Reinhart Collection,
'Am Römerholz', Winterthur,
Switzerland.

On Sunday December 23, 1888 Vincent, who had been drinking absinthe, quarrelled with Gauguin and threatened him with a razor. Returning to his bedroom in the Yellow House in Arles, where he was living with his fellow-artist, van Gogh hacked off the lower portion of his ear, wrapped a towel round his bleeding head and walked to the local brothel. There he gave the severed ear to Rachel, a prostitute whom he used to visit, then went back to his lodgings.

The police, finding Vincent in bed, bleeding copiously and 'giving almost no sign of life', took him to the hospital in Arles. Van Gogh was fortunate enough to be treated by Félix Rey, a sympathetic doctor who eventually allowed him out of the depressing ward in which he was placed to visit the Yellow House and continue painting, on the understanding that Vincent would return to the ward to eat his evening meal and sleep in his cubicle.

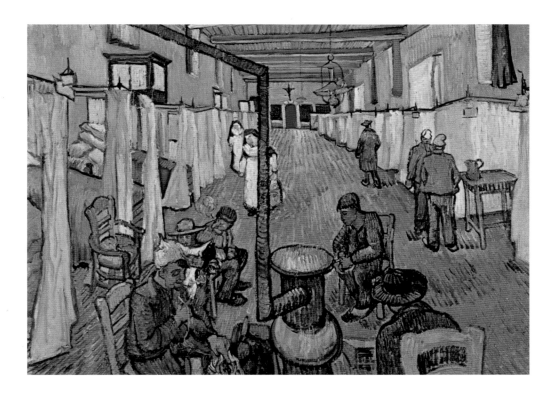

Vincent van Gogh
The hospital ward, Arles, 1889.
Oil on canvas.
29 × 36 in (74 × 92 cm).
Oskar Reinhart Collection,
'Am Römerholz', Winterthur,
Switzerland.

Dr. Rey must have suspected that, left to his own devices, Vincent would once more eat little and spend his allowance on absinthe, paint and canvas. Nevertheless, he eventually allowed Vincent to sleep at home. But on February 7, 1889 the artist was brought back to the ward by the police, suffering from delusions that he was being poisoned. His cleaning lady had become scared and informed the police, and the Superintendent of Police had had him re-arrested.

After three days back on the ward Vincent was once again returned to the Yellow House. By now his neighbours were alarmed by his behaviour and appearance, and the local children pestered and jeered at him. The narrow-minded residents of Arles complained to the mayor that van Gogh was drinking again and 'constituted a threat to women', so the Superintendent of Police promptly had Vincent readmitted to the hospital as a madman. In the grim

hospital ward with its tightly-packed rows of beds there was no privacy and paper labels identified each patient. This painting of it – made in October 1889 from memory – is one of the most desolate of all Vincent's works.

By that time Vincent had moved to the asylum at Saint-Rémy, where he was a voluntary patient from May 8, 1889 to May 20, 1890. There, as he was not allowed out of the asylum, he painted the garden and immediate surroundings.

On 9 May 1889, the day following van Gogh's admission to the Asylum at Saint-Rémy, Dr. Peyron, director of the asylum, diagnosed Vincent as suffering 'acute mania with hallucinations of sight and hearing . . . subject to epileptic fits at very infrequent intervals'. While the original medical evidence does not permit firm conclusions, absinthe addiction may have played some role in Vincent's illness.

Over the years theories about the cause of van Gogh's illness have ranged from manic-depressive psychosis to Ménière's disease, which causes hearing disturbances, or even syphilis working on his brain. In Amsterdam he did live with a prostitute, and in Paris Vincent, the former preacher, had been introduced to the dubious attractions of brothels and absinthe by Toulouse-Lautrec. Artists and writers of the period called absinthe the 'Green Muse' and believed it expanded consciousness, inspired imagination and had a powerful aphrodisiac effect. Vincent may have been impressed with its power when he painted a glass of the milky-green fluid; by the time he reached Arles he was drinking quantities of it, and it was here that Vincent concentrated on achieving 'the high yellow note' in his work.

The thujones contained in absinthe came from thuja oil, a cerebral stimulant and convulsant, which has a cumulative action, found in wormwood leaves and flowers. As early as 1906 Cushney claimed that the 80% proof liquor was 'the cause of epilepsy in chronic absinthe drinkers', though absinthe was not banned by the French Government until 1922. In addition to causing epileptic-type convulsions, regular absinthe drinking produced auditory and visual hallucinations, stomach upsets, general anxiety, insomnia and impotence (all symptoms of which Vincent complained at one time or another).

Gaddum's *Pharmacology* describes thujones as accumulating in the brain and slowly poisoning it. Thujones are known to affect the optic nerve, causing the addict to hallucinate and 'see' objects surrounded by a yellow or greenish corona. In *Wormwood* (Lupton, New York, 1890), Corelli describes an addict as 'seeing a burning halo'. This could help to explain Vincent's passion for yellow skies in his Yellow House period, his green sky with its yellow corona in *Landscape at Saint-Rémy with couple walking under a crescent moon* (Art Museum of São Paulo, Brazil) and the burning golden-yellow of *The mulberry tree* (pp. 108–109).

Addiction to thujones and their related chemical compounds – terpene and camphor – would also explain why Vincent tried to drink a *quart* of turpentine on an outing from Saint-Rémy to Arles with his friend Signac, who had to

Vincent van Gogh
Asylum and chapel at Saint-Rémy, 1889.
Oil on canvas.
17½ × 23½ in (44 × 60 cm).
Johanna van Gogh-Bonger sold this work to Paul Cassirer, who in 1907 resold it to the translator of Vincent's letters into German. Fifty-six years later it was bought by Elizabeth Taylor.

(Photograph: courtesy of Christie's, New York).

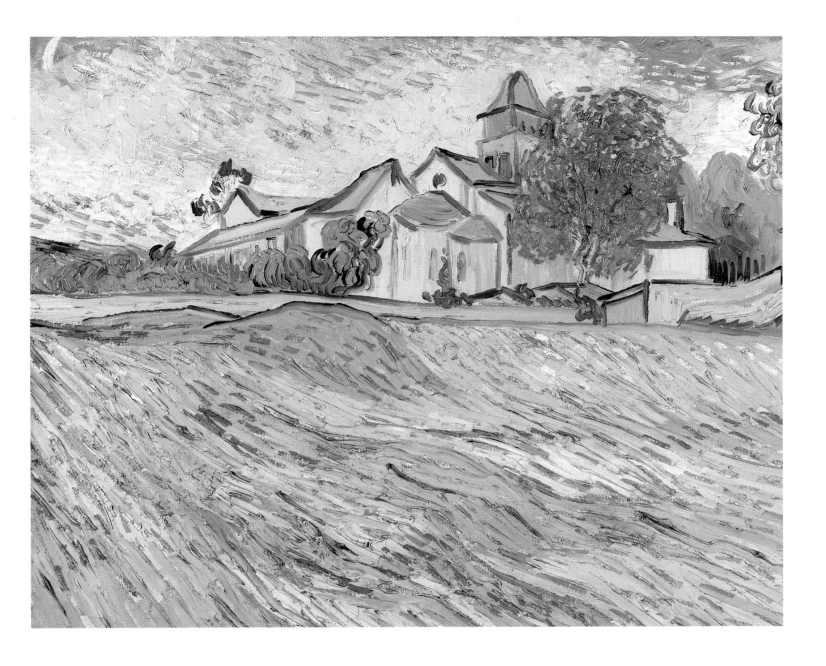

struggle to restrain him. Thujone, terpene and camphor have similar molecular structures and pharmacodynamics; all three can cause convulsions. Complaining of insomnia in Arles, Vincent was allowed to sleep with what he described as 'a very, very strong dose of camphor under my pillow and mattress'. At Saint-Rémy he may also have used camphor, and he was treated there with bromides. These are now known to interact badly with ketone-thujone-terpene-camphor compounds, as does tobacco; and van Gogh appears to have been allowed to continue smoking his pipe in the asylum.

Vincent's epileptic fits often occurred on his return from trips to Arles, a town where absinthe consumption was then four times the national average. As a voluntary patient, Vincent was allowed to visit Arles, and his letters mention his visits to Mme. Ginoux, in whose all-night café well-meaning friends would doubtless have offered him a glass of his favourite tipple. Like most

addicts, van Gogh would surely have hidden his drinking from his doctors. His early letters to Theo from Arles contained sanctimonious exhortations about the dangers of drinking, sex and smoking – written when Vincent was spending absinthe-filled nights in Mme. Ginoux's café, smoking his pipe and visiting brothels!

On July 7, 1889 Vincent visited Arles, suffering an epileptic fit so severe that it stopped him painting for six weeks. Early in September, in a period of splendid weather for painting, he wrote, 'I am overwhelmed by a feeling of loneliness to such a horrible extent that I shy away from going out.' But by early October Vincent had recovered enough to paint this view of the asylum and its stone wall from the parched field outside it.

On Thursday December 27, 1888, thirty-seven-year-old Augustine Roulin, wife of Joseph Roulin, postmaster of Arles, visited van Gogh in Arles Hospital, where he had been committed for cutting off his ear. She had already posed for him once, but now she was worried that she had committed herself to posing for a madman. Vincent must have convinced her he was harmless, so Mme. Roulin agreed to start sitting for him again, although by now her husband had left for Marseilles, where he would earn more money working as a postmaster than in the small town of Arles.

Augustine Roulin, her ample breasts heavy with milk, rocked her baby's cradle with a rope handle as she posed. Vincent invested her with all the significance of a Virgin in an icon. In return for posing, Mme. Roulin was allowed to choose one of the five versions van Gogh had painted as a gift; her preference was for the one with the most brilliantly-coloured background. Van Gogh's comment was that she 'had a good eye and took the best'.

The mulberry tree was painted when Van Gogh was in the asylum at Saint-Rémy. The twisting, flame-like lines of the yellow mulberry tree have an electric energy never before seen in western art. Van Gogh was pleased with his picture, and in a letter to his sister Wil in Holland, he tried to explain how, 'I have a terrible lucidity at moments . . . when nature is so beautiful, I am not conscious of myself and the picture comes to me as in a dream.'

The mulberry tree, with its vivid yellow leaves, is one of the most powerful images of nature ever painted, equal in its intensity to van Gogh's cypresses. Did the artist use this vivid yellow to create a dramatic effect? Or was a deep yellow tree what he *thought* he saw; his brain affected by years of absinthe poisoning, which gave him the *illusion* the mulberry tree was yellow?

Vincent van Gogh
Woman rocking a cradle, 1889.
Oil on canvas.
36 × 29 in (91 × 74 cm).
Six years later, the impoverished Roulins sold all the paintings Vincent had made of the family, including his portraits of Augustine Roulin's two sons, to Ambroise Vollard for very little money. As van Gogh's prices rose steeply in the next four decades, it is ironic that had Roulin's sons hung on to their portraits until the end of their lives, they would eventually have become millionaires. This painting of their mother was in a number of private collections in France and Switzerland before being purchased by Mr. and Mrs. Walter Annenberg.

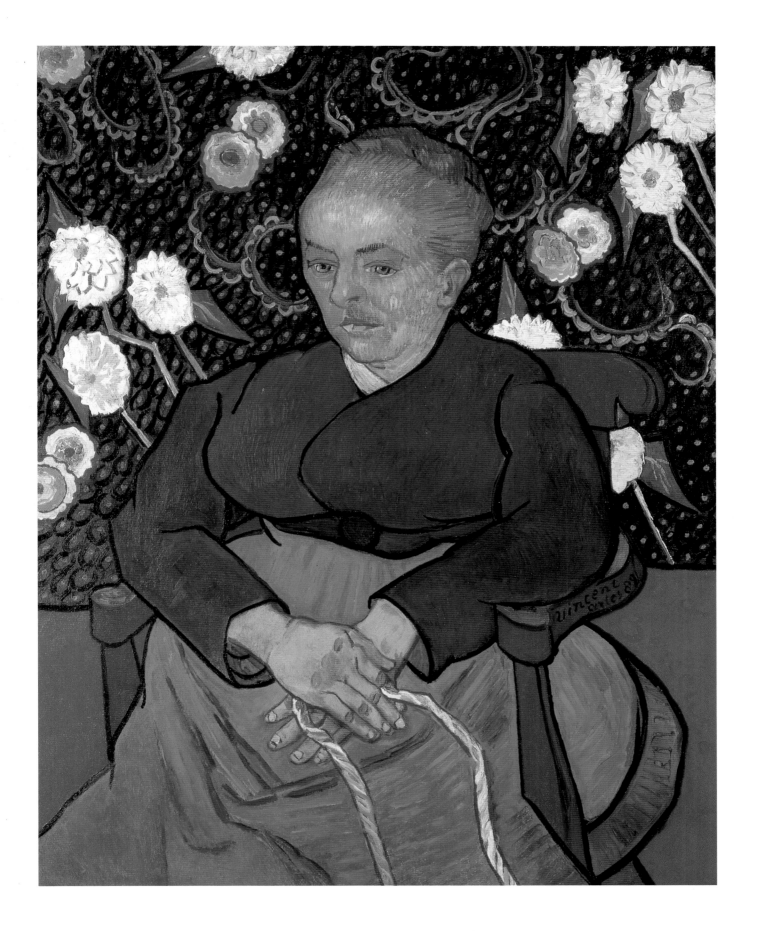

Vincent van Gogh
The mulberry tree, 1889.
Oil on canvas.
21½ × 25½ in (54 × 65 cm).
Now in the collection of the
Norton Simon Foundation,
Pasadena, California.

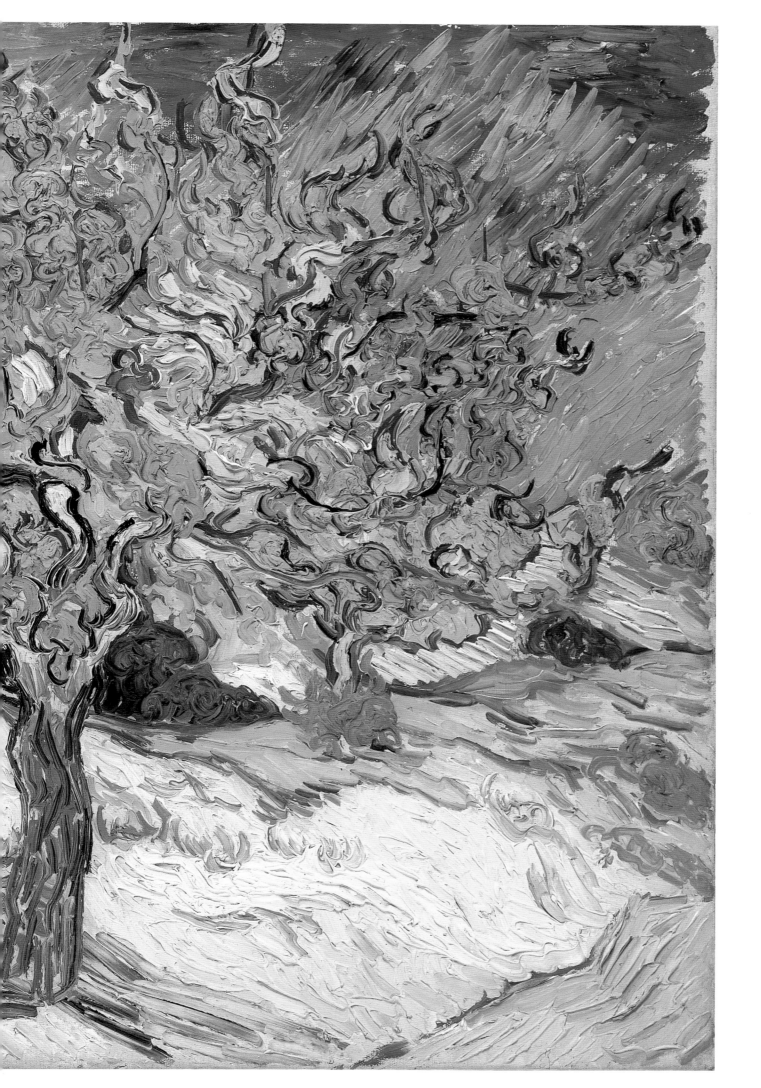

In 1889 two paintings by van Gogh were exhibited in Paris, one of them *Irises*, painted at the asylum in Saint-Rémy. There, freed from housekeeping duties, Vincent could devote his whole day to painting. The asylum's director forbade him to go outside their garden, but he was able to make several studies of flowers, including this remarkable canvas of blue and white irises. Van Gogh, always passionate for anything remotely Japanese, painted them in a frieze-like composition that resembles an antique Japanese screen. One gigantic white iris stands out from the rest, like a lone white butterfly above a patch of deep red earth.

Vincent was encouraged and wrote to his brother Theo saying, 'I *am* making progress and I firmly believe that with perseverance I shall win.' Although he had only ever managed to sell one painting for more than the cost of the canvas and paint, Vincent packed up *Irises* and ten other pictures and sent them to Theo in Paris. Theo van Gogh immediately recognised the extraordinary quality of *Irises* and sent it and Vincent's great *Rhône river at night* (Musée d'Orsay) to the Salon des Indépendants that September. Theo wrote back to Vincent telling him how 'they have put *Irises* on the end wall of the room, and it strikes the eye from afar. It is a beautiful study, full of air and life.'

Critic Félix Fénéon admired the painting, which he described as having 'violet petals on sword-like leaves', but it did not sell and eventually ended up in the art-supply shop of Père Tanguy. Julien Tanguy, a lover of avant-garde art, had, when Vincent was living in Paris, encouraged him by giving him tubes of paint and canvas in return for some of his paintings, which he displayed on the walls of his shop for sale. Crowded out of his Parisian apartment by canvases, Theo van Gogh had hired an attic room above Tanguy's shop to store Vincent's canvases and his own collection of paintings by Signac and Guillaumin.

After Vincent and Theo's deaths Tanguy sold *Irises* to art critic and writer Octave Mirbeau for three hundred francs. Mirbeau proudly showed *Irises* to Monet. 'How,' Monet asked, 'did a man who loved flowers and light to such an extent and who rendered them so well, how then did he still manage to be so unhappy?'

Vincent van Gogh
Irises, 1889.
Oil on canvas.
28 × 36½ in (71 × 93 cm).
After Julien Tanguy and Octave Mirbeau it was in the collections of Auguste Pellerin and Jacques Doucet. It was

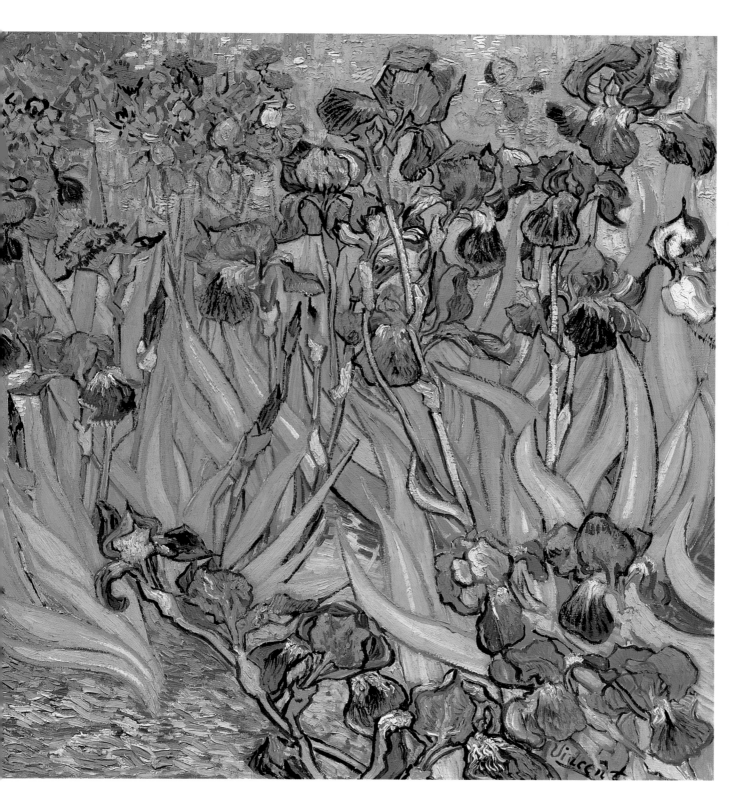

purchased by Mrs. Joan Whitney Payson in 1947 for $84,000, sold at Sotheby's to Alan Bond in 1988 for $51,000,000, repossessed, then re-purchased by the J. Paul Getty Museum, Malibu, for an undisclosed sum.

After Alan Bond went to jail, Sotheby's Australia emphatically denied that he had only possessed a copy of *Irises* and that they had retained the original in their safe in London.

(Photograph: courtesy the J. Paul Getty Museum, Malibu.)

PAUL GAUGUIN (1848–1903)

'When we were married I had no idea he was interested in the arts,' complained Gauguin's wife later in life. Mette Gad, a middle-class Danish girl, had met Gauguin when she was studying French in Paris. Both she and her conventional family thought Mette had made 'a good catch', landing a wealthy young stockbroker with good prospects as a husband. In view of Gauguin's subsequent flight from western civilisation to dedicate himself to art and Tahitian *vahines*, Mette Gauguin's remark is a classic understatement.

But how could Mette have foreseen that her wealthy stockbroker would leave her with no income and five children to provide for, so that he could devote himself entirely to 'ecstasy, calmness and art'? Gauguin did not start painting as a recreation until 1873, when he was twenty-five and the couple had children, but the following year he visited the first Impressionist exhibition, and the sight of paintings glowing with reflected light confirmed in him a burning desire to paint.

During the summers of 1879, 1880 and 1881 Gauguin had a brilliant teacher in Camille Pissarro, but at first he had difficulty exhibiting with the Impressionists; some of them disliked his work and his arrogant attitude. However, the fact that he bought their paintings eventually won over the poorer members of the group, while Pissarro and Degas argued for his inclusion on artistic grounds. While working for a bank as a stockbroker's agent, Gauguin had spent freely, buying works by Manet, Pissarro, Renoir, Cézanne, Monet, Guillaumin and Sisley. He used his quick, retentive brain to learn the mechanics of the stockmarket, and he made a large additional income speculating in shares. But in 1882 the stockmarket collapsed, and Gauguin decided that it was time to become a professional artist. 'From now on,' he announced, 'I will paint every day.'

Released from daily work, Gauguin spent the coldest days of winter painting views of the gardens in the Vaugirard district, where he lived. These reveal how well he had absorbed the principles of Impressionism under Pissarro's tuition and while studying the paintings in the art collection he had bought. Japanese influence is evident in this cropped view, while Gauguin's shadows are pink and blue like those of Pissarro, Monet and Sisley, rather than black. In January 1884, mistakenly believing that the inhabitants of Rouen would buy his work, Gauguin moved Mette and their five children to a cheaper house there, exhibiting some of his works at Eugène Murer's hotel – but with little success. It was the beginning of the end of their marriage.

Paul Gauguin
Snow scene, 1883.
Oil on canvas.
23½ × 20 in (60 × 50 cm).
A paler version, without the figures, was purchased by Copenhagen's National Gallery from Mette Gauguin as she sold off her husband's paintings to support her family. This version is from a private collection.

(Photograph: courtesy of the Bridgeman Library, London.)

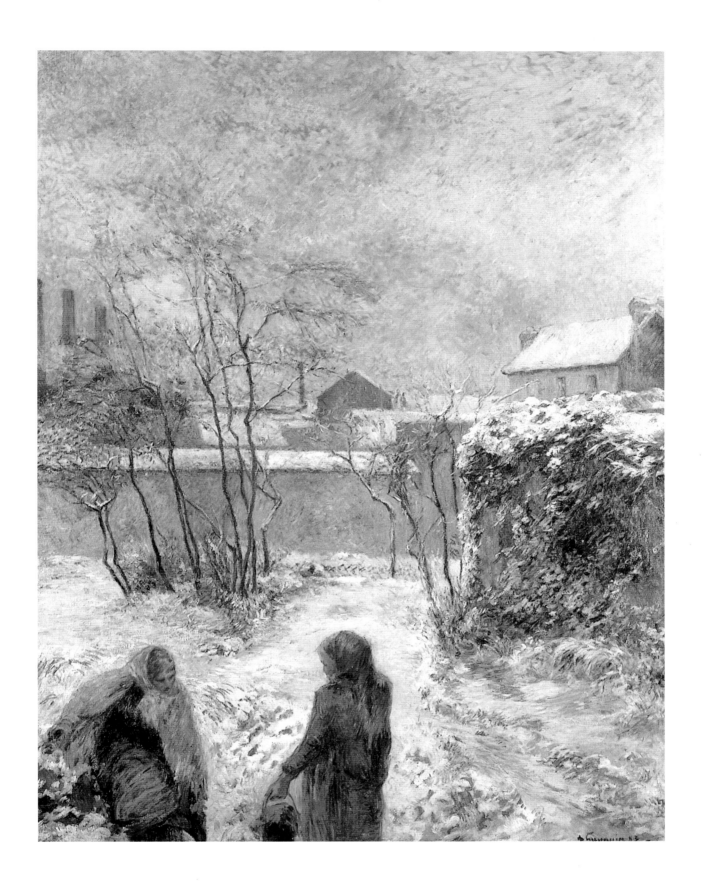

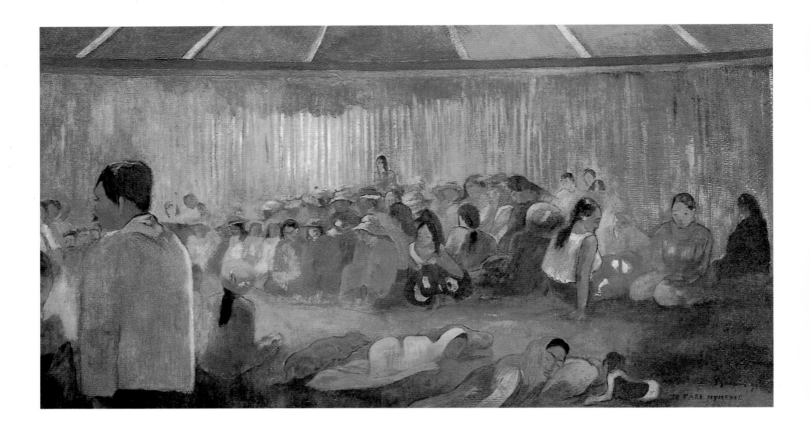

The house of hymns was painted during Gauguin's first stay on Tahiti in 1891, which he financed by the sale of the Impressionist paintings he had collected. In his book *Noa-Noa*, Gauguin described how the islanders 'assemble in a sort of communal house to sing and talk. They start with a prayer: an old man recites it first, very carefully, and everyone else repeats it as a refrain. Then they sing or even tell stories and sometimes make each other laugh.' Soft firelight envelops a joyful, united community practising rites which are half-religious, half-entertainment. The artist wrote in his *Carnet de Tahiti* that it was painted 'before the end of April 1892'. In January–February 1892 Gauguin was undergoing treatment for syphilis in hospital in Papeete, and he was only able to paint again at the end of February; so it must have been painted between then and April. Tahitian folklore and beliefs also appear in *Matua Mua (In olden times)*, where Gauguin recreated a Tahitian idyll, including one of the great stone figures which had escaped the missionaries' destructive zeal.

Paul Gauguin
The house of hymns, 1892.
Inscribed 'Te Fare Hymenee'.
Oil on burlap.
20 × 35½ in (50 × 90 cm).
The painting was owned by Algur Hurtle Meadows and has also been in the Josefowitz Collection.

(Photograph: courtesy of the Bridgeman Library, London.)

Paul Gauguin
Matua Mua (In olden times), 1892.
Oil on canvas.
36 × 27 in (91 × 69 cm).
It was bought jointly by Bolivian tin heir Jaime Ortiz-Patiño and Baron Thyssen-Bornemisza, but the Baron subsequently repurchased it for multi-millions when it was offered at auction. It is now in the collection of the Thyssen-Bornemisza Foundation, Lugano, Switzerland.

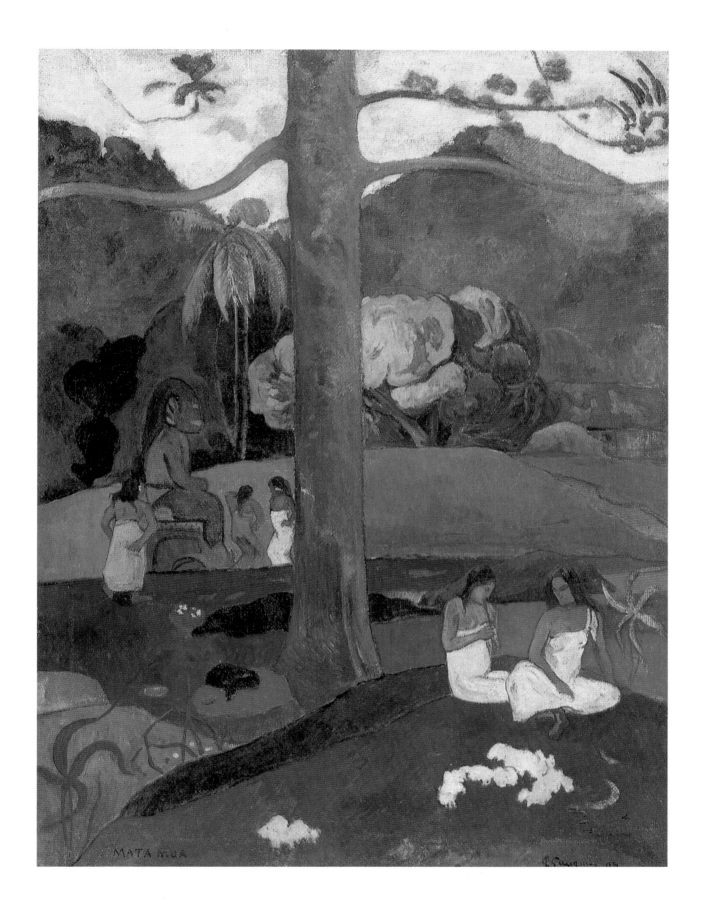

When Gauguin arrived back in Paris from his first trip to Tahiti, he hoped that his wife and children would join him, but by now Mette Gauguin had had enough. She refused to return, leaving Gauguin to live alone in a rented studio in the rue Vercingétorix. An exhibition of his Tahitian works failed to make money, but he received an unexpected windfall – a legacy from an uncle.

In December 1893 Ambroise Vollard introduced Gauguin to the half-Indian, half-Malaysian Annah. She had been working as a housemaid for an opera singer, who had sacked her after what Vollard insisted was nothing but 'a little domestic drama'. Vollard suggested Gauguin should employ Annah as maid and live-in model in his bachelor studio.

Annah's exotic oriental looks delighted Gauguin, who believed she was Javanese. (Java and its temple carvings had enchanted him ever since he had visited a Javanese display at the Exposition Universelle.) With money from his uncle's legacy, Gauguin bought Annah some new colourful clothes, a monkey and a parrot. In return Annah posed for him without the clothes, the monkey by her side. Very little housework took place. Instead, Annah and Gauguin caroused away their nights with a Bohemian crowd of artists, musicians and writers. Vollard described Gauguin walking through Paris, 'a fur cap on his head and a cloak thrown round his shoulders, followed by his little half-breed East Indian girl, dressed in bright coloured finery'.

At the end of April 1894 Gauguin and Annah visited Le Pouldu in Brittany in an attempt to redeem paintings pledged against unpaid board and lodging with his former innkeeper, Mme. Henry. In May, accompanied by Gauguin's friend Séguin, they made an excursion to the primitive port of Concarneau, where Annah and her monkey pranced around the harbour. Amazed by Annah and her flamboyant clothes, small boys started calling her names and throwing stones. Séguin siezed one boy by the ear, and the boy's father ran to his defence. A fight between Séguin, Gauguin and the fisherman ensued, in which Gauguin's leg was broken and his ankle badly cut.

Due to Gauguin's syphilis, his ankle never healed. Taking morphine to dull the pain, Gauguin had to walk with a stick and sued his assailant. The case was tried months later in the town of Quimper, and although Gauguin was awarded damages, most of these were swallowed up by his legal, medical and hotel expenses. To make matters worse, Gauguin lost his case against Mme. Henry, who was awarded possession of the paintings.

When he returned to Paris, Gauguin found his studio bare. Annah had vanished along with what remained of his money, the parrot and the monkey. Fortunately, she had left her own large-scale portrait as well as Gauguin's other paintings – probably believing them to be valueless. Disillusioned with Paris, Gauguin sold off some of his art collection and sailed back to Tahiti, hoping a warmer climate would cure his festering ankle.

Paul Gauguin
Annah the Javanese, 1893.
Oil on canvas.
45½ × 32 in (116 × 81 cm).
Private collection.

(Photograph: courtesy of the Bridgeman Library, London.)

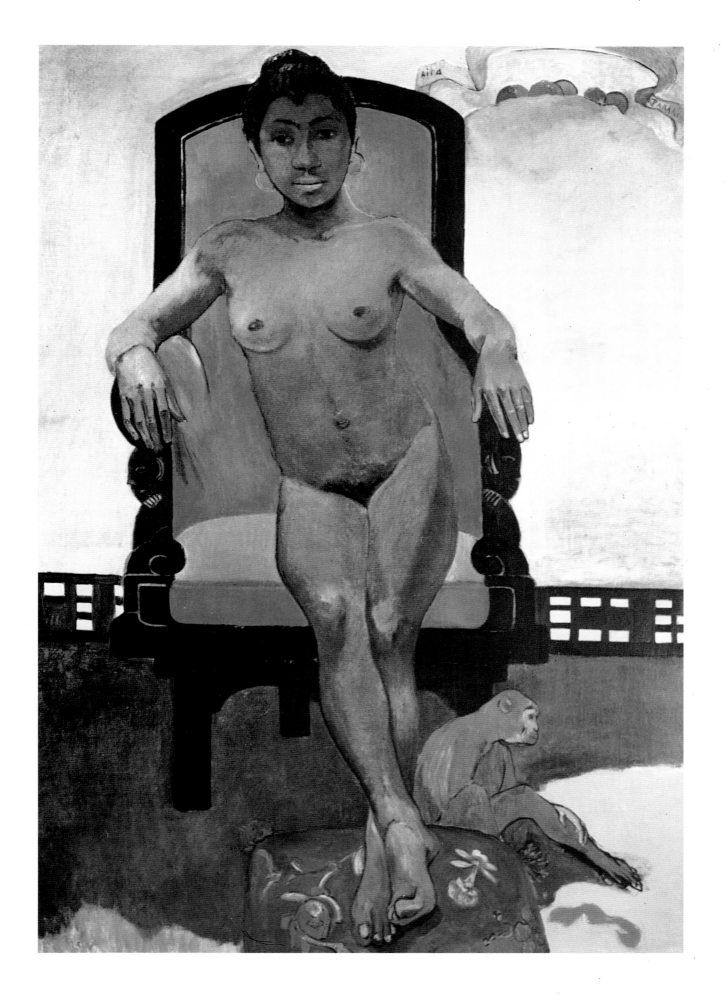

Gauguin's Tahitian paintings show a lush, mysterious land, inhabited by nubile, vividly-clothed native girls – *vahines*. The bands of brilliant colour and the strong design of these paintings had a profound effect on art in the twentieth century.

This group of somnolent women enjoying a siesta captures the viewer's imagination. They wear bright dresses, made from cotton specially woven in Manchester and donated by missionaries, who were horrified by the Tahitians' casual approach to unmarried sex and nudity. Gauguin's composition is mysterious: why are all his sitters facing away from the viewer, except the older woman who is ironing? Some authorities believe that Gauguin adapted his composition from a Japanese woodblock print; others that the strong diagonals of the floorboards were inspired by a reproduction of a Degas painting Gauguin had taken with him to the South Seas.

The legend of 'lost' Gauguins has spurred numerous collectors to visit Tahiti looking for them. Author Somerset Maugham appears to have been the only successful searcher: while writing his novel about Gauguin, *The Moon and Sixpence*, Maugham found a hut where a Tahitian was offering a Gauguin for sale. The Gauguin turned out to have been painted on the glass panel of a cheap imported interior door. Unfortunately, the children of the house had scratched away at much of the background, but Gauguin's nude *vahine* was still as arresting as ever. Maugham bought the painting for a pittance and had it shipped back to his villa at Saint-Jean Cap Ferrat in the South of France.

Poet Rupert Brooke also spent time in Tahiti searching for lost Gauguins, but he found none. Instead, he lived with a *vahine* in Gauguin-like fashion for several months. When the French Government set up a Gauguin Museum in Tahiti, they too searched the islands for lost Gauguins, but in vain. And being unable to afford the multi-millions Gauguin's works now fetch at auction, the Museum has had to make do with photographs. Paintings found in Gauguin's hut on the island of Hiva-Oa after his death were shipped back to Papeete and auctioned off to pay the artist's unpaid fines for libelling the Bishop of the island and his housekeeper, but those deemed 'indecent', along with carvings from Gauguin's 'House of Pleasure', were burned by the missionaries. They hated Gauguin because he had lived with a series of young Marquesan schoolgirls and encouraged them to leave the mission school. So it is unlikely that any undiscovered Gauguins still remain in the Marquesas. In his early days on Tahiti, Gauguin often despaired of finding collectors to buy his work: he wrote to Mette from there, at a time when she was trying desperately to sell his paintings in Copenhagen, 'My canvases appall me. Never will the public accept them.' He was right. Acceptance from collectors took a long time.

The man responsible for Gauguin's posthumous success was Ambroise Vollard. Vollard shrewdly accumulated in his own collection the best of Gauguin's works (including *The siesta*) and then held a landmark Gauguin exhibition in 1903 at his Paris gallery. During the artist's final years on Hiva-Oa, Vollard was deeply convinced of Gauguin's talent and he made an agreement with the artist whereby, for a fixed payment every month, Gauguin would send back regular shipments of his paintings to Vollard's Paris gallery.

In his last year Gauguin was tormented by eczema and syphilitic sores which

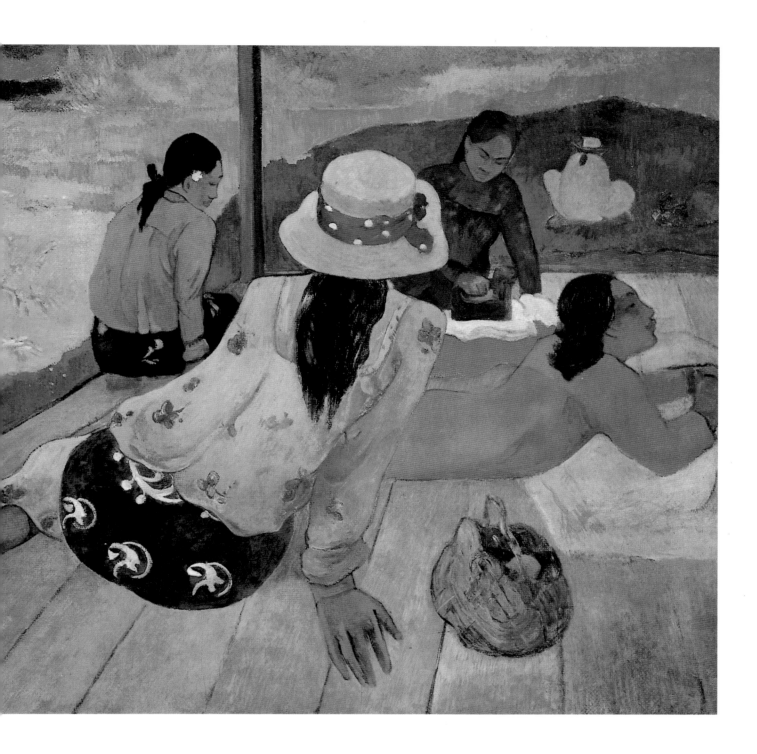

Paul Gauguin
The siesta, 1892–4.
Oil on canvas.
34½ × 45½ in (87 × 116 cm).
Bought by Vollard from
Gauguin, it was later owned by
Prince Matsukata. It was in the
collection of Mrs. Ira Haupt
before being bought by Mr. and
Mrs. Walter Annenberg.

never healed; he drank to excess to kill the pain and eventually wished to return to Paris to die. Vollard wrote back discouraging him, fearing that if the ailing artist (known for his quarrelsome temperament) made a distressing personal appearance at the opening of Vollard's Gauguin exhibition, he would only detract from his own legend – the man who gave up the comforts of civilisation for his art. Ironically, the copra trading ship containing Vollard's cheque took so long to reach Hiva-Oa that Gauguin died believing that Vollard had swindled him out of money earned by the exhibition and sale of his work.

COUNT HENRI DE TOULOUSE-LAUTREC-MONTFA (1864–1901)

Henri de Toulouse-Lautrec's parents, who were first cousins, separated after his younger brother died as an infant. Not long afterwards, the combination of a rare bone disease and two serious riding accidents caused young Henri's legs and lower body to stop growing, giving him the appearance of a dwarf with withered and fragile legs. In the streets people would stare at him, usually more in pity than disgust, and his bizarre appearance made him unwilling to join the aristocratic world of his parents.

Sent by his mother to study painting, he tired rapidly of the unimaginative task of copying plaster casts of the human figure or drawing from professional models at the Académie des Beaux-Arts and Cormon's atelier. Instead, Lautrec painted the cabaret artistes and street-walkers of Montmartre – 'Ordinary models are always so stiff and stuffy,' he said, 'but prostitutes are alive' – and he was especially fascinated by the way that their most loving relationships were often with each other rather than with men. Ironically, it was the prostitutes he immortalised who actively encouraged his alcoholism, because they received a large commission from the brothel-owners on all drinks ordered by clients. They also gave Lautrec the syphilis which eventually killed him.

When his brothel paintings were included in Lautrec's large one-man show at the Manzi-Joyant gallery in 1896, they were displayed in a locked upstairs room because the gallery's directors feared that the erotic subject-matter might drive away their customers. Degas came to see the pictures and gazed around at them humming softly. On the way out, he said quietly, 'Aha, I see Lautrec that you are one of us.'

In this painting, which clearly shows Degas's influence, a mature prostitute, naked except for her trademark of black knee-stockings, stands before a mirror taking stock of her spreading hips and dimpled thighs, possibly seeking reassurance that the rest of her figure is still good. Small details like the frilled peignoir on the love seat and the rumpled bedclothes suggest that she has just been with a client. The bedroom with its patterned carpet, scarlet-upholstered love seat and scarlet walls is similar to the decor of Degas's *After the bath* (p.32), but Lautrec's treatment of the woman is kinder than that of Degas.

During the 1890s, when Lautrec was most prolific as a lithographer, the rapidly expanding city of Paris was a sex centre equivalent to modern Bangkok or Manila (the French capital then had 200 brothels and more than 30,000 prostitutes, the majority forced on to the streets by desperate poverty). Lautrec spent his nights drinking in the cabarets and dance-halls of Montmartre and recording quick psychological studies of their inmates. Back in his studio he would turn his drawings into paintings and, if necessary, invite his subjects back for a paid sitting later. But there was also a booming market for lower priced works amongst collectors, and to satisfy this clientele, Lautrec reworked some of his drawings as lithographs.

This involved drawing onto a series of polished lithographic stones with a

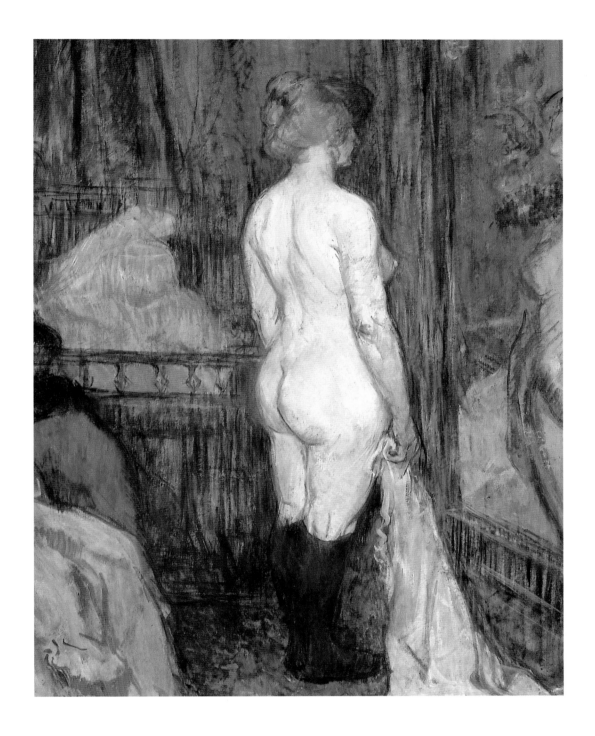

Henri de Toulouse-Lautrec
Woman before a mirror, 1897.
Oil on board.
24½ × 18½ in (62 × 47 cm).
Lautrec gave the painting to his
old schoolfriend Maurice
Joyant, who became his dealer
and biographer. It was in the
New York collection of Mrs. Ira
Haupt before being acquired by
Mr. and Mrs. Walter Annenberg.

greasy wax crayon, to which ink would adhere, a different stone being used for
each colour. In the press the stone came into contact with the dampened paper,
and the crayon image was transferred to the paper. Lithography was a time-
consuming medium, but it was one to which Lautrec's pared-down lines and
strong sense of design were ideally suited. His lithographs and posters forecast
many of the developments in art of the twentieth century: today, a century after
his death, his influence can still be seen in advertising, strip cartoons and film.

The tiny top-hatted count with his black beard was a familiar figure around
the nightspots of Montmartre, cigar clamped firmly between his teeth, sketch-
book always at hand. He also carried a hollowed-out silver-handled cane in
which he kept an emergency supply of his favourite drink – absinthe. Absinthe

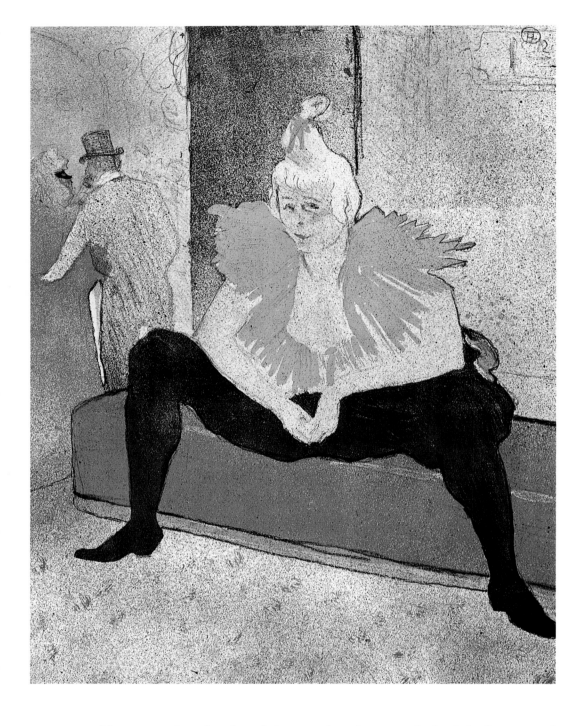

Henri de Toulouse-Lautrec
The seated clowness, 1896.
Colour lithograph published by
Gustave Pellet.
21 × 16 in (53 × 41 cm).
This has always been Lautrec's
most popular lithograph, both
because of its striking design
and for the artist's salacious
visual pun. Several states (or
printings) exist and the exact
number printed is not known.
Although it was included in the
Elles album, the red monogram
on the lower left of the margin
meant that this print could also
be purchased individually.

addiction combined with syphilis contributed to an early death for Lautrec and
for his friend Charles Conder, both of whom believed that the 'Green Muse'
inspired them and kept them awake (in the same way that some contemporary
artists believe cocaine provides inspiration).

Lautrec's tragedy was that, although he adored the company of women and
had normal sexual appetites, his physical deformities made most of the women
who fascinated him in the dance-halls and cabarets unable to return his feel-
ings. Instead, in oils, lithographs and colourful posters he immortalised these
women, whom he referred to as his 'fascinations of the moment'. Cha-U-Kao,
one of his longer-lasting 'fascinations', was a French acrobatic dancer and oc-
casional prostitute. At this period, anything Japanese was considered fashion-

Henri de Toulouse-Lautrec
Two friends or *Dancing at the Moulin Rouge*, 1897.
Colour lithograph published by Gustave Pellet.
18 × 14 in (46 × 36 cm).
Based on a painting dated 1892 (now in the National Gallery, Prague), it was printed in an edition of 20. It shows a woman who has been identified as Cha-U-Kao (left) dancing with her female lover, who is dressed as a man. The bilious 'Lautrec' green of the background duplicates the harsh light on the dance floor of the Moulin Rouge, which accentuated facial wrinkles. On the right is Jane Avril, who performed the can-can like an 'orchid in ecstasy'. At the table behind her, wearing a dark trilby hat over his blond hair, is artist Charles Conder.

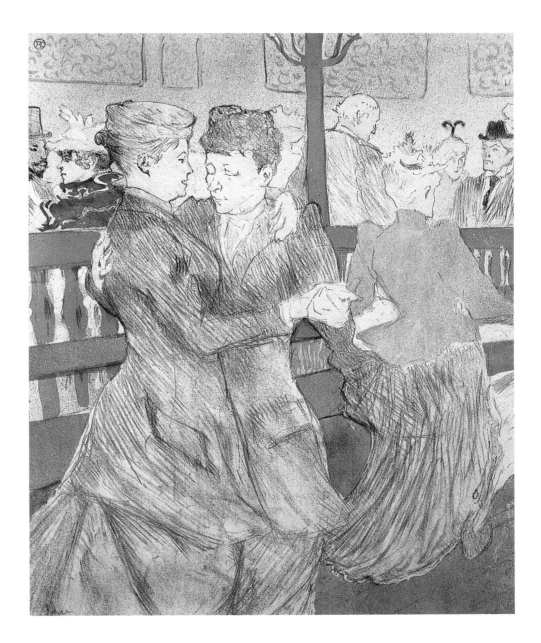

able, but the Japanese look of her name was only a joke: it was derived from the French *chahut chaos*, the wildest part of the can-can. Cha-U-Kao had become notorious among the men who frequented dance-halls and 'pick-up joints' like the Moulin Rouge for her erotic act, in which she performed the splits, and she also worked as a clowness.

She appeared in several of Lautrec's pictures, often in her clowness's costume. In *Cha-U-Kao in her dressing-room* (Musée d'Orsay) the artist emphasised the dancer's ample breasts as she adjusted the black strapless costume and brilliant yellow ruff that were her trademark. The painting was donated to the Musée du Luxembourg but was considered so scandalous that the trustees at first refused to hang it. In another portrait (sold in 1985 by Sotheby's, New York, for $5.28 million from the collection of Florence J. Gould), Lautrec showed Cha-U-Kao posing in front of a mirror in his studio, brilliantly capturing her piercing sapphire-blue eyes and general air of jaunty determination.

In a third painting, *At the Moulin Rouge, the clowness Cha-U-Kao* (Oskar

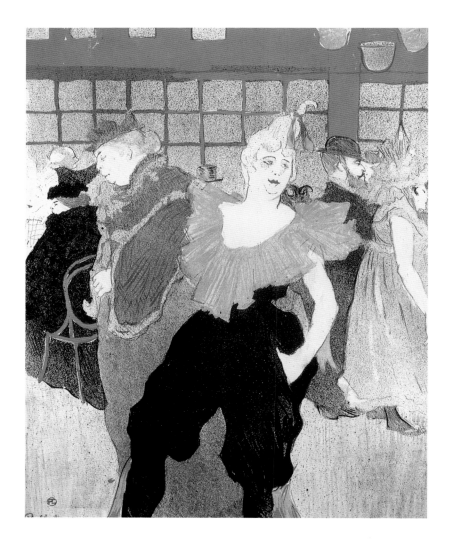

Henri de Toulouse-Lautrec
The clowness at the Moulin Rouge, 1897.
Lithograph published by Gustave Pellet.
16 × 12½ in (41 × 32 cm).
Based on the painting of Cha-U-Kao in the Reinhart Collection, this lithograph was printed in an edition of 20.

Henri de Toulouse-Lautrec
At the Moulin Rouge: the clowness Cha-U-Kao, 1895.
Oil on canvas.
30 × 21½ in (77 × 55 cm).
One of Lautrec's masterpieces, this vivid painting of Cha-U-Kao strutting around the circular promenade of the Moulin Rouge is in the Oskar Reinhart Collection, 'Am Römerholz', Winterthur, Switzerland.

Reinhart Collection), she again appears in her yellow ruff and black costume, this time posed under the Japanese lanterns of the vast raised gallery that surrounded the dance-floor of the Moulin Rouge. This was the 'market-place of love', where women available for hire promenaded. Beside her, possibly as a warning, Lautrec painted an elderly dancer and part-time prostitute, forced by poverty to work as a flower-seller. Two years after he had made this painting of Cha-U-Kao, Lautrec reworked it as a lithograph, and he did the same with yet another painting, in which she has been identified as one of the models – *Two friends* or *Dancing at the Moulin Rouge*.

In April 1896 *Elles*, an album of ten lithographs of women by Lautrec, was first exhibited for sale at the offices of a Parisian newspaper. Two months later the albums were again exhibited to collectors at Vollard's gallery. *Elles* revealed to a shocked public the daily routine of the women in the luxurious brothel in the rue des Moulins, where the artist had lived for several periods over the previous three years, as well as scenes at other 'houses' in the rue d'Amboise and the rue Joubert. Some art historians believe that *Elles* referred to the daily life of Cha-U-Kao and her female lover, an inmate of the rue des Moulins establishment: a striking five-colour image of Cha-U-Kao with her legs spread-eagled on a scarlet divan in front of a mirror was the first plate in the album.

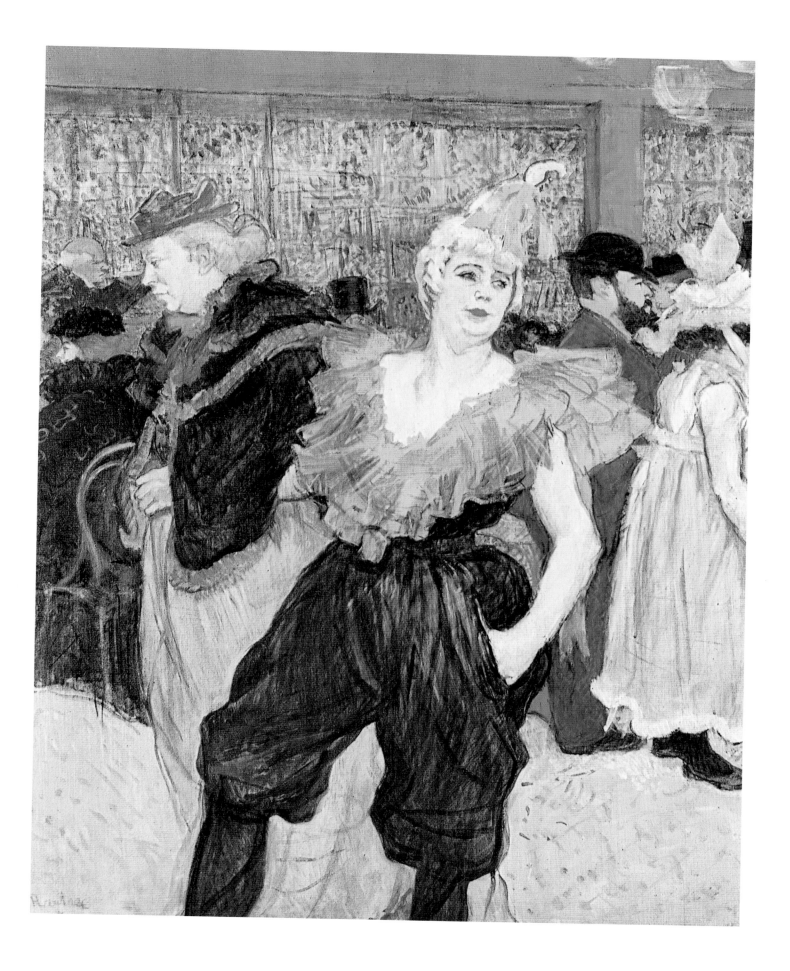

125

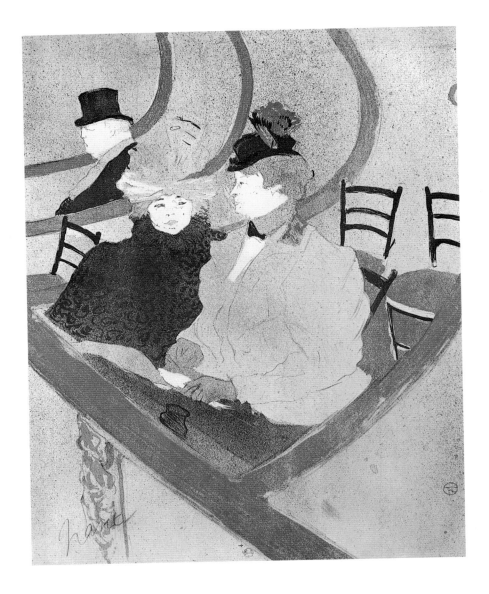

Henri de Toulouse-Lautrec
The large theatre box, 1897.
Lithograph published by
Gustave Pellet.
20 × 15½ in (51 × 40 cm).
Only 12 copies were printed,
making it one of Lautrec's rarest
lithographs.
Private collection.

Henri de Toulouse-Lautrec
The large theatre box, 1896.
Oil thinned with turpentine
and gouache on cardboard.
22 × 19 in (56 × 48 cm).
Private collection.

(Photograph: courtesy of the
Bridgeman Library, London.)

Lautrec made a daring visual pun by showing the dancer's long fingers cupped between her splayed legs to reveal a small dark triangle.

One hundred *Elles* albums were printed, but it was considered so scandalous that only a few were sold, and Gustave Pellet, the publisher, remaindered some of the sheets individually. Today the lithographs are highly sought after by collectors, and a single print can fetch huge sums.

The large theatre box, produced as a lithograph the year after *Elles*, shows the courtesan and actress Emilienne d'Alençon (seen full-face) sitting beside Mme. Brazier, the owner of a lesbian bar where Lautrec was a regular customer. In the Belle Epoque people took a box at the theatre to see and be seen; in *Nana* Zola described a typical audience made up of 'the Paris of letters, finance and pleasure, a few writers, stockbrokers, more tarts than respectable women, an oddly mixed world'. It is interesting to compare the sketch in oil and gouache with the final print: in order to provide a theatrical atmosphere for the lithograph, Lautrec lightened the background, flicking tiny droplets of colour from a toothbrush with a rasp to create shadowed effects or 'splatter' work, while the strong blocks of colour create a still more striking composition.

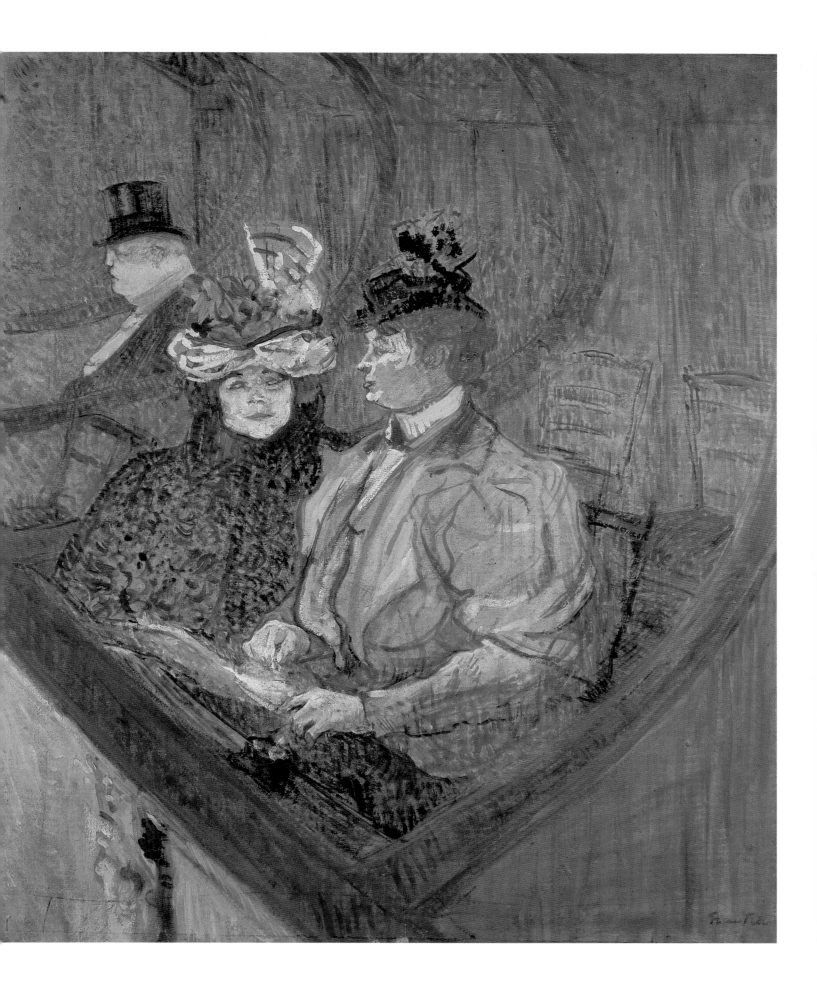

GEORGES SEURAT (1859–1891)

Georges Seurat
The clearing, 1882.
Oil on canvas.
15½ × 18 in (39 × 46 cm).
Chosen by Lila Witt Wallace, it is now in the Corporate Art Collection of Reader's Digest Association, Inc.

While Seurat's cool leafy *The clearing*, painted when the artist was only twenty-three, is a typical Impressionist picture, his *Sunday afternoon at the Grande Jatte* created a sensation when it was included in the final Impressionist exhibition in 1886, even among the avant-garde Impressionists. Seurat's painting of neatly-dressed Parisians out for their Sunday stroll shocked viewers and art critics by its revolutionary dots of colour.

Camille Pissarro was so impressed by it that he decided to have a try at *Pointillism* himself, but the rest of the group were outraged, demanding that works by Seurat, Signac and Pissarro should be exhibited in a separate room from their own. One witty Parisian critic observed that 'the City has ordered the [Impressionists'] exhibition to be closed – as three visitors have succumbed to smallpox caused by standing in front of a painting composed entirely of dots.'

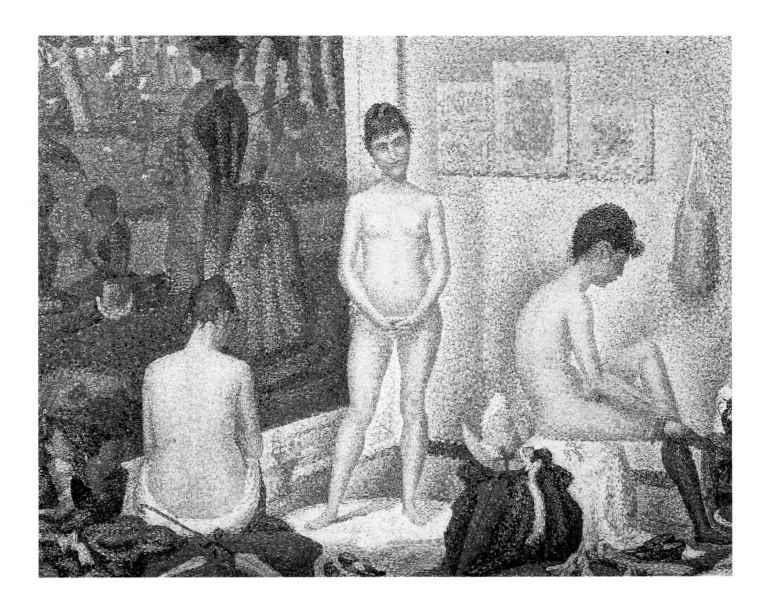

Georges Seurat
The models, 1888.
Oil on canvas.
15½ × 19 in (39 × 49 cm).
It was in a number of French collections, including that of Alphonse Kann until around 1920, when it went to the U.S.A., where it was owned by Marius de Zayas, John Quinn and his heirs and Henry P. McIlhenny. It was acquired for the Berggruen Collection in 1973 and is now on loan to the National Gallery, London.

When Seurat started on yet another masterpiece, the Impressionists' exhibition had closed and *Sunday afternoon at the Grande Jatte* had been returned to him – unsold. So Seurat simply propped it against the side wall of his studio and used it as a background. And here it is, surrounded by his young models' hats and clothes as well as their shopping bags and parasols.

The artist obviously enjoyed his visual joke, contrasting naked models with pearly skin and pert breasts with the 'respectable' women in pot hats and bustles who appear in the background of his previous painting. He made one nude hold her hands over her pudenda, a second undress and the third turn her back; all have the cool nonchalant poise of the professional model. Their stance cleverly echoes compositions from classical French painting, but this sparkling painting is no mere copy – it has its own subtle mathematical balance. This version may have been a sketch for the much larger version (eventually bought by the eccentric Dr. Albert Barnes) or it might have been painted as a replica.

PAUL SIGNAC (1863–1935)

Signac's parents intended their son to become an architect. However, a chance visit to an exhibition of Monet's paintings inspired the idealistic young man to become an artist, although, despite the fact that he could easily have afforded it, he never underwent any formal training. Signac took part in the final Impressionist exhibition, but by that time he had already come to believe that the Impressionists were relying far too much on instinct and impulse. Through his involvement in the first Salon of the Society of Independent Artists in 1884 Signac had met Georges Seurat, and from that time each of the young artists was to exert a powerful influence over the other, Seurat by his technique and Signac through his theories.

During the summer of 1887 Signac painted open-air scenes on the riverbanks of Parisian suburbs. *The Seine at Saint-Cloud* is one of his most haunting images; it has all the delicate luminous tonalities he had fallen in love with in the work of Monet, but here they form mosaic-like blocks of singing colour. Signac's later works have a higher-keyed palette and the artist often altered the size of his brushwork to suit their larger dimensions.

After Seurat's death, Signac became leader of the Neo-Impressionists and his book *From Eugène Delacroix to Neo-Impressionism* (1899) became the group's manifesto. In it he explained how 'no lack of respect is implied when we say that Neo-Impressionist technique assures integrity of colour, luminosity and harmony better than that of the Impressionists.'

Paul Signac
The Seine at Saint-Cloud, 1903.
18 × 21½ in (46 × 55 cm).
The painting is reproduced

from the Robert Holmes à
Court Collection.

HEIRS OF THE IMPRESSIONISTS

George Pauli (1855–1935)
Pierre Bonnard (1867–1947)
Lilla Cabot Perry (1848–1933)
Jean Henri Martin (1860–1931)
Richard Emil Miller (1875–1943)
William Merritt Chase (1849–1916)
Frederick Carl Frieseke (1875–1939)
Childe Hassam (1859–1935)
Albert Henry Fullwood (1863–1930)
Rupert Wulsten Bunny (1864–1947)
Philip Wilson Steer (1860–1942)
Charles Edward Conder (1868–1909)

George Pauli
On the pier, c. 1901.
Oil on canvas.
39½ × 55 in (100 × 140 cm).
It was formerly owned by the
writer Carl Laurin and is now
in a private collection.

(Photograph: courtesy of
Christie's and Dr. Anna
Castberg, London.)

GEORGE PAULI (1855–1935)

On the pier is one of the finest paintings by the Swede George Pauli. The warm but fading evening light and the women awaiting the arrival of the steamer convey a strong sense of wistful nostalgia, typical of 'Scandinavian Impressionism'. Pauli went to France and painted with the Barbizon School and in Brittany, and later he joined an artist's colony at Grez-sur-Loing on the edge of the Forest of Fontainebleau. In his homeland he was a founder member of the Konstnarsforbundet (Art Union), taught at Gothenburg's Valands Art School from 1893 to 1897 and edited the influential art magazine *Flamman*. In 1887 he married the painter Hanna Hirsch.

In *On the Pier* Pauli rejected conventional Salon painting, preferring to re-interpret everyday Nordic scenes in terms of French Impressionism. Here his skilful handling of light is worthy of Monet. His people are grouped against the strong diagonals of the jetty's wooden boards (a device reminiscent of Degas), while another older woman has been cropped by the artist in the manner of a Japanese print. A focal point is supplied by the woman in the white hat who holds a vivid bunch of summer flowers. Like Renoir at Argenteuil and Chatou, Pauli shows us ordinary people in moments of quiet enjoyment; here they wait for the steamer to take them to one of the islands of the Stockholm archi-pelago, where the Swedish upper classes went to escape city life in summer.

PIERRE BONNARD (1867–1947)

Pierre Bonnard was one of the great chroniclers of domestic life in the twentieth century, and his 'Intimist' paintings can be regarded as a splendid finale to Impressionism. Like Monet, Bonnard adopted certain themes which he continued to explore repeatedly throughout his life, and on his frequent visits to Vernon, not far from Giverny, he often spent time with Monet at his farmhouse. As Bonnard grew older, his palette became lighter and richer and his brushwork more exuberant.

From 1909 Bonnard spent his summers on the Mediterranean coast, eventually buying a villa at Le Cannet, near Cannes. Here he lived with Marthe Boursin, who had been his companion since 1893 and whom he eventually married. Bonnard painted Marthe – who eventually changed her name to the more aristocratic 'de Meligny' – day in day out, and in his paintings she never aged. Even when she was sixty, Bonnard still showed her with the voluptuous body of a young woman, but by then he was painting her from memory.

However, Bonnard's home life was not nearly as idyllic as it would appear from his paintings. Marthe suffered from tuberculosis, she was insecure and neurotic, driving most of Bonnard's friends away from the house with screaming scenes of possessive jealousy. She also suffered from a compulsive washing neurosis, so that she would bathe herself as much as a dozen times a day. But her obsessional personality and narcissistic behaviour perfectly suited the rather introverted artist in search of a model, so that, instead of seeking help for Marthe's psychological problems, Bonnard actively colluded with her, endlessly painting her as she bathed, sponged and dried herself.

In this work Bonnard gazes down on Marthe in her bathtub. The window forms one pattern, the strong outline of the bath another and, following the Japanese influence, the artist has cropped the edges of the painting. This and its companion work, *The bath* (Tate Gallery), are among Bonnard's finest explorations of his own obsession – Marthe bathing.

Pierre Bonnard
Nude in the bathtub, 1925.
Oil on canvas.
40½ × 25 in (103 × 64 cm).
It was purchased from the artist's estate by Mr. and Mrs. Walter Annenberg, who exhibited it at the Tate Gallery in 1966 but then sold it at auction, where it was bought by the late Robert Holmes à Court and his wife, Janet.

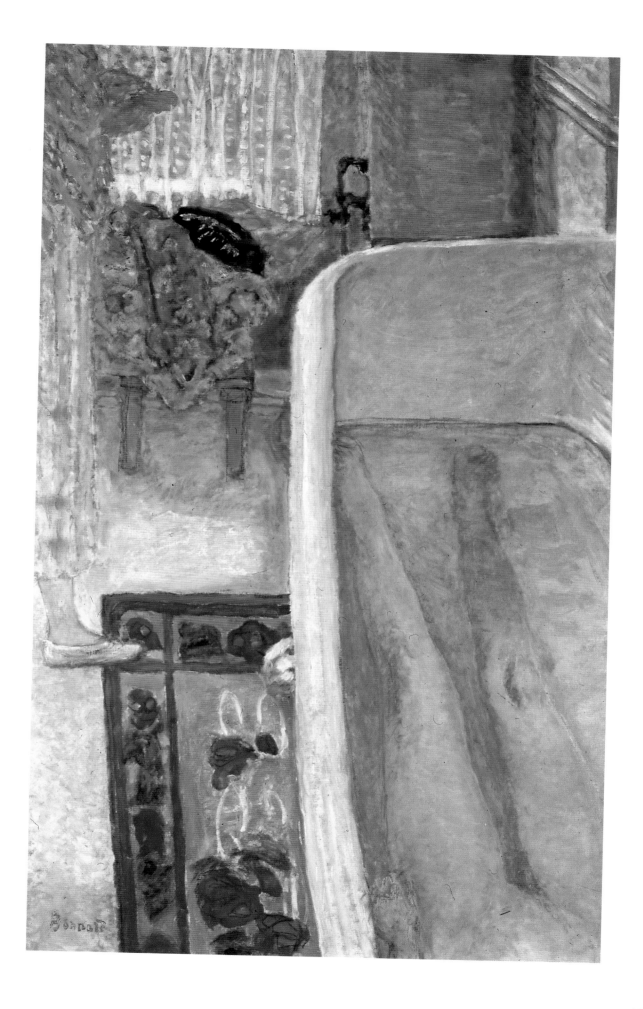

LILLA CABOT PERRY (1848–1933)

Lilla Cabot Perry
Autumn afternoon, Giverny.
Oil on canvas.
26 × 32 in (66 × 81 cm).
Boston-born Cabot Perry visited
Monet at Giverny most
summers for two decades,
except for the four years she
and her husband lived in
Tokyo. The Perrys bought
paintings direct from Monet's
studio, and Cabot Perry often
painted outdoors with him.
Through her articles in
American art journals she also
constantly encouraged
American collectors to buy
Impressionist works. This
painting is now in the Daniel
J. Terra Collection (Terra
Museum of American Art,
Chicago).

JEAN HENRI MARTIN (1860–1931)

Henri Martin
Gabrielle at the garden gate,
1910.
Oil on canvas.
79 × 41 in (201 × 105 cm).
With his sensuous brushwork,
joie de vivre and control of
diffused light, Martin has much
in common with Renoir,
though the style he evolved was
distinctively his own. This was
painted at the artist's home in
southern France; it is
reproduced from the Robert
Holmes à Court Collection.

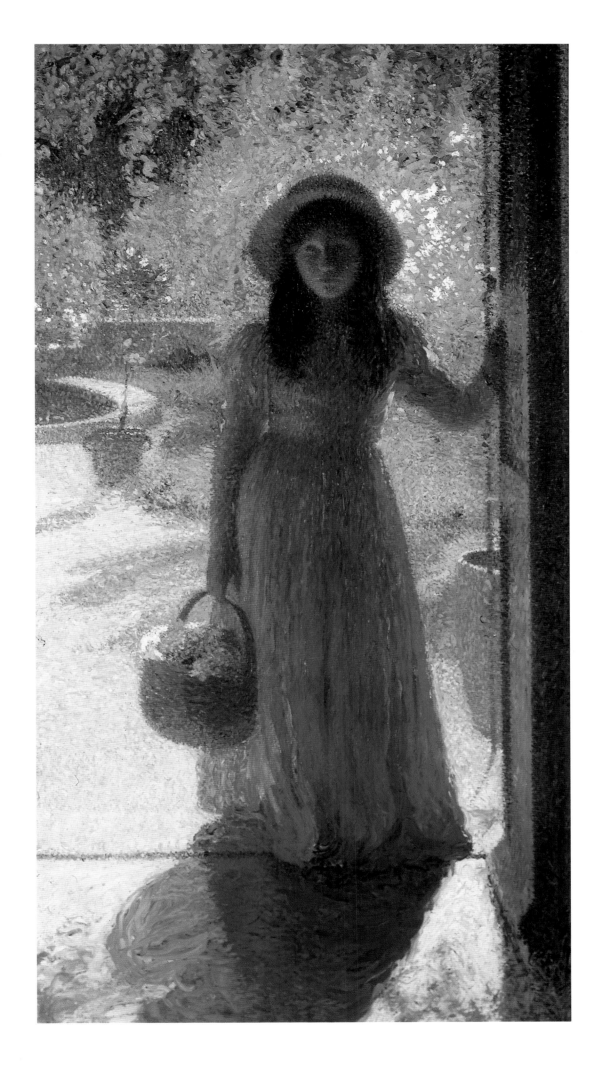

RICHARD
EMIL MILLER
(1875–1943)

Richard Emil Miller.
Night café, 1906.
48×67 in (122×170 cm).
In 1898 Miller left Missouri to
study art in Paris. He spent
twenty years painting in France,
exhibiting and teaching art each
summer at Giverny. Like Manet
before him in *The bar at the
Folies-Bergère*, Miller was
fascinated by the number of
beautiful Parisiennes, who
earned their living by dressing
stylishly and offering themselves
for a fee. During Miller's time
there, the war-torn city of Paris
was widely regarded as the sex
and recreation capital of the
world. This painting, once
owned by Fritz Thaulaw, the
artist who was Gauguin's
brother-in-law, is now in the
Daniel J. Terra Collection (Terra
Museum of American Art,
Chicago).

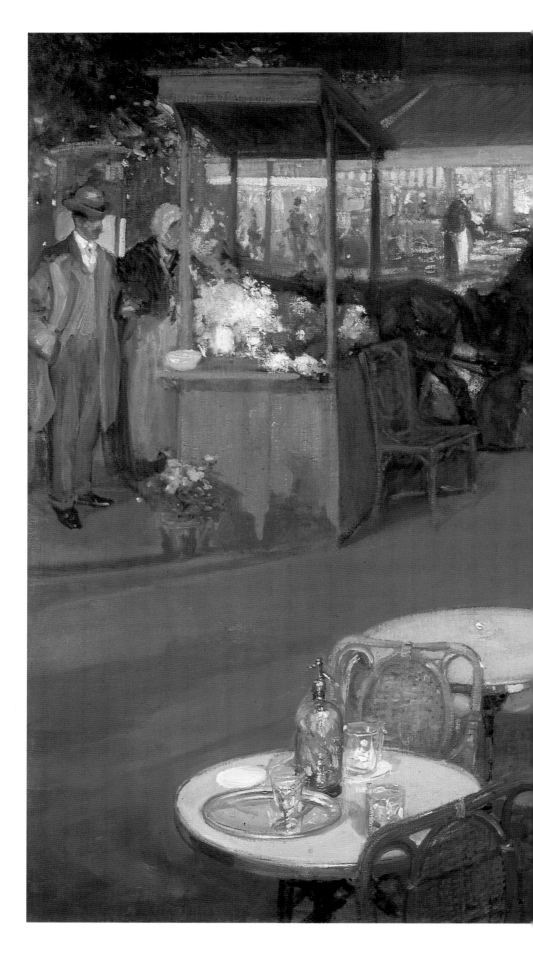

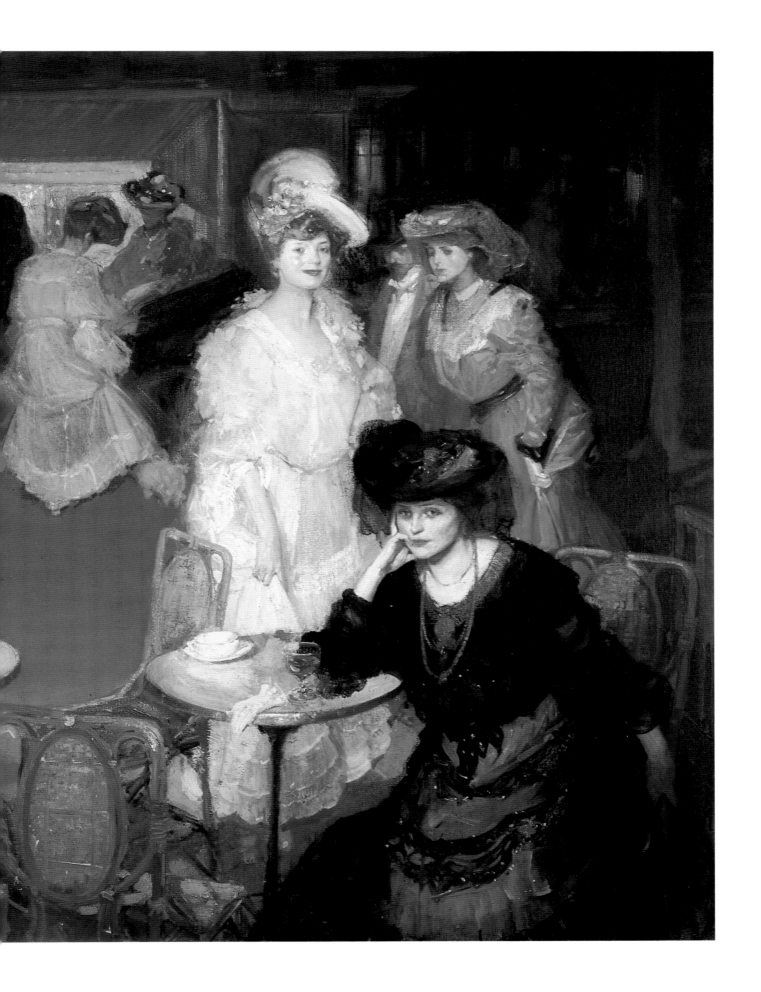

WILLIAM MERRITT CHASE (1849–1916)

William Merrit Chase
Young girl on an ocean steamer.
Pastel on paper.
29×24 in (71×61 cm).
Warner Collection of the Gulf
States Paper Corporation,
Tuscaloosa, Alabama.

William Merritt Chase was born and raised in Indiana until he was twenty-one. After studying briefly at the New York National Academy of Design, he left to go and work in St. Louis, a wealthy city with few portrait or still-life artists. Interested local collectors and patrons were so impressed by Chase's work that they opened a fund in order to send him to Europe to study art, and in 1872 he left America for six years. These were spent studying in Munich and touring France.

Chase saw the work of Manet exhibited in Paris and this had a profound influence on both his artistic taste and his subsequent technique. He changed his palette from the dark tonalities he had learned in Munich to the lighter tones of Impressionism; he sent back some avant-garde 'European' works to exhibitions in the United States; and on his return to America in 1878, Chase did everything possible to encourage the spread of Impressionism there. Five years later he organised an exhibition of paintings at the National Academy of Design to help raise funds to build a pedestal for the Statue of Liberty. Naturally this exhibition included works by Chase's favourite artist, Edouard Manet, and there was also a large selection of works by Monet, who would eventually become the most popular of all the Impressionists with American collectors.

Merritt Chase became a renowned art teacher in America, and during the era of railroad and steel barons and entrepreneurial financiers his influence was decisive in persuading collectors like Frank Thomson, James S. Inglis, Cyrus J. Lawrence, George Vanderbilt and James F. Sutton to buy the work of the French Impressionists. However, the society portraits for which Chase was best known, and which, like those of John Singer Sargent, were much in demand, were never painted *en plein air* but always inside his beautifully decorated studio in the Tenth Street Studio Building.

Chase was his own best advertisement. Tall and strikingly handsome, with deepset eyes, he would stride along Fifth Avenue and through Central Park, wrapped in a dramatic black cloak and wearing a black felt hat, on his daily walk, holding a white wolfhound on a lead. In his New York studio Chase employed an oriental manservant in exotic costume to greet his patrons, and his frequent studio parties were meeting grounds for 'personalities' from the twin worlds of American society and the arts.

In 1890 Chase was elected a member of the National Academy, and for many years he was on the faculties of the Art Students' League and the Pennsylvania Academy of Fine Arts. During the 1890s his work was so popular that he taught at two art schools named after him – the Chase School in New York and a summer art school at Shinnecock, Long Island. This summer school continued until 1902 and Chase's more famous students included Georgia O'Keeffe and Edward Hopper.

Tender portraits of the artist's beautiful wife, Alice, and his dark-haired daughters, painted at Shinnecock Hall, reveal that their home was furnished in Whistlerian mode with dark Spanish-style furniture, peacock feathers in blue-and-white oriental vases and Japanese fans. William Merritt Chase hung

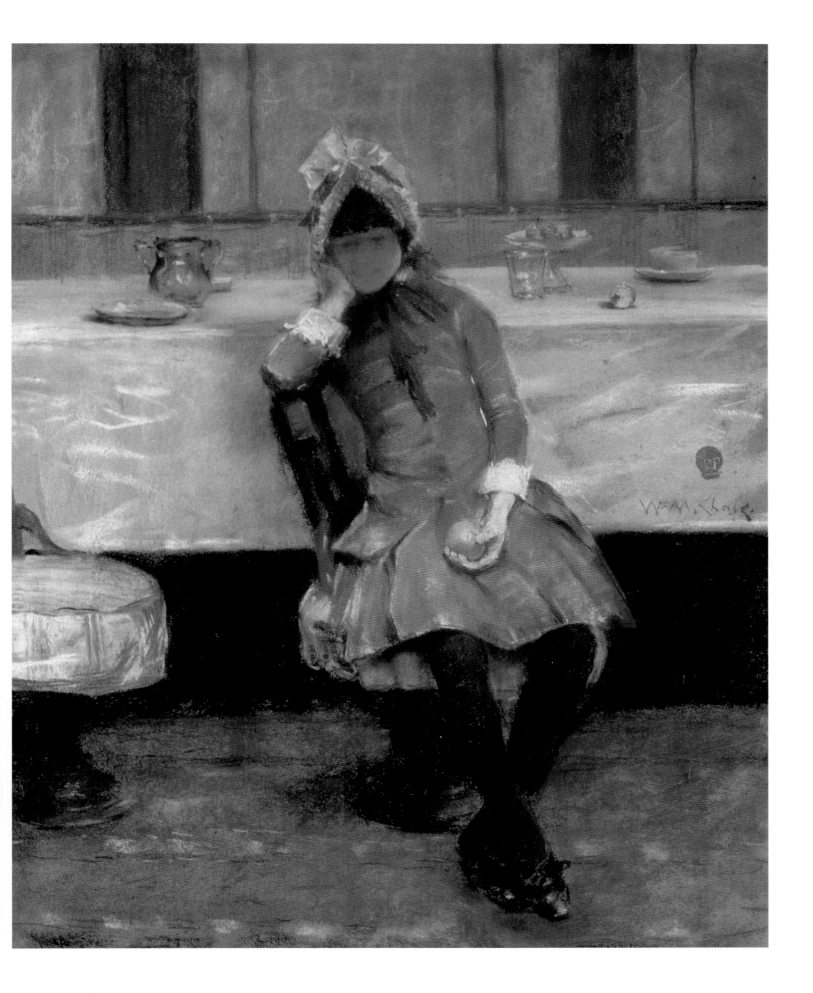

his vast picture collection around the walls. On the beach at Shinnecock, Chase painted works in a far more impressionist idiom, revelling in texture and colour. He had a remarkable ability to capture a 'sensation' of intimacy and glowing light and create a dramatic and original composition. *Morning on the breakwater, Shinnecock*, with its sparkling water and breeze-blown sky has almost the freshness of an early Monet. Chase and his family also adored Europe and frequently summered there. *Young girl on an ocean steamer* may well be a portrait of one of Chase's own daughters. Here, the broad brushwork, bold placement of the central figure and simplification of colours, all show the strong influence of Manet.

Eventually Chase replaced the influential John Twachtman as the leader of the break-away 'Group of Ten' painters. Although not all of the artists in the group were impressionistic in viewpoint and technique, Merritt Chase was supported by J. Alden Weir, John Twachtman and Childe Hassam in his admiration for French Impressionism. Chase's work was extremely popular in his lifetime, but after his death interest in his works waned, due in part to the introduction

William Merritt Chase. *Morning on the Breakwater, Shinnecock, Long Island*, 1897. Oil on canvas. 40 × 50 in (102 × 127 cm). Daniel J. Terra Collection (Terra Museum of American Art, Chicago).

William Merritt Chase.
Shinnecock Hall, 1892.
Pastel on canvas.
32 × 41 in (81 × 104 cm).
Daniel J. Terra Collection
(Terra Museum of American
Art, Chicago).

to the American market of works by Matisse and Picasso. However, tastes
change. By 1981 Chase's luminous pastel *Gravesend Bay* brought $902,000 at a
New York auction, and only seven years later it fetched well over double that
price, indicating that American collectors had at long last realised the power-
ful appeal of their own 'Impressionists'.

Today Chase's works hang in the Metropolitan and other major art museums,
and occupy an important place in the Terra Museum of American Art, set up
by Daniel J. Terra to show major works by native-born artists.

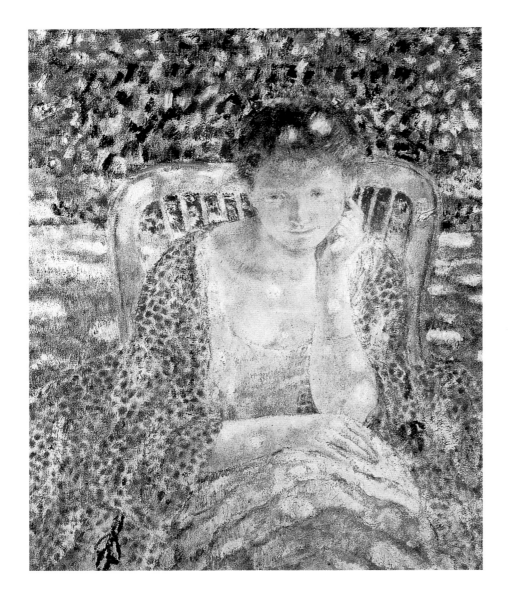

Frederick Frieseke
Lady in a wicker chair (Sun spot no. 2), 1919.
Oil on canvas.
32 × 25 in (81 × 64 cm).
It was purchased from Altman/Burke Fine Art, New York, by an American collector.

Frederick Frieseke.
Lady in a garden, c. 1912.
Oil on canvas.
32 × 25 in (81 × 64 cm).
It is now in the Daniel J. Terra Collection (Terra Museum of American Art, Chicago).

FREDERICK CARL FRIESEKE
(1875–1939)

Frieseke studied art in Chicago and New York before attending the Académie Julian in Paris, where his master was the portrait-painter Jean-Paul Laurens. After 1900, like many other American artists, Frieseke spent his summers at Giverny, renting the cottage where Theodore Robinson had once lived, next to Monet's home, Le Pressoir. By now Monet was annoyed by the band of eager young Americans who hung around his favourite haunts hoping to learn his techniques, and Frieseke never enjoyed his close friendship as Robinson had done. Perhaps this is the reason why Renoir's portraits exerted more influence on Frieseke than Monet's Giverny scenes.

In those golden summer days Frieseke painted girls in pink and white dresses and sun-dappled nudes in his flower-filled garden.

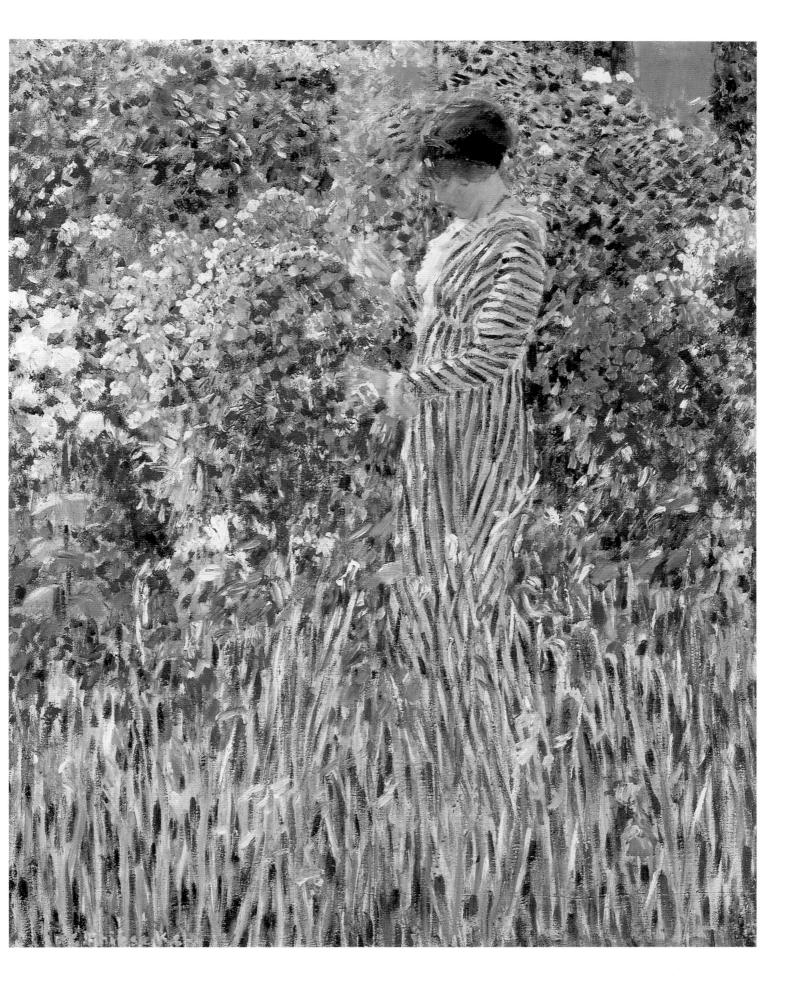

Frederick Frieseke
Lilies.
Oil on canvas.
25 × 32 in (64 × 81 cm).
Now in the Daniel J. Terra
Collection (Terra Museum of
American Art, Chicago).

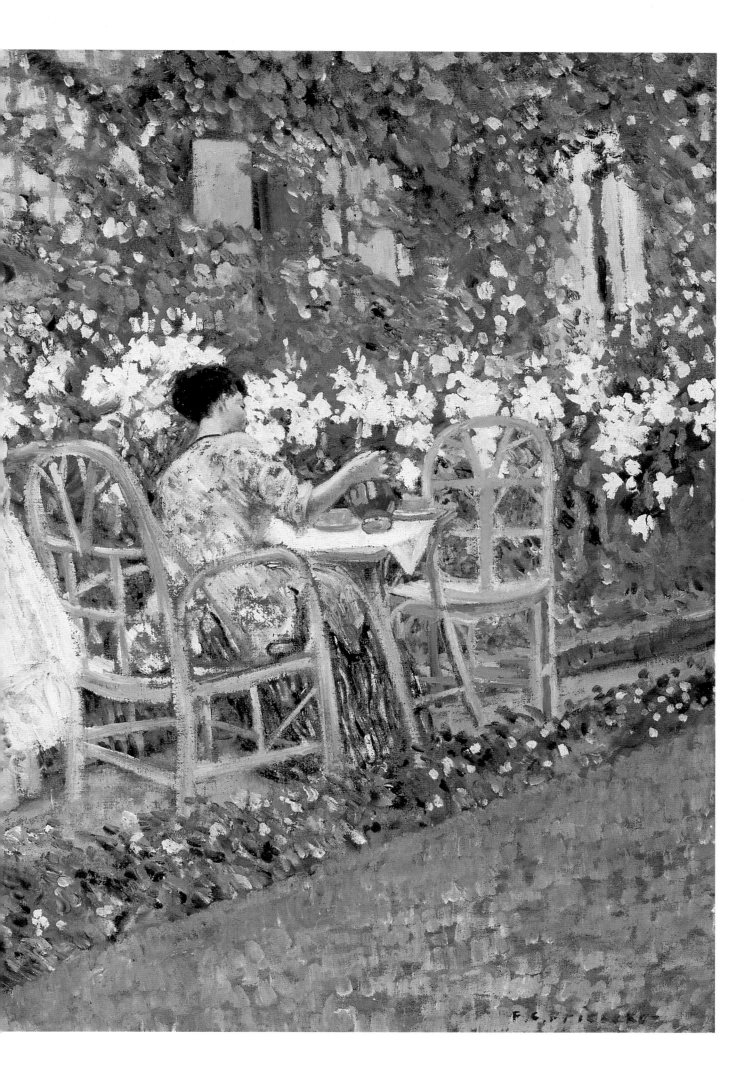

F.C. Frieseke

CHILDE HASSAM (1859–1935)

In the late summer of 1889 Childe Hassam returned to America after many years spent painting in France. He rented a studio on New York's Fifth Avenue and joined the artists who became known as 'The Group of Ten'.

In 1917 he made a series of twenty-four American flag paintings in an Impressionist idiom. He described how, 'there was that Preparedness Day, and I looked up the avenue and saw those wonderful flags waving, and I painted the series.' The Preparedness Day parades, which took place in May 1917, were organised as a patriotic response to the entry of the United States into World War I that April, and Hassam's paintings show the streets of the city in that euphoric time.

The Fourth of July is one of the most important paintings of Hassam's entire 'Flag' series. The bold brushwork and vibrant reds assert a new patriotic strength in the work of a painter who had been best known for his gentler Parisian and American street scenes, often seen in the rain. In these, he appeared to be influenced by the bird's-eye views of Pissarro, which, in their turn, had been influenced by the techniques of contemporary photography and the compositions of Japanese woodblock prints.

When Childe Hassam's painting was exhibited the year it was painted at New York's illustrious Montross Gallery, the *Christian Science Monitor* described it in glowing terms: 'Then comes the climax, that fairly shouts hurrah for Old Glory! "The Fourth of July" – Fifth Avenue is a sea of stars and stripes floating in the breeze from tall buildings on either side of the great American thoroughfare. And even this enthusiasm is kept within the ordered restraint of an art ever true to its sense of colour relations and atmospheric harmony.'

In sharp contrast to the opposition to war shown by many artists younger than himself, in this dramatic series Hassam gave a fresh interpretation to the deep symbolism of his country's flag. American as he was, in artistic terms he placed his all-American symbol fairly and squarely in the great tradition of French Impressionism. In this magnificent and unforgettable painting Childe Hassam acknowledged a debt to Manet and Monet, whose colourful bird's-eye views of flag-decked windows had become icons of the movement.

Childe Hassam
The Fourth of July (The greatest display of the American flag ever seen in New York, climax of the Preparedness Parade in May), 1917.
Oil on canvas.
36 × 26 in (91 × 66 cm).
The painting was owned for many years by Mr. and Mrs. Frank Sinatra.

(Photograph: courtesy of Christie's and Berry Hill Galleries, New York.)

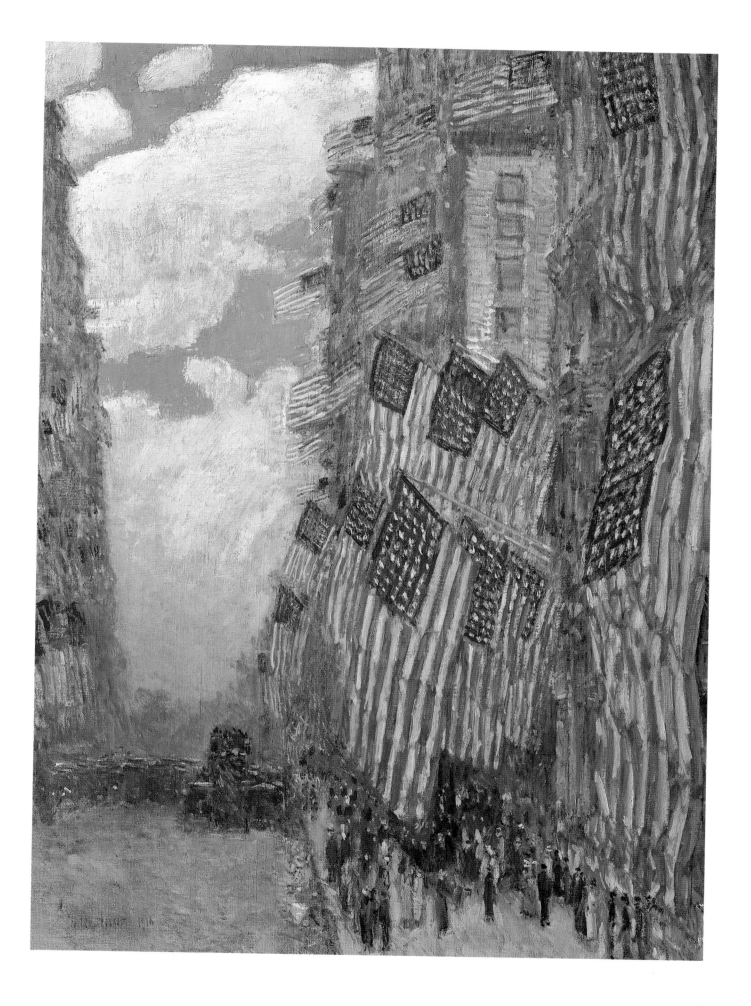

149

ALBERT HENRY FULLWOOD
(1863–1930)

Henry Fullwood, as he always preferred to be called, was born and brought up in Birmingham, England, where he won a scholarship to study drawing, painting and engraving at the local Art Institute; then, at the age of nineteen, he emigrated to Australia. There he toured the country, working on illustrations for a Centenary project, *The Picturesque Atlas*, that he had been commissioned to make. Returning to Sydney, he joined Impressionists Tom Roberts and Arthur Streeton at a painting camp at Little Sirius Cove in the Sydney harbourside suburb of Mosman.

Fullwood and Roberts were dissatisfied with the stuffy and amateurish Art Society of New South Wales, and they set up the breakaway avant-garde Society of Arts for professional artists. However, in 1900 the depression in Australia persuaded Fullwood to return to England, taking his wife Clyda, the daughter of a Sydney photographer, and their two young sons. He auctioned some of his Australian paintings to pay for the trip and travelled by way of New York, where he held an exhibition. From 1906 he exhibited at London's Royal Academy and at the Paris Salon.

During World War I Fullwood served as an official Australian war artist, but at the end of the war he found himself in financial difficulties, and once again Australia seemed the answer. He returned with his family, bringing some of his best works, painted both in Australia and in Britain, back to Sydney in the hope of finding buyers. However, he had to send many of them, including *Women with parasols, looking towards St. Paul's Cathedral*, back to friends in Britain to avoid paying import duty, since, to his fury, the Australian Customs insisted that both his British and Australian works were taxable as 'imported goods'.

Albert Henry Fullwood.
Women with parasols, looking towards St. Paul's Cathedral.
Oil on board.
10×13½ in (26×34 cm).
Formerly in a collection of the portrait-painter Sir James Guthrie (1859–1930) and his descendents, it is now in an Australian private collection.

RUPERT WULSTEN BUNNY (1864–1947)

Rupert Bunny's mother was a talented musician who came from a distinguished German family; his father was a judge. Rupert, who was born in Melbourne, spoke German from an early age and was partly educated in Europe, but at the age of seventeen he entered Melbourne University to study engineering. Finding that he loathed the course, he braved bitter family opposition and joined the National Gallery Art School in his native city, hoping that he would be able to return to Europe as an artist.

In 1884 Judge Bunny, now convinced of his son's artistic talent, relented and took him to Europe. Rupert Bunny studied in London before going to Paris to become a pupil of J.P. Laurens. For the next forty-six years (from 1886 to 1933) he lived and worked in France. At the age of twenty-two he became the first Australian artist to receive a *mention honorable* at the Paris Salon, and his portraits of elegantly attired women were equally admired at the Royal Academy Summer Exhibitions and the Royal Society of British Artists. In 1900 he was awarded a bronze medal at the Paris Exposition Universelle, and ten of his paintings were later purchased from the Salon d'Automne by the French government.

Bunny also exhibited at the Carnegie Institute in Pittsburgh, and through his Paris dealer, Georges Petit, he received portrait commissions from wealthy industrialists in Buenos Aires and Spain, who were happy to pay high prices for flattering portraits of their wives. In 1893, the prime minister of Hungary purchased Bunny's *Pastorale*, and in 1902 he finished a memorable portrait of singer Nellie Melba. Tall and distinguished-looking, speaking fluent French and German, Bunny was by far the most successful of all the Australian expatriate artists.

Rupert Bunny was converted to *plein air* painting, initially purely for his own pleasure, by his fiancée, art student Jeanne Morel, the daughter of a colonel in the French army. On a visit to London in 1902 he married Jeanne, who became his favourite model. Her delicately modelled face and tall, voluptuous figure appear in many of the works Bunny executed in a Renoiresque style of sensuous, leisured elegance, for his talent adapted as easily to the techniques of Impressionism as to academic painting. But, like American 'society' portrait painters John Singer Sargent and William Merritt Chase, Bunny's income came not from these impressionistic works but from highly-finished 'studio' portraits of society women.

In 1911, at the height of his reputation, Rupert Bunny held immensely successful exhibitions in London, Melbourne and Sydney. Monet's biographer Gustave Geffroy described the women in Bunny's paintings as having 'a soft radiance, a peaceful strength, a secret charm... [they are] real women who watch, think, breathe and dream.' Bunny's women gaze pensively from sunlit verandahs on to summer landscapes, or fan themselves on lamplit balconies gazing out into warm velvety darkness. The painter was fascinated by transient effects of light, and soft, semi-transparent fabrics draped around his models.

But Bunny's elegant world was shattered by the horrors of World War I. As a volunteer helper at the American Hospital in Paris, he was deeply depressed by the mutilated patients he tended, and when the war ended he was faced with a

Rupert Wulsten Bunny
The four-leafed clover.
Oil on canvas.
28½ × 36 in (73 × 92 cm).
The artist's wife, Jeanne, is on the left of the painting. It has been in a Sydney private collection since 1989, when it was purchased from the descendants of a French artist who was a friend of Rupert Bunny.

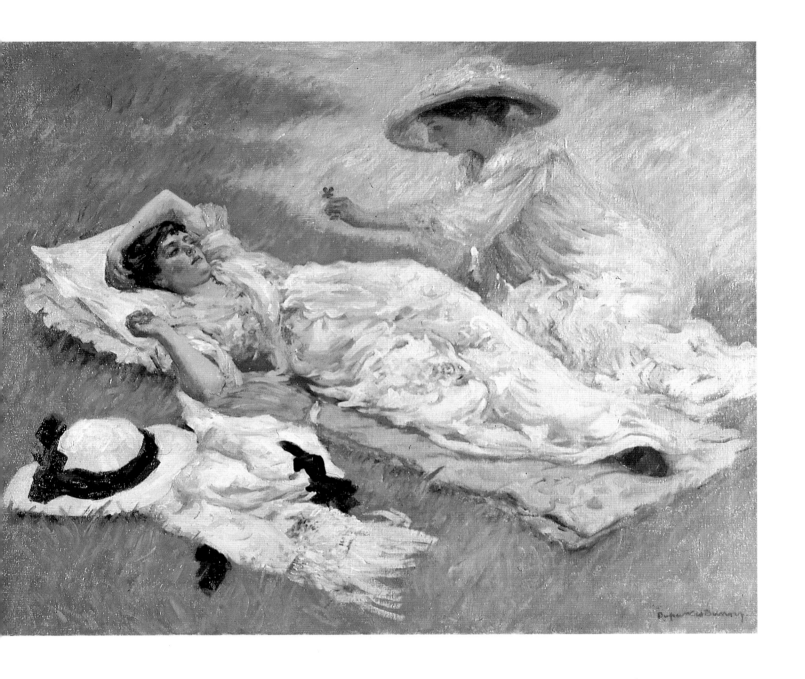

financially depleted Europe and a lack of patrons. Bunny, now in his fifties, suffered a mid-life crisis and, in search of 'the new', experimented with Cézannesque Provençal landscapes, decorative myths and allegories, and made several trips to Australia to exhibit his work.

In 1933, he finally returned to Melbourne, where he remained after Jeanne's death from a heart attack, but his hands gradually became so badly afflicted with arthritis that Bunny gave up painting and returned to his first love – music – and spent his final years composing scores for ballets.

Forgeries of his work, currently all too common in London and Buenos Aires, usually bear a monogram – RB in a square – rather than his full signature.

PHILIP WILSON STEER (1860–1942)

Philip Wilson Steer
Girl reclining on a sofa, 1892.
Oil on canvas.
24 × 30 in (61 × 76 cm).
The painting was for many
years in the collection of Sir
William Eden.

(Photograph: courtesy of
Sotheby's and Whitford and
Hughes Gallery, London.)

Philip Wilson Steer, son of an English provincial drawing master, first studied art at Gloucester Art School. He was perhaps lucky to have failed to win a place at art school in London, because his father paid for him to go to Paris to attend the Académie Julian and, later, the State-run Ecole des Beaux-Arts. While he was in Paris, Steer may well have seen some of Manet's paintings, though there is no record of his having seen the work of Monet or Renoir, who were then relatively unknown. In 1884 Steer returned to London, and over the next decade his work had much in common with that of Monet (and to a much lesser extent that of Manet), as well as undertones of Whistler, for whom his friend Walter Sickert worked as a studio assistant.

Although the techniques of Impressionism aroused wide interest in America, the movement was not yet popular in Britain. Collectors initially thought the colours too bright and even considered the 'realistic' subject-matter rather vulgar. In 1886 Steer and Sickert formed the New English Art Club to exhibit Impressionist painting in Britain. Steer, encouraged by Sickert, who had met Degas and the Impressionist circle in Paris, painted seascapes and scenes of children playing on the beach, sparkling with reflected light.

Steer created a scandal when he made this portrait of his favourite model, fifteen-year-old Rose Pettigrew. For maximum effect, he decided to enclose her body in a bravura display of gossamer, which floats in a transparent cloud around her. Steer had already been using Rose as a model for four years, and her sensual body language in this painting hints to the viewer that she was more to the artist than just a model. Rose watches Steer, rather than the viewer, from beneath half-closed eyelids; her right arm deliberately curves backwards, emphasising the thrust of her budding breasts and the seductive curve of her hips and thighs, while her long legs are displayed to their best advantage. Rose Pettigrew reveals all the artful grace of Nabokov's Lolita – a young girl who realises the effect of her developing body on a mature, sensitive and passionate man.

Two years after it was painted Steer's memorable portrait was included in his one-man show at the prestigious Goupil Gallery in Bond Street (whose Paris branch had exhibited Monet's Antibes paintings in 1888). There was widespread speculation in Victorian society as to the precise nature of the artist's relationship with his teenage model, and the scandal intensified because Steer, by then thirty-four years old and married, was under consideration for a teaching position at the Slade School.

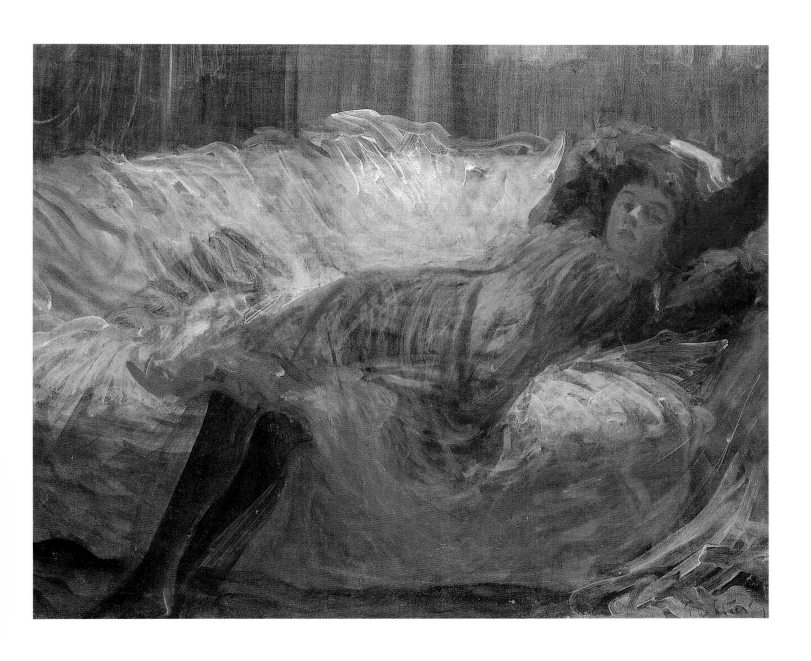

CHARLES EDWARD CONDER
(1868–1909)

Charles Conder
Landscape near Swanage, 1904.
Oil on canvas.
18 × 21½ in (45 × 55 cm).
The painting was owned by
British publisher John Lehmann
before entering the collection
of the late Sir Leonard and
Lady Trout.

Charles Conder is best known as an Australian artist, yet in his whole life he spent only five years in Australia. Born in London, he accompanied his parents to India, where his father was an engineer. When he was seven his mother died, and he was sent back to school in England. When at the age of fifteen Conder announced that he wished to become an artist, his outraged father promptly shipped him off to Sydney. His uncle, an official in the State Lands Department found him a job on a survey team – as camp cook. Conder hated it but loved the light and the colour of the Australian bush, and he enrolled in painting classes at Sydney's Royal Art Society.

In a harbourside wine shop Conder met Tom Roberts, who had come into indirect contact with the work of the Impressionists on a painting tour of Spain with John Peter Russell. In 1888 Conder joined a painting camp with Roberts and Arthur Streeton at Eaglemont Farm near Melbourne, and the results of this 'golden summer' were paintings influenced more by the Barbizon School and Corot than by Manet, Monet or Renoir. The following year, Conder participated in the important '9 × 5' Impressionist exhibition. Its name came from the inch measurements of the pictures – painted on cigar-box lids because the artists were too poor to afford canvas – which Conder described as 'records . . . often of a very fleeting character'. The show aroused as much hostility among the Australian art establishment as had the first Impressionist exhibition in France fifteen years earlier.

In 1890 Conder's uncle paid his fare to Paris, so that he could continue his studies at Cormon's atelier and the Académie Julian. Conder became friendly with fellow-students William Rothenstein and Henri de Toulouse-Lautrec, and the latter helped him improve his drawings of the human figure. Conder's handsome profile, blond hair falling over one eye, appears in four of Lautrec's pictures, and under his expert guidance Conder skipped classes, made nightly rounds of the Moulin Rouge and Lautrec's other haunts, and developed an addiction to absinthe.

In 1892–3 Conder exhibited his work, including paintings of can-can dancers and of grainstacks painted at Giverny and other French landscapes, both at the Pottier Gallery in Paris (where they were admired by Pissarro) and at the Beaux Arts Gallery in London. Success seemed within his grasp. But the pleasures of the twilight world of Montmartre enslaved him; and whenever Conder sold a painting, he would spend entire days and nights in the brothels.

In 1894, attempting to lead a more regular life, he courted Louise Kinsella, daughter of a wealthy art-loving American family (Conder's portrait of Louise, *The green umbrella*, is in the Tate Gallery). However, by now he had embarked on a fiery relationship with a Montmartre prostitute named Germaine. Louise Kinsella broke off their romance, and eventually Conder's descent into alcoholism drove Germaine to move in with Edouard Dujardin, a poet with a considerable private income.

Alone and drinking heavily, Conder spent the summers of 1894 and 1897 in Dieppe, along with other British expatriates, who included Aubrey Beardsley,

Walter Sickert and Oscar Wilde. In order to make money, Conder started painting silk fans with pseudo-Arcadian scenes, in the manner of Watteau seen through the eyes of Beardsley. He would sit down in front of a blank length of silk with a bottle at his elbow, rising a couple of hours later with the painted fan completed but an empty bottle before him.

When sober, Conder could still be amusing and charming. His friend Rothenstein arranged for an exhibition of Conder's fans to be held in London, and Conder remained in the city, supporting himself by teaching while British doctors tried, unsuccessfully, to treat his syphilis. Worried by his illness, Conder hated ever to be alone, and he would spend drunken nights with Augustus John, declaiming poetry and discussing art. Later, he also spent a holiday with John at Swanage, where he managed to produce nine paintings — one in a style often reminiscent of Manet's *Young woman among flowers* (p. 25) — several of which were exhibited at the New English Art Club.

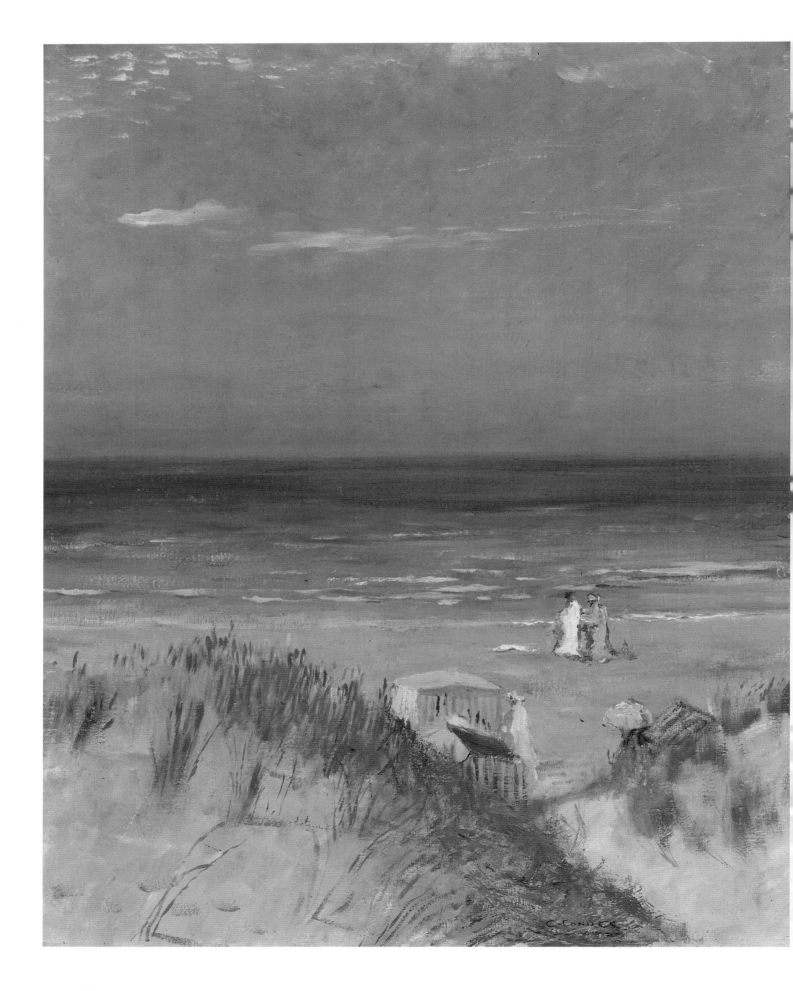

Charles Conder
Dunes at Ambleteuse, 1901.
Oil on canvas.
27 × 19 in (69 × 48 cm).
The women on the beach are
Stella Maris Belford, Conder's
future wife, and Mrs. Florence
Humphrey, Stella Maris's aunt
and Conder's pupil, who had
invited the artist Conder to
join the Ambleteuse
house-party. The painting is in
a private collection.

An invitation to a summer house-party at Ambleteuse, on the northern coast of France, led to a holiday romance with a wealthy young Canadian widow, Stella Maris Belford, and in 1901 they married. Under her stabilising influence, Conder's talent blossomed. For a brief period in their Chelsea house Conder was able to enjoy the life he had always craved. But the quality of his art declined as his illness took hold, and although Stella Maris devoted her entire income to consulting doctors in Germany and London, Conder eventually died in Virginia Water asylum just before his forty-first birthday. The cause of death was given as 'grand paralysis of the insane', the result of tertiary syphilis.

THE COLLECTORS

GUSTAVE CAILLEBOTTE (1849–1894)

Caillebotte's paintings (see pp.38–9) are now receiving deserved recognition, but this should not be at the expense of his importance as a collector and supporter of his fellow impressionist painters. He bought major works like *The swing* and *Ball at the Moulin de la Galette* from Renoir; he donated money to Monet and bought his works at a time when Monet was struggling to survive; and he also bought paintings from Degas, Pissarro, Sisley and Cézanne. At auctions Caillebotte even bought back his own paintings (sometimes at artificially inflated prices) to create confidence in Impressionist works.

Still more important for forcing the Paris art world to come to terms with Impressionism, he bequeathed his entire collection of Impressionist works to the French people, on condition that his collection would be hung in the Louvre. Caillebotte appointed his friend and fellow artist Renoir as executor of this will, in which he declared that he would finance entirely the next exhibition of the group of 'painters known as the Intransigents or Impressionists'.

Caillebotte died of a stroke, unmarried and childless, in his forty-fifth year, bequeathing some of his own paintings to his family and others to Charlotte Berthier, his favourite model, with whom he had lived at Petit-Gennevilliers. Renoir was now faced with the thankless task of negotiating with the French Government's art 'advisors' about his Impressionist collection. The advisors were on the Academic jury of the Paris Salon, and they declared that many of the paintings in the Caillebotte Bequest were not worthy of acceptance by a major museum!

Only half of Caillebotte's great bequest, which included many works now regarded as icons of Impressionism, was therefore accepted by the Government. And it did not go to the sacred corridors of the Louvre but to the Luxembourg Museum, which had just been set up to show 'contemporary art'. A clause in Caillebotte's will enabled Renoir to take one work for himself. Renoir chose his own magnificent *Ball at the Moulin de la Galette*; however, Caillebotte's family insisted that such a major work must be seen by the public in the Luxembourg. Annoyed, Renoir chose instead a Degas (whose work then commanded higher prices than his own) and immediately sold it for a very good price.

By 1928 the prices of Impressionist works had soared along with their reputations, and the French Government was delighted to receive the remaining canvases from the magnificent bequest their 'art advisors' had once rejected. Today the words 'Caillebotte Bequest' appear under some of the most important works in the Musée d'Orsay — the successor to the Luxembourg.

ERNEST HOSCHEDÉ (1837–1891) AND ALICE HOSCHEDÉ-MONET

Ernest Hoschedé enjoyed spending money on art and good living. With money from the dowry of his wife Alice he started a large department store in Paris — and spent its takings on lavish entertaining at his apartment on Paris's Boulevard Haussmann, and at the elegant Château de Rottembourg at Montgeron that was also part of Alice's dowry.

Hoschedé collected paintings by Corot and Boudin as well as works by more *avant-garde* artists like Manet and Pissarro, partly because he thought it would impress his guests and partly because he thought they would increase in value. Manet and Sisley, as well as the society portrait-painter Carolus-Duran, were invited to stay at the Hoschedés' chateau, brought in a specially chartered train from Paris direct to the local station at Montgeron. Monet, too, stayed there in 1877, and he and Alice became lovers.

Hoschedé seemed determined to risk his and Alice's fortunes by his overpowering ambition to earn still more money, although some of his financial speculations were extremely foolhardy. When Jean-Baptiste Faure successfully auctioned some of his paintings, Hoschedé decided that he too could make money out of 'contemporary' art. In January 1874, immediately before the first Impressionist Exhibition, Hoschedé auctioned one hundred paintings from his large collection, including works like Monet's *Blue house at Zandaam*, which sold well.

However, Hoschedé continued to collect, buying — perhaps at Alice's suggestion — an important group of Monet's works. By 1877 Hoschedé's business was facing bankruptcy, and the court ruled that the Chateau de Rottembourg and the art collection had to be sold. But the second Hoschedé auction at the Hôtel Drouot was a great disappointment. Scornful press criticism of the Impressionists' exhibitions had devalued their prices in the eyes of cautious collectors, and Hoschedé's five Manets, nine Renoirs, thirteen Sisleys, nine Pissarros and sixteen Monets were sold for derisory prices. Only Manet, who had wisely decided to seek success through the Salon and had not exhibited with the Impressionists, did well at the Hoschedé auction with his *Ragpicker*, *Woman with a parrot* and *Young man costumed as a majo*.

Durand-Ruel bought only one painting — a Pissarro — and a few more Pissarros were sold off very cheaply after the auction. Pissarro wrote to Sisley complaining that 'I discovered a possible patron the other day, but the Hoschedé sale has ruined the whole thing for me; as [the patron] can now get them cheap at the Drouot.' Pissarro was forced to reduce the price of his work for several years.

To save money, the Hoschedés decided to pool their resources with the Monets, although the artist's wife Camille had fallen ill, and they shared the Monets' rented villa at Argenteuil, and then even cheaper accommodation at Vétheuil. Hoschedé spent a great deal of time in Paris trying to sort out his financial affairs, but Alice still had a small portion of her fortune to contribute to their meagre budget. A portrait by Monet of Alice in a Paris designer gown (sold at Sotheby's New York in 1989 to a private collector) shows Alice posing on a daybed in the garden at Argenteuil.

Alice nursed Camille until her death, and she then told her husband that she could not join him in Paris as she had to stay on to care for Monet's motherless boys, Jean and Michel. Hoschede was apparently unaware of anything between Monet and Alice until an article commenting on the ambiguous nature of their relationship appeared in *Le Gaullois* in January 1880. When he demanded that his wife should leave Monet and join him in Paris, she refused and moved to Poissy with Monet.

Hoschedé then installed himself in Paris, working as an art journalist, and although his 'impecunious bachelor life' depressed him greatly, his interest in art may well have saved him from a total nervous collapse. In his role as a journalist, Hoschedé attended all the latest Paris exhibitions and even some of the dinners held by the Impressionists. In 1881 he published a book of art criticism entitled *Impressions de mon voyage au Salon*. Pissarro noted dryly that Hoschedé's appraisal of Monet's latest work was now somewhat less than approving. When Hoschedé fell ill in 1891, he was cared for by Alice until his death, and the following year she was finally able to marry Monet.

CLAUDE MONET (1840–1926)

At Giverny, Monet's favourite paintings hung in tiers around the walls of the studio so that he could rework them whenever the fancy took him. However, the accounts by visitors, such as the American Impressionist artists Lilla Cabot Perry (p.136) and Theodore Robinson (p.56) also describe his collection of works by fellow Impressionists. He owned posters by Toulouse-Lautrec,

twelve paintings by Cézanne, a Corot, four Jongkinds, a Fantin-Latour flower painting, two Caillebottes, three Pissarros, a Sisley, nine of Renoir's finest works, two Signacs and five water-colours by Berthe Morisot. There was also a pastel by Vuillard, several Rodin bronzes and some Impressionist watercolours by Manet and Sargent, as well as three works by Delacroix and a large collection of the Japanese prints which had such a strong impact on many aspects of impressionist technique.

Louis Vauxcelles, the critic and art historian, who visited Monet in December 1905, described how 'above the wide, low bed hung a beautifully voluptuous Renoir. There was a velvety portrait of a young woman by Manet, and Cézanne's *Negro*, a great masterpiece . . . a landscape by Pissarro, vibrant with light, some domestic scenes by Berthe Morisot, a *Woman bathing* by Degas, Cézanne's *Apples* and a *View of L'Estaque*, as well as his *Snow-covered forest*, two portraits of Monet and one by Renoir.' A poignant souvenir for the artist was his own painting of the Batignolles group in Fantin-Latour's Paris studio and a portrait of himself by Séverac.

The majority of Monet's collection, including some of his *Waterlilies* series were bequeathed to his second son Michel, who eventually donated the collection to the Musée Marmottan in Paris. Only replicas remain on view at Giverny today, where the house is now open to the public (after being restored with money donated by Lila Witt Wallace and Walter Annenberg amongst other benefactors).

HILAIRE EDGAR DEGAS (1834–1907)

Degas received a handsome allowance from his banker father, and he was therefore able in the early years of Impressionism to buy works by fellow artists like Monet and Renoir who needed money. But in 1874 Degas's father died, and since he was now forced to take over the debts of his brother Achille, he was no longer able to spend money on pictures. Nevertheless, by the 1890s Degas was again in a position to buy paintings direct from their creators. At the auction held by Gauguin in 1892 to raise money for his passage to Tahiti, Degas purchased a Gauguin *View of Martinique*, as well as his *Belle Angèle* (for a then record price of 450 francs), which the French Government was to purchase from his estate on his death. It is now in the Musée d'Orsay.

Degas's housekeeper, Zoé Closier, recorded that Degas begrudged spending money on food, preferring instead to buy paintings and Old Master drawings. His collection eventually included works by El Greco, Ingres, Delacroix, Corot, Manet, Pissarro, Sisley and Renoir, as well as van Gogh's study of two sunflowers against a cross-hatched background and Morisot's *Woman and child on a terrace* (Norton Simon Foundation). His Manets were early works and included *Departure of the Folkestone boat* (Reinhart Collection) and a section of *The execution of the Emperor Maximilian*. Like Monet, he also collected Japanese prints.

By the final years of Degas's life he had become obsessed with a need to hang on to his art collection and to his own paintings. Although he toyed with the idea of bequeathing his paintings to a museum, he neglected to write this into his will. As a result the contents of his studio were inherited by his brother René, who found paintings, pastels and 150 small wax models of horses, bathers, jockeys and dancers; also some portfolios of brothel sketches, which were destroyed. Adrien Hébrard's iron foundry made limited edition bronzes from the waxes and preserved the wax originals in wire cages, while the paintings were auctioned off in four separate studio sales held at the Galerie Georges Petit in March, May, November and December 1918.

STANISLAS HENRI ROUART (1833–1912)

Henri Rouart exhibited his own paintings, as well as the works that he owned by his fellow artists, in all but one of the Impressionists exhibitions. He was a generous patron of the group and once even put up the money to pay for their exhibition hall. In style, his own paintings resemble early works by Monet rather than by Degas, who had been his close friend since childhood. Two of Rouart's own canvases, *Church of San Michele*, *Venice* and *Terrace by the Seine*, are now in the Musée d'Orsay.

Rouart studied engineering and became a successful industrialist, making his fortune from the invention of an ice-making machine. He was also a keen Sunday painter. A portrait by Degas shows him resplendent in top hat and frock coat standing outside his Boulevard Voltaire factory. Their friendship had been strengthened when they served in the same artillery regiment in the 1870 Franco-Prussian war, and although Degas's sharp tongue caused him to fall out with many of his contemporaries, he and Rouart were always close. Degas used to dine with the Rouart family every Friday evening, and the Rouart household, crammed with paintings from floor to ceiling, was like a second home to the bachelor artist. Rouart's death left an enormous void in Degas's life.

Naturally, Rouart's own collection contained some of Degas's best works, including numerous portraits of the family, of which the best-known is the sombre, enigmatic portrait of Rouart's daughter Hélène, who acted as her father's housekeeper after her mother's death (National Gallery, London). At a sale at the Galerie Manzi-Joyant of works from his collection, held in the year of Rouart's death, Louisine Havemeyer, bidding through Durand-Ruel and advised as usual by Mary Cassatt, purchased Degas's great study in yellow and brown, *Dancers practising at the bar*, painted in 1876, at what was then a world record price for the work of a living artist. (Eventually Louisine left this great Degas to the Metropolitan Museum of Art, New York.) Jacques Doucet, who had just sold his own collection of eighteenth century works, paid a notably high price at the same sale for Manet's *On the beach* (Musée d'Orsay, Paris). In addition to works by El Greco, Goya, Poussin and Breughel, Rouart had owned five paintings each of Manet, Cézanne, Pissarro and Monet, and three canvases by Renoir. Although Rouart's son Ernest, an artist, married Berthe Morisot's daughter, Julie Manet, there was only one painting by Morisot in the whole of Rouart's collection.

DR. PAUL-FERDINAND GACHET (1828–1909)

Dr. Paul Gachet who was born at Ryssel, near Lille, took part in the Impressionsts' exhibitions under the pseudonym 'Paul van Ryssell'. Although a 'collector', Gachet rarely bought paintings; he usually acquired them in return for medical services or prolonged hospitality at his home at Auvers-sur-Oise, a village near Giverny.

Dr. Gachet practised in Paris as a homeopathic surgeon and Cézanne's *Hamlet and Horatio* (Rothberg Collection) may well have been given to Gachet in exchange for medical attention to Cézanne's son. Renoir, who was far too poor to pay the doctor, gave Gachet a portrait of a favourite model after her death, in lieu of medical services rendered.

Gachet's collection also contained works by Courbet, Daumier and Manet, and he owned one of Sisley's finest water views *Barges on the canal, Saint-Martin, Paris* (p.63). After Gachet's death, it was purchased by Paul Durand-Ruel.

Pissarro, closer in age to the doctor than the other Impressionists, became a good friend and they often painted together. It was Pissarro who asked Gachet to look after van Gogh when

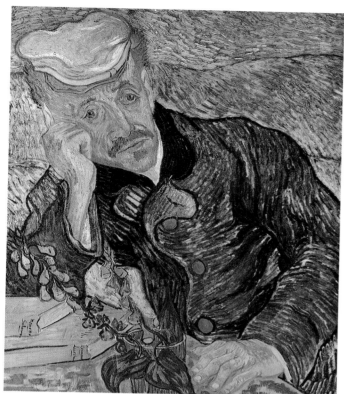

Vincent van Gogh
Portrait of Dr. Gachet.
Oil on canvas.
26×22 in (66×57 cm).
Two copies were made: one for Gachet (now in the Musée
d' Orsay) and the other for van Gogh. This was van Gogh's copy
which was consigned by Theo's widow Johanna to Ambroise
Vollard, who having found it difficult to sell, bought it himself.
Eventually he sold it to German dealer Paul Cassirer, and it was
bought by the Frankfurt City Art Gallery. However, classed as
'decadent' during the Nazi period, it was de-accessioned and sold to
the banker Siegfried Kramarsky, who lived in America. After
Kramarsky's death the painting was bought at Christie's New York
by the Japanese collector, Ryoei Saito, for $82.5 million, making it
then the most expensive painting in the world.

he wanted to leave the asylum. at St. Rémy. Vincent believed he
had found a stable friend in Dr. Gachet and noted their physical
and mental resemblance, commenting 'how very nervous and
very queer in his behaviour' Gachet was. (Gachet, like van
Gogh, suffered from mood swings.) Gachet showed Vincent how
to use an etching needle and prepared a copper plate for him.
Then Vincent made his first etching of the doctor. The first
portrait he painted of him in oils is unforgettable; it reveals Dr.
Gachet's high forehead, sad eyes and protruding chin.

However, Dr. Gachet's and Vincent's friendship soured when
Vincent saw how Gachet had piled his collection of unframed
canvases on the studio floor. Distressed and angry, Vincent
pointed out the damage done to a painting by his friend Armand
Guillaumin. There are suggestions that Vincent threatened
Gachet with a gun when he discovered that Gachet was making
copies of works by the Impressionists and signing them with his
own name. This theory is supported by the fact that some fakes
of the artist's work, presumably by Gachet, were donated to the
Musée Orsay. Although copying was a usual exercise at that
time, signing the original artist's name was not.

In spite of their differences, Vincent insisted that Dr. Gachet
attend him when he lay dying and they were reconciled at the
end.

Some canvases from the deceased Dr. Gachet's collection were
bought by dealer Paul Durand-Ruel; other important works were
donated by the family to the French Government and they now
hang in the Musée Orsay.

VICTOR CHOCQUET (1821–1891)

Victor Chocquet has become famous in the art world not only
for the portraits Cézanne and Renoir made of his gentle, sym-
pathetic face, with its shock of white hair, but also for his
reputation as the collector who wore shabby clothes so that he
could afford to buy works by his favourite artists. Chocquet was
a middle-ranking Customs officer who hated his work and lived
frugally. During the 1870s he spent a large proportion of his
salary on art that was then regarded as so *avant-garde* that no one
else seemed inclined to buy it. Chocquet was a truly dedicated
collector in the best sense of the word.

Chocquet had a good eye and haunted the auctions at the
Hôtel Drouot from the early 1860s onwards, and it was there
that he first met Renoir. Chocquet and Renoir shared a passion
for the works of Delacroix and this drew the two men together
and led Chocquet to commission the struggling young artist to
paint a portrait of Chocquet's wife. Renoir, who described
Chocquet as a 'delightfully crazy creature who starved himself to
buy the pictures he liked', took him to the shop of Pére Tanguy
to see the works by Cézanne which were hanging on the walls.
Chocquet would buy a Cézanne whenever he had money avail-
able and eventually owned fifty of the painter's works.

The Chocquets had an only child who died young, and Victor
Chocquet's passion for collecting art, bronzes, porcelain and
antique silver seems to be a clear case of displacement activity,
whereby the pastime of collecting took the place of the dead
child. However, his life changed when his wife came into a large
inheritance from her mother (consisting of land and buildings in
the north of France). From this time onwards he seems to have
stopped collecting and busied himself with his wife's business
affairs, and in 1890 the couple purchased a large house in Paris.
Shortly after Victor Chocquet had moved his collection to his
sumptuous new residence, he died. His widow closed up the
house and moved away from Paris, and when she died eight
years later, everything was sold up by her nephews. Thirty-two
Cézannes, including *The house of the hanged man*, went under the
hammer, as did eleven Renoirs, including the smaller version of
Ball at the Moulin de la Galette (which was sold at auction in 1980
for $80,000), eleven Monets, five Manets, one Pissarro and a
Sisley.

PAUL DURAND-RUEL (1831–1922)

Paul Durand-Ruel was undoubtedly the most influential of the
great dealer-collectors. He believed that 'a true picture dealer
should also be an enlightened patron'. This courageous philo-
sophy led him to support Pissarro, Sisley, Renoir, Monet and,
sometimes, Degas both financially and emotionally at a time
when they desperately needed money to survive.

He had inherited a picture selling and rental business from his
father, and in 1870 he moved into an elegantly appointed gallery
at 16 rue Laffitte, the street which became the hub of the art
dealing world until World War I. The gallery had a more modest
rear entrance at 11 rue le Peletier, near the Opéra, and it was
here that in 1876 the controversial — and financially unsuccessful
— second exhibition of the Impressionists was held. Six years
later, due to dissension in the ranks of the Impressionists, it was
left to Durand-Ruel to organise the seventh Impressionist exhibi-

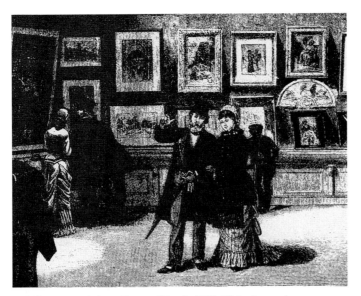

Exhibition at Galerie Durand-Ruel, 1879. This shows the very latest in picture lighting and a rare intimacy of display for the period. Wood engraving after E. Bichon.
Private Collection.

tion, which was mainly composed of canvases from his gallery's stock and from his private collection. This, too, was not a great financial success.

During the Franco-Prussian war, Durand-Ruel, then in his early forties, took off with some of his best paintings for London, where he held exhibitions in a gallery he had rented at 168 New Bond Street. He exhibited works by Manet, Monet, Renoir, Degas and Sisley, but they were too innovative to appeal to the taste of most English collectors, and in 1875 he closed the gallery. When he exhibited them again in London in 1882 and 1883 it was hardly more successful.

Durand-Ruel bought his first canvases from Degas, Renoir, Manet and Sisley in 1872, and by the standards of the time he paid little for them. But Renoir, Pissarro, Sisley and Monet came to depend financially on sales achieved at the Galerie Durand-Ruel, or on the regular advances that he undertook to pay them during their earlier years. However, the concept of 'enlightened patronage' did not prevent Durand-Ruel fighting with the Impressionists, and he came to believe that the support he had given them in their early years gave him exclusive rights over their work. This was not a view always shared by 'his' artists, who often sold works through other dealers without telling him. Monet and Degas on occasion quarrelled with him over this practice, and in a letter dated July 12, 1888, Pissarro told his son Lucien, 'Durand is annoyed to see Monet do business with Boussod et Valadon, he wanted to hold on to the rights'. Even in his later years, Monet, always mindful of his early struggles, played Durand-Ruel off against the other important dealers.

The artists may well have had in mind the period in the early 1880s when Durand-Ruel's support was largely withdrawn because of his own financial difficulties. In 1882 the failure of the Union Général bank plunged Durand-Ruel into debt, which made it difficult to continue the artists' living allowances or to buy stock for his gallery. By the following year, rumours were circulating in the art world that Durand-Ruel would soon be out of business. However, he managed to keep going and brought off a brilliant coup when during April and May 1886 he organised an exhibition in New York entitled 'Impressionists of Paris'. A second exhibition followed in 1887, which was even more successful than the first, and Durand-Ruel decided to open a gallery in New York. His youngest son, Charles, was put in charge of it, and after Charles's premature death, his brothers, Joseph and George, took over. The gallery was extremely successful at selling Impressionist works in the 1890s.

Paul Durand-Ruel combined the twin roles of canny dealer and devoted collector. His collection may perhaps have filled the vacuum in his life after his wife, who had borne him five children, died in 1871. He never remarried, living quietly in his apartment on the rue La Fayette surrounded by his favourite paintings by Renoir, Monet, Degas, Pissarro and Cassatt — which he consistently refused to sell. Arsène Houssaye described him somewhat ironically as 'a very peculiar dealer, who resisted all the entreaties of buyers to the very end — a very peculiar collector, who only agreed to show his pictures to a very limited number of interested persons, whether or not they were capable of understanding them.' The gems of his personal collection were Renoir's *Luncheon of the boating party* (Phillips Collection) and the same artist's *The theatre box*, which was sold after his death to Samuel Courtauld.

Paul Durand-Ruel brought many new collectors into the Impressionist fold. Early on, he was responsible for converting the opera-singer Jean-Baptiste Faure from Barbizon works to those of the Impressionists, and he also persuaded Ernest Hoschedé to collect works by the then relatively unknown group. He was largely responsible for the collections built by Count Isaac de Camondo, François Depeaux and Charles Ephrussi, as well as those two great benefactors of French museums, Etienne Moreau-Nélaton and Antonin Personnaz. Along with Mary Cassatt, he greatly assisted Louisine and Harry Havemeyer in building up their collection. The year before his death, Paul Durand-Ruel received the Legion of Honour for his services to art.

THÉODORE DURET (1838–1927)

Théodore Duret's father was a wealthy notary who owned Jules Duret et Cie, a successful brandy distillery in the Cognac region. Théodore found that he had a talent for writing, and a handsome allowance enabled him to devote himself to reviewing and collecting *avant-garde* art and to enter the field of politics without any worries about earning an income.

Manet's portrait of Duret (Petit Palais, Paris) shows a debonair bearded man-about-town with a lofty forehead and dark lively eyes. Duret and his friend Emile Zola were part of Manet's group of young artists and writers that met over the marble-topped tables of the Café Guerbois to admire the latest Japanese prints that Duret and Zola had bought, and to argue about issues of contemporary art and literature.

Duret and Manet had met by chance in a hotel in Madrid, where both had gone to study the work of Goya and Veláquez. A close friendship developed between the two wealthy bachelors, and during the Franco-Prussian war Manet entrusted Duret with his favourite canvases when he had to do his military service. Duret had a weakness for the 'shock of the new' in art and literature and gave very public support to Courbet when the artist was prosecuted for helping the mob destroy the Vendôme column during the violent days of the Commune. However, after the reactionary Thiers Government came to power and imprisoned Courbet, Duret thought it wise to leave France. He took a long holiday visiting Europe, the Far East and America in the company of a fellow collector named Henri Cernuschi. While in Japan both collectors bought Japanese prints and Oriental bronzes. In London Duret first saw the work of Pissarro and admired it.

Duret became a fervent apostle of Impressionism. He persuaded other wealthy collectors in his circle, such as Cernuschi, Charles Déodon, Etienne Baudry and Charles Ephrussi, to buy the Impressionists' paintings, and he also used his knowledge of the world of commerce, gained from his father's cognac business, to give the struggling Impressionist artists some good advice on marketing their work. Some of his letters of encouragement to

the Impressionists show an engaging cynicism about the eternal verities of the art market.

In 1873 Duret purchased five paintings from Pissarro, at a time when the artist was having trouble keeping food on his table, and in a letter the following year he wrote: 'People who are good judges of painting and who face the mockery and scorn are few — and rarely ever millionaires. . . . Everything, even fame and fortune will come in the end; and in the meantime, the opinion of connoisseurs and friends compensates you for the oversight of fools.'

In 1878 Duret published a spirited defence of his Impressionist friends under the title *Les Peintres impressionistes*. In this slim volume he explained the aims of the new art movement and defended his friends against criticism, and he included in it biographies of the individual artists. However, soon afterwards Duret's father fell ill, and he had to leave Paris for Cognac to take over the family distillery, though he was still able to make occasional visits to London and Paris on business. By now he was regarded as something of an expert on the new school of painters and wrote introductions to exhibition catalogues for Monet and Renoir. After Manet's death he dedicated a collected edition of his critical articles to his old friend. A clause in Manet's will had requested that Duret organise the exhibition and auction of his paintings.

At the Manet studio sale Duret purchased one of Manet's masterpieces, *Père Thuile's restaurant* (Musée des Beaux Arts, Tournai), but he did not keep it for long. In 1894 the firm in Cognac encountered financial problems due to the failure of the grape harvest, and Duret was forced to sell much of his collection at the Hôtel Drouot in Paris. Monet, always insecure over anything that affected his purse or his reputation, was outraged at the thought that some of his best works might be appearing at a gigantic bargain sale. Duret owned the study of white turkeys Monet had painted for Ernest Hoschedé, a view of Saint-Adresse and *Woman in the grass*, and Monet feared that the auction would affect the prices of his other works on sale in art galleries. 'What a shark Duret is! I hope he will fall flat on his face,' Monet wrote. Degas also predicted that the Duret collection would be a failure in the saleroom and said that he would never shake Duret by the hand again. Both of them were wrong; the works that were sold set record prices.

Once Duret's business picked up again, he turned his artistic eye and his scholarship towards a new area of collecting. He haunted Pére Tanguy's shop and the galleries of Vollard and Boussod et Valadon, where he bought important works by the Post-Impressionists. Once again he persuaded friends that they too should buy works by younger artists like Gauguin, Toulouse-Lautrec and Vincent van Gogh. Duret also acted as a source of introductions between the Impressionists and eminent collectors like the Havemeyers, Sir Hugh Lane and Wilhem Hansen, founder of the Ordrupgaard Museum near Copenhagen. Duret, always a collector of Japanese prints, loved the Japanese influence in van Gogh's works and was responsible for publicising the artist's work in Japan through the Japanese language edition of his book on van Gogh which was published in 1916. He also wrote comprehensive studies of other artists he had admired and befriended, including Cézanne, Courbet, Toulouse-Lautrec, Whistler and Renoir, and his important history of Impressionism of 1878 was republished in 1906 in a greatly enlarged and updated edition.

When, in his late eighties, Duret donated items from his collection to the Petit Palais Museum in Paris, it became evident that his eyesight was now so bad that some of his superb Impressionist and Post-Impressionist works had been replaced by forgeries without his knowledge. Unscrupulous dealers had taken advantage of the aging collector and had also flattered him into buying some of their forgeries.

In 1928, the year after Duret's death, his collection once again passed under the hammer at the Hôtel Drouot. Such was Duret's fame as an author and collector that the paintings were all sold, unchallenged by the trade. However, when a second Duret auction took place three years later there was a scandal over fakes and forgeries, and the Drouot's experts demanded that all 'suspect' signatures be scraped off before the sale. It is unfortunately quite probable that some of these works have been 'resigned' and may well hang in private collections today — a fact which would have enraged the great collector and defender of Impressionism.

Pierre-Auguste Renoir.
Portrait of Eugène Murer, 1877.
Oil on canvas.
Collection of Mr. and Mrs. Walter Annenberg.

EUGÈNE MURER (1846-1906)

Eugène Murer (also known by his step-father's name of Meunier) was an astute, tight-fisted restaurateur, who made a great deal of money out of buying paintings at rock-bottom prices. Over the years Murer bought and exchanged for meals a large collection of works by Pissarro, Monet, Renoir, Sisley, Cézanne, van Gogh and Guillaumin.

Murer's avarice was the result of his illegitimacy and an unhappy childhood; his parents refused to have anything to do with him and left the boy to be brought up by his grandmother. He left school early to become apprenticed to a pastry-cook. His schoolfriend Armand Guillaumin introduced him to the Impressionists, and Murer was glad to buy their paintings, but only if he felt he was getting a bargain.

Murer was approached for work by Renoir and Pissarro when they were extremely short of money and he paid them to paint the walls of his café-pâtisserie. He also advanced cash to Pissarro (after the death of Pissarro's friend and benefactor Piette) and to Renoir, Sisley and Monet during the 1870s when they all had severe financial problems. But these advances were made in return for a specified number of oils to be painted for him. It was a purely commercial deal; and Murer hoped that one day his

impoverished artists would become famous and the prices of their pictures soar in value.

Murer was relentless in his dealings with the artists. He often insisted on receiving larger paintings than they had originally agreed to supply, and he always paid the bare minimum, normally between 50 and 100 francs for a picture. However, on some occasions, Pissarro was desperate enough to accept 20 francs. According to Renoir's friend Georges Rivière, Murer perfected a cunning system whereby he would visit the Impressionists around the time their rent was due, and by this strategem he was able to buy up whole armfuls of their paintings for tiny sums.

By 1887 Murer's collection contained eight Cézannes, twenty-five Pissarros, ten Monets, twenty-eight Sisleys, twenty-two Guillaumins and sixteen Renoirs. Pissarro's portrait of Murer (Museum of Fine Arts, Springfield, Mass., James Philip Gray collection), painted in 1878, shows a shifty-eyed dark-haired man with a bitter mouth: not nearly as flattering as Renoir's portrait, made the previous year, where he looks more spiritual, sensitive and aristocratic. It is hardly surprising that Renoir, the master of the flattering brush, was Murer's favourite artist.

In 1877 Renoir made a delightful portrait of Murer's only son, Paul, entitled *The child in velvet* (Private collection, Baden), but even Renoir could do very little to turn Marie, Murer's half-sister (National Gallery of Art, Washington, Chester Dale Collection) into a beauty. However, it was the homely but charming Marie who helped Murer run his Boulevard Voltaire restaurant after his wife's death, and who eventually used some of the proceeds from the sale of the collection to provide her dowry when she married the struggling poet, Jèrôme Doucet late in life.

In 1881 Murer sold up his restaurant and bought a hotel in Rouen, where he accepted paintings on sale or return and displayed them on the walls of the hotel restaurant. However, there were suspicions amongst the Impressionists that he kept paintings for himself rather than returning them when unsold. During the period when Gauguin was living at Rouen, Murer tried unsuccessfully to promote Gauguin's work by hanging it in his hotel. In a letter to Pissarro dated July 1884, Gauguin described how Murer had made an insultingly low offer for one of his paintings, referring to Murer derisively as 'that joker Murer'.

As he grew wealthier and was able to retire from active participation in the restaurant business, Murer appeared on the surface to have mellowed. He seemed to enjoy the company of creative people, took up writing and painting, and even gave dinners for the Impressionists in his own home. But his basic insecurities were too deep for him ever to overcome them; throughout his life Murer always tended to regard his paintings as commodities rather than companions. By the spring of 1880 Dr. Gachet recorded Murer smugly and insensitively informing Monet 'that with the hundred paintings I own, I'm beginning to feel quite well off in Impressionists', as though his paintings were gold bars or pigs in a pen. However, at the end of his life, Murer fell out with his only son and died lonely and unwanted — but still wealthy.

JULIAN TANGUY (LE PÈRE TANGUY)
(1825–1894)

Father Tanguy had started out as a commercial traveller selling artists' materials around Paris, and through his work he had met Pissarro, Monet and Renoir. Like Pissarro and van Gogh he was a Utopian Socialist, and this formed a strong bond between them. He had been arrested as a communard and narrowly escaped death during the Commune, when he was taken prisoner, but Henri Rouart recognised him and intervened to save Tanguy's life. From 1873 Tanguy owned a dingy art shop in the rue Clauzel where he used to grind colours for artists. He was an enthusiastic supporter of the Impressionists, hanging their paint-

ings on the walls of his shop, but he generally had difficulty in selling them.

Tanguy told young artists that they should lay their paint on thick and eliminate brown undercoats or 'tobacco juice'. He was suspicious of the artistic credentials of anyone asking for a tube of black paint, since like many of the Impressionists he believed shadows should be multi-coloured.

Père Tanguy eventually owned a large collection of Impressionist pictures, including van Gogh's celebrated *Irises*, as well as works by Monet, Sisley, Pissarro, Cézanne and Gauguin. Like Murer, Tanguy exchanged paintings rather than purchasing them, but he gave the artists painting materials rather than meals. One of the finest paintings he acquired in this way was Cézanne's portrait of *Achille L'Emperaire*. Cézanne had so much faith in Father Tanguy that he used to leave the keys of his studio with him when he went south to Aix in summer. If anyone wanted a painting by Cézanne that was not on the walls of Tanguy's shop, Tanguy would take them to the artist's studio, where they could choose for themselves. Prices were fixed: forty francs for a small canvas, one hundred for a large one.

Van Gogh made two copies of his powerful psychological study, *Portrait of Père Tanguy* (Musée Rodin). One was a preliminary oil study (Niarchos collection) and the other, which was bought by Rodin after Tanguy's death, was meant to be the finished portrait. Both show Tanguy wearing a blue reefer jacket and a low-crowned Breton hat, sitting in front of a wall covered in Japanese prints. In the preliminary study, a narrow red line encloses the figure of Tanguy, which gives the work greater éclat, but, for reasons unknown, Vincent decided to leave this out of the finished work. The Japanese prints behind the sitter vary between the two works and were painted from his own collection in his studio, as Tanguy did not himself deal in them. Vincent may have wished to create the feeling of a Dutch seventeenth-century portrait, in which the sitters generally wore their hats, but he also gave Father Tanguy the air of a Buddhist priest, reflecting his idealised view of Japanese society and the spiritual meaning of its art.

Octave Mirbeau, critic and writer, bought van Gogh's *Irises* from Father Tanguy after Vincent's death, but the powerful Mirbeau, at whose acid reviews aspiring artists trembled, did not dare tell his wife he had bought the painting. He made Tanguy pretend that it had been given to him in return for praising the artist in one of his articles.

Tanguy died virtually penniless and his widow was forced to sell some of the Cézannes and van Goghs he had taken instead of money. Both artists were still unknown, and the six Cézannes were bought by a young dealer called Ambroise Vollard, who had just set up a gallery and would eventually become Père Tanguy's successor in his enthusiasm for Cézanne.

DR. GEORGES DE BELLIO (1824–1941)

Georges de Bellio came from a wealthy art-loving Romanian family, who sent him to Paris to study homeopathic medicine. He enjoyed living in the art capital of Europe so much that he never went home. De Bellio was one of the main buyers at the first Impressionist Exhibition, where his purchases included Monet's controversial *Impression, sunrise* (Musée Marmottan).

But de Bellio was more than just a discerning collector of *avant-garde* art. After Monet's first wife, Camille, died, he became a friend and advisor to the painter, who contemplated suicide and poured out his soul in letters to de Bellio talking of 'putting an end to an intolerable existence'. From Vétheuil Monet pleaded that unless de Bellio could advance him money, he and his family would be 'expelled from this lovely little house where I am able to live modestly and work so well'. Once more de Bellio provided money and psychological support.

Dr. de Bellio also attended Renoir in his last illness and befriended him when a favourite model died, helping Renoir through his period of grief. Not surprisingly, the doctor's collection contained works by Renoir, Sisley and Pissarro, as well as by Monet, most of which were bought in the group's lean years — 1874–1880. Eventually de Bellio's art collection was so large that he had to rent an empty shop to house his overflow of art and antiques. Dr. de Bellio bequeathed his art collection to his married daughter, Mme. Dunop de Monchy, who in turn bequeathed much of it to the Musée Marmottan.

JEAN-BAPTISTE FAURE (1830–1914)

Faure was the greatest baritone of his day, a portly bon-viveur and a good friend to the Impressionist artists he collected with such enthusiasm. Some of the large fees Faure received for singing in the opera houses of Europe he invested in paintings that appealed to him by 'contemporary' artists like Manet, Degas, Monet, Pissarro, Sisley and Renoir.

Faure's father died when he was seven, so the singer's childhood was plagued with money worries. The feelings of insecurity that this engendered never left him, and Faure always felt he must put away money for the time when he could no longer fill opera houses with his melodious voice. However, collecting and later selling for a profit his collection of Barbizon works made Faure feel he could repeat his success with the Impressionists. The fact that Faure attempted to make a profit out of his collection by allowing substantial parts of it to be offered at several well-publicised art auctions (including one in 1878 that was a financial disaster) led to his being termed a 'dealer-collector' by

his contemporaries, and he did frequently work in partnership with Durand-Ruel.

But Faure was far more than this. He was an important and generous patron of the Impressionists' work at a period when few collectors believed in them. He gave hospitality to several of the painters; Sisley stayed as Faure's guest for four months in 1874 at a house he owned in England, and he invited Monet as a house-guest in 1884 and 1885 to his beach house at Etretat.

In 1873 Faure acquired his first Manets through Paul Durand-Ruel, who was now starting to promote Impressionist art. At one time or another Faure owned sixty-seven works by Manet, including many of Manet's greatest works. Faure loved showy dramatic paintings, and one of his favourites was Manet's *Masked ball at the Opéra*. Other highlights of Faure's collection of Manets were the unforgettable *Bon bock* and *Gare St. Lazare* with its two enigmatic girls standing in front of a high cast-iron fence.

Faure bought nearly thirty works direct from Sisley; he also dealt directly with Pissarro on occasions, and he owned ten superb works by Degas. For a time Faure was Degas's main buyer, but friendship between these two explosive characters soured rapidly when Degas failed to deliver paintings on time. It ended with Faure's bitter threats of a lawsuit against the artist in 1887, and during the 1890s the singer resold his Degas collection to Paul Durand-Ruel. He also set aside a room in his apartment on the Boulevard Haussmann as a small gallery, which wealthy collectors — especially Americans — were allowed to visit and purchase minor works.

Faure's wife died in 1905, and this seems to have been a factor in his decision to sell much of his collection. Durand-Ruel purchased most of the Manets at prices which gave the singer a good profit, but — possibly for sentimental reasons — Faure hung on to his Sisleys and Pissarros and some minor Manets. The remains of his collection were sold by his daughter in 1919.

Anders Zorn.
Portrait of Jean-Baptiste Faure, 1891.
Oil on canvas.
Reproduced from a private collection, courtesy of Sotheby's London.

EMMANUEL CHABRIER (1841–1894)

Chabrier was a close friend of Mme. Suzanne Manet, who was herself a talented pianist. Chabrier is best-known today as the composer of the suite *España*, but he was one of the most distinguished opera composers of his time and also a talented conductor. He lived in the same apartment block as the Manets and was a regular guest at their musical *soirées*. Manet's portrait of the composer (Fogg Art Museum) reveals him as portly, balding and moustached.

Chabrier, the son of a judge, had an excellent eye for painting. At Manet's studio sale Chabrier invested money his wife had recently inherited and bought, among other works, Manet's great *Bar at the Folies-Bergère* (p. 24), which increased by four times its original value in ten years. Chabrier bought a Monet street scene with flags, and one of his views of the Seine, as well as *Anna*, one of Renoir's most beautiful nudes (later purchased by Russian collector Sergei Shchukin and now in the Pushkin Museum).

CHARLES EPHRUSSI (1849–1905)

Charles Ephrussi, who came from a wealthy Jewish banking family, studied art in his birthplace, Odessa, and in Vienna. In 1871 he came to Paris to work in the family bank. Edmond de Goncourt wrote scathingly that Ephrussi attended six or seven *soirées* every evening in his bid to be appointed Minister of Fine Arts and find a rich wife. However, Ephrussi never became

Minister; instead in 1865 he bought half the prestigious *Gazette des Beaux-Arts* and wrote about art.

Ephrussi was immortalised by his friend Renoir as the only man wearing a frock coat and top hat among the relaxed crowd in *Luncheon of the boating party* (pp.86–7). Aspects of his character also appeared in Swann in Proust's *A la recherche du temps perdu*, as Proust worked for a time as Ephrussi's secretary. Ephrussi's collection included works by Dürer and other Renaissance painters and Japanese prints as well as Monet's *La Grenouillière* (National Gallery, London) and a number of works by Manet and Morisot. Ephrussi greatly respected creativity, and when Manet was fatally ill he overpaid him by a fifth for *The bunch of asparagus* (Wallraf-Richartz Museum, Cologne), aware of Manet's financial problems. Out of gratitude Manet sent Ephrussi another small painting as a gift — an exquisite still life of one single asparagus spear acompanied by a note 'Your bunch was one short.'

MAURICE JOYANT (1864–1930)

A childhood friend of Henri de Toulouse-Lautrec, Maurice Joyant eventually became a companion in Lautrec's Montmartre night adventures. The two would go out in the evenings, tour the dance halls and brothels and return early in the morning.

In 1891, after the death of Theo van Gogh, Joyant was appointed manager at the art dealers Boussod et Valadon. The following year he arranged an important exhibition of the works of Berthe Morisot, but he became frustrated at not being allowed to buy Impressionist works for the gallery and decided to join Michel Manzi, a friend of Degas, in a dealing partnership. Joyant had enough money to be able to buy what he pleased, and Toulouse-Lautrec also gave him many of his best paintings. After the artist's death, Joyant produced a catalogue of Lautrec's work, which is still in use today for the authentication of Lautrec's works.

When considering Joyant's contribution to art, it is important to remember that Lautrec's work met with scant success during his lifetime. At the time of his death *Courier Français* wrote, 'it is fortunate for humanity that there are few artists of this sort. Lautrec's . . . was an evil talent, exercising a pernicious and depressing influence.' It was Joyant who persuaded the Comtesse de Toulouse-Lautrec to donate the artist's own copies of his lithographs and posters (which had remained in his studio) to the Bibliothèque Nationale in Paris, when she was so shocked by some of her son's subject-matter that she had contemplated burning them. The Library was bound by the terms of its establishment to accept all donations of printed matter, and today, thanks to Joyant's perseverance and vision, the Bibliothèque National owns a collection of 371 Lautrec posters and lithographs in various states, including 192 lithographs personally donated by Joyant from his own collection. These were originally donated by the collector to the Musée du Luxembourg and eventually passed to the Library. It was also thanks to Joyant that the Comtesse de Toulouse-Lautrec agreed to exhibit many of the artist's paintings in a special Toulouse-Lautrec Museum housed in the Palace de la Berbie, near the artist's birthplace, at Albi. The Toulouse-Lautrec Museum was officially opened on 30 July 1922.

AMBROISE VOLLARD (1865–1939)

Like Pissarro, Vollard was born in the French colonies. He was sent to Paris to study law, but instead he became an assistant in a private art gallery. Within a short time he opened his own small gallery in the rue Laffite, and began buying the works of the Impressionists.

Vollard described in his memoirs how after Manet's death he visited the artist's widow in his attempt to obtain a selection of her husband's drawings, which he eventually exhibited at his gallery. When Vollard asked Suzanne Manet if he could buy a portrait by Monet showing Manet painting in his garden, Mme. Manet refused saying she was afraid Monet might see the painting in Vollard's window and be offended. Vollard was amused to learn that she had sold this portrait to a German dealer and commented wryly, since he knew the German dealers well, that she had no idea how fast paintings would travel back to France from Germany if there was a suitable cash buyer involved.

In April 1888, when Renoir exhibited in the Salon his celebrated portrait of the three daughters of Catulle-Mendès grouped around the piano, Vollard also started to buy Renoir's work. Then, acting on Pissarro's recommendation, he began to buy works by Cézanne, acquiring nearly one hundred canvases. In 1895 Vollard organised a one-man show of fifty works by Cézanne, but the public protested and Vollard had to withdraw some from his window. Nevertheless, the exhibition had good results: Auguste Pellerin, the margarine tycoon, and Count Isaac de Camondo purchased many of Cézanne's best works, so that overnight Vollard acquired a reputation as a canny dealer and connoisseur of art. Even though this was not the case, he had enough native cunning to listen to the judgements of other artists and then back them with his own money.

In 1896, possibly acting on the advice of Degas, Vollard wrote to Gauguin in Tahiti and negotiated a contract with him, whereby Vollard would have the right to Gauguin's complete output in return for a monthly stipend. Vollard was convinced that Gauguin's works were so good that they must eventually sell, even though most art critics sneered at Gauguin's bright

Pierre-Auguste Renoir.
Ambroise Vollard.
Oil.
Courtauld Collection, Courtauld Institute Galleries, London.

colours and faux-primitif style. Vollard's enthusiasm and professionalism, like that of Paul Durand-Ruel, played an important part in forming a taste for *avant-garde* art among collectors and breaking the power of the Salon. Along with his rivals, Boussod et Valadon, Knoedler, Georges Petit, and eventually his neighbours Bernheim-Jeune, Vollard's many successful one-man shows did much to increase the Impressionists' and Neo-Impressionists' reputations.

Vollard's portrait was painted once by Cézanne and at least three times by Renoir, to whom he was undoubtedly closer than other artists in his stable. One of the Renoirs, dated 1908, shows the dealer admiring a statue by Maillol (Courtauld Institute of Art), while in another he wears a torero's suit he had bought in Spain. Cézanne's portrait is quite different; while Renoir's Vollard is a smiling, hedonistic, bon-viveur, Cézanne refused to allow Vollard to talk while he painted him, and he showed his sitter as gaunt and impressive, much closer to the description given by Gertrude Stein, who called Vollard 'a great tall black man with a melancholy expression.'

Vollard was an eccentric dealer, who found that his eccentricity and a knowledge of sales psychology paid off handsomely. He never employed staff and would give clients the impression that they were lucky to be shown anything at all, as he really did not want to part with his paintings. He would extract four or five pictures from a well-stocked cupboard, since very little was framed up and there was often nothing in the window, and then would sound reluctant to sell anything. If the clients decided that they wanted to go away and think about a painting, Vollard would never pressure them but, when they returned, that painting was no longer for sale. The result of Vollard's clever tactics was that wealthy customers, like Camondo, would stuff their pockets with money so that they could pay immediately and walk out with their painting rather than risk disappointment. He was also frequently rude to his clients, who would then go away and pay even more for a work at the luxurious Galerie Bernheim-Jeune next door. What they did not know was that the work they had just bought was often owned jointly by Bernheim-Jeune and Vollard.

Vollard even proved a match for the unscrupulous American pharmacist Dr. Albert Barnes, who constantly bargained over prices. Vollard would at first have nothing to do with him, and when Barnes wanted a particular Cézanne for his collection, he was forced to deal with Vollard through Durand-Ruel. However, Barnes eventually realised that if he wanted to buy the best Cézannes for his collection, he would have to go through Vollard. Eventually the two men buried the hatchet, and in 1936 Vollard crossed the Atlantic for the first and last time, invited by Dr. Albert Barnes. A radio programme was arranged to celebrate Vollard's visit and Barnes praised Vollard's sponsorship of Gauguin, Renoir, Picasso and le douanier Rousseau. Three years later Vollard was dead, killed in a car accident.

COUNT ISAAC DE CAMONDO (1851–1911)

The Count was the first of the long line of publicity-hunting collectors in the twentieth century. In 1900 he created a newspaper sensation when he bid the then-fabulous sum of 43,000 francs for one of Sisley's magnificent paintings entitled *Floods at Port Marly*. The bid that electrified the saleroom did wonders for the Count's social and sexual life *and* for Sisley's prices. (Ironically Sisley had died only the previous year in such poverty that he had had to borrow money to pay his doctor's fees.) At the sale of Victor Chocquet's collection in 1908 the Count, urged on by Monet, once more paid a record and widely-reported auction price for a Cézanne. However, Camondo was nobody's fool. He had an excellent eye and what he had just bought was Cézanne's first masterpiece, the *House of the hanged man*.

However, this record bid was Camondo's swan song on the auction scene. He died three years later, bequeathing his enormous art collection to the Louvre. Today, hanging on the walls of the Musée d'Orsay, bearing the label 'Camondo Bequest' are major works by Degas, Renoir, Cézanne, Pissarro, Sisley, van Gogh and the Count's fellow nobleman, Count Henri de Toulouse-Lautrec. The Camondo Collection included fourteen major Monets and ten superb Manets, including one of the best-loved icons of Impressionism — a small boy in military costume known the world over as *The fifer*.

PRINCE LOUIS ALEXANDRE DE WAGRAM (1883–1917)

Described by Marcel Proust in *Le Côté de Guermantes* as 'a young prince who liked Impressionist paintings and motoring', the impulsive Prince de Wagram collected cars and paintings so devotedly that he nearly bankrupted himself. He had inherited a fortune from his mother, who was a Rothschild, and his trustees ensured that the young Prince received an annual income rather than the capital. Nevertheless, in the three years between 1905 and 1908 the young Prince went on a gigantic spending spree, buying forty-seven van Goghs, fifty Renoirs, forty Monets, twenty-eight Cézannes, eleven Degas and twelve Manets. An officer cadet at the Saint-Cyr Military Academy, the Prince was now stationed near Metz, some distance from Paris, so in his orgy of buying he employed the services of an 'art advisor', the gallery director, Adrien Hébrard, whose foundry was responsible for casting in bronze the works of Degas and Rembrandt Bugatti. Hébrard, who also owned the newspaper *Le Temps*, lived way above his means and was renowned for his greed, but he impressed Wagram by telling him that he regularly purchased artworks on behalf of museums, though he doubtless did not tell him that he was on a handsome rate of commission from other art dealers for all the Prince's purchases. Hébrard drew up a purchasing plan for his new client, advising him to buy some of Gauguin's works, because in ten years time they would have appreciated enormously. He then went to Vollard and bought the Prince not one but two dozen Gauguins, including the great *Nave, nave, moe (Sacred spring)*, also known as *Sweet dreams* (now in the Hermitage).

In 1905, introduced to Durand-Ruel by Hébrard, the Prince bought some of Renoir's finest early works, including a view of *La Grenouillière*. The same year he bought some of the collection formed by Dr. de Bellio, now owned by his daughter Mme. Dunop de Monchy. Only the choicest items ever hung on the silk taffeta covered walls in the Prince's town house in the Avenue de l'Alma or in his apartment on the Quai d'Orsay. Like today's Japanese collectors, the Prince kept many of his paintings in store.

Naturally, Hébrard was delighted with the Prince's buying habits and urged him on, flattering the impressionable youth by telling him that he had 'sure and personal taste'. He even made the Prince a partner in his bronze foundry. But at the same time the Prince fell under the spell of Jos Hessel, a partner in Bernheim-Jeune (a firm of dealers forever immortalised by Vuillard in a satirical series of paintings, where they add up their account books and wait for clients like spiders awaiting a fly). For three months, from January to May 1907, the Prince became a sleeping partner in a company owned by Hessel, a short-lived partnership dissolved by an expensive law suit.

In a very short time the Prince's extravagance, and his addiction to gambling, meant that he had to sell off most of his collection. Among the works he sold — in the same chaotic fashion in which he had bought them — between 1909 and the outbreak of World War I, was the smaller of the two versions of Renoir's *Ball at the Moulin de la Galette*, once owned by Victor

Chocquet, which in 1990 was sold for $80 million to Ryoei Saito at Christie's, New York.

The Prince de Wagram died at the age of thirty-four, serving in the trenches during World War I.

AUGUSTE PELLERIN (1852–1929)

Pellerin had made millions out of his factories which manufactured margarine in France, Sweden and Norway, and this allowed him to indulge a passion for Impressionist paintings. According to Sylvie Gache-Patin of the Musée d'Orsay, at one time Pellerin owned over 150 works by Cézanne, including early canvases like *The dream of the poet*, *Pastoral*, *Woman with mirror*, *The temptation of St. Anthony*, *The apotheosis of Delacroix* and *Bathsheba*, a portrait of the artist's wife, and four different versions of bathers, all painted between 1875 and 1895.

When Berthe Morisot's daughter, Julie Manet, visited Pellerin's home in Paris, she described him in her diary as 'this man who knows nothing of painting and yet seems to worship my uncle Edouard's work.' Pellerin had just bought *A bar at the Folies-Bergère* (p.24) from Emmanuel Chabrier's sale. Julie Manet's sharp eyes noted that Pellerin owned three works by her mother (Berthe Morisot), a study of a mother and child by Renoir, a Sisley and several Monet landscapes. She also described how a quick Manet oil sketch of a nude had been 'improved' by the Galerie Bernheim-Jeune with the addition of a background behind the nude figure, so that they could charge Pellerin more money. Having noticed that the gallery had taken the painting to Manet's widow Suzanne to authenticate it, Julie asked her aunt about authenticating and signing an 'improved' work and was informed that Suzanne's brother, Ferdinand Leenhoff, had 'repainted several of my uncle's canvases'.

On his death, Pellerin bequeathed to the Louvre three of Cézanne's finest still lifes; the rest of his collection was divided between his son and daughter, and more works from Pellerin's collection have subsequently been donated French public museums.

MAURICE GAGNAT (1856–1924)

Maurice Gagnat was a business associate of Alfred Natanson, founder of the *avant-garde* art magazine *La Revue blanche*. Gagnat retired early in life and in 1905, when he was fifty-one, took up art collecting with great enthusiasm. He bought paintings by Vuillard, Renoir and Cézanne and became a close friend of Renoir, frequently staying as a guest at the artist's home at Cagnes-sur-Mer.

Renoir believed Gagnat had a good eye and, doubtless flattered by the painter's good opinion of him, Gagnat eventually bought more than 150 paintings direct from Renoir, although some were small, late works. He also commissioned some family portraits from Renoir. After Gagnat's death, one of Renoir's finest paintings, *Gabrielle with roses* (1911), a companion work to *Gabrielle with jewellery* (p.89), was donated by Gagnat's son to the French nation in memory of his father. It is now one of the most popular works in the Musée d'Orsay. The rest of Maurice Gagnat's Renoir collection was sold in 1925.

'PRINCE' MATSUKATA MASAYOSHI (1835–1924)

Intriguing photographs taken at Giverny show the bespectacled Prince Matsukata accompanied by Monet on a tour of the artist's famous waterlily pond and admiring the paintings in Monet's studio.

Matsukata Masayoshi was the first large-scale collector in Japan of Impressionist works. He came from an unlikely background and was the ninth child of an ambitious but uneducated farmer, who ensured that Matsukata received the patronage of the local samurai and had a good education. After school the ambitious young man entered the Royal household, where his remarkable grasp of finance ensured that he rapidly rose to be Chief Steward. Matsukata's first contact with Western ideas came when he went to Nagasaki to study Western science and mathematics, intending to take up a high position in the Navy. However, in 1868 he was appointed Governor of Hita Prefecture, charged with collecting funds from rich merchants on behalf of the Government, and a job as Minister of Finance followed. His brilliant financial brain ensured that between 1878 and 1885 Matsukata succeeded in reversing Japan's inflation, restoring the value of paper money and creating a unified convertible currency system. In 1878 'Prince' Matsukata made his first trip to Europe as the official Japanese represenative at the Paris International Exposition.

Doubtless in George Petit's or Durand-Ruel's galleries (like so many of the great American collectors), Matsukata saw his first Monets and started his career as an art collector. As he was now immensely wealthy through shrewd speculations in land and property, it seems likely that Matsukata collected Western art not with any thought of financial gain but purely because he was fascinated by aspects of Western culture. He invited many foreigners to his Tokyo home to see his art collection at a period when this was very unusual, and he was also a great reader, in translation, of Western books and newspapers.

Matsukata was appointed a 'Genro' or Elder Statesman by the Emperor, but on retirement from the post of Lord Keeper of the Privy Seal he was given the highest rank — equivalent to that of Prince — a courtesy title accorded to him on his travels in the West. His wife Masako, who accompanied him on occasions, had raised nineteen children, nine of them the offspring of concubines. 'Prince' Matsukata died in July 1924 at the age of eighty-nine, after being injured in the great Tokyo Earthquake of September 1, 1923, and some of his Renoirs and Monets are now in Japanese art museums.

HENRY O. AND LOUISINE HAVEMEYER (1847–1907) and (1885–1929)

Harry Havemeyer became famous for the sugar that his company manufactured, while his wife Louisine became equally famous for her passion for collecting Impressionist art.

Before her marriage, the adventurous Louisine Waldron Elder had been a friend of Philadelphia-born artist Mary Cassatt, and it was on Cassatt's advice that Louisine started collecting works by Degas. At first Harry Havemeyer preferred Old Masters and Oriental artworks, but as the Havemeyers filled their new mansion with art — and as other American collectors gradually 'discovered' Impressionism — Harry too allowed his artistic taste to be guided by Mary Cassatt. The Havemeyers bought many of the best Manets, including some of those owned previously by Jean-Baptiste Faure, and they also bought paintings with the paint still wet on them from Degas's studio.

The spur to collecting may well have been that the Havemeyers were ostracised from New York 'polite' society for

many years because Louisine Elder married her aunt's ex-husband while her aunt was still alive. Harry Havemeyer (whose drinking problem had soured his first marriage) promised his young strong-minded second bride he would never drink again. So the pair harnessed the energy that most turn-of-the-century millionaires invested in the 'social' round of charity balls and enormous dinner parties into attending art auctions and haunting Durand-Ruel's gallery both in New York and on their annual visits to Paris. They did not follow Cassatt's advice slavishly; they bought for the best of reasons, because each work 'said' something special to them. They also bought only when they *both* agreed the work in question should enter their collection and that the price was not too high.

In 1910 Louisine received a letter from the Sicilian gang 'The Black Hand' demanding a vast ransom, or else the gang would blow up the Havemeyer's New York mansion and its valuable artworks. The Havemeyers paid up but informed the police, and when the blackmailers arrived to collect their ransom the police discovered the 'dangerous gang' were only a couple of frightened adolescent boys.

Unfortunately no catalogue of the Havemeyer's vast Impressionist collection was ever made. Some paintings were always on loan to America's public art museums, others were moved between the Havemeyer's Fifth Avenue mansions designed by Louis Comfort Tiffany and their holiday home. Today the walls of the Metropolitan Museum (which received a bequest of nearly 2,000 items of art and Oriental textiles), the National Gallery in Washington, the Los Angeles Museum of Art and many other major public galleries are hung with some of the greatest works by Degas, Manet, Cézanne and Monet, as well as paintings by El Greco and Goya, that were once tracked down and bought by the art-loving Havemeyers.

Mrs. Potter Palmer displayed her great frieze of Monet masterpieces.

For the paintings to decorate Palmer Castle the Palmers took the advice of Chicago 'art advisor' Sarah Hallowell and of Mary Cassatt, who over tea and scones at her Paris home sang the praises of Degas and Monet. Bertha bought her first Impressionist paintings in 1889, when President McKinley appointed her the only woman commissioner for the United States to the Paris Exposition that year, but Durand-Ruel's invoices show that her great buying spree took place between 1891 and 1892. She bought Renoir's lyrical masterpiece *Luncheon by the river*, which shows Caillebotte sitting under an ivy pergola at Chatou, and *Two little circus girls*. Today, they are two of the most popular paintings in the Art Institute of Chicago. She also bought one of Monet's finest views of *Argenteuil-sur-Seine* and three of Pissarro's best works. In 1891, at Cassatt's urging, Bertha Honoré visited Monet at Giverny and bought the first of many Monets direct from the artist.

Chicagoans were impressed by the Potter Palmer private art gallery, and under Bertha Honoré's influence many more newly rich millionaires went on pilgrimages to Paris to adopt exquisite little Renoir girls to hang on their own walls.

Potter Palmer died in 1902, and without him beside her at Palmer Castle, Bertha Honoré's interest in art collecting waned. As a wealthy and still beautiful widow she spent much of each year in Paris and London, played golf with Edward VII, gave lavish parties at which Pavlova danced and Nellie Melba sang. She was rumoured to be considering marriage with candidates drawn from the British aristocracy but never remarried. Bertha died on an estate in Florida which she was developing with fruit orchards. Shunning the idea of an 'ego museum', she bequeathed the bulk of her paintings to the Art Institute of Chicago.

BERTHA HONORÉ POTTER PALMER
(c.1850–1918)

Guests of honour at the World's Columbian Exposition in Chicago in 1893 were received by Mrs. Potter Palmer in her battlemented castle on the windy shores of Lake Michigan. Bertha Honoré, now in her early forties, had been born in Kentucky to a family of illustrious French ancestry, and all her life she dressed in French haute couture and considered that all taste and refinement originated from France. She was also a keen campaigner for women's right to work on an equal footing with men. Through her chairmanship of the Women's Building at the Chicago Exposition she made a lasting contribution to the welfare of women, and she commissioned her friend Mary Cassatt to design a large mural for the Building.

Chicago was then expanding from a prairie town into an industrial and manufacturing centre, and there was a keen rivalry with New York. In order to upstage the snobbish 'Mayflower' New York millionaires who affected to despise the Mid-West, the Chicagoans bought their culture direct from Paris, where the French, unaware of any difference, lumped them all together as 'les riches Americains'.

Through her marriage to Potter Palmer, one of the richest and most influential men in Chicago, and thanks to her own social graces, Bertha Honoré became the undisputed queen of Chicago society and President of many of the city's numerous women's luncheon clubs. Palmer, a former grocer's clerk turned property developer and hotel owner, gave Bertha a jewel collection second only to that owned by the Queen of Italy, and under his wife's influence he added an art gallery to the marble and granite halls of Palmer Castle. A Chicago newspaper described this as a 'Norman Gothic castle' but in its stylistic confusion it boasted a white-and-gold Louis XVI drawing room and a red velvet ballroom with iridescent chandeliers of Tiffany glass, around which

Bertha Honoré Potter Palmer. Samuel Courtauld.

SAMUEL COURTAULD (1876–1947)

Samuel Courtauld's ancestors were hardworking, frugal Huguenot silversmiths, who had fled from France to avoid religious persecution. Later they became prosperous British silk merchants, and Samuel, instead of going on to Oxford or Cambridge like the majority of his peer group, was sent to Germany and France to study weaving in preparation for entering the family business. In 1901 he married Elizabeth Kelsey, who was to share his deep interest in art collecting. He gradually worked his way up to

become Chairman of Courtaulds in 1921, a position he held until his retirement in June 1946.

Samuel Courtauld built his collection at a time when conventional English taste for French art leaned heavily towards the muted tonalities of the Barbizon School, while works by the Impressionists were regarded as too gaudy to decorate British stately homes. But after the death of Sir Hugh Lane, it was Courtauld who took over Lane's crusade to make their paintings more widely known across the Channel and, encouraged by his wife, he set out at the age of forty-six to acquire the very best collection of French Impressionists in Britain. Over the next ten years, aided by advice from dealer Percy Moore Turner and art expert Roger Fry, he acquired highly important Impressionist and Post-Impressionist works, many internationally recognised as key works in the careers of the artists who painted them.

Courtauld was a strong-minded collector and would often reject paintings on the dealers' walls and browse through their stockrooms to make his choice. Although open to advice, once he had made up his mind about a picture he did not care what the 'experts' said about it. Like Emil Bührle, he always preferred to take a proposed purchase home with him and keep it there for several weeks to see if he could live with it.

His first purchases were modest enough for the times — a Toulouse-Lautrec drawing, a late Renoir oil and a Degas. In the works of Manet and Monet he discovered something of the 'wonderful mastery allied with strong emotion' that he had already found in the Old Masters. Gradually he progressed to the works of Gauguin, Cézanne, van Gogh and Seurat. Renoir's famous *The theatre box*, beloved of greetings card manufacturers the world over, was acquired in 1925, while other icons of Impressionism in his collection included Cézanne's sombre *Card players*; Gauguin's brooding *Nevermore* and van Gogh's moving *Self-portrait with bandaged ear*.

He did not hesitate to spend what were large sums for the period, purchasing Manet's last masterpiece, *A bar at the Folies-Bergère* from the Auguste Pellerin Collection for a record price. Within twenty years Samuel Courtauld's own collection was unique in British art circles, and he was responsible for changing British concepts of what constituted 'good taste' in art. He also made a generous donation (known today as The Courtauld Fund) to the Tate Gallery, to enable it to acquire major nineteenth-century French works.

The Courtaulds had no children and when his wife died Samuel Courtauld offered the remaining fifty years lease on his Georgian house in Portman Square to the University of London 'to endow an institution for the promotion of education in art'. After Courtauld's death his collection was divided between the Tate, the National Gallery and his own Courtauld Institute of Art, which moved from Portman Square to Somerset House in 1990.

Inspired by the beauty of his favourite paintings, Courtauld described them in an anthology of curiously bad verse. However, in a footnote to one of his poems he conveyed superbly the attraction Renoir's works held for him, writing, 'No other Impressionist . . . has rendered the subtle charm of surfaces, the colour of atmosphere or the beauties of texture with so sensitive and rich a brush.'

GWENDOLYN ELIZABETH (1882–1951) AND MARGARET SIDNEY (1884–1963) DAVIES

After their father's death in 1898, the Davies sisters and their brother David (later Baron Davies) inherited a considerable fortune from their grandfather, a self-made man whose wealth was based on coal mining and railway construction.

Gwendolyn and Margaret, neither of whom married, led busy and active lives dedicated to the promotion of the arts and to the development of the first medical school in Wales. Margaret had

briefly attended the Slade School in London, and they had been exposed to great art when they travelled widely in France with their stepmother and her companion Miss Jane Blaker. In 1908, the sisters jointly began to form a collection of Barbizon School pictures, advised at first by Hugh Blaker, the brother of Jane. By 1912 they were buying Impressionist works by Monet, whose Venetian scenes they had seen in an exhibition in Paris at the Bernheim-Jeune gallery. They were now advised on their purchases by David Croal-Thomson, who worked for the English branch of Paul Durand-Ruel, and they made their purchases through dealers or at auctions in London and Paris. Their collection eventually included three Manets, three Renoirs, a van Gogh, two paintings and six drawings by Pissarro, nine Monets, five Cézannes, a Morisot and a Sisley and two Degas bronzes, mainly purchased in London and Paris on Croal-Thomson's advice.

During World War I Gwendolyn organised a Red Cross centre at Troyes in Northern France, where Margaret also worked. It was during the war that Gwendolyn purchased the outstanding work in the collection, Renoir's *The Parisienne*, and their three Cézanne oils. After the war, the sisters purchased Gregynog Hall in Montgomeryshire, only ten miles away from their birthplace, which they converted into a centre for the arts in Wales, where their art collection could be displayed to fine advantage. From the 1920s onwards, the sisters spent most of their annual income converting and modernising Gregynog Hall, equipping it with a printing press, artists' studios and music rooms. Under the direction of R.A. Maynard, The Gregynog Press became famous for its beautiful limited edition books.

The Depression of the 1930s forced the two sisters to stop buying art for several decades. On Gwendolyn's death her paintings, including Renoir's *The Parisienne*, were bequeathed to the National Museum of Wales in Cardiff, but Margaret now sold some of her major paintings and resumed collecting in a small way until her death, buying relatively minor works by Bonnard, Marquet, Sisley and Utrillo.

Throughout their long and fruitful lives both sisters were generous patrons of the University, the National Library of Wales and the National Museum of Wales. Ultimately they bequeathed Gregynog Hall to the University of Wales and Margaret's collection joined Gwendolyn's at the National Museum of Wales.

SERGEI IVANOVICH SHCHUKIN (1851–1936)

Sergei Shchukin was a shrewd and extremely wealthy businessman, buying textiles for his family's firm in Europe and selling them expensively in Russia. He began collecting art around 1890 and applied the same energy and determination that he had given to buying textiles — on the grand scale. Competitive by nature, he sought to excel in a sphere that could be all his own, but in collecting Russian art his way was blocked by the Tretyakov family, who created Moscow's Tretyakov Gallery. Shchukin's work frequently took him to Paris, and he decided to make his name in Moscow by collecting contemporary French art. Unlike the Morosov brothers, Shchukin actively disliked taking advice: inevitably he made mistakes in his early years of collecting, but he was a quick learner and had an excellent eye.

He started his collection of French art with Monet, buying the great *Luncheon on the grass*, then around 1903 (at a time when very few other collectors were interested) he moved on to Gauguin, and by 1910 he had the best collection of the artist's work in the world. He bought two major van Goghs, *Women of Arles, Reminiscences of the garden at Etten* and *Lilac bush*, both now in the Hermitage. After acquiring a superb collection of Degas pastels, he began buying Cézannes, including a particularly fine *Mont Sainte Victoire* (Pushkin Museum) (p.94). Later he

developed an interest in Matisse, Derain and Picasso.

Shchukin's taste was always for colour and strong dramatic compositions. He gradually acquired a deep sense of mission as a collector, dreaming of a gallery that would be open to the Russian public, housing the most influential and daring European art of his time. With this aim, after his father's death, Sergei took over the family company and bought himself the splendid Trubetskoy Palace in Moscow. Here his Gauguin masterpieces hung in serried rows around the dining room, interspersed with colourful works by Matisse. The gallery was opened to the public every Sunday, and he himself occasionally acted as gallery guide.

Shchukin's collection was taken from him by the Bolsheviks. With his fortune also gone, he left Moscow to live in Paris, and today his paintings are divided between the Pushkin and the Hermitage museums.

SIR HUGH LANE (1875–1915)

Sir Hugh Lane started working for a picture dealer and in 1898 decided to set up as an art dealer himself. By 1905 he was recognised as the leading authority on Impressionist art in Britain and he had started to buy paintings by the Barbizon School and the Impressionists for his own collection. Included among his earliest major purchases were Manet's *Music in the Tuileries Gardens* and *Portrait of Eva Gonzalès*; and Renoir's masterpiece in two different styles, *The umbrellas*, now one of the glories of London's National Gallery. He continued collecting with great enthusiasm until his tragically early death in the wreck of the *Lusitania* in 1915. It was his intention eventually to donate his collection to an art museum or public gallery in Dublin, as soon as suitable premises were found or built. In the meantime, he offered his entire collection of thirty-nine important works as a loan to London's National Gallery. However, his death intervened, and the complex terms of Lane's will meant that his paintings were stored in the National Gallery's cellars for two years before being finally hung in 1917, when they became the first Impressionist and Post-Impressionist works to go on view there.

Possession of Lane's great paintings inspired a bitter lawsuit between the National Galleries of London and Ireland, which continued for nearly half a century. The whole affair has given birth to the phrase 'a Hugh Lane clause' for a bequest by a collector involving sharing paintings between two galleries.

MIKHAIL MOROSOV (1870–1903) AND IVAN MOROSOV (1871–1921)

The Morosovs were one of pre-Revolutionary Russia's most commercially successful dynasties. Ivan and his elder brother Mikhail lost their father as children and were raised by their mother in a moneyed and cultured home, where art and creativity were greatly admired. Both brothers studied painting with a leading Russian Impressionist artist, and Ivan continued painting landscapes for most of his life. They travelled frequently to Paris on business for their family's textile empire, and there they would buy paintings from Durand-Ruel's gallery, although they were prudent in their choice and took advice from a number of different sources. On occasions they purchased through agents and had paintings shipped to them in Russia, and later Ambroise Vollard's stockroom would become an important source of paintings for Ivan.

The brothers were totally different in character. Mikhail had a wild gambling streak that once lost him over a million gold

roubles. His liking for dramatic works, especially those that featured women, led him to buy Renoir's glowing *Portrait of Jeanne Samary*, considered one of the artist's great works (Hermitage Museum).

Ivan Morosov had more restrained and delicate tastes. His first purchase was a sparkling Sisley landscape, and eventually he owned eighteen of Cézanne's major works. In 1907 he bought *Under the trees*, *Moulin de la Galette* (Pushkin Museum), which had initially been in the collection of Eugène Murer, through Durand-Ruel; he also purchased Renoir's enchanting *Child with a crop* and *Girl with a fan* (both Hermitage Museum). Ivan Morosov was the first Russian to appreciate the delicate dreamy nudes of Pierre Bonnard, and he also brought back from Paris important works by Manet, Monet, Degas, Gauguin and Toulouse-Lautrec.

At the Revolution, his great collection was 'nationalised', and he had to flee for his life from the Bolsheviks. His paintings are now split between Moscow's Pushkin Museum and St. Petersburg's Hermitage Museum.

HELENE EMMA JULIANA KRÖLLER-MÜLLER (1869–1939)

Helene Müller's father, W. H. Müller, headed a highly profitable Düsseldorf shipping enterprise, which also had mining interests, and she married Anton Kröller, the manager of the firm's Rotterdam office. On her father's death, a year after the marriage, her husband took over the management of the family company.

Helene Kröller-Müller first had the idea of forming her own art collection in 1907 when she was in her late thirties and enrolled in an art appreciation course with Hendricus Petrus Bremmer (1871–1956). Two years later, with Bremmer's encouragement, she made her first major auction purchase — three masterpieces by van Gogh — a version of *Sunflowers* (originally painted to decorate Gauguin's room in the Yellow House at Arles), *The sower* and *Still-life with bottle and lemon*.

At that time most private collectors bought from dealers, but with Professor Bremmer at her side the German shipping heiress, energetic and determined in everything that she undertook, was able to build a magnificent collection of nineteenth- and early twentieth-century European art. During the following decades she tracked down and purchased the quite amazing number of 278 van Goghs. Helene Kröller-Müller and the professor paid regular visits to art galleries and salerooms in Paris, where Bremmer advised her to buy important paintings, and at auctions she would always bid herself. She quickly gained a reputation as a millionairess who pursued her quarry to the end, and this ensured that very few dealers or private buyers dared to bid against her. On one occasion some art dealers formed a 'ring' against her and tried to run her up to an unrealistic price on a painting. She bid against them but then, at the last minute, pulled out, leaving her rivals to pay a price at which they could never re-sell the painting to a client. When they offered it to her, she refused to buy it. This was the last occasion on which any dealer tried to outbid her at auction, and she and her husband were able to pay realistic prices for such great works by van Gogh as *Potato eaters*; a haunting study of a peach tree in blossom; his great *The café terrace at night*; a version of Mme. Roulin known as *Woman rocking a cradle* (p.107); the iconic *Road with cypress and star*; as well as a Rodin statue of Camille Claudel.

Bremmer gives his verdict, a watercolour by Cornelius Veth (Kröller-Müller Museum, Otterlo) shows Mrs. Kröller-Müller on one of her rare visits to an art dealer. She sits ramrod stiff in a high-backed chair, lorgnette in hand, eyeing one of van Gogh's cornfield paintings held by an assistant awaiting Professor Bremmer's approval. Bremmer, pipe in mouth and hands thrust deep in the pockets of his rumpled tweed jacket, appraises the

painting. The uniformed chauffeur waits attentively — ready to carry the van Gogh out to his owner's waiting limousine, but *only* if Bremmer approves.

In 1925 Helene Kröller-Müller published a collection of essays entitled 'Observations concerning the Development of Modern Painting', in which she categorised what she regarded as the two main trends in 'modern' art, namely the 'realistic' and the 'idealistic' approach, illustrating her theories with examples drawn from paintings in her own collection. She always saw van Gogh as 'the ultimate artist' and placed his works way above her own somewhat rigid classification of realism and idealism.

Her husband gradually became more and more interested in the collection and supported her efforts to obtain major works, which were always bought with funds from the family company. The Kröller-Müller collection had started off in their home in The Hague, where it could be seen on Mondays and Fridays by those members of the public who applied directly in writing to her. But by the early 1920s the collection was now so valuable and well-known that for protection it was moved to a hunting lodge, 'St. Hubertus', on their magnificent estate called the 'Hoge Veluwe' near Otterlo.

In the late 1920s shipping and mining were caught in the general down-turn in the economy, and the Kröller-Müller family company turned in a large loss. In order to protect the Hoge Veluwe estate from being split up into building blocks and the art collection from being sold if the company failed, it was decided in 1928 to set up the Kröller-Müller Foundation, which would own both the land and the paintings. However, since the Foundation still depended on company funds for the maintenance of the vast Hoge Veluwe estate, the land was offered for sale to the Government to be used as a National Park, on condition that they would fund the construction of a museum according to the plans previously prepared by architect Henry van de Velde.

In 1935, after protracted negotiations, the Hoge Veluwe was sold to the Government for 800,000 guilders and the entire art collection was donated to the nation, although no firm commitment was given to build the museum. However, in the end a more modest version of van de Velde's original design was constructed as an employment project during the Depression, with some financial assistance from the family company. In 1938 the building was completed and, although she was now unwell, Mrs. Kröller-Müller personally supervised the hanging of her collection on its walls. At the opening of the museum, on July 13, 1938, Mrs. Kröller-Müller was too ill to attend. She died at Otterlo on December 14, 1939 and was buried on what had once been her land, near her beloved paintings. She left instructions for her tombstone to be engraved with her credo 'I believe in the perfection of all creativity'. Before she died she had been told of the enormous number of the public who visited the Hoge Veluwe National Park and admired her collection in the new Kröller-Müller museum.

Today, the Rijksmuseum Kröller-Müller (open daily except Mondays) stands on the vast acreage which the Kröllers sold to the Government for a nominal amount and which is now Holland's largest National Park. Some of Kröller-Müller's major van Goghs have been moved to the van Gogh Museum in Amsterdam.

CLARIBEL AND ETTA CONE
(1864–1929, 1870–1949)

'They were two of them, they were sisters, they were large women, they were rich, they were very different one from the other . . .' wrote Gertrude Stein about her close friends, the Cone sisters. The Cone sisters' family name was originally Kahn, Americanized to Cone when their father emigrated from Germany, and they were born in Tennessee where Herman Cone ran a modest grocery store. Eventually he would own cotton mills and the world's largest denim manufacturing business, from which the two sisters' substantial fortune derived.

Claribel, six years older than Etta, studied medicine and became Lecturer on Hygiene at the Woman's Medical College, Baltimore, while Etta ran the Cone family household and cared for numerous siblings and elderly parents. Both sisters remained unmarried; both formed long-lasting lesbian attachments. Each sister managed her own finances, and purchases of important works by Bonnard, Cézanne, Manet, Renoir and Matisse were entered in their account books, along with relatively trivial purchases of fruit, hosiery and dresses. While Claribel bought landscapes by Cézanne, Etta bought powerful paintings by Gauguin, including the magnificent *Woman with mango*, and van Gogh's celebrated *Pair of boots*.

Initially the Cones bought works from the Steins, or direct from artists the Steins introduced them to, but after World War I they started buying through French dealers. Claribel would buy a van Gogh, and then Etta would buy one shortly afterwards. Claribel would buy a Renoir and Etta would follow suit. When Claribel died, she bequeathed her large collection of paintings and books to Etta, who continued to collect, eventually leaving the whole magnificent collection of paintings, prints, drawings and illustrated books to the Baltimore Museum of Art, where it is now on view in the Cone Wing, endowed by Etta Cone.

LILLIE P. BLISS (1864–1932)

In June 1932 the New York newspapers announced that Miss Lillie Bliss's will had left the people of New York over a million dollars worth of art — an amazing sum — and, provided that 'it was on a firm financial basis to receive them', the majority of works in her collection were to go to the newly-founded Museum of Modern Art, which was still under construction.

The reclusive life of unmarried Lillie Bliss remains a mystery, but she had been involved, along with Mrs. John D. Rockefeller, Chester Dale and Duncan Phillips, in founding the Museum of Modern Art, and at the time of her death she was the Museum's Vice-President. Her vast wealth stemmed from the family company Bliss, Fabyan & Co. described as 'dry goods commission merchants', while her father, Cornelius N. Bliss, had been Secretary of the Interior in the Cabinet of President McKinley.

Lillie Bliss's collection contained twenty-one Cézannes, including portraits of his wife and of Victor Chocquet, a Toulouse-Lautrec pastel of dancer May Belfort; one of Seurat's Port-en-Bessin views; several Degas pastels, a Renoir and three major Gauguins, along with important works by Picasso and Matisse.

ROBERT STERLING CLARK (1877–1956) AND FRANCINE CLERY CLARK (1877–1960)

Robert Sterling Clark graduated from the Sheffield Scientific School at Yale in 1899. He was a soldier before he became a collector, serving in the United States Army from 1899 to 1905, winning a silver star in action against the Boxer forces in Tientsin, China. Between 1908 and 1909 Clark led a scientific expedition to northern China, and he published a book about his exploits, *Through Shen Kan*, in 1912.

He and his younger brother, Stephen, were among the heirs to the colossal Singer sewing machine fortune, and on receiving their inheritance on their mother's death, they decided to collect French art. In 1913 the two brothers (who later fell out) went on

an art buying spree around Europe. They took the sculptor George Gray with them as an advisor, because their original plan was to found a joint art museum, but this was the last time the opinionated Sterling Clark took advice on art from anyone except his wife. For the rest of his life he was sceptical of the advice of art critics, curators and auctioneers, preferring to deal direct with his friends on the staff of the Galerie Durand-Ruel and the art dealers Knoedlers.

From his years in Paris Sterling Clark acquired a great knowledge of art as well as the foundation of his art collection. He purchased some Old Masters there as well as exceptionally good examples of works by the two artists who were to become his favourite Impressionists — Degas and Renoir. But on his return to New York he concentrated on acquiring late nineteenth-century French paintings, as well as antique silver, prints, drawings and illustrated books.

In 1919 Sterling Clark married an attractive art-loving French-woman named Francine Clery, and the couple would visit art dealers together. Clark called her his 'touchstone in judging pictures', describing her as 'an excellent judge, much better than I am at times, though I have known her to make mistakes on account of charming subjects'.

Charles Durand-Ruel has described Clark's frequent visits to his gallery when, if the collector liked a painting, he would twirl his silver-topped cane at the canvas and point in excitement. The Clarks purchased most of their Renoirs from Durand-Ruel: mainly landscapes, figures in domestic interiors, reading, playing music or resting, which would probably have appealed greatly to Francine Clark. Sterling Clark preferred Renoir's early works, writing how 'right up to 1905–1910 Renoir painted some good pictures and was always good in color up to 1913. His really great year, the 'apogé de son talent' was 1881 . . . but from then on he drew and composed less well, with flashes of his best work from time to time . . . After 1881 that inimitable freshness of hope and youth was lacking. But what a great master . . . ever the same in subject, color or composition both in figures and landscape. No one as far as we know ever had an eye as sensitive to harmony of color.'

During Robert Sterling Clark's lifetime his great art collection was relatively unknown, much of it kept in storage, but he and his wife had decided to endow an Institute at Williamstown, Massachusetts, to contain galleries as well as a major art-historical research library. He had chosen Williamstown because he had become preoccupied with finding a 'safe' home for their collection after the dropping of the atomic bomb. He also had a family association with Williams College and loved the beauty of the surrounding Massachusetts countryside. He remained an intensely private man and wrote to a friend, 'Do not mention the opening of the Institute to anyone, as you will treat me to a cloud of newspapermen to the detriment of my health.' Its doors opened in May 1955, eighteen months before Sterling Clark's death.

Clark's collection had brought him enormous pleasure, and in his seventies he enjoyed the planning of the museum, where the intimacy of the galleries cleverly suggests that the visitor has been invited to see a private collection. During their lifetime, an apartment for the Clarks was constructed in three of the galleries so that they could be near their beloved 'children'.

Important Renoirs in the Institute include *Sleeping girl with cat*, *Blonde bather*, *Bridge at Chatou*, *Bay of Naples*, the colourful *Girl with a fan* and two still lifes, *Onions* and *Peonies*. The Clarks also owned a major early Degas of a ballet rehearsal, as well as four Toulouse-Lautrecs, four Sisleys, seven Pissarros, six Monets, two Cassatts, one Berthe Morisot — together with many earlier works by Dutch, Flemish and French artists.

Chester Dale.

CHESTER DALE (1883–1962) AND MAUD DALE (?–1953)

Chester Dale in his early days seemed unlikely to become a great art collector. He was a dropout from school and then became a professional welter-weight boxer for a short time, though he was still in his teens when he began his business career. However, in mid-life, Dale became a partner in the Galerie Georges Petit, one of the best known dealers in Impressionist and Post-Impressionist canvases, thus gaining a behind-the-scenes knowledge of the art trade that was unique among American collectors.

Chester Dale started as a runner on New York's Stock Exchange. Then, while working as an office boy for the Wall Street firm of F.J. Lisman, he studied mortgages and tried his hand at the market. By 1904 he was trading on his own and in 1909 he went into business with a friend. He was to become a millionaire investment broker and utilities magnate, and came to be known as the 'wolf of Wall Street'.

Dale's interest in French art was greatly influenced by his first wife, Maud Murray, whom he married in 1911. Maud had studied painting and suggested that they begin to collect art. On a trip to Paris in 1916 they bought their first French art, and that was what they both came to love most. Initially Maud would search out their acquisitions, and Chester Dale would buy them. After ten years they had purchased about 700 canvases, mostly of Impressionist and twentieth-century French art.

Dale and his wife rented an apartment in New York's Carlyle Hotel for many years, and solved their space problem by having racks for their pictures installed over the spare bathtubs. 'Chesterdale', as he was most often referred to, once said that they collected because Maud had the knowledge and he had the acquisitiveness.

Though they were never cheap, prices for Impressionist paintings remained fairly stable during the boom years of the 1920s, even though stock and bond prices escalated daily; and when the crash came, while securities fell to a fraction of their former prices, Impressionist paintings held up reasonably well. The Dales bought a house at 20 East 79th Street to accommodate their collection, which also included Vuillard's great portrait of Théodore Duret, a magnificent study in old age.

Chester Dale made his first gift of paintings to the National Gallery in Washington on becoming a trustee in 1943, and he also had many works from his collection on loan there until the end of his life. After Maud Dale's death in 1953, Dale married Mary Bullard, Maud's personal assistant and curator of the couple's art collection for many years, and he and Mary continued to buy Impressionist and Post-Impressionist art. On his death he left 252 major paintings and sculptures to the National Gallery, as well as money to establish a purchase fund and an endowment for student fellowships in art history.

DUNCAN PHILLIPS (1886–1966)

Duncan Phillips was born into wealth, the grandson of the co-founder of the Jones and Laughlin Steel Company and President of the First National Bank of Pittsburgh. The family were 'old money', and it was pure love of art rather a desire for social status or increased wealth that led Phillips to establish his own art museum in Washington in 1918. The young Duncan attended

Yale University, where he wrote an article for the Yale Literary Magazine containing an impassioned plea for Yale to establish courses in art history. After graduating, he travelled widely in Europe in order to gain first-hand knowledge of art and to meet art dealers and practising artists. In 1911 at Paul Durand-Ruel's gallery he saw works by Impressionist artists and was carried away with admiration, describing Renoir as 'the best of all'.

The concept of the Phillips Collection was born in 1916, when Duncan wrote to his father suggesting that they set aside $10,000 a year to invest in art. His father, who had made another fortune manufacturing window glass, agreed, and a fund was established for that purpose. Following the death of his father in 1917 and his brother James a year later, Duncan Phillips decided to found a private art gallery as a memorial to his two closest male relatives. It was the first real museum of modern art in America.

At an exhibition of works he had loaned to New York's Century Club, Duncan Phillips met and eventually married a young art student named Marjorie Acker. Building on his own small collection and aided by Marjorie, Duncan Phillips had assembled more than two hundred paintings by the time his two-room museum opened to the public in 1920. The couple moved into the third floor of the Washington house on 21st Street. This is still home to the Phillips Collection; in 1930 the Phillips moved into a new residence and the remaining nine rooms of their old house were converted into picture galleries.

By the time of his death in 1966, Duncan Phillips and his wife had bought more than 2,000 works of art and created one of the world's finest non-government supported art galleries.

Visiting Paris in the summer of 1923 Phillips had bought what he described as 'one of the great pictures of the world. Every inch of the canvas is alive and worth framing for itself.' This was Renoir's *Luncheon of the boating party* (pp.84–5), which has become the centrepiece of an exceptional collection of Impressionist paintings, though the works range from Goya to Picasso. Other impressionist treasures in the Phillips Collection include several outstanding works by Degas and Sisley's *Snow at Louveciennes* (p.61), painted from the artist's window. Yet another view from an artist's window, this time in the South of France, is by Pierre Bonnard, who visited the Phillips Collection in 1926 and from whom Duncan Phillips bought a large group of works over the years. There is also a great Cézanne, one of the series of paintings showing the dramatic cone of Mont Sainte-Victoire, a particularly richly patterned Vuillard interior, a fine early Seurat and a pale, misty Monet showing the cliffs of Dieppe.

Duncan and Marjorie Phillips c. 1922 in the part of their house that they had turned into a museum.
Photograph by Clara Sipprel, courtesy of The Phillips Collection.

DR. ALBERT C. BARNES (1872–1951)

Albert Barnes was a self-made millionaire, born in the toughest suburb of South Philadelphia. His father worked as a slaughterman-porter in an abattoir, and Barnes came from a poverty-stricken and deprived household; he remained belligerent and defensive for the rest of his life. Brilliantly intelligent but emotionally unbalanced and given to wild fits of rage and aggression, Barnes took a variety of menial jobs as a young man in order to study at Faculties of Medicine and Chemistry in American and German universities. Having graduated, he worked in a pharmaceutical laboratory, and in 1907, at the age of thirty-five, he invented and marketed world-wide a purgative named Argyrol and a disinfectant which was used in large quantities by the French Army in an attempt to control the high rate of syphilis. These two preparations earned Barnes a vast fortune while he was still young enough to enjoy it, though he continued to loathe those he believed to be 'the idle rich'.

Barnes started by collecting Barbizon School works in a small way, but the American Impressionist painter Walter Glackens, with whom Barnes had once played as a child, steered him towards Impressionism. When unable to buy direct, Barnes became a client of Durand-Ruel, and he acquired part of the Impressionist collection of the spendthrift Prince de Wagram before the advent of World War I.

His collection of works by Renoir was acquired in the early 1920s, when many of them came onto the market after the artists' death in 1919. Some thirty are masterworks, but there are many of Renoir's late oils, which other artists who felt more financially secure might have hesitated to sell; some were mere sketches found in Renoir's studio after his death. Barnes never could resist a bargain, and during the Depression he openly boasted of cheating elderly European collectors who desperately needed to sell.

Barnes also saw himself as an art critic and authority, and in 1935 he published his own book *The Art of Renoir*, following it up in 1939 with *The Art of Cézanne*. He was helped in that he now owned 62 Cézannes, including a giant *Bathers*, and 171 Renoirs (of varying quality), along with seven van Goghs and significant works by Seurat, Manet and Monet. Barnes acquired notoriety with curators and art historians, to whom he took special delight in refusing admission to what was then the largest collection of Renoir and Matisse in America — a circumstance which prompted art historian Bernard Berenson to ask him with mock innocence, 'Why do you have one hundred and fifty of the same paintings by Renoir and Matisse, when they are all practically identical?'

In 1924 Barnes opened his own Foundation — an ego museum at Merion outside Philadelphia — for the purpose of teaching 'scientific' methods of art analysis to students prepared to accept his tirades and weird aesthetic theories for the privilege of living with great art. Here he became increasingly hostile to the public; he blockaded himself behind a spiked iron fence and lived in almost pathological isolation in a mansion built from specially imported French limestone, which Vollard had persuaded him into buying. Practically everyone who requested permission to see his paintings was refused — often in the crudest of terms.

Even after his death the Foundation's hostility to visitors persisted. Barnes's will dictated that his pictures should remain hung in vertical stacks exactly as he had placed them, many being, apparently deliberately, hung in positions that made them difficult to see. Barnes placed a ban on children visiting his Foundation or on academics lecturing their students there. Only ten people were admitted at any one time, and they had to arrange their visits in writing in advance. But despite this, a visit to the Barnes Collection is essential for any serious student of Renoir or Cézanne, and it is to be hoped that Barnes's eccentric whims may soon be disregarded by the new management of the Foundation.

PAUL GUILLAUME (1891–1934) AND MME. JULIET GUILLAUME (LATER MME. JULIET WALTER) (?–1977)

Paul Guillaume's early background remains a mystery, but he is presumed to have come from an affluent Parisian family. At the age of twenty-three, he managed to raise sufficient capital to open his own gallery in the centre of Paris, and it soon became apparent that Guillaume had a natural eye for paintings, as well as for publicising and selling the work of talented innovative artists. He was encouraged by the poet Guillaume Apollinaire to buy works by Henri 'Douanier' Rousseau, long before they became fashionable, and in 1916 he held a highly successful Derain exhibition, followed two years later by a joint Matisse-Picasso show. He was for a time the main supporter of both Modigliani and Soutine, as well as being one of the first collectors in Paris of African art.

In 1920 Guillaume married Juliet Lacaze, whose cool beauty was celebrated in several portraits by Derain. In the boom years of the 1920s the couple led a glittering social life, frequently recorded in paint by their friend Kees van Dongen, at whose studio parties, where high society mingled with Paris's creative community, they were frequent guests. Guillaume continued to collect art and always considered his personal art collection as a kind of resource centre for contemporary artists. He planned to endow a house-museum where his collection (which now included major works by Manet and Cézanne) could be available to artists and scholars, but the plans were abandoned on his death.

Eleven years later his widow re-married. Juliet's second husband, Jean Walter, was an architect and industrialist, but he was also a keen art lover, and with his encouragement Juliet continued to devote her time to art, greatly enriching the collection she had inherited from Paul Guillaume. After Walter's death in the late 1950s, she donated some of the collection to the Musée de l'Homme in Paris, but the bulk of it was auctioned at the Hôtel Drouot after 1965. However, she made a generous arrangement with the French Government whereby they would receive paintings from her collection, provided that they were displayed in an independent museum. As a result, it was decided that the 'Walter-Guillaume' collection, as it was called, should be hung in the Musée de l'Orangerie in the Tuileries Gardens, which had been specifically designed to display many of Monet's great waterlilies series.

This joint collection is naturally rich in works of the twentieth-century school of Paris, but there is also a very important collection of Impressionist works. It is not certain whether most of these were chosen by Juliet Walter or her second husband, although she certainly acquired the Sisley, several of the major Renoirs and most of the fourteen Cézannes, which include the magnificent *Park at the Château Noir* and a fine portrait of Mme. Cézanne.

Many of the Renoirs had been purchased earlier by Paul Guillaume direct from the artist's studio sale. Among paintings which one might expect to find unsold in an artist's studio, several stand out, especially the paintings of his young sons. These include the superb *Claude Renoir at play* and the haunting image of 'Coco', the young Claude dressed in his red clown-suit. *Gabrielle and Jean* (p.88) is one of Renoir's tenderest works, showing the beautiful dark-haired nursemaid playing with the artist's blonde baby son. Its emotive appeal — it was not purchased at the studio sale — suggests Juliet Walter's involvement.

In 1952 Juliet Walter had entered the pages of collecting history with a record-breaking bid (35,000 francs) for Cézanne's *Apples and biscuits* at the Cognacq sale. The French press eagerly publicised the story of the elegant Parisienne who bid a fortune at an obscure sale. Is it a measure of her largesse of spirit and loving devotion (or just a sardonic comment on the self-effacing role of women in French society) that the great art collection with which Juliet Walter was so deeply involved bears only the names of her two deceased husbands and omits her own?

Jacques Doucet.

JACQUES DOUCET
(1853–1929)

Jacques Doucet was the Parisian couturier who designed the sweeping tea-gowns and ball dresses appliquéd with silk flowers, and the flattering, filmy outfits worn by leading stage personalities of the Belle Epoque. His clients included Réjane, Sarah Bernhardt and Marcel Lender, and the *grandes cocottes*, Cléo de Mérode, Emilienne d'Alençon and La Belle Otéro.

During the opulent years before the outbreak of World War I, Doucet's large and luxurious fashion house on the rue de la Paix was frequented by wealthy American ladies and their daughters hoping to catch a glimpse of the great couturier, but Doucet left the business side of Maison Doucet to his managers and would only see his most important clients. He much preferred art collecting to pinning dresses onto demanding women. As a designer he was superb — and enormously successful — but his heart was never really in the family couture business, which he had inherited as a young man. As a sideline, he speculated in property on a rising market and was eventually so wealthy he was able to sell off the Maison Doucet and its premises and devote himself to his true passion — collecting.

Doucet had an unerring eye for line and colour in paintings as well as fashions. During his long lifetime he formed three important picture collections, as well as collections of furniture and decorative arts. He had started when only twenty-one, buying works by Degas and Monet in the 1870s; then in 1875 he bought his first Watteau drawing and began to collect eighteenth-century art and antiques, with which he furnished an entire house for the great love of his life. After her tragic death in a riding accident Doucet wanted to obliterate all memories of their time together — selling off the house along with his eighteenth-century antiques and paintings.

To forget his personal tragedy, Doucet's passion for collecting took a new turn, and he now returned to collecting Impressionist and Post-Impressionist art, buying major works by Degas, Monet, Cézanne and van Gogh. In 1925 Doucet bought van Gogh's *Irises* from Auguste Pellerin through Bernheim-Jeune (there is no record of how much he paid for it). But by this time, under the influence of the young Surrealist poet André Breton, whom he had met in 1919, Doucet's taste had changed again. Breton worked part-time as Doucet's secretary-librarian, and it was he who urged Doucet to collect works by Rousseau, Picasso and Matisse, including Picasso's great *Demoiselles d'Avignon*.

OSKAR REINHART (1885–1965)

Oskar Reinhart typifies the devoted, altruistic collector, and his motivation could not be more different from the egocentricity of Dr. Alfred Barnes or the attention-seeking of Count de Camondo. From his early youth, Oskar Reinhart was convinced that he had a vocation to collect great art. An entry in his diary for 1922 describes how he wished 'to serve his fellow-men with his knowledge and his possessions'.

Born in 1885 in Winterthur, Switzerland, the youngest son of Dr. Theodor Reinhart-Volkart, a wealthy merchant who collected European paintings with a strong emphasis on Swiss art, Oskar Reinhart grew up in a household where appreciation of

'Am Römerholz', Winterthur, Switzerland, where Oskar Reinhart's collection can be seen by the public.

not until the end of his life would Manet again paint with such loose brushwork in the open air. Reinhart so loved *At the café*, Manet's vivid rendering of belle-époque life in Paris, that he kept track of its whereabouts for thirty years before he was finally able to purchase it.

In Oskar Reinhart's former library hangs a Degas pastel of a dancer and some particularly fine Cézanne watercolours — he eventually owned eleven works by the artist — but his favourite was Renoir. Among his twelve Renoirs are *Confidences* and a view of *La Grenouillère*, the bathing place on the Seine where Renoir and Monet painted together in the open air and worked out the principles of what would become known as Impressionism. Reinhart also purchased Renoir's sensitive portrait of the first collector of his works, Victor Chocquet. He tracked down and bought four paintings and two drawings by van Gogh (pp.100–1), and he also recognised the quality in Toulouse-Lautrec's vivid portrait of that unforgettable lesbian acrobat and dancer Cha-U-Kao marching boldly through the corridors of the Moulin Rouge (pp.124–5). All these works have found a place in the museum collection that the sculptor Maillol described as 'the finest in the entire world'.

the visual arts, literature and music was deemed important. Artists were often invited to meals and were regarded as very special people by the Reinhart family. Dr. Theodor Reinhart was a member of the management committee of his local art gallery, the 'Kunstverein' of Winterhur, and in 1916 he funded the building of a 'Reinhart' wing at the gallery.

The collecting philosophy of the family was expressed in a speech Dr. Theodor Reinhart-Volkart made at the opening of an exhibition of paintings from his collection, when he talked of 'a debt of honour owed by art-collectors to artists, living and dead, whose pictures are buried in private homes . . . to make art widely known to those who are not in a position to acquire such works but are entitled to see and enjoy them.'

Following in his father's footsteps, Oskar Reinhart hoped to dedicate his life to studying art history and collecting, but his father insisted he join the family firm of Volkart, international merchants. For many years he travelled widely on business, in France, Austria, Germany, Denmark, England and later in India. On his travels he spent his free time in art galleries, and when World War I made travelling impossible, Reinhart studied art history and became deeply interested in the work of the Impressionists.

After his father's death in 1919, Oskar Reinhart had the money to buy art on a grand scale and he built up one of the finest art collections of the twentieth century. His home soon became too small for his acquisitions, so he purchased a second house, 'Am Römerholz', on the northern outskirts of Winterthur to house them. It is here, in this beautifully maintained house-museum, that his French eighteenth- and nineteenth-century works and Old Masters can now be seen by the public, just as the great collector had always wanted. He also set up the Oskar Reinhart Foundation in the centre of Winterthur, which contains 600 of the great collector's paintings by German, Swiss and Austrian artists.

During his visits to galleries in London, Reinhart had discovered Constable's open-air landscapes, and his purchases of Impressionist paintings were a logical progression from this. The Reinhart collection contains numerous fine landscapes by Pissarro and Monet — Monet's visions of shining summer days at Pontoise with fields in bloom, which contrast with his great canvases of melting ice on the river; one of Sisley's great paintings of sparkling water, *Barges on the Canal Saint-Martin, Paris* (pp.62–3); as well as a fascinating and very early example of Manet's work painted *en plein air* and once owned by Degas, the little-known *Departure of the Folkestone boat*. The painting is a little immature in contrast with Manet's later development, but

CALOUSTE SARKIS GULBENKIAN
(1869–1955)

Gulbenkian was born in Istanbul and spoke fluent English and French from an early age. His Armenian father was a banker and kerosine exporter who sent him to England, where Calouste took a degree in engineering. At nineteen he entered his father's oil business in the Caucasus. In order to escape the ravages of World War I, he returned to London, moving his business there and becoming a naturalised British citizen. After the war, at a time when the Bolshevik Government badly needed Western currency, Gulbenkian was allowed to go and choose what he would like to buy from among the great works of European art in Leningrad's Hermitage Museum. Among the Rembrandts and other art treasures he chose were some fine Impressionist works from the former collections of Morosov and Shchukin, including Renoir's portrait of Mme. Monet and several very fine early Monets.

Gulbenkian's legendary wealth and his nickname 'Mr. Five Percent' were based on his holding of one-twentieth of the shares of the Anglo-Iranian Petroleum Company. He owned a mansion on Paris's elegant Avenue d'Iéna but always slept (usually with one of his mistresses) at the Ritz Hotel, of which he was also part-owner. In 1936, when it became apparent that France would eventually be at war with Germany, Gulbenkian moved many of his art treasures to the same Welsh colliery to which London's National Gallery sent their own paintings, while the rest were sent to Washington's National Gallery. The Portuguese Government gave Gulbenkian refuge from the Nazis and helped him get back some of the property they had confiscated and, in return, Gulbenkian left the bulk of his fortune and his priceless art collection to his own Gulbenkian Foundation in Lisbon.

EMIL GEORG BÜHRLE (1890–1956)

The Bührle Collection, one of the most prestigious private collections created this century, is particularly rich in Impressionist works. Among the 321 artworks are eight Manets; seven Cézannes, including one version of *The boy in a red vest*; six van Goghs, five Gauguins, including a rare portrait of the artist's wife, Mette; five works by Degas; Renoir's delightfully tender

portrait of red-headed little *Mlle. Irène Cahen d'Anvers*; as well as major paintings by Pissarro, Degas and Monet.

As a student of philosophy, literature and art history in his home town of Freiburg, a visit to the Impressionists on show at Berlin's National Gallery made a powerful impression on the young Bührle. He determined that one day he would surround himself with works by Monet, Manet, Renoir and Degas. In 1922 he was sent to run the debt-ridden Oerlikon machine tool factory in which his father-in-law, a banker, had a financial interest. The ailing enterprise soon recovered under his capable direction, and from then onwards art provided a welcome relief from the stress of running a gigantic and remorseless industrial enterprise which was forced to manufacture guns during World War II.

Unlike most collectors, Bührle was fortunate to possess a solid groundwork in art history. Had the circumstances of his life been different Emil Bührle would undoubtedly have had the drive, the connoisseurship and the refined taste to have made an outstanding director of a national art gallery anywhere in the world. If he did not immediately take a strong liking to a painting he would take it home, placing the work on a broad shelf in his library that he called 'the bench for the accused'. The painting might stand there for a week or more before a decision was reached as to whether or not it should join the other treasures in his collection.

Oskar Kokoschka painted Bührle's portrait in 1952, four years before the collector's death. He described how Bührle 'often stayed in his office until dawn . . . every once in a while he would invite me, almost shyly, to walk over to the neighbouring building with him and look at his collection, even though it could only be viewed under artificial light . . . We would contemplate this or that painting, which he had just acquired. His brown eyes could truly see, which is not generally the case with collectors.'

Emil Bührle
Courtesy Bührle Foundation.

SIR ALFRED CHESTER BEATTY (1875–1968)
AND LADY CHESTER BEATTY (?–1952)

'Chester' Beatty spent his boyhood in mining camps, where he had a passion for fossicking for semi-precious stones from the waste dumps along the Hudson River. He started his career as a pick-and-shovel underground worker before attending the Colorado School of Mines. His intuitive 'nose' for minerals led him to become a prospector in the Rocky Mountains, camping out and riding John Wayne-style, a pistol in his boots and a Winchester on the pommel of his saddle. In 1900 he went to work for the legendary Guggenheim brothers at their goldmine in Mexico's Sierra Madre. They appointed him Manager at Cripple Creek, then the world's biggest and richest goldfield, where militant unionists tried to kill him and wreck the goldmines. Using Texas gunmen and Pinkerton detectives, Beatty fought the miners and won, but his health was badly affected. He returned to New York and became mining consultant to the Guggenheims.

He married and settled down in a New York mansion, where he kept his collections of rocks and stamps. In 1911, shocked by the death of his young wife from cancer and with his own health considered so poor that no life insurance company would cover him, the widowed thirty-six-year-old Beatty retired to start a new life as a collector of rare books and manuscripts in England. However, Herbert Hoover, the future American President, then working as a mining consultant in London, rekindled Beatty's interest in forming another exploration company. Beatty's Selection Trust found copper in Russia and Yugoslavia, opened up the West Coast of Africa for diamonds and became the main developer of what is now Zambia's copperbelt. Beatty became one of the richest men in the world.

In 1928 Beatty gave his second wife, Edith Dunn Stone, a cheque for £100,000 with the instruction to go out and buy some good Impressionist paintings. The works she acquired included major paintings by Manet, five van Goghs (including the great *Sunflowers* which was sold to a Japanese insurance company in the mid 1980s), Cézanne's, *The stove in the studio* and *The Avenue at Chantilly*, now in London's National Gallery, as well as two Renoir nudes.

During World War II Beatty was appointed one of Winston Churchill's 'backroom boys', planning the disruption of German supplies of strategic raw materials by pre-emptive buying on world markets. He and Churchill also planned a 'snatch' of industrial diamonds from Occupied France, and Beatty was the brains behind the design and development of the 'Northover' gun, the artillery of the British Home Guard. Beatty was knighted for his wartime services and retired once more from business to devote himself to collecting and philanthropic projects. A generous donation of early illuminated manuscripts to the Irish National Library ensured him a State Funeral in Dublin when he died, aged 92. Some of his paintings and much of his vast fortune were donated to public institutions, while other paintings were bequeathed to descendants.

ADELAIDE MILTON DE GROOT (1876–1967)

'I used to be a social butterfly,' Miss Adelaide de Groot said in 1953, 'but then I inherited a great deal of money and went to work.' The work she spoke of was collecting the very best paintings she could find. She liked sharing her paintings with others. 'I never believe in shutting up pictures,' she said. 'I want them to be seen.'

Adelaide de Groot was born in New York but her family travelled widely — her father was an extremely wealthy ship owner in the China trade — and she started collecting paintings in a modest way in the early 1920s, when she had her own studio on Paris's Left Bank. Her family let her become an artist on the understanding that she never tried to sell one of her paintings, and she was only an amateur painter of modest achievement, specialising in flower studies and portraits. She described herself as 'like one of those Henry James girls — wealthy, social and just the sort of girl you'd expect to marry a European nobleman, only I didn't.'

In 1933, after her parents died, she returned to live in New York. With the money she had inherited, Adelaide de Groot might have lived in a Fifth Avenue mansion, but she chose instead to live modestly in a two-room walk-up apartment, cook her own meals on a single gas ring and never dine out or entertain. She devoted her wealth to hunting down and buying magnificent artworks — including a self-portrait by Vincent van Gogh, important Monets and Renoirs, and major works by Gauguin and Toulouse-Lautrec, as well as paintings by the American Impressionist William Merritt Chase. In the 1950s she placed her superb art collection in the Metropolitan Museum on extended loan, eventually bequeathing it to the museum.

SAMUEL A. LEWISOHN (1885–1951)

One of five children of a family celebrated for its patronage of music in the State of New York, Sam Lewisohn attended Princeton, where he studied under Woodrow Wilson. At Columbia Law School he was a classmate of Franklin D. Roosevelt, but he renounced a distinguished legal career to work in his family's stockbroking business, while continuing to be very active in philanthropic and artistic organisations.

As a collector, he preferred late nineteenth- and early twentieth-century French and American paintings, being especially fascinated by the Impressionists and Post-Impressionists. In 1937 he wrote a book entitled *Painters and Personality* discussing the life and work of artists whose work he collected, including van Gogh, Gauguin, Degas and Renoir. Many of his paintings were left to his family, but he also bequeathed a number of important works to the Metropolitan Museum — Gauguin's *Te Orana Maria*; Seurat's *Afternoon on the island of la Grande Jatte*; van Gogh's *L'Arlésienne*, a painting of Mme. Ginoux; and Cézanne's *Still life of apples and pot of geraniums*. To the National Gallery, Washington, he bequeathed Renoir's *Boatmen at Chatou* and Gauguin's *Bathers*.

HAL B. WALLIS (1898–1988)

From 1922 onwards Hal Wallis worked as an independent producer of some of Hollywood's most popular motion pictures, including *Casablanca*, *Beckett* and *Gunfight at the OK Corral*. Profits from his million-dollar movies enabled him to buy Impressionist and Modern paintings that mirrored the drama of moments he had created on the silver screen.

In the carefully-chosen collection which hung on his walls for so many years, a young dancer takes a bow in Edgar Degas's *On the stage*; a group of cardplayers are silhouetted against a warm golden light in Vuillard's *Card game (The brothers Natanson, Misia and Léon Blum)*; and a young mother plays with her child against Mary Cassatt's vivid blue and orange background. Wallis also owned one of Monet's most important views of the River Thames painted from the windows of the Savoy Hotel, which shows the sky at sunset as a wall of flames behind the silhouette of the British Houses of Parliament.

After Wallis's death, his collection was given to Christie's, New York, for sale in May 1989 during the height of the boom in Impressionist art. Wallis had bought Monet's *Parliament, sunset* in 1971 for $204,000 and it more than doubled Christie's estimate of $5–7 million to reach $14.3 million.

EDWARD G. ROBINSON (1893–1973)

In 1937 Edward G. Robinson, a movie actor best remembered for his numerous gangster roles, bought his first Impressionist paintings — a Pissarro, a Degas and a Monet. However, twenty years later, judgement in his divorce settlement forced him to sell most of the seventy Impressionist and Post-Impressionist paintings that he always referred to as his 'children' to Stavros Niarchos for $3,000,000. He kept only a dozen favourites.

Anne Douglas, wife of actor Kirk Douglas — whose own collection was sold at Christie's, New York, in 1990 for $5.3 million — recalled with gratitude, 'We never made a purchase without Robinson's advice. When he had to sell his art collection it nearly broke his heart. He was a true collector. Even if he only made $500 one week, he would spend $400 of it on a painting!'

Greta Garbo.

GRETA GARBO (GRETA LOUISA GUSTAFSSON) (1905–1990)

Greta Gustafsson's father was a street cleaner, and she started her remarkable rise to fame as a soap lather girl in a barber's shop in her native Sweden. She studied dancing and singing before her elusive and haunting beauty was discovered by director Mauritz Stiller, who took her to Hollywood.

In 1941 Garbo retired from the screen at the height of her fame and invested her millions wisely — mainly in real estate. Art collecting also became a secret passion. In November 1990 Sotheby's, New York, billed her treasures as 'The Great Garbo Collection' and sent the highlights of her collection for exhibition in Tokyo, but it was clear that many of Garbo's paintings were interior decorator material — colourful, sentimental views of flowers, poodles, clowns and babies.

However, she did buy some good Impressionists on a brief spending spree in New York in 1942, including a stunning Bonnard of poppies in a jug; three Renoirs, including a tender and colourful study of Léontine (the nursemaid who replaced Gabrielle) reading to the artist's son Coco. When she also wanted to buy Renoir's *Seated child dressed in blue*, a portrait of Renoir's nephew Edmond, the dealer apologised — the work was already spoken for. Suddenly a little man popped out from a back room and said magnanimously, 'Young lady, you take it instead. You won't regret this purchase.' The little man was Dr. Albert C. Barnes and this was a rare moment of magnanimity in his life. Barnes, like most men, fell under Garbo's spell; he invited her to view his collection and gave her art books to read but, despite this, Garbo never made any more important purchases. Although the Sotheby's sale made a total of $18.2 million (against Sotheby's pre-sale estimate of $26 million), more than three-quarters of this sum was accounted for by the Bonnard and the two Renoirs.

LILA WITT WALLACE (1889–1984) AND THE READER'S DIGEST ASSOCIATION ART COLLECTION

'Great art is something to be appreciated, not only in solitude but also in our flying moments as we advance our daily lives,' said Lila Witt Wallace, who along with her husband, made a fortune from publishing *The Reader's Digest*, the world's most-read magazine. As she had no children, she gave much of her fortune away, donating millions of dollars to the Metropolitan Museum of Art, the Metropolitan Opera and to the restoration of Monet's house and gardens at Giverny, to which she was the major benefactor.

Lila Acheson was born in Western Canada, daughter of a Presbyterian minister. She was one of a large family of children. Although there was little money to spare for buying original artworks in the Acheson home, both art and education were greatly valued there. She graduated from the University of Oregon and worked as a social worker in a munitions factory during World War I, then in 1921 she married Witt Wallace and helped her husband found *The Reader's Digest* the following year. When the company built its Georgian-style headquarters at Pleasantville, Mrs Wallace took on the project of decorating the

building. She wanted to create an ideal working environment for her employees and devoted herself to turning the Reader's Digest offices into an elegant, comfortable home, filling the offices and reception areas with antique furniture, sumptuous draperies, oriental rugs and fine paintings. Eventually the Reader's Digest Collection numbered about 3,000 paintings ranging through Monet, Manet, Degas, Seurat, Bonnard, Pissarro, van Gogh and Gauguin to Picasso.

Lila Wallace's passion for exotic flowers influenced her choice of subject-matter for her paintings. The perfume of fresh-cut flowers filled the building, while paintings by Renoir, Monet and Bonnard adorned the walls of conference rooms, reception areas, the library, offices and the employees' cafeteria. Every painting, pastel, or piece of sculpture that Lila Wallace ever bought reflected her personality and the interests that guided her intellectual life.

Pleasantville is not an art museum but a working environment for people in publishing. There are no uniformed guards, no ropes, no 'don't touch' signs here. The employees volunteer to act as guides for visitors and attend educational lectures arranged by the company.

Over 2,000 visitors are granted permission to tour the collection every year. An exceptionally beautiful Monet *Waterlilies* stands above an antique sideboard in the hall, while other works in the collection include Manet's *Young woman among flowers* (p.25); two pastels of dancers by Degas, one of which is the masterly *Pink dancer* (p.31); Seurat's very early and distinctly Impressionist oil of trees and bushes (p.128); an unusually dense, verdant Sisley of women washing clothes (p.59); and Monet's appealing *Landscape with orchard and figures* (p.47).

This deliberate policy of acquisition for beauty rather than for investment has been faithfully continued after Lila Wallace's death by the present curator, Frances Chaves. In 1989 highlights from the collection toured around the world, bringing enormous pleasure to all those who love art and flowers.

Lila Wallace, who was honoured with the Presidential Medal of Freedom, had a simple philosophy for purchasing thousands of prints, paintings and sculptures, which had nothing to do with financial or social advancement: 'If I could not live without them, I bought them.' She died serenely, surrounded by the flowers and paintings she loved, aged 94.

ALGUR HURTLE MEADOWS (1899–1978)

Texan-born oil multi-millionaire Hurtle Meadows graduated from Centenary College Law School in 1926. He started his remarkable rise to power in the Texan oil industry by becoming an accountant at Standard Oil. By 1941 he was Chairman of General Finance Company and had his own empire — the multi-million General American Oil Company.

Sumptuously furnished Dallas and Palm Beach mansions housed Meadows's enormous art collection, but appearances and social status were important, and he appears to have bought 'names' rather than possessing any deep knowledge of art. He collected over a wide range of periods — from El Greco and Goya to Gauguin, at one time owning Gauguin's great *House of hymns* (p.114).

Many paintings that he had bought he donated to Southern Methodist University in Dallas, and he endowed the building for the Virginia Meadows Museum, intended as a memorial to his first wife, who died in 1961. However, although the majority of the works in his own collection and that of the museum, for which he spent millions of dollars during the early 1960s, were genuine, in 1967 Meadows became suspicious of the wonderful 'finds' that he was buying through the Legros Gallery in Paris. He was the first collector smart enough to test for new paint by sticking a pin into a 'Toulouse-Lautrec' sold to him by Legros,

who was acting as agent for master forger Elmyr de Hory. Hurtle Meadows called in the police and Legros — who offered to exchange the works for others equally dubious — was arrested, tried and jailed. The trial revealed the embarrassing fact that the wealthy and powerful Meadows had purchased over $2 million worth of de Hory forgeries.

Ailsa Mellon Bruce.

PAUL MELLON (b. 1907)
AND
AILSA MELLON BRUCE
(1901–1969)

Paul Mellon is the last of America's great patrician patrons, famous among art lovers for his understated philanthropy. He once described his aim as to 'spend my fortune sensibly'. During his lifetime Paul Mellon has donated over $1 billion to education, art, the humanities and art conservation.

Andrew Mellon, Paul's father, was gifted with brilliant business acumen. He financed and set up the Mellon Bank and some of America's most successful corporations, such as Alcoa, Gulf Oil and Carborundum. In doing this he became prodigiously wealthy and, encouraged by the wily art-dealer Lord Duveen, he began collecting what now forms the core of the Washington National Gallery's holding of Old Masters. In 1936, Andrew Mellon wrote to President Roosevelt offering the American nation his prestigious art collection along with funds for a building in which to house it and a substantial endowment. The gift remains one of the largest ever made by any individual to any government. Andrew Mellon lived to see work start on the Gallery's foundations, but died before it was finished.

Horse racing and horse breeding have been Paul Mellon's recreation, and he has said that 'it was through horses that I really got interested in art.' Degas is his favourite artist, and his interest broadened to include all the French Impressionists and Post-Impressionists. Mellon's collection is also rich in works by such leading English artists as Constable, Turner, Stubbs, Hogarth and Rowlandson, spanning the fields of sporting art, portraits and topographical painting. The bulk of Paul Mellon's collection of British art has already gone to the Yale Study Center for British Art, which he founded. Along with his sister Ailsa, Paul Mellon also provided nearly two-thirds of the funding for the construction of the East Building of the National Gallery in Washington and he has subsequently given them over a thousand works of art, including major works by Manet, Monet, Renoir, Bazille, Cézanne, Degas, van Gogh, Gauguin, Morisot and Cassatt. For the Gallery's fiftieth anniversary he undertook to give them a version of Cézanne's *Boy in a red waist-coat*, along with thirty-one of the surviving sixty-nine wax sculptures modelled by Degas, having previously given seventeen others.

Paul Mellon's sister, Ailsa, was also a keen collector. When she was only twenty, she accompanied her father to Washington, where she became his official hostess. She took on the same role when, in 1932, Andrew Mellon was appointed Ambassador to the Court of St James in London. After World War II, when her marriage ended in divorce, Ailsa Mellon Bruce established the Avalon Fund, by which the National Gallery in Washington could purchase important American works, and in 1962 she set up the even more substantial Ailsa Mellon Bruce Fund, which was used by them to purchase Leonardo da Vinci's haunting *Ginevra de Benci* and other major works. Ailsa Mellon Bruce began collecting relatively late in life and her preference was for the works of Mary Cassatt and the French Impressionists

especially their smaller, more intimate canvases. She purchased the important collection of French couturier Edouard Molyneux, which included van Gogh's *Farmhouse in Provence* and Morisot's *Harbour at Lorient*. In her will Ailsa Mellon Bruce bequeathed over 200 beautiful paintings and drawings to the National Gallery, including some of Mary Cassatt's finest works.

Norton Winfred Simon

NORTON WINFRED SIMON (b. 1907)

Endowed with a photographic memory and the ability to calculate figures in his head at lightning speed, Norton Simon attended college for only six weeks before launching himself into finance. Legend has him investing $3,000 in the American stock market just before the crash of 1929, emerging unscathed and having turned $3,000 into $35,000. Simon bought up poorly-managed companies with undervalued stock, quietly accumulating enough shares until he could demand a place on the board of directors. He built much of his fortune marketing the soft drink 'Canada Dry'.

Simon has applied these qualities of vision, determination and good financial planning to art collecting. He first became interested in art in the 1950s, when an interior decorator brought around some paintings on approval for his home. The paintings did not appeal to Norton Simon, so he visited art galleries in New York and Los Angeles and bought three paintings that he *did* like — by Renoir, Gauguin and Bonnard. Simon soon discovered he had an excellent eye for paintings and became passionately interested in art; he sought advice from art historians and devoured art books. He realised that art gave certain tax advantages to American collectors, so he set up several tax-exempt foundations specifically to buy paintings. He followed André Malraux's principle of creating a 'museum without walls' that loaned works for public display.

In 1964 the Norton Simon Foundation purchased for $15 million what remained of the collection assembled by Joseph Duveen, including Duveen's magnificent 2,000-volume art library. Having collected carefully over decades, Simon now owns over one hundred of Degas's finest paintings, pastels and sculptures, including the great *Ballet rehearsal*. The Norton Simon Museum also contains such other outstanding Impressionist works as Monet's *The artist's garden at Vétheuil* (p.48); Manet's powerful *The ragpicker*; van Gogh's *The mulberry tree* (p.108–9); and Pissarro's *Poultry market at Pontoise* (p.75); as well as the delightful *The yellow boat* (p.39) by Gustave Caillebotte.

Simon's collection represents over 2,000 years of European and Asian art, containing Old Masters, French works from Watteau to Manet, Impressionist and Post-Impressionist masterpieces, Rodin sculptures and a unique set of bronze dancers and race-horses cast from wax models which were found in Degas's studio after his death. There is also an important collection of letters written by artists, including Rubens, van Gogh and Picasso, as well as original engravings and lithographs by Goya, Rembrandt and Picasso — all providing firm evidence of a cultured taste, far removed from mere speculation.

Simon was responsible for much of the planning of the Los Angeles County Museum, sat on its Board of Trustees and loaned them some $15 million worth of artworks. At one time it was believed that the Norton Simon Collection would finish up in the Los Angeles Museum, but Simon's relationship with the board gradually soured; in 1971 he resigned, removed his works of art and loaned major items to the Princeton University Art Museum, the National Galleries in Washington and London, and the Rijksmuseum — all of which hoped they might eventually receive Simon's collection. However, that same year Simon began to give extremely generous financial assistance to the Pasadena Art Museum, which had opened three years earlier, with the principal aim of displaying contemporary art. Simon took over the Pasadena Museum's $1,000,000 operating debt in return for 75 per cent of their space and gave a further $3 million. Seven years later, the Museum's name was changed to the Norton Simon Museum, and today it is one of California's showpieces.

DANIEL J. TERRA (b. 1911)

Early in the twentieth century major American collectors like Mrs. Potter Palmer of Chicago, George Vanderbilt, Louisine Havemeyer and Andrew Mellon much preferred French paintings to the works of their own compatriots. Louisine Havemeyer's friend Mary Cassatt was saddened to find that, being American and female, her work sold far less easily in America than that of Degas, Renoir and Monet. Recently, however, American collectors have come to realise the strength of their own Impressionist art.

Much of this can be attributed to the hard work of one dedicated collector, Daniel J. Terra, who over a long period has purchased many of the finest works available by American artists of all periods. Terra is a self-made industrialist, while his artistic wife, Adeline, was an art historian, who always believed that Americans should realise the strength of their own art. Now the public are able to see a well-chosen selection of the best of American art in Chicago, where the museum occupies an entire block on North Michigan Avenue and at Mr. Terra's latest project, le Musée Americain in the French village of Giverny, an hour's drive from Paris.

In 1981, Daniel J. Terra was appointed American Ambassador at Large for Cultural Affairs, and he is now widely known as a spokesman for American art. The Terra Collection is particularly rich in the work of such American Impressionists as Frederick Carl Frieseke, Theodore Robinson, Lila Cabot Perry (both of whom painted with Monet at Giverny) and those three American expatriates with an international reputation, John Singer Sargent, J.M. Whistler and Mary Cassatt.

THE WARNER COLLECTION

Tuscaloosa, Alabama, is home to one of America's most interesting corporate collections, formed by the old-established Gulf States Paper Corporation under the direction of their chairman, Jack Warner, who describes himself as an 'apple-pie, flag-waving American', and after whom the collection is named.

The collection is eclectic: it includes paintings by members of the Hudson River School; Mary Cassatt, James McNeil Whistler and Charles Conder; and by the younger American Impressionist William Merritt Chase; as well as major works by Georgia O'Keeffe.

Under the personal guidance of Mr. Warner, the collection has made some major purchases and is still expanding. It is divided between the Corporation's headquarters, a gallery at the North River Yacht Club and the Mildred Warner House in Tuscaloosa, while paintings from the Warner Collection have been exhibited throughout the United States, in Europe and in Asia.

HEINZ BERGGRUEN (b. 1914)

Heinz Berggruen was born in Berlin and grew up there in the period between the two World Wars. He studied medieval art at the University of Toulouse and then returned to Berlin as correspondent for the *Frankfurter Zeitung*. A scholarship allowed him to leave for California, where he joined the *San Francisco Chronicle* before becoming Assistant to the Director of the San Francisco Museum of Art. During World War II Heinz Berggruen, by now an American citizen, joined the United States army and served in Europe, staying on in Paris to join the Arts Department of UNESCO. 'It was most tedious. All we did was write memoranda from one office to another — a horrible bore!' he relates.

In 1947, aged thirty-three, Berggruen embarked on his new career as a dealer. At the time he had no capital and worked from a tiny space at the back of a bookdealer's store in the Place Dauphine. His first transaction was the purchase of a portfolio of Toulouse-Lautrec lithographs, the famous album *Elles*, for the equivalent of £1,000 in today's currency. Within six months he had been offered double that amount by the great Toulouse-Lautrec collector Ludwig Charell, and from that moment his dealing activities escalated. Through Surrealist poets Eluard, Breton and Aragon, Berggruen met artists like Picasso and Braque, whose works he bought for re-sale to collectors. Eventually he could afford to buy their works for his own collection.

In 1950 Berggruen sold his shop on the Place Dauphine to his neighbours, film stars Simone Signoret and Yves Montand, and bought the gallery at 70 rue de l'Université, where he remained for thirty years until his retirement in 1980. Berggruen greatly enjoyed the contact with his varied clientele of collectors. His former assistant recalled, 'He didn't mind whether the client was rich or not, so long as he displayed a serious interest in what he saw. It was interesting to me that he clearly derived as much pleasure in concluding a deal for a 10 franc poster as for a 10,000 franc lithograph or an important painting.'

When Heinz Berggruen started out as a dealer he had no idea that he would ever have the ambition or the financial opportunity to build his own collection. Both developed gradually. But he never saw the point of collecting 'just a group of pictures by great names. It had to be something exceptional, very special and close to my taste.' During the first ten years he could only manage to retain a few works by Klee and some by Picasso — which were to form the basis of one of the most important collections of these artists' works in private ownership. In 1962 he bought a superb portrait of Cézanne's wife, followed by two drawings by Seurat. In 1973 he bought Seurat's *The models* (p.129) which he describes as 'the jewel of my collection'.

Although his gallery never dealt in the works of Seurat, van Gogh or Cézanne, Berggruen said that it was a great advantage for him as a collector to own a gallery, because it gave him access before other collectors to many works of art. Like Chester Dale before him, Heinz Berggruen was often his own best client: an advantage that some collectors obviously resented. Berggruen counters this by saying, 'For no good reason that I can see, they seemed to assume that a dealer has no right to keep anything. However the justification for doing so is evident here . . . my collection is now at the disposal of a vast public of art lovers. This makes me very happy.'

In 1991, the London National Gallery's holdings of late nineteenth- and early twentieth-century art were considerably enriched by the loan of a large part of the Berggruen collection. This five-year loan, which many art lovers hope will last for much longer, includes forty-one Picassos, eight Cézannes, two van Goghs, including *Arles, view from the wheat field* and *Autumn garden*, as well as fourteen works by Seurat.

BARON HANS HEINRICH THYSSEN-BORNEMISZA (b. 1921)

One of the world's most dedicated art collectors, Baron Thyssen's private gallery at his home on the Lake of Lugano became famous for its vast collection of Old Masters, many inherited from his father and some which he bought himself. But a number of large and well publicised exhibitions, as well as the display of 787 of his finest pictures at Madrid's Villahermosa Palace right opposite the Prado, have allowed a far larger public access to the Baron's collection. They have also revealed the wider scope of the collection, including a rich harvest of Impressionists.

An exhibition of Impressionist, Post-Impressionist and Fauvist paintings held in 1990 at the Villa Favorita revealed that the Baron owned some previously unknown and interesting Pissarros and a superb early Gauguin, showing the influence of Pissarro on his pupil. Renoir's *Field of corn*, which has a strong similarity in style to *Spring at Chatou* (pp.78–9), also reveals a heavy debt to Monet. This was the Baron's first Impressionist acquisition made in London some thirty years ago and is, like all his paintings, in excellent condition.

Baron Thyssen, now reputed to be the richest man in Europe, was educated in the Hague and at Fribourg University, before taking over his father's business empire. He brings the same razor-sharp intellect that has enabled him to expand this empire to his collecting, and he is insistent on the condition of the works he buys. 'If a work is heavily overpainted, you're buying the restorer,' he rightly says.

Among the French Impressionists, Degas is the Baron's favourite, and he owns three superb examples of Degas's works. His van Goghs all have strong associations for him — like the sombre view of workman unloading boats, *The stevedores at Arles*, which was bought by the Baron because his family business, based in Germany, originally concerned the unloading of coalboats. Two Impressionist portraits that are among the Baron's favourites are Berthe Morisot's *The cheval glass* (p.65), one of her most delightful and thoughtful works, and Manet's spirited study, *Woman in a riding habit, full face*.

STAVROS SPYROS NIARCHOS (b. 1909)

Stavros Niarchos was born to a wealthy family, but his father, a tobacco merchant, lost all his money speculating on the stock market after World War I, when young Stavros was attending an expensive private school. He had to leave, and suddenly his secure leisurely world vanished. Later he described bitterly how his uncles made no attempt to help his parents during their bankruptcy. This made Stavros Niarchos introverted, self-reliant, aloof and somewhat cynical about human nature. His enormous fortune stemmed from his far-sighted conviction that, after World War II, oil would replace coal. He built vast supertankers, which he chartered under the Liberian flag, and he was astute enough to sell most of his ships just before the worst shipping crisis in maritime history arrived in the late 1970s. He then invested in real estate, great art and bloodstock, until his shipping interests were only a small part of his fortune.

Niarchos started his collection in 1949, and his purchase of the Edward G. Robinson collection was a tremendous coup. By 1958, when his collection was exhibited in Ottawa, Boston and London's Tate Gallery, it already contained works by all the major Impressionists, including ten Renoirs, seven van Goghs, four Cézannes and eight Degas.

The best known work (which had been one of Robinson's) is van Gogh's own version (a preliminary study) of Père Tanguy's portrait (the version the artist gave to Père Tanguy was bought by Rodin and now hangs in the Musée Rodin). This is one of van Gogh's most powerful works and just as important as the record-breaking *Portrait of Dr. Gachet*. Niarchos also owns Toulouse-Lautrec's original oil sketch for his famous poster of *Jane Avril dancing*, and Gauguin's masterly *Horsemen on the beach* painted in the artist's final years in the Marquesas. But even great collectors can make the occasional mistake. Niarchos also owns a Gauguin (not from Robinson's collection) which achieved the dubious distinction of being named in the exhibition catalogue published by the Arts Council of Great Britain in 1986 entitled *Don't Trust the Label — Fakes, Imitations and the Real Thing*. The catalogue inferred that one of Niarchos's Breton-period Gauguin's was a pastiche cleverly incorporating a figure of a young girl copied from Gauguin's *The willows* (National Museum of Oslo).

Niarchos never appears to have made donations to public art galleries like the Mellon family, Lila Witt Wallace or Walter Annenberg. Instead, he has paid vast sums to transform a barren Aegean island into a personal Paradise and turn his Paris home into one of the world's most glittering private repositories of art, while each of his other homes around the world has been turned into a living museum displaying the choicest French furniture, fine silver, Sèvres porcelain and great Impressionist and Modern paintings.

WALTER ANNENBERG, K.B.E. (b. 1908)

When asked which of his collection of major Impressionist and Post-Impressionist works he liked best, millionaire and former publisher Walter Annenberg replied: 'My pictures are like children, I love them all equally.'

Walter Annenberg's father, Moses, worked for publishing mogul William Randolph Hearst before going into business on his own account. Eventually Annenberg's Triangle Publications became a large publishing group, whose mastheads included *The Philadelphia Inquirer* and *The Miami Tribune*. Business rivalry meant that a competitor complained to the Treasury: Moses Annenberg was indicted for tax fraud and went to jail, since in a cruel deal, the Justice Department offered indemnity for the son if the father filed 'a plain unvarnished plea of guilty'. Moses Annenberg died in 1939, leaving Walter to take over the company and care for his mother and seven sisters.

'Tragedy will either destroy you or it will inspire you,' said Walter Annenberg. A plaque on his desk reads, 'Cause my works on earth to reflect honour on my father's memory.' Walter Annenberg took this literally and established a charitable institution in memory of his father. He has, in addition, been a major sponsor of the Philadelphia Art Museum, the National Gallery in Washington and the Metropolitan Museum of Art, New York. It is significant that he made his donation of $15 million during the lean period when donations to museums did not count as tax deduction. Unlike many donors, he attached no strings as to what the museums should buy with his money: 'Once you give a gift don't be overbearing and tell them what to do with it,' he is quoted as saying.

Walter Annenberg acquired much of his vast fortune when he had the vision to realise how important television would become to the American public and started up the now-ubiquitous *TV Guide*. By the time he had sold out his vast multi-media interests, mostly to Rupert Murdoch, for an estimated $3 billion, the estimated worth of the seven Annenberg sisters exceeded $50

million each, with Walter Annenberg's own personal fortune considerably in excess of this figure.

Appointed Ambassador to the Court of St. James from 1969 to 1974 and decorated by Queen Elizabeth II for his services to art and philanthropy, Walter Annenberg's practical love of art became apparent when he made the gentlemanly gesture of donating $300,000 towards the purchase of a Henri Rousseau for London's National Gallery. He had considered buying the painting himself until he heard that the National Gallery was interested. He also donated funds to install air-conditioning in the National Gallery's Impressionist and Post-Impressionist rooms, and he has also contributed towards the restoration of Monet's home at Giverny.

Walter Annenberg is a collector who treats his paintings as companions rather than investments. He recalls, 'a dealer called me offering $50 million for my Gauguin, *The siesta*' (which is one of the most important works in my entire collection). Annenberg replied politely, 'Thank you for the compliment, but it would be like selling a member of my own family.'

Annenberg's collection holds a wide selection of paintings, watercolours and drawings, including five van Goghs — among which are *Vase of roses* and the most powerful version of *Woman rocking a cradle* (p.107). Annenberg also owns van Gogh's *Olive trees*, for which he remembers paying $24,000 in the mid-1940s. His six Monets include a particularly fine *Water lilies* and portraits of Monet's first wife (p.43) and of his stepdaughter, Suzanne Hoschedé-Monet (p.57). Annenberg also owns Renoir's important portrait of the three beautiful daughters of Catulle Mendès (p.83).

After a touring exhibition in 1990–1, Annenberg's collection remained in New York's Metropolitan Museum of Art.

 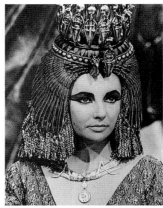

Portrait of Walter Annenberg, 1978, by Andrew Wyeth.

Elizabeth Taylor in *Cleopatra* in 1963, the film which gave her the money to buy a van Gogh.

ELIZABETH TAYLOR (b. 1932)

The author first met Elizabeth Taylor and her then husband Eddie Fisher in S'Agaró, Spain's most elegant beachside resort, at a party on board producer Sam Spiegel's yacht during the filming of *Suddenly Last Summer*. The yacht was adorned with Impressionist paintings, and it was Sam Spiegel and his wife who persuaded many Hollywood stars to collect/invest in Impressionist and Post-Impressionist art. But Elizabeth Taylor is different. Her paintings have not been chosen for her by 'art advisors' or interior decorators. She has a refined taste in art and chooses and buys her own paintings.

On the walls of Elizabeth Taylor's Bel-Air mansion hang a colourful Roualt and a delicate colour-speckled Pissarro. Over

the living-room fireplace is an arresting portrait by one of the Dutch artists who inspired Manet — Frans Hals. A needlepoint cushion on a chair is embroidered with the owner's credo, 'It's not the having . . . it's the getting.'

Elizabeth Taylor's father was a London art dealer, who haunted the Bond Street and King Street salerooms, buying on behalf of his uncle, Howard Young, who ran a gallery in New York. She herself started collecting in the mid-fifties, buying work by Degas, Renoir, Pissarro, Monet, Cassatt, Rouault, van Dongen, Utrillo and Vlaminck, but she always knew she wanted a major van Gogh. She searched for over twelve years to find just what she wanted, then, in 1963 while living in London with Richard Burton during the filming of *The V.I.P.s*, she happened to see that van Gogh's *Asylum and chapel at Saint-Rémy* (p.105), with its haunting view of the long stone wall that had imprisoned the artist during some of the most tragic moments in his life, was to be auctioned. Her father persuaded her not to attend the sale, pointing out that if other dealers saw her bidding 'you'd double the price!' He bid discreetly for her while she and Burton went to Paris, and the painting was secured for 'about $230,000'. She paid for it out of the record $1 million fee she had received for starring in *Cleopatra* the previous year.

The van Gogh was offered at an auction in Christie's in December 1990 when Miss Taylor was believed to be selling it to donate the money to AIDS research. However, in the very depressed state of the art market the painting failed to reach its reserve price and was withdrawn.

ALAIN DELON (b. 1935)

Filmstar Alain Delon represents the art collector turned brilliantly successful wheeler-dealer. Possessed of an excellent eye, Delon has been aided in his purchases by his advisor, Paris dealer Jacques Laurent. Delon became well-known as a collector after the extremely successful sale of his collection of bronzes by Rembrandt Bugatti at a Sotheby's auction in 1990. He also collects works by artists of the School of Paris, such as Modigliani, and pencil drawings by Degas (p.32).

For two decades Delon has been buying, holding and then selling art with a skill most art dealers envy. Some of the best drawings in the J. Paul Getty Museum at Malibu were bought from Delon, including a Dürer stag-beetle and a watercolour still life by Cézanne.

IMELDA ROMUALDEZ MARCOS (b. c.1930)

President Ferdinand Marcos and his wife, Imelda, were avid rather than philanthropic collectors of Western status symbols. They feasted off solid silver plates that once belonged to the 3rd Earl of Egremont and hung Old Masters and Impressionist canvases on their walls. After they were forced to flee the Philippines in 1986 following the popular revolt, some of Imelda Marcos's extensive art collection is believed to have been bought and stored for her by close friend, the Saudi Arabian entrepreneur Adnan Khashoggi.

The Presidential Committee on Good Government was created on 28 February 1986 by President Aquino 'to recover the ill-gotten wealth accumulated by former President Marcos.' In January 1991, Christie's International Magazine announced that their firm had held several highly successful New York auctions on behalf of the PCGG, selling furniture, paintings, silver and decorative accessories from the Marcos's town house and apartment, both of which were in New York city. The money was to be used primarily to fund Agrarian Reform in the Philippines. The PCGG found treasures like Lord Egremont's hundred-piece silver dinner service made by Georgian silversmith, Paul Storr. An El Greco and other paintings found in France led to the unsuccessful indictment of Imelda Marcos and financier Adnan Khashoggi. However, the Marcos's Impressionist paintings are still unaccounted for at the time of writing.

THE BRITISH RAIL PENSION FUND COLLECTION

While most collectors collect with enthusiasm, passion or even obsession, the British Rail Collection was put together coldly and rationally over a ten-year period starting in mid-1974. This was a period of high inflation, when the stock market had plunged dramatically and the commercial and domestic property market was totally flat. Foreign investment was also tightly controlled, so that holding art and antiques as an inflation-proof investment seemed like a good idea.

The collection had one aim only; to make a profit for the beneficiaries of British Rail's Pension Fund, rather than to enrich the workers' lives in any way. The man who started the concept was Christopher Lewin, a quiet, precise actuary and a keen collector of books and manuscripts. He had calculated that art and antiques were an excellent hedge against inflation, and he persuaded the rest of the British Rail Board to adopt the idea of collecting art, with a small proportion (some three per cent) of the annual pension money paid into the Fund by the workers.

The opportunity to advise such a potentially large collection set up by virtual novices was extremely appealing to Sotheby's chairman Peter Wilson, and the British Rail Impressionist Collection was formed, guided by the advice of Michel Strauss, Head of Sotheby's Impressionist Department. It was a financial masterstroke for Sotheby's: they received a buyers' commission on the works when British Rail bought them and then received a further commission when they were sold. The arrangement attracted strong criticism in 1977, when the stock market was soaring, and other dealers complained that it was extremely unwise to ask Sotheby's to advise on expensive purchases, in some of which they had a financial interest. However, Lewin kept a fairly tight rein on costs, and the Fund's advisors recommended the purchase of a large number of books and manuscripts, probably because Lewin felt comfortable with them. They also bought Egyptian bronzes, eighteenth-century French furniture, Chinese porcelain, one of the most beautiful T'ang horses ever seen, Renaissance gold jewellery, classical antiquities and Old Master drawings and paintings, on which one-third of the Fund's money was spent. Only ten per cent of the money was spent on Impressionist paintings because Lewin thought prices rather high.

Most of the Impressionist collection was sold during the 1980s when there was a boom in both the art and stock market. The Getty Museum purchased the Fund's star Impressionist painting, Renoir's *The promenade* (p.77), while the same artist's portrait of Cézanne (p.91) and Monet's misty *Santa Maria della Salute and the Grand Canal, Venice* (pp.44–5) went to private collections.

British Rail's actuaries finally decided that shares represented a better long-term investment than art and would give them fewer storage and insurance costs (although they had been intelligent enough to loan many of their paintings to public art galleries). In March 1989 it was announced that, taken overall, the sales of silver, furniture, books and Japanese prints had produced a return of three per cent per annum in real terms, discounting storage and transport, while Georgian furniture gave them an amazing 21 per cent annual return and Impressionist paintings a respectable return of 5.7 per cent.

SIR LEON (1906–1978) AND LADY TROUT (d. 1988)

In June 1989 the Trout Auction became the third largest house sale Christie's had ever held anywhere in the world. Over 5,000 people flocked to pre-sale viewings at Everton House, the land-rich Trouts' curiously tasteless Brisbane mansion, with its prison-like barred windows. Here Lady Peggy had spent her final years, locked in at night against the burglars she dreaded might break in and steal her paintings.

For many years Lady Trout's collection had been the subject of eager speculation amongst auction houses and dealers as to who would eventually handle its sale. Her quarrels with friends and family had made her increasingly isolated at Everton House, but Lady Trout enjoyed the sense of power that the collection gave her. Her social life revolved around its disposal, and dealers, auctioneers and public gallery trustees wooed her with lavish dinner parties and trips on the river. She consistently refused advice to sell or give what remained of her collection to the Queensland Art Gallery, or to move with a few cherished works into a maximum-security apartment.

In fact, a codicil to the final version of her will — which she had repeatedly changed — would have bequeathed her collection to the Queensland Art Gallery, but she had failed to sign it. In the event, a fact of which many of the buyers at the Trout Sale were ignorant, the Queensland Art Gallery had been given a million dollars to spend at the Trout auction by former Queensland Premier Mike Ahearne. With this they could now bid for major works previously promised by Lady Trout. Art dealer Joseph Brown bid on behalf of the Gallery, and following his lead amazing prices were paid by usually-conservative Brisbane doctors and lawyers at the sale.

The eager hordes that poured into the Trout residence were confronted by an amazing mixture of masterpieces and mediocre paintings in her vast private gallery, which had been built onto the main house. Experts curled their lips at Lady Peggy's passion for vapid Conders, painted at the end of the artist's life when syphilis was beginning to ravage his brain and its side effect — locomotor ataxia — to paralyse his hands, but a Rodin master-piece — a solid silver portrait bust of John Peter Russell's beautiful wife Marianna — was one of the highlights.

Sir Leon Trout purchased his first paintings in the 1920s, when he was a young law student; and the Trout Collection was assembled over a period of sixty years. It contained works by Australian Impressionists Tom Roberts, Charles Conder, A.H. Fullwood, Sir Arthur Streeton and Walter Withers, as well as some French Post-Impressionists. In particular, the Trouts bought important works by Australian Impressionist John Peter Russell at a time when this talented 'Lost Impressionist', who lived and painted in France, was virtually unknown.

Unlike the dynamic and domineering Lady Peggy, who favoured sun-dappled Conders and their French equivalents — works by Signac, Loiseau and Henry Moret, Sir Leon's taste initially ran to busty nudes by Norman Lindsay and bosomy bronzes; later in his career he became seriously interested in traditional portraits of famous Australians, bought with the intention of donating them to the Queensland Art Gallery, so that it should eventually become the Australian equivalent of London's National Portrait Gallery. During their lifetimes the Trouts donated seventy paintings (worth six million Australian dollars) to the Queensland Art Gallery, and their generosity ensured that they were made Trustees of the Gallery. They were closely involved in the Gallery's move to much larger premises on the Brisbane River, but after Sir Leon's death, Lady Peggy fell out with the other Trustees over some of the Gallery's more *avant-garde* acquisitions, and her failure to sign the final codicil to her will led to the sale of the collection, with the money realised going to Brisbane hospitals and charities.

On my visits to Lady Trout at Everton House, I saw that the paved streets around it, bisecting the blocks of land the Trouts had sold off to buy paintings, bore the names of leading Australian artists, in accordance with their wishes. Perhaps the streets are the Trouts' best memorial, rather than the dismantled art collection.

In 1992 the Australian police asked me to identify 48 paintings found in a drug bust on a Gold Coast motel. Among them, I was stunned to recognise two of the late Lady Trout's John Peter Russells, stolen from the Savill Gallery in Sydney two years previously.

Sir Leon and Lady Trout.

THE ROBERT HOLMES À COURT (1937–1990) COLLECTION

Janet and Robert Holmes à Court met at the University of Western Australia, where they were both students. Together they built up their family company, Heytesbury Holdings, until it became a vast empire with property interests in Australia, England and America, ranging from cattle ranches to some of the best known of London's West End theatres. Since her husband's sudden death in September 1990, Janet Holmes à Court has won the admiration of all Australians for the quiet determination with which she has taken over the running of the huge enterprise.

Recession and resulting cashflow problems have seen some French paintings quietly offered for sale, as well as the family mansion in central London where many were housed. However, the collection is still so vast and is housed in so many locales that it needs the services of a curator and a registrar to administer it. Like Jeanne Walter-Guillaume before her, Mrs Holmes à Court insists that the collection remains in her late husband's name as a memorial to him. Perhaps one day there may even be a Robert Holmes à Court Collection public gallery.

In the early and less affluent days of their marriage, when Robert was a young lawyer and his wife a teacher, the Holmes à Courts started off collecting with taste and flair. Their first purchases were historical works by Australian artists. Later they added Aboriginal art and Impressionists and Post-Impressionsts, including Monet, Morisot, Bonnard, van Gogh, Camille and Lucien Pissarro and van Rysselberghe, as well as Conder and Bunny, beloved by Australians.

In 1985 they paid $2.9 million for one of the most beautiful of Monet's grainstacks (pp.54–5), seen in misty pink twilight. Another coup was the purchase of van Gogh's *The yellow books* (p.101). During the mid-1980s, Robert Holmes à Court owned shares in Christie's, which may explain why so many of their major purchases have come through Christie's salerooms. At the time when the author worked for an art auctioneer, it was understood that Robert Holmes à Court would conduct his own bidding — over the telephone during a sale. For the purchase of French Impressionists through London or New York from Australia, it meant sitting up far into the night so that he could bid in person, rather than leaving such an important event to his curator.

The model for the Robert Holmes à Court Collection may well have been those of American billionaires whose great private col-

lections have become public endowments, thus ensuring their donors both immortality and tax benefits. The couple were always extremely generous with their collection. They loaned portions of it to exhibitions throughout Australia, as well as to Harvard University, and they have also lent minor works to public hospitals and mental health clinics.

Robert and Janet Holmes à Court.

ALAN BOND (b.1938)

'What you get now are not true collectors, but people who buy and sell, who are in it purely for the money' said Impressionist expert Eugène Thaw, on learning that Alan Bond had bought van Gogh's *Irises* for a world record price. Thaw was thinking about the great philanthropist-collectors of the '20s and '30s and did not like what he saw happening with Impressionist paintings in the late 1980s.

After he won the America's Cup, Bond was Australia's national hero. However, unlike America, Australia has no great tradition of cultural philanthropy in donating major paintings to public art galleries. London-born Alan Bond, considered by his critics to be *the* stereotype of the speculative art investor of the 1980s, emigrated to Western Australia with his parents as a young boy and worked as a signwriter before launching himself into his first speculations — in property. By the time Bond bought *Irises* late in 1987 he was Chairman of Bond International Corporation, and had interests in gold mines, Hong Kong high-rise property, a TV station, brewing, gas and airships.

Bond's introductory message in the catalogue of his collections states proudly that 'I decided to start investing in art seriously in 1980 for two reasons. Firstly because I enjoy looking at good paintings and secondly I realised that owning a valuable collection would not only be stimulating, it would be a sound investment.' With this aim Bond employed Angela Nevill, a goddaughter of the Queen, as his art advisor. Unkind critics suggested that since Bond had just bought the entire village of Glympton in England along with the manor house, he was hoping that Miss Nevill's connections would help him gain an English knighthood to go with it.

By the end of the Impressionist boom of the 1980s, some Impressionist paintings had increased in value by an incredible 500 per cent in four years. According to the liquidator's of his private company, Dalhold Investments, Bond's art collection was once valued at around $100 million. The collection contained seven major French Impressionist and Post-Impressionist works, a fine collection of Australian colonial art and major paintings by Australian Impressionists such as Rupert Bunny, Tom Roberts, Arthur Streeton and Charles Conder.

Bond's private company Dalhold Investments (which leased many of the paintings with the money that Australian and foreign banks were only to happy to lend Bond) had employed a young Edinburgh University graduate, Diana de Bussy, to curate the collection and keep records. Ms. de Bussy was recruited in Britain by Ms. Angela Nevill to prepare an illustrated catalogue of Bond's art collection. An exhibition of this corporate collection was seen by some critics as an attempt to improve Bond's flagging image, as share prices in Bond enterprises slumped.

In 1989 Bond's French Impressionist works were being rotated around Australian State galleries at a time when there was considerable ill-feeling among Chilean refugees over his purchase of the Chilean telephone service (which many claimed had been tapped to entrap those hostile to the Chilean dictatorship). Protestors at Bond's involvement in Chile threw red paint into the fountain at the Western Australian Art Galleries when *Irises* was on exhibition there. It was subsequently revealed that the most expensive painting in the world was not insured. It was, in fact, 50 per cent owned by Sotheby's Financial Services, who then repossessed the painting like a secondhand car. *Irises* was offered around the world, and was turned down by several collectors, including Norton Simon, before being purchased by the Getty Museum at an undisclosed price.

After a steep rise in bank interest and Bond's misguided attempts to repeat his outstanding success in the brewing industry by diversification into television and other enterprises, Manet's *The promenade* (p.21) was sold by Sotheby's for a profit of millions of dollars to make up the shortfall owed to their Financial Services Department on *Irises* (p.110–1). The Chemical Bank subsequently announced that they had financed the purchase of *The promenade* (p.21) and so were entitled to some of the $13 million dollar profit the painting had made at auction, but the outcome of this remains a mystery.

In July 1991 Dalhold Investments went into liquidation and there was considerable acrimony over who actually owned the remaining paintings: members of Bond's family claiming that certain paintings had been given to them prior to the bankruptcy.

Items of Bond's boardroom furniture were sold at Christie's in 1991, but investigations by the liquidator delayed the bankruptcy sale of Bond's Australian paintings, most of his major French Impressionists had been sold previously in Europe and Japan.

In October 1991, the Bond Collection was again in the news when one of Rupert Bunny's finest paintings, *A sultry night*, (purchased for just over a million dollars at auction in Australia by Dalhold) was burned to ashes in a fire that destroyed the warehouse of specialist art shippers James Bourlet in London. Bond's Rupert Bunny masterpiece had been awaiting shipment back to Australia after restoration. It seemed a sad end to what had once been Australia's finest private art collection.

AKRAM OJJEH (b. c.1924)

Akram Ojjeh, a multi-millionaire Saudi Arabian, has been collecting art for over two decades. He lives in France but shuns all publicity and his passion for secrecy means that he never lends any of his exquisite collection of Impressionists and Post-Impressionists to public exhibitions. Indeed, the general public only became aware of his existence when he bought, refurbished and then re-sold the famous liner *France*, which he had filled with fine paintings in a specially designed art-gallery.

Educated in Beirut, his parents decided he should make a career in the postal service, but young Akram begged to be allowed to finish his studies in Paris. A few months after his arrival the city was invaded by the German army, but Ojjeh showed all the *chutzpah* and talent for self-preservation which has brought him his multi-millions. He left Paris and spent the rest of the war in Nice, then part of unoccupied Vichy France,

where he worked as a lifeguard and perfected his knowledge of France and the French. A chance meeting with a member of the Saudi Royal family would change his life: in 1971 he was appointed exclusive agent for a number of international companies, and much of his fortune was acquired during the oil price hike of the 1970s, when the Saudi Government bought aviation, guns, shipping and other weaponry in enormous quantities.

Ojjeh is a passionate and clever collector, who has fulfilled the cardinal law of collecting and bought only the very finest works by the artists he loves. His important Impressionist collection is a logical manifestation of Ojjeh's long love-affair with France. His superb Monet sunsets and snow-scenes, his Renoirs, Sisleys, Bonnards and Fantin-Latours hang over exquisite eighteenth-century French side tables and commodes. His van Goghs are from the artist's Arles period — golden glowing paintings with arguably the finest version of the great *Bridge at Trinquetaille*, where Vincent has filled both river and sky with yellow light.

RYOEI SAITO (b. 1917)

In 1990 Japanese woodchip tycoon Ryoei Saito achieved a burst of fame by spending over $160 million in a single week on two paintings. Both of Mr. Saito's purchases are versions of paintings already well known and widely reproduced in art books: Renoir's *Ball at the Moulin de la Galette* (of which a larger version from the Caillebotte Bequest is in the Musée Orsay) and van Gogh's *Portrait of Dr. Gachet* (of which Dr. Gachet's own version is now also in the Musée d'Orsay). What both Mr. Saito's paintings have in common, and what helped boost their price, is their excellent provenance. The Renoir was purchased from the artist by Victor Chocquet, while van Gogh's own copy of Dr. Gachet's portrait was sold after the artist's death to Ambroise Vollard by Johanna van Gogh-Bonger.

Both paintings were bought at New York auctions in mid-1990 — just before the market for average Impressionist works crashed so spectacularly. It is believed in banking circles that even Mr. Saito, one of Japan's richest men, had to borrow from a bank against his considerable landholdings to help pay for his record-breaking purchases. According to the *Yomiuri Shimbun* newspaper, Mr. Saito paid more than $5 million in taxes in the year before he made his record-breaking purchases and told the newspaper, 'It [*The portrait of Dr. Gachet*] cost 5 billion yen [some $42 million] more than I anticipated. But that's nothing. Next I want the Renoir [*Ball at the Moulin de la Galette*].'

It appears that Mr. Saito lost much of an earlier art collection (whose contents are not known) when his business Daishowa Paper Manufacturing Co., Japan's second largest paper company, suffered reversals in 1981 due to increased oil prices. He was then forced to step down from the firm's presidency and become chairman. A decade later, his well-publicised buying spree caused the financial press to speculate that this could well be Mr. Saito's way of showing the world that both he and his company have made a comeback. In the same year, he also bought a superb Rodin sculpture for nearly $5 million (which received far less publicity than the Impressionist paintings).

Unlike Yasuda Fire and Marine Insurance, who purchased van Gogh's *Sunflowers* in the mid-1980s for $40 million, Ryoei Saito has not yet announced any plans to display the paintings that he bought, and he has not answered any written queries about them. However, the American *Journal of Art* has suggested that they may be warehoused for another ten years and eventually finish up in the Shizuoka Prefecture Museum which is run by Mr. Saito's younger brother, who is Governor of Shizuoka Prefecture. Private museums have been multiplying at about two per month in Japan, since tax benefits are received for the construction and expansion of museums rather than for donations of artworks in the American manner. Dealers report that many important (and not-so-important) Impressionist and Post-Impressionist works remain in shipping crates in Japanese bank vaults and in the air-conditioned rooms in the basement of some of Tokyo's most expensive homes.

SELECTED BIBLIOGRAPHY
— ART REFERENCE MONOGRAPHS

Adhémar, Jean, *Toulouse-Lautrec: Complete Lithographs and Drypoints*, Alpine Fine Arts Collection, London, 1987.

Adler, K. and Garb, T., *Berthe Morisot*, Phaidon, Oxford, 1987.

Beaumont-Maillet, *L'Oeuvre de Toulouse-Lautrec au Département des Estampes*, Bibliothèque Nationale, Paris, and Queensland Art Gallery, Brisbane, 1991.

Boyle, Richard, *American Impressionism*, New York Graphic Society, Greenwich, Conn., 1974.

Butel, Elizabeth, *The Lost Impressionist*, Sydney, 1979.

Cabanne, P., *The Great Collectors*, Farrar, Straus, 1963.

Daulte, François, *Auguste Renoir, Catalogue Raisoné de l'Oeuvre Peint*, Lausanne, 1971.

Denvir, Bernard, *Encyclopaedia of Impression*, Thames & Hudson, London, 1991.

Distel, Anne, *Impressionism, the First Collectors 1874–1886*, Harry N. Abrams, New York, 1990.

Duret, Théodore, *Histoire de Manet et de son Oeuvre*, Paris, 1902.

Faith, Nicholas, *Sold — The Revolution in the Art Market*, Hamish Hamilton, London, 1985.

Farr, Dr. Dennis, *English Art 1870–1940*, Oxford University Press, Oxford, 1984.

Galbally, Ann, *The Art of John Peter Russell*, Sun Books, Melbourne, n.d.

Garb, Tamar, *Women Impressionists*, Phaidon, Oxford, 1986.

Gaunt, W., *The Impressionists*, Thames & Hudson, London, 1980.

Gerdts, W. H., *American Impressionism*, Abbeville, New York, 1984.

Gulbenkian, Nubar, *Pantaraxis*, Hutchinson, London, 1965.

Herbert, Robert L., *Impressionism, Art, Leisure and Parisian Society*, Yale University Press, New Haven, Conn., 1988.

Hoff, Ursula, *Charles Conder, his Australian Years*, National Gallery of Victoria, 1971.

Hoschedé, Jean-Pierre, *Claude Monet, ce Mal-connu*, Paris, 1960.

Ingamells, J., *The Davies Collection of French Art*, National Museum of Wales, Cardiff, 1966.

Julian, P., *Les Grandes Collectionneurs*, Flammarion, Paris, 1966.

Laughton, B., *Philip Wilson Steer*, Clarendon Press, Oxford, 1971.

Lloyd, Christopher, (ed.) *Studies on Camille Pissarro*. Routledge & Kegan Paul, London and New York, 1987.

McColl, D.S., *Life, Work and Setting of Philip Wilson Steer*, Faber & Faber, London, 1946.

Nagera, Dr. Humerto., (Foreword by Anna Freud.), *Vincent van Gogh. A Psychological Study*, Allen & Unwin, London, 1967.

Pickvance, Ronald, *Van Gogh in Saint-Rémy and Auvers*, Metropolitan Museum of Art and Harry N. Abrams, New York, 1986.

Pool, P., and Orienti, S., *The Complete Paintings of Manet*, New York, 1967.

Reitlinger, Gerald, *The Economics of Taste*, Barrie & Rockliff, London, 1961–70.

Rewald, John, *History of Impressionism*, Secker & Warburg, London, 4th edition, 1980.

Rewald, John, *Cézanne and America, Dealers, Collectors, Artists and Critics, 1891–1921*, Thames & Hudson, London, 1989.

Richardson, John, *Manet*, Phaidon, Oxford, 1982.

Rothenstein, John, *The Life and Death of Conder*, Dent, 1938.

Rouart, Denis and Wildenstein, Daniel, *Edouard Manet, Catalogue Raisonné*, Lausanne, 1975.

Roudebush, Jay, *Mary Cassatt*, Bonfini Press, Switzerland, n.d.

Saarinen, A.B., *The Proud Possessors*, Random House, 1958.

Schneider, P., *The World of Manet*, New York, 1968.

Sérullaz, Maurice, *Concise History of Impressionism*, Omega Books, London, 1984.

Stein, Susan Alyson, *Van Gogh, a Retrospective*, Bay Books, London and Sydney, 1986.

Terasse, Antoine, *Degas*, Thames & Hudson, London, 1974.

Thomas, D., *Rupert Bunny*, Lansdowne Press, Melbourne, 1970.

Turnbull, Clive, *The Art of Rupert Bunny*, Ure Smith, Sydney, n.d.

Wilson, Michael, *The Impressionists*, Phaidon, Oxford, 1983.

Zurcher, Bernard, *Van Gogh: Art, Life and Letters*, Rizzoli, New York, 1985.

GENERAL AND ART JOURNAL ARTICLES AND EXHIBITION CATALOGUES

Ash, Russell, Selection from The Reader's Digest Collection. Intro by John Rewald. Reader's Digest Association, Inc., 1985, London.

Aspects of the Trout Collection. Philip Bacon Galleries, Brisbane, 1989.

Bailey, Colin B., Rishel, Joseph J., Rosenthal, Mark & Thielemans, Veerle, *Masterpieces of Impressionism and Post-Impressionism*. The Annenberg Collection, Philadelphia Museum of Art, Philadelphia, 1990.

Bergler, E., 'The Psychology of the Snob.' From *Selected Papers of Edmund Bergler*, M.D. Grune & Stratton, 1969.

Bernard, Emile, 'L'enterrement de Vincent van Gogh', *Art Documents*, February 1953.

Bruce, David S., *Robert Sterling Clark*, Nagoya Art Museum, n.d.

Cazalet, Camilla, *Heinz Berggruen. A Personal View*, National Gallery, London, 1991.

Correspondence between Auguste Rodin and John Peter Russell. Archives. Musée Rodin, Paris.

Czestochowski, J., 'Childe Hassam, painting from 1880–1900', *American Art Review*, January 1978.

Dickson Wright, Dr. A., 'Venereal Disease in the Great', *Journal of Venereal Diseases*, London, Vol. 47, 1971.

Farr, Dr. Dennis, *Masterpieces from the Courtauld Collection*, Yale University Press, New Haven, Conn. & London, 1987.

Fénéon, Felix, 'Salon des Indépendants, Paris, 1889', *La Vogue*, September 1889.

Finley, D.J., 'John Peter Russell: Australia's link with French Impressionism' *Journal of the Royal Society of Arts*, December 1966.

Gerdts, William H., American Impressionism. Thyssen-Bornemisza Foundation-Eidolon/Benzinger, Einsiedeln, 1990.

Gache-Patin, Sylvie, Douze Oeuvres de Cézanne du Collection Pellerin, *Revue du Louvre*, Vol. 34, Pt 2, 1984.

Haystacher, Paul. Monet in the Nineties. Exhibition Catalogue, Museum of Fine Arts, Boston & Yale University Press, New Haven, Conn., n.d.

House, Dr. J. and Distel, Anne, Renoir. Catalogue from the Hayward Gallery. Arts Council of Great Britain, London, 1985.

Hughes, Robert, 'On Art and Money', *The New York Review of Books*, 6 December 1984.

Kostenivich, Albert, Shchukin and Morosov — Article in 'The Russian Taste for French Painting — from Poussin to Matisse'. Metropolitan Museum, New York, 1990.

Le Bronnec, Guillaume, 'Gauguin's Life in the Marquesas', *Bulletin of the Oceanic Studies Society*, 1954.

Masterpieces of the Norton Simon Museum, n.d. Norton Simon Museum, Pasadena, California.

Mirbeau, Octave, 'Le Père Tanguy', *Des Artistes*, February 1894, Flammarion, Paris.

Old Masters New Visions — The Phillips Collection, Australian National Gallery, Canberra, 1988.

Richardson, Brenda, Dr. Claribel and Miss Etta. Baltimore Museum of Art, Baltimore, 1985.

Thannhauser, H., Van Gogh and John Russell. Some Unknown Letters and Drawings. *Burlington Magazine*, xxiii, 1938.

Van Gogh á Paris. Exhibition Catalogue. Ministére de la Culture et de la Communication, Paris, 1988.

Whitfield, Sarah, Impressionismus und Postimpressionismus. Fondazione Thyssen-Bornemisza and Electa, Milan, 1990.

INDEX

Numbers in italics represent paintings or illustrations